A SHORT HISTORY OF THE MIDDLE AGES

A SHORT HISTORY OF THE MIDDLE AGES

VOLUME I: FROM *c.*300 TO *c.*1150

BARBARA H. ROSENWEIN
SIXTH EDITION

UNIVERSITY OF TORONTO PRESS
Toronto Buffalo London

© University of Toronto Press 2023
Toronto Buffalo London
utorontopress.com
Printed in the U.S.A.

ISBN 978-1-4875-4606-9 (paper) ISBN 978-1-4875-4713-4 (PDF)
 ISBN 978-1-4875-4712-7 (EPUB)

Library and Archives Canada Cataloguing in Publication

Title: A short history of the Middle Ages / Barbara H. Rosenwein.
Names: Rosenwein, Barbara H., author.
Description: Sixth edition. | Also published together in one complete volume. | Includes bibliographical references and indexes. | Contents: Volume I: From c.300 to c.1150
Identifiers: Canadiana (print) 20220266840 | Canadiana (ebook) 20220266875 | ISBN 9781487546069 (v. 1 ; softcover) | ISBN 9781487547127 (v. 1 ; EPUB) | ISBN 9781487547134 (v. 1 ; PDF)
Subjects: LCSH: Middle Ages. | LCSH: Europe – History – 476–1492.
Classification: LCC D117 .R67 2023 | DDC 940.1 – dc23

We welcome comments and suggestions regarding any aspect of our publications – please feel free to contact us at news@utorontopress.com or visit us at utorontopress.com.

Every effort has been made to contact copyright holders; in the event of an error or omission, please notify the publisher.

We wish to acknowledge the land on which the University of Toronto Press operates. This land is the traditional territory of the Wendat, the Anishnaabeg, the Haudenosaunee, the Métis, and the Mississaugas of the Credit First Nation.

University of Toronto Press acknowledges the financial support of the Government of Canada and the Ontario Arts Council, an agency of the Government of Ontario, for its publishing activities.

ONTARIO ARTS COUNCIL
CONSEIL DES ARTS DE L'ONTARIO
an Ontario government agency
un organisme du gouvernement de l'Ontario

Funded by the Financé par le
Government gouvernement
of Canada du Canada Canadä

For Sophie, Natalie, Joshua, Julian, and Benji, with love.

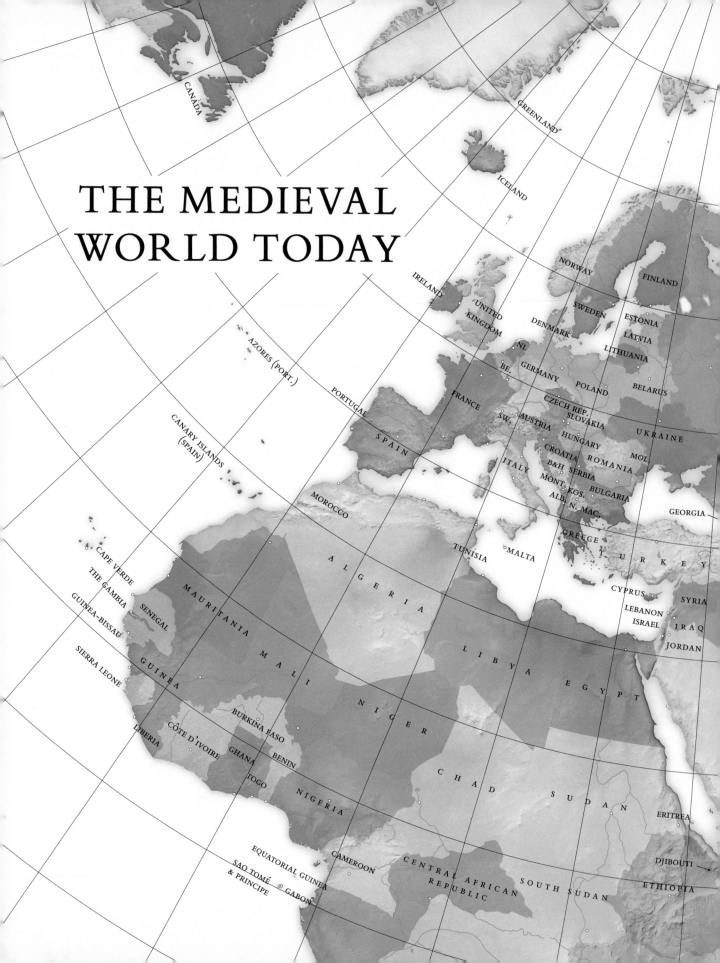

THE MEDIEVAL WORLD TODAY

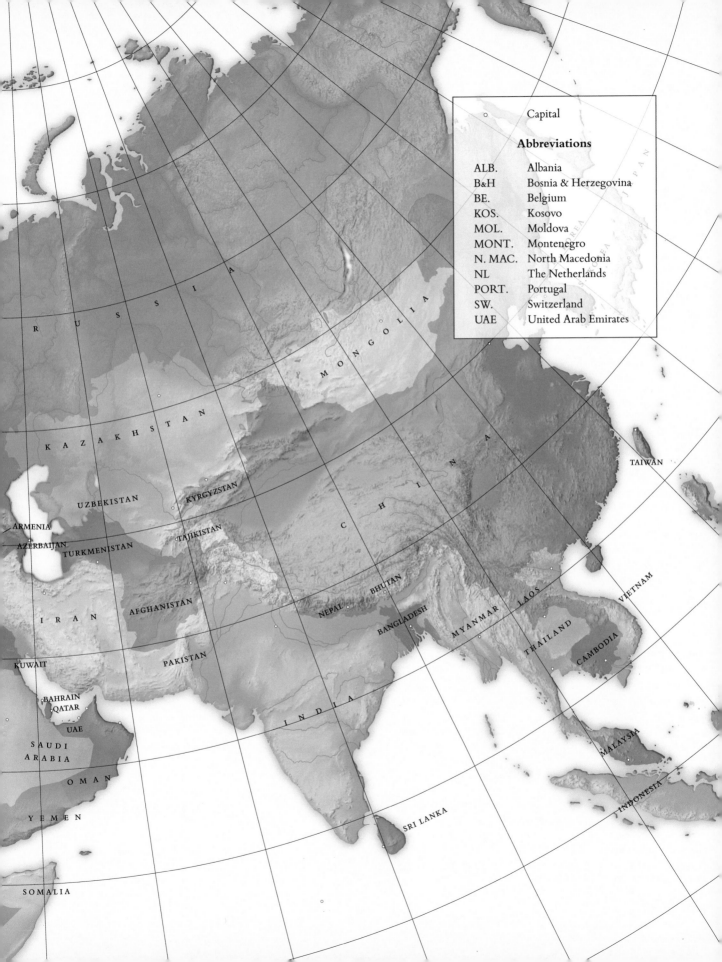

Capital

Abbreviations

ALB.	Albania
B&H	Bosnia & Herzegovina
BE.	Belgium
KOS.	Kosovo
MOL.	Moldova
MONT.	Montenegro
N. MAC.	North Macedonia
NL	The Netherlands
PORT.	Portugal
SW.	Switzerland
UAE	United Arab Emirates

RUSSIA

MONGOLIA

KAZAKHSTAN

UZBEKISTAN KYRGYZSTAN

ARMENIA

AZERBAIJAN

TURKMENISTAN TAJIKISTAN

CHINA

TAIWAN

IRAN AFGHANISTAN

NEPAL BHUTAN

BANGLADESH

MYANMAR LAOS

VIETNAM

KUWAIT PAKISTAN

THAILAND CAMBODIA

BAHRAIN
QATAR

UAE

SAUDI
ARABIA

INDIA

MALAYSIA

OMAN

INDONESIA

YEMEN

SRI LANKA

SOMALIA

The union of the Roman Empire was dissolved; its genius was humbled in the dust; and armies of unknown barbarians, issuing from the frozen regions of the North, had established their victorious reign over the fairest provinces of Europe and Africa.
Edward Gibbon, *The Decline and Fall of the Roman Empire*

It may very well happen that what seems for one group a period of decline may seem to another the birth of a new advance.
Edward Hallett Carr, *What Is History?*

CONTENTS

MAPS

PLATES

GENEALOGIES

FIGURES

WEBSITE

 For practice questions about the text, maps, plates, and other features – plus suggested answers – please go to

www.utphistorymatters.com

There you will also find all the maps, genealogies, and figures used in the book.

ABBREVIATIONS
AND CONVENTIONS

Abbreviations

c.	circa. Used to indicate that dates or other numbers are approximate.
cent.	century
d.	date of death
emp.	emperor
fl.	flourished. This is given when even approximate birth and death dates are unknown.
pl.	plural form of a word
r.	dates of reign
sing.	singular form of a word

Conventions

All dates are CE/AD unless otherwise noted (the two systems are interchangeable). The dates of popes are not preceded by r. because popes took their papal names upon accession to office, and the dates after those names apply only to their papacies.

The symbol / between dates indicates uncertainty: e.g., Boethius (d.524/526) means that he died sometime between 524 and 526.

The Church as an abstract institution is capitalized. But when a church is a physical building in a particular place, the word is not capitalized. Similarly, the abstract State is capitalized, but when state refers to an individual polity, it is not.

ACKNOWLEDGMENTS

I thank Riccardo Cristiani for reading all chapters and providing pertinent suggestions and cautions. He also authored two "Material Culture" inserts, which I have lightly updated here. I am similarly indebted to Albrecht Diem, who read and commented on all the chapters and wrote the website questions. This sixth edition has benefited enormously from maps produced by medievalist and cartographer Erik Goosman, whom I thank most warmly. I owe a debt of gratitude as well to archaeologist Elizabeth Fentress, who generously read and critiqued my discussion of Volubilis/Walila, a North African site; and to sinologist Robert Hymes, who clarified various hypotheses about the original location of the medieval variant of the plague. I am equally grateful to all the readers, many anonymous, who made suggestions for improving earlier editions of *A Short History of the Middle Ages*. A full list of names of the many scholars who helped with particular sections would begin to sound like a roll call of medievalists, both North American and European; I hope they will forgive me if I thank them collectively here. At UTP, I am indebted to Judith Earnshaw, Natalie Fingerhut, Tania Therien, and Alexandra Grieve. Matthew Jubb at Em Dash Design beautifully enhanced the "look" of the book.

NOTE TO READERS

This new edition continues to stress the changing nature of history by making clear where historians have changed their minds or disagree about key issues. History is not a set of "facts," though those (when known!) are useful. Equally important, if not more so, are the interpretations and connections that historians constantly make – and remake – of those facts.

In keeping with recent research, this edition also continues and expands its wide purview, placing new emphasis on global connections where relevant. Although the term "Middle Ages" was coined for a period in European history, I do not find it particularly meaningful except to refer to a chronological slice of time, around 300 to 1500. That *period of time* was equally experienced everywhere. But the particular focus of medieval history – which I take to be the whole region once ruled by Rome, plus the successors of that Empire, plus the permutations experienced by those successors, including their conquests and their conquerors – impels me to bring in the rest of the world where its history intersects with that of the heirs of Rome in important ways.

CHAPTER ONE
HIGHLIGHTS

Reign of Emperor Constantine
306–337
Promotes the Christian God; sponsors Christian churches; issues (with co-emperor Licinius) the Edict of Milan (313); and presides over the Council of Nicaea (325).

Edict of Milan
313
Declares toleration for all the religions of the Roman Empire; restores Church property taken during the persecutions.

Council of Nicaea
325
Declares the laws and doctrines of the Christian Church; condemns the Arian view of Christ's nature.

Death of Augustine of Hippo
430
The major Church Father in the West. His *City of God* defines the relationship between this world and the next; his *Confessions* remains a model of self-exploration.

Reign of Emperor Justinian
527–565
Sponsors major legal initiatives including the Codex Justinianus and the Digest that will be consulted and built upon for centuries; temporarily reconquers North Africa and Italy; builds Hagia Sophia at Constantinople; supports the construction of San Vitale at Ravenna.

Benedictine Rule
530–560
Written mainly for the monks of Monte Cassino, it becomes (9th cent.) the major monastic rule in the West.

Pope Gregory the Great
590–604
Asserts the power and importance of the papacy in Italy and elsewhere; sends missionaries to England to convert the kings and people to the Roman Catholic form of Christianity.

ONE

PRELUDE: THE ROMAN WORLD TRANSFORMED (*c.*300–*c.*600)

At the beginning of the third century, the Roman Empire wrapped around the Mediterranean Sea like a scarf. (See Map 1.1.) Thinner on the North African coast, it bulked large as it enveloped what is today Spain, England, Wales, France, and Belgium, and then evened out along the southern coast of the Danube River, following that river eastward, taking in most of what is today called the Balkans (southwestern Europe, including Greece), crossing the Hellespont and engulfing in its sweep the territory of present-day Turkey, much of Syria, and all of modern Lebanon, Israel, Egypt and the rest of North Africa. All the regions but Italy comprised what the Romans called the "provinces." All its inhabitants had initially come under Roman rule by force of arms; all its freemen had (by 212) been granted the burdens and privileges of Roman citizenship.

This was the Roman Empire whose "decline and fall" was famously proclaimed by the eighteenth-century historian Edward Gibbon. The idea persisted; even today, it prevails in some quarters. But in the 1960s, it was fundamentally challenged by Peter Brown. Dubbing the period 150–750 "Late Antiquity," he stressed its cultural and religious vitality. Although more recently that positive assessment has been called into question by scholars such as Bryan Ward-Perkins and Kyle Harper, most historians now accept a nuanced view. While it is undoubtedly true, as Ward-Perkins and Harper argue, that some in the Roman Empire suffered from a steep decline in standards of living, climate change, and the ravages of pandemic, others did not. Judith Herren insists that Late Antiquity was an era of extraordinary dynamism because it ushered in "a newly Christianized world." (For all modern author references, see Further Reading at the end of each chapter.) At this point, it is probably best to stress two points: first, it is not that one historian is "right" and the other "wrong" but that good historians will base their interpretations on different criteria; second, the Roman Empire was not a monolith but rather a patchwork of diverse regions and communities. A decline for one group often meant rejuvenation for another.

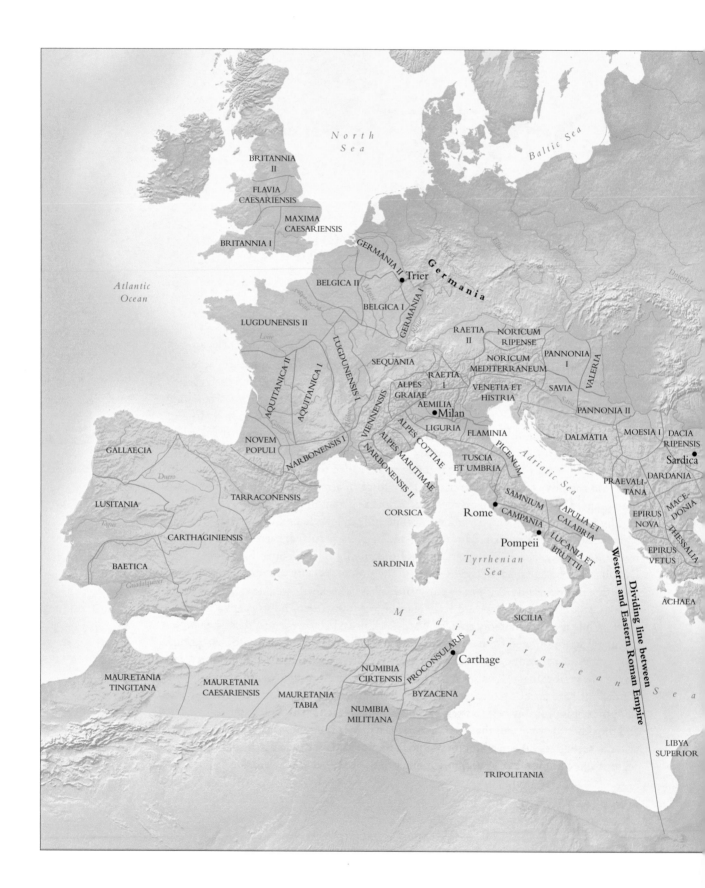

Map 1.1 The Roman Empire, c.300

Caspian Sea

Black Sea

DIOSPONTUS

SCYTHIA

PAPHLAGONIA

PONTUS
POLEMONIACUS

Dnieper

MOESIA II

Danube

PICENUM

ARMENIA
MINOR

Sasanid Empire of the Persians

HAEMIMONTUS

THRACIA EUROPA

Chalcedon

Kızıl Irmak

Byzantium

Nicomedia

RHODOPE

Nicaea

BITHYNIA

CAPPADOCIA

MESOPOTAMIA

GALATIA

HELLESPONTUS

PHRYGIA
II

PHRYGIA I

OSRHOENE

Euphrates

*Aegean
Sea*

LYDIA

PISIDIA

CILICIA

ASIA

Ephesus

SYRIA COELE

CARIA

LYCIA ET
PAMPHYLIA

ISAURIA

Antioch

AUGUSTA LIBANENSIS

Palmyra

CYPRUS

PHOENICIA

Damascus

CRETA ET
CYRENAICA

Jerusalem

ARABIA I

PALAESTINA

ARABIA II

Alexandria

AEGYPTUS
IOVIA

LIBYA INFERIOR

AEGYPTUS
HERCULIA

Nile

THEBAIS

TRIPOLITANIA	Roman province

0 500 km

0 300 mi

Certainly, the old elites of the cities, especially at Rome itself, generally regretted the changes taking place around them *c.250–c.350*. They were witnessing the end of their political, military, religious, economic, and cultural leadership. That role was passing to the provincials (the Romans living outside of Italy) for whom this was in many ways a heady period, a long-postponed coming of age. They did not regret that Emperor Diocletian (r.284–305) divided the Roman Empire into four parts, each ruled by a different man. It was tacit recognition of the importance of the provinces. But even the provinces eventually lost their centrality, as people still farther afield (whom the Romans called "barbarians") moved in *c.400–c.500*. The barbarians, in turn, were glad to be the heirs of the Roman Empire even as they contributed to the political demise of its western half.

THE PROVINCIALIZATION OF THE EMPIRE (*c.250–c.350*)

The Roman Empire was too large to be ruled by one man in one place, except in peacetime. This became clear during the so-called crisis of the third century, when two different groups from two different directions bore down on the frontiers of the Empire. From the east came the Persians, an ancient culture ruled by a king whose pride and pretensions were as great as those of the Roman emperors. From the north, beyond the Rhine and Danube Rivers, came diverse peoples whom the Romans dubbed "barbarians," a demeaning term signifying "not us" – not Roman citizens, not Latin- or Greek-speaking. Less unified than the Persians, they nevertheless presented a significant military challenge. To contend with the attacks on both its flanks, the Roman government responded with wide-ranging reforms that brought new prominence to the provinces.

Above all, the government expanded the army, setting up crack mobile troops and reinforcing the standing army. Soldier-workers set up new fortifications, cities were ringed with walls, farms gained lookout towers and fences. It was hard to find enough recruits to man this newly expanded defensive system. Before the crisis, the Roman legions had been largely self-perpetuating. The legionaries, drawn mainly from local provincial families, had settled permanently along the borders and raised the sons who would make up the next generation of recruits. Now, however, this supply was dwindling: the birthrate was declining, and *c.252–267* an epidemic of smallpox ravaged the population further. Recruits would have to come from farther away, from Germania (the region beyond the northern borders of the Empire) and elsewhere. In fact, long before this time, Germanic warriors had done stints in the Roman army and then gone home. But in the third century the Roman government began a new policy: it settled Germanic and other barbarian groups within the Empire, giving them land in return for military service.

The challenges faced by the Empire were not only the outside invaders, but also the internal woes of disease and political turmoil. Suffering from a pandemic (likely a viral hemorrhagic fever) that began mid-century and persisted for about twenty years, the Empire also endured a political succession crisis. Between the years 235 and 284, more

than twenty men were declared emperor; none lasted long. Most of them came from the Lower Danube region, provinces far from Rome. Creatures of the army, they were chosen to rule by their troops. Some led "breakaway empires," symptomatic of increasing decentralization, disaffection with Rome, and the power of the provincial army legions. The city of Rome itself was too far from any of the fields of war to serve as military headquarters. For this reason, Emperor Maximian (r.286–305) turned Milan into a new capital city, complete with an imperial palace, baths, walls, and circus. Soon other favored cities – Trier, Sardica, Nicomedia, Constantinople (formerly Byzantium), and much later Ravenna – joined Milan in overshadowing Rome.

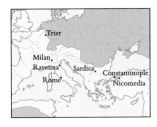

Map 1.2 The Capital Cities of the Empire

The primacy of the provinces was further enhanced by the need to feed and supply the army. To meet its demand for ready money, the Roman government debased the currency, increasing the proportion of inferior metals to silver. While helpful in the short term, this policy produced severe inflation. Strapped for cash, the state increased taxes and used its power to requisition goods and services. To clothe the troops, it confiscated uniforms; to arm them, it set up factories staffed by artisans who were required to produce a regular quota of weapons (spears, short swords, shields) for the state. Food for the army had to be produced and delivered; here too the state depended on the labor of growers, bakers, and haulers. New taxes assessed on both land and individual "heads" were collected. The wealth and labor of the Empire moved inexorably toward the provinces, the hot spots where armies were clashing.

The whole Empire, organized for war, became militarized. In about the middle of the third century, Emperor Gallienus (r.253–268) forbade the senatorial aristocracy – the old Roman elite – to lead the army. Tougher men from the ranks were promoted to command positions, and some became emperors. They brought provincial tastes and sensibilities to the very heart of the Empire, as we shall see.

From the reaches of the Lower Danube came Diocletian (r.284–305), who brought the crisis under control, and Constantine (r.306–337), who brought it to an end. For administrative purposes, Diocletian divided the Empire into four parts (called the Tetrarchy), later reduced to two. Although the emperors who ruled these divisions were supposed to confer on all matters (and even be the best of friends, as Plate 1.6 on p. 19 suggests), the partition was a harbinger of things to come, when the eastern and western halves of the Empire would go their separate ways. Meanwhile, the pandemic came to an end, the wars over imperial succession ceased with the establishment of Constantine's dynasty, and political stability halted the border wars.

A New Religion

The Empire of Constantine was meant to be the Roman Empire restored. In fact, his rule marks its transformation, as it was ever more surely marked by the culture and religion of its provinces.

The province of Palestine was among the foremost of these. Although the elites of Italy considered it a dismal backwater, in fact Palestine had long been a hotbed of creative religious and social ideas. Chafing under Roman dominion, experimenting with new notions of morality and new ethical lifestyles, the Jews of Palestine gave birth to religious groups of breathtaking originality. One coalesced around Jesus. After his death, under the impetus of the Jew-turned-Christian Paul (d.c.67), a new and radical brand of monotheism in Jesus's name was actively preached to Gentiles (non-Jews), not only in Palestine, but also beyond. Its core belief was that men and women were saved, that is, redeemed and accorded eternal life in heaven, by their faith in Jesus – at once the son of God and the Messiah (that is, the savior, the Christ, the anointed one).

At first, Christianity was of nearly perfect indifference to elite Romans, who were devoted to the gods that had served them so well over years of conquest and prosperity. Nor did it attract many of the lower classes, who were still firmly rooted in old local religious traditions. The Romans had never insisted that the provincials whom they conquered give up their beliefs; they simply added official Roman gods into local pantheons. Or (as in Plate 1.5 on p. 18) the locals changed the name of their gods to accord with those worshipped by the Romans. For most people, both rich and poor, the rich texture of religious life at the local level was both comfortable and satisfying. In dreams, they encountered their personal gods, who served them as guardians and friends. At home were their household gods, evoking family ancestors. Outside, on the streets, they visited temples and monuments to local gods, reminders of home-town pride. Here and there they encountered monuments to the "divine emperor" put up by rich town benefactors. But not just the emperor was divinized; all the dead left in their wake divine spirits that continued to have power over the living. Their tombs, erected in cemeteries located outside of the cities, were the focal point for a nine-day festival of offerings to the spirits of the dead. That and other religious ceremonies punctuated the Roman year. Paganism was thus at one and the same time personal, familial, local, and imperial.

But Christianity had its attractions, too. Romans and other city-dwellers of the middle class could never hope to become part of the educated upper crust. Christianity gave them dignity by substituting "the elect" – those saved by God – for the elite. Education, long and expensive, was the ticket into Roman high society. Christians had their own solid, less expensive knowledge. It was the key to an even "higher" society – the one in Heaven.

In the provinces, Christianity attracted women and men who had never been given the chance to feel truly Roman. The new religion was confident, hopeful, and open to all. As the Empire settled into an era of peaceful complacency in the second century, its hinterlands welcomed the influence of the center, and vice versa. Men and women whose horizons in earlier times would have stretched no farther than their village now took to the roads as traders – or confronted a new cosmopolitanism right at their doorsteps. Uprooted from old traditions, they found comfort in small assemblies – churches – where they were welcomed as equals and where God was the same, no matter what region the members of the church hailed from.

Map 1.3 Christian Populations
at the End of the 3rd cent.

The Roman establishment persecuted Christians, but at first only locally, sporadically, and above all in times of crisis. At such moments, the adherents of the old religion feared that the gods were venting their wrath on the Empire because Christians, most of whom were Roman citizens, would not carry out the proper sacrifices. Roman Jews also refused to honor the pagan gods, but Roman officialdom could usually tolerate – just barely – Jewish practices as part of their particular cultural identity. Christians, however, claimed their God not only for themselves but for all. Major official government persecutions of Christians began in the 250s, with the third-century crisis.

By 304, on the eve of the promulgation of Diocletian's last great persecutory edict, perhaps only 10 per cent of the population of the Roman Empire was Christian. Even so, Christianity was taking root in the major cities (see Map 1.3), and it was spreading beyond the Empire as well: in Edessa (shown on the map) and soon in parts of the Caucasus and in the Aksumite kingdom of Ethiopia in the Horn of Africa.

Despite their tiny absolute number, the Christians in the Roman Empire were well organized. Gathered into "churches" (from the Greek word, *ekklesia*, meaning "assembly"), they formed a two-tiered institution. At the bottom were the people (the "laity," from the Greek *laikos*, meaning "of the people"). Above them were the clergy (from the Greek word *kleros*, meaning "lot," or "inheritance," and referring to the biblical book of Deuteronomy

18:2, where the Levitical priests have no inheritance but "the Lord himself"). In turn, the clergy were supervised by a regional bishop (in Greek *episkopos*, "overseer"), assisted by his "presbyters" (from the Greek *presbyteroi*, "elders," the priests who served with the bishops), deacons, and lesser servitors. Some bishops – those of Alexandria, Antioch, Carthage, Jerusalem, and Rome, whose bishop was later called the "pope" – were more important than others. No religion was better prepared for official recognition.

This it received in 313. In the so-called Edict of Milan, Emperors Licinius and Constantine declared toleration for all the religions in the Empire "so that whatever divinity is enthroned in heaven may be gracious and favorable to us."[1] In fact, the Edict helped Christians above all: they had been the ones persecuted, and now, in addition to enjoying the toleration declared in the Edict, they regained their property. Constantine was the chief force behind the Edict: it was issued just after his triumphant battle at the Milvian Bridge against his rival Maxentius in 312, a victory that he attributed to the God of the Christians. Constantine seems to have converted to Christianity; he certainly favored it, erecting and endowing church buildings, making sure that property was restored to churches that had been stripped during the persecutions, and giving priests special privileges. Under him, the ancient Greek city of Byzantium became a new Christian city, residence of emperors, and named for the emperor himself: Constantinople. The bishop of Constantinople became a patriarch, a "superbishop," equal to the bishops of Antioch and Alexandria, although not as important as the bishop of Rome. In one of the crowning measures of his career, Constantine called and then presided over the first ecumenical (universal) Church council, the Council of Nicaea, in 325. There the assembled bishops hammered out some of the doctrines and laws (known as "canon laws") of the Church.

After Constantine, it was simply a matter of time before most people considered it both good and expedient to convert. Toward the end of the century, as the highest echelons of the Roman elite began to shower their countless riches on Christian churches, Emperor Theodosius I (r.379–395) declared, in a series of laws, that the form of Christianity determined at the Council of Nicaea applied to all. Christianity was now the official religion of the Roman Empire. In some places, Christian mobs took to smashing local pagan temples. Thus did a fragile religion hailing from an obscure province triumph everywhere in the Roman world.

But "Christianity" was not one thing. In North Africa, Donatists – who considered themselves purer than other Christians because they had not backpedaled during the period of persecutions – fought bitterly with other believers all through the fourth century, ready to kill and die to prevent priests and bishops from resuming their offices if they had handed over their Bibles, church furnishings, and other emblems of their faith to Roman authorities to escape death. As paganism gave way, Christian disagreements came to the fore: what was the nature of God? where were God and the sacred to be found? how did

1 *The Edict of Milan*, in *A Short Medieval Reader*, ed. Barbara H. Rosenwein (Toronto: University of Toronto Press, 2023), pp. 1–2 and in *Reading the Middle Ages: Sources from Europe, Byzantium, and the Islamic World*, 3rd ed., ed. Barbara H. Rosenwein (Toronto: University of Toronto Press, 2018), pp. 1–4.

God relate to humanity? In the fourth and fifth centuries, Christians fought with each other ever more vehemently over doctrine and the location of the holy.

DOCTRINE

The so-called Church Fathers were the victors in the battles over doctrine. Already in Constantine's day, Saint Athanasius (*c.*295–373) – then secretary to the bishop of Alexandria, later bishop there himself – had led the challenge against the beliefs of the Christians next door. He called them "Arians," rather than Christians, after the priest Arius (250–336), another Alexandrian and a competing focus of local loyalties. Athanasius promoted his views at the Council of Nicaea (325) and won. It is because of this that he is considered the orthodox catholic "Father," while Arius is the "heretic." For both Athanasius and Arius, God was triune, that is, three persons in one: the Father, the Son, and the Holy Spirit. Their debate was about the nature of these persons. For the Arians, the Father was pure Godhead while the Son (Christ) was created. Christ was, therefore, flesh though not quite flesh, neither purely human nor purely divine, but mediating between the two. To Athanasius and the assembled bishops at Nicaea, this was heresy – the wrong "choice" (the root meaning of the Greek term *hairesis*) – and a damnable faith. The Council of Nicaea wrote the party line: "We believe in one God, the Father almighty,... And in one Lord Jesus Christ, the Son of God, begotten from the Father,... begotten not made, of one substance [*homousios*] with the Father."[2] Arius was condemned and banished. His doctrine, however, persisted. It was the brand of Christianity that Ulfila (311–*c.*382), a Gothic bishop with Roman connections, preached to the Goths beyond the borders of the Empire, at the same time translating the Bible into the Gothic language. (For the Goths, see pp. 23–26.)

Arianism was only the tip of the iceberg. Indeed, the period 350–450 might be called the "era of competing doctrines." Already the Council of Nicaea worried not only about Arians but also about groups (later called Monophysites or Miaphysites) who held that the "flesh" that God assumed as Christ was nevertheless entirely divine. Thus, the Nicene Creed went on to declare that Jesus Christ, "because of us men and because of our salvation came down and became incarnate." That is, Jesus became *human* flesh.[3] Despite that decision, ratified by later councils, especially one held at Chalcedon (451), Monophysite belief in the divinity of Christ's flesh nourished the Armenian, Coptic (Egyptian), and Ethiopian Christian churches and still does so today.

Even Augustine (354–430), eventually the bishop of Hippo, a saint, and the most influential Western churchman of his day (and for many centuries thereafter), flirted in his youth with yet another variant of Christianity, Manichaeism. The Manichees, armed with a revelation from Mani, "apostle of Jesus Christ," believed in two cosmic principles, one godly, spiritual, and light; the other evil, material, and dark. For the Manichees, Jesus's human nature was not real; its materiality and suffering were only apparent. Human beings were

2 *The Nicene Creed*, in *Reading the Middle Ages*, p. 11.
3 *The Nicene Creed*, in *Reading the Middle Ages*, p. 11.

mired in the material world, but they might liberate themselves from its shackles by fasting, renouncing sex, disdaining all forms of property, and clinging to the special knowledge brought to mankind by Christ's apostles. People who did that were Manichaean saints, but others, too weak to be saints, showed their support of their purer brethren "by their faith and their alms."[4] They nurtured the hope of being reborn in new bodies and eventually becoming one of the saints.

Another heretic was Pelagius, a contemporary of Augustine. Pelagius also was interested in what human beings could do to achieve salvation. He thought that conversion bleached out sins, and thereafter people could follow God by their own will. But just as Augustine repudiated the Manichees for their dualism, which made God only one of two cosmic powers, so he rejected Pelagianism for its woeful misreading of human nature. In Augustine's view, human beings were capable of nothing good without God's grace working through them: "Come, Lord, act upon us and rouse us up and call us back! Fire us, clutch us, let your sweet fragrance grow upon us!"[5]

Like arguments over sports teams today, these disputes were more than small talk: they identified people's loyalties. They also brought God down to earth. If God had debased himself to take on human flesh, it was critical to know how he had done so and what that meant for the rest of humanity.

For these huge questions, Augustine wrote most of the definitive answers for the Latin West, though they were certainly modified and reworked over the centuries. In the *City of God*, a huge and sprawling work, he defined two cities: the earthly one in which our feet are planted, in which we are born, learn to read, marry, get old, and die; and the heavenly one, on which our hearts and minds are fixed. The first, the "City of Man," is impermanent, subject to fire, war, famine, and sickness; the second, the "City of God," is the opposite. Only there is true, eternal happiness to be found. Yet the first, however imperfect, is where the institutions of society – local churches, schools, governments – make possible the attainment of the second. Thus "if anyone accepts the present life in such a spirit that he uses it with the end in view of [the City of God],... such a man may without absurdity be called happy, even now."[6] In Augustine's hands, the old fixtures of the ancient world were reused and reoriented for a new Christian society.

THE SOURCES OF GOD'S GRACE

The City of Man was fortunate. There God had instituted his Church. Christ had said to Peter, the foremost of his twelve apostles (his "messengers"):

4 *Manichaean Texts*, in *Reading the Middle Ages*, pp. 10–11.
5 *The Confessions of Saint Augustine* 8.4, trans. Rex Warner (New York: A Mentor Book, 1963), p. 166.
6 Augustine, *The City of God*, in *A Short Medieval Reader*, pp. 11–13 and in *Reading the Middle Ages*, pp. 16–20.

Thou art Peter [*Petros*, or "rock" in Greek]; and upon this rock I will build my Church, and the gates of hell shall not prevail against it. And I will give to thee the keys of the kingdom of heaven. And whatsoever thou shalt bind upon earth, it shall be bound also in heaven; and whatsoever thou shalt loose on earth, it shall be loosed also in heaven. (Matt. 16:18–19)

This passage was variously interpreted, and the popes at Rome maintained it meant that, as the successors of Saint Peter, the first bishop of Rome, they held the keys. But no one doubted that the declaration confirmed that the all-important powers of binding (imposing penance on) and loosing (forgiving) sinners were in the hands of Christ's earthly heirs, the priests and bishops. In the Mass, the central liturgy (service) of the earthly Church, the bread and wine on the altar became the body and blood of Christ, the "Eucharist." Through the Mass the faithful were joined to one another; to the souls of the dead, who were remembered in the liturgy; and to Christ himself.

The importance of the Mass was made clear in the very architecture and decoration of Christian churches. An example is the sixth-century church of San Vitale in Ravenna, where the apse (a large semi-circular structure at the eastern end of the church) forms a brilliant marble and mosaic halo around the altar. Above the altar, full-length figures of the emperor (on the left) and empress (on the right) along with their retinues bring the bread and wine to the altar. (See Plate 1.12 and further discussion on pp. 33–37.) In this way, the emperor and empress associated their earthly power with the Eucharist and the Mass.

The Eucharist was one potent source of God's grace. There were others. Above all, there were the saints – people so beloved by God, so infused with his grace, that they were both models of virtue and powerful wonder-workers. In the early Church, the saints had mainly been the martyrs, men and women who died for their faith. After the time of Constantine, when Christians were no longer persecuted, the saints of the fourth and fifth centuries found ways to be virtual martyrs even while alive. A few were like Saint Symeon Stylites (c. 390–459), who climbed a tall pillar and stood there for decades. But many were inspired by the model of Saint Antony (250–356), who lived as a hermit for a time and eventually led a community of committed ascetics. Symeon, Antony, and others like them were "athletes of Christ." Purged of sin by their ascetic rigors – giving up their possessions, fasting, praying, not sleeping, not engaging in sex – these holy women and men offered compelling role models. So, for example, twelve-year-old Asella, born into Roman high society, was inspired by such athletes to remain a virgin. She shut herself off from the world in a tiny cell where, as her admirer Saint Jerome put it, "fasting was her pleasure and hunger her refreshment."[7] This sounds a bit like Manichaeism, and the similarities are certainly real. But Asella was also devoted to the shrines of martyrs, which were very much part of the material world and yet, for Christians, were godly as well.

7 Jerome, *Letter 24 (To Marcella)*, in *Reading the Middle Ages*, pp. 28–30.

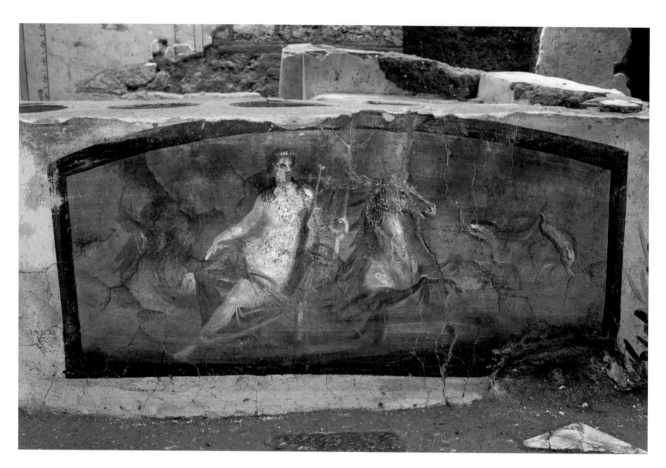

Plate 1.1 Nereid Astride a Seahorse (1st cent.). Numerous frescoes have been uncovered at Pompeii, once a bustling get-away for Romans before a fatal volcanic eruption at nearby Mount Vesuvius. In what was once a busy town square was this low wall fronting a "street food" counter. Decorated with gorgeous, brightly colored paintings, it was designed to attract the attention of hungry customers. The portion shown here features a nereid riding an iridescent seahorse, perhaps alluding to the seafood that vendors were ready to dole out from the pots behind her.

Beyond offering models of Christian virtue, the saints interceded with God on behalf of others and made peace among bickering neighbors. Saint Athanasius told the story of Saint Antony: after years of solitude and asceticism the saint emerged

> as if from some shrine, initiated into the mysteries and filled with God.... When he saw the crowd [awaiting him], he was not disturbed, nor did he rejoice to be greeted by so many people. Rather, he was wholly balanced, as if he were being navigated by the Word [of God] and existing in his natural state. Therefore, through Antony the Lord healed many of the suffering bodies of those present, and others he cleansed of demons. He gave Antony grace in speaking, and thus he comforted many who were grieved and reconciled into friendship others who were quarreling.[8]

Healer of illnesses, mediator of disputes, worker of wonders, Antony's power was not only spiritual but also physical and judicial.

But who was in charge of such power, and who had the right to control it? Bishop Athanasius of Alexandria claimed Antony's legacy by writing about it. Yet writing was

8 Athanasius, *The Life of Saint Antony of Egypt*, in *A Short Medieval Reader*, pp. 5–8 and in *Reading the Middle Ages*, pp. 30–34.

only one way to appropriate and harness the power of the saints. When holy men and women died, their power lived on in their relics (whatever they left behind – their bones, hair, clothes, sometimes even the dust near their tombs). Pious people knew this very well. They wanted access to these "special dead." Rich and influential Romans got their own holy monopolies simply by moving saintly bones home with them. Plate 1.8 on p. 21 shows the wall of just such a house, decorated with the image of an orant (a praying figure) – perhaps representing a martyr – and two kneeling women. Above them, hidden and yet tantalizingly present behind a grate, were the precious remains of martyrs.

Men like Saint Ambrose (339–397), bishop of Milan, wanted clergymen, not laypeople, to be the overseers of relics. With great fanfare, he "discovered" the bones of the martyrs Gervasius and Protasius. As he reported to his sister, when he transported the relics to his new-built cathedral, he was joined by crowds of people. A blind man was healed, possessed people were cured, and Ambrose buried the bones under the altar of his church. In this way, he allied himself, his successors, and the whole Christian community of Milan with the power of the saints. His actions set a precedent for many other churches. But laypeople continued to find private ways to keep precious bits of the saints near to them, enclosed in rings, lockets, purses, and belt buckles.

From Local Identities to Imperial Culture

Just as Christianity came from the periphery to transform the center, so too did various provincial artistic traditions. Classical Roman art was based on the Hellenistic models and styles that had been introduced to regions east of Greece by Alexander the Great and his successors. After Greece became part of the Roman Empire in 133 BCE, those styles were emulated by Roman artists. Their main features are nicely exemplified by two paintings and a cinerary coffer from the first century (Plates 1.1, 1.2, and 1.3). The paintings play with light and shadow, evoke a sense of atmosphere – of earth, sky, air, water, light – and offer the illusion of movement. In all three plates, figures – sometimes lithe, sometimes stocky, always "plastic" – suggest volume and weight. They interact and touch one another, caring little or nothing about the viewer.

In Plate 1.1 the muted colors – purples, blues, and orange-pinks – create the impression of watery depths. As if illuminated, a sea-nymph (a nereid) – a female divinity and model of feminine beauty – holds a lyre and rides a rainbow-hued horse. The artist captures a sense of motion and sun-dappled waves. Even though the nereid is meant to beckon customers to buy the food that has been prepared in pots hidden behind the low wall on which she is painted, she acts as if no one is looking at her. She and the dolphins who leap around her are utterly self-absorbed, glimpsed as if through a window onto their private world.

That world was recognizably natural, much like the one the viewers lived in. Plate 1.2 is a panel from an extensive fresco originally painted in a corridor of the Villa Farnesina, located in a suburb of Rome. It features lithe figures painted with rapid brushstrokes and engaged in various activities. Some (on the far left) fill water jugs at a fountain. Others

Plate 1.2 (following pages) Harbor Scene (late 1st cent. BCE). One of many painted panels in a long corridor at the Villa Farnesina (today on display at the Palazzo Massimo in Rome), the scene suggests an idealized outside world: spacious, busy, airy, and light.

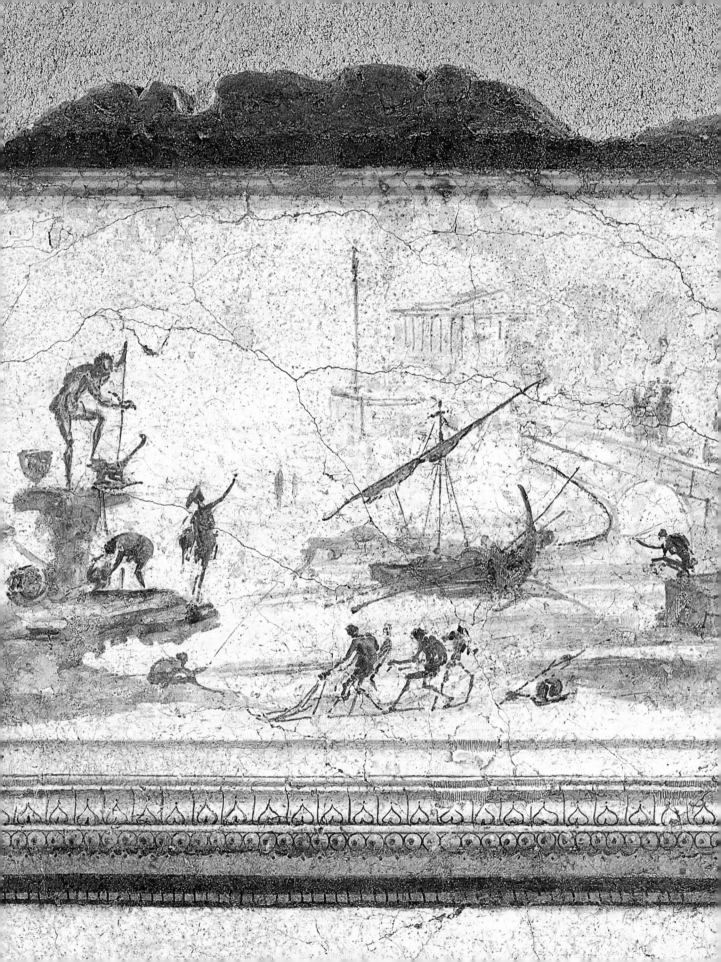

Plate 1.3 Cinerary Coffer of Vernasia Cyclas (1st cent.). This marble coffer was commissioned to hold the ashes of the twenty-seven-year-old Vernasia Cyclas, the "most excellent" wife of Vitalis, a former slave of the emperor who eventually became a high-court official. Eventually his own ashes would be added to the box. The sculptor shows husband and wife with right hands joined, a gesture symbolizing their marriage ceremony. It was a moment highly prized by Vitalis, since as a slave he had had no right to marry. The couple stands before the door of a temple, their bodies solid and weighty, as once they were in flesh. Like the nereid in her watery world, they too are entirely absorbed in each other, unaware of the living who might come to visit and honor them.

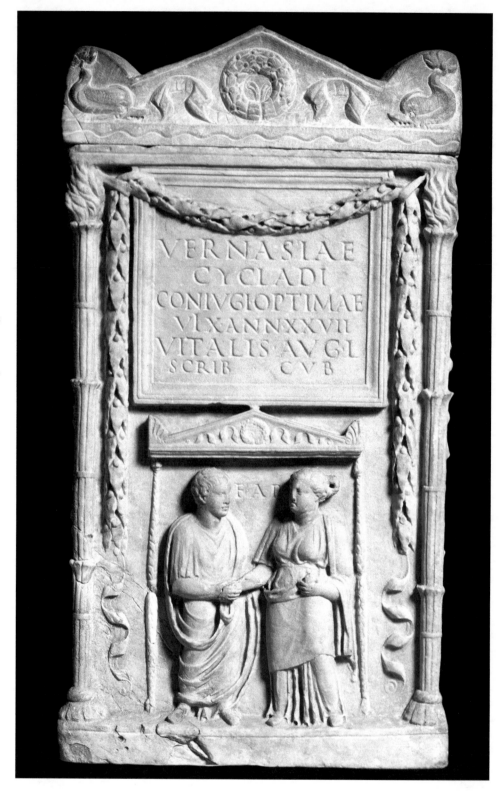

VERNASIAE
CYCLADI
CONIVGIOPTIMAE
VIXANNXXVII
VITALIS AVG L
SCRIB CVB

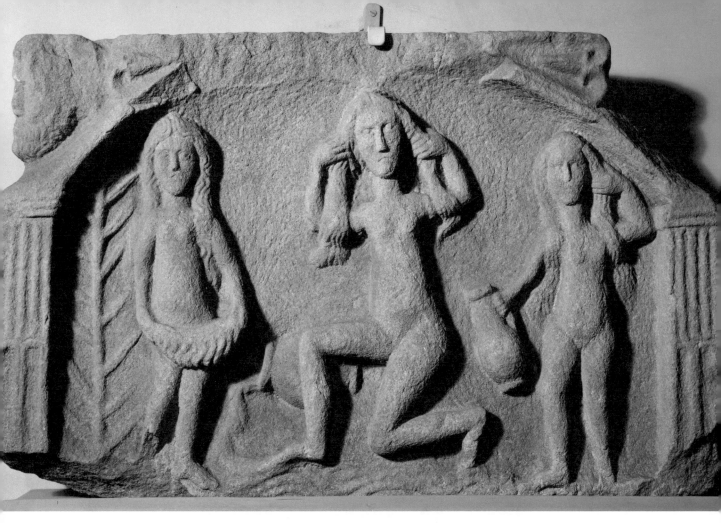

ready their fishing nets. Still others pass by a two-story villa. In the distance, across the water, are the faint outlines of a building that may be a temple. Here the artist has evoked space and distance by using the optical illusion of "perspective," where some elements seem to recede while others – smaller and less precisely delineated – come to the fore. The Villa Farnesina itself was too far from Rome's working port for this to represent its local landscape. But the likely owner, the Roman statesman and architect Agrippa, had in fact built a bridge over the Tiber River and thus was personally involved in the very fabric of the life as depicted here.

The cinerary coffer in Plate 1.3 shows a married couple turning to one another, each holding the other's right hand. The sculptor has created a sense of space by experimenting with different levels of "relief," so that some elements are carved almost in the round and therefore come to the fore, while others, flatter and nearly two-dimensional, seem to recede into the distance.

These works of art are without question dominated by Hellenistic classical styles. But very different artistic values and conventions had once flourished in the provinces of the Empire. For many years those local styles had been tamped down, though not extinguished, by the juggernaut of Roman political and cultural hegemony. Then, in the third

Plate 1.4 Venus and Two Nymphs, Britain (2nd or early 3rd cent.). This relief originally decorated the front of a water tank that stood before the headquarters of the Roman fort at High Rochester (today in Northumberland), strategically located on the road to Scotland. Compare the depiction of the nymphs here with the nereid in Plate 1.1 (p. 12) to see the very different notions of the human body and beauty that coexisted in the Roman Empire.

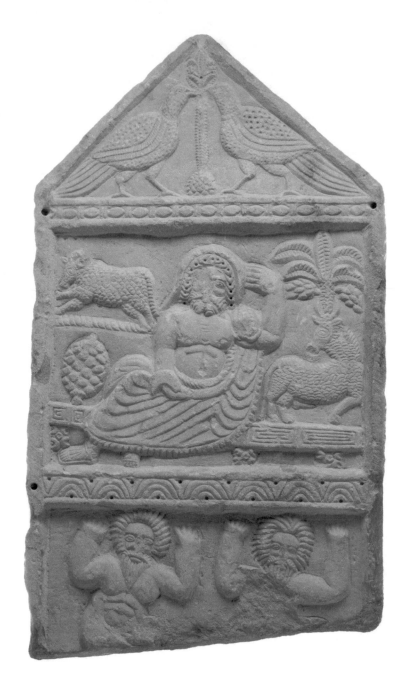

Plate 1.5 Votive Stela to Saturn, Tunisia (2nd cent.). After Rome conquered the North African Carthaginian Empire in 146 BCE, its god Baal was renamed for the Roman god Saturn. He is depicted here with his traditional attributes: a sickle in his right hand and a mantle draped over his head. Votive stelae (stone slabs offered in fulfillment of a vow) such as this were enormously popular in North Africa in both the pre-Roman period and long after the Romans conquered it – indeed, until the mid-fifth century.

century, with the new importance of the provinces, some regional artistic traditions began to compete with those at Rome.

Among the provinces that asserted themselves artistically in spite of Rome's influence were Britain and North Africa. Consider the relief of Venus and two nymphs from the north of Britain in Plate 1.4 on p. 17. Venus is the center of attention here not because she is part of a story meant to draw the viewer into an alternative world but because she is right in the center and taller than anyone else. Neither she nor her handmaids interact

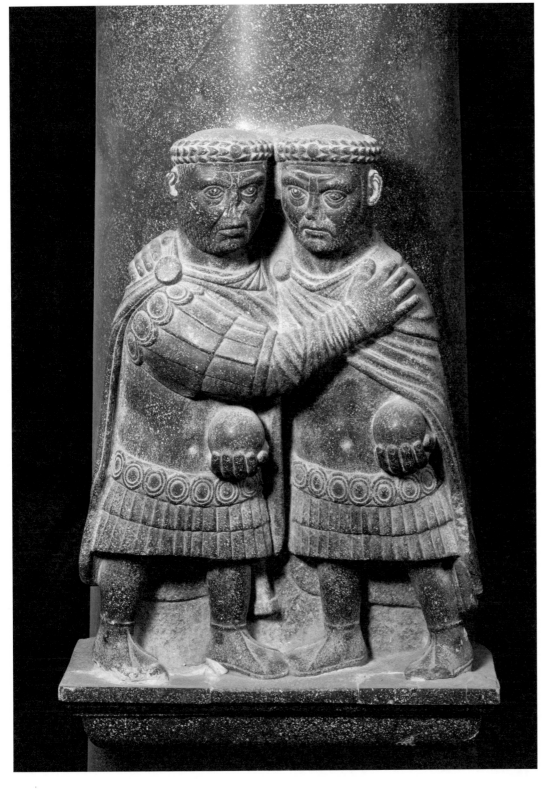

Plate 1.7 Diptych of the Lampadii (396). Consular diptychs had long been offered as gifts by high-ranking dignitaries to their friends and followers on important occasions in their careers. Although made for a Roman official, this carving was inspired less by the classical forms of the cinerary coffer in Plate 1.3 than by the stylistic conventions of the Tunisian votive stela in Plate 1.5. That style was suited to telegraphing hierarchy and authority, exactly the point of this depiction of Lampadius.

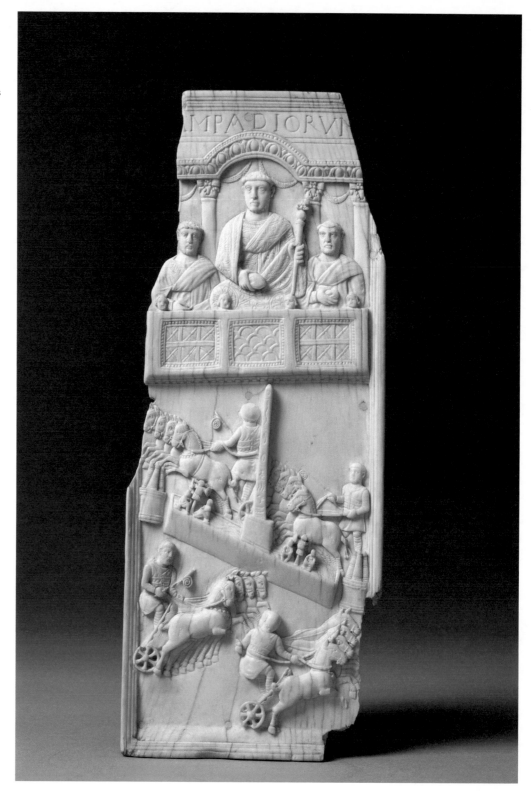

with each other; they look straight out, to a reality beyond the viewer. The little here that evokes nature has been turned into a design: the tree on the left plays with diagonal lines; the "grass" is a series of waves. Hair is composed of decorative swirls. These goddesses seem to exist in a place that transcends the here and now.

The same emphasis on hierarchy and decoration explains the horizontal zones of the North African limestone votive stela in Plate 1.5 (p. 18). In the center is the god Saturn, seated on a throne and surrounded by animals (a bull and a lamb) that are to be sacrificed to him. Beneath are two worshippers who symbolize the dedicants of the stela. They hold up their arms in the ancient gesture of prayer. In the top tier are two peacocks flanking a stylized tree, an image of the heavenly realm. The sculptor is inter-

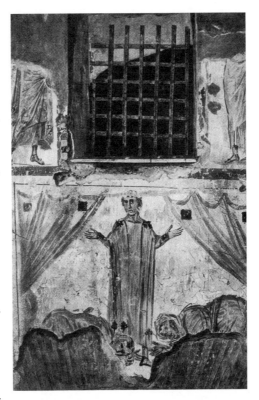

Plate 1.8 Orant Fresco, Rome (second half of 4th cent.). In a private house located in a posh neighborhood in Rome, an imposing figure commands the lower wall of a small room serving as a *confessio*, which contained the remains of martyrs. At the time, the house functioned as a *titulus*, or community church. We see here the sorts of lay devotional initiatives – a confessio in a private house – that Bishop Ambrose of Milan hoped to end.

ested in patterns – flattening the figures, varying them by cutting lines for folds, hands, and eyes, and hair. Any sense of movement here comes from the decoration, not the rigid figures. Unlike the harbor scene of the Villa Farnesina in Plate 1.2, this stela is no window onto a private world; unlike the couple on the cinerary coffer of Plate 1.3, its figures do not interact or betray emotion. Rather, they exist to teach and preach the god's importance.

There may be something to the idea that such works of art were "inferior" to the Hellenistic style of Roman products – but not much. The artists who made them had their own values and simply were uninterested in classical conventions. Indeed, in the third century, even artists at the heart of the Empire – at Rome, at Constantinople – adopted some of the provincial styles. Those conventions spoke best to new needs and interests.

The "new" official style is nicely illustrated by the depiction of two emperors in Plate 1.6 (p. 19). Carved out of expensive, "imperial" porphyry stone, it was meant to telegraph amity and authority. When Diocletian divided the Empire into four administrative districts, each ruled by a "Tetrarch" (ruler of a quarter), their unity was broadcast in a profusion of just such sculpted images. The two in Plate 1.6 are nearly identical; gone is the impulse (evident, for example, in the Vernasia Cyclas coffer) to individualize. The sculptor is interested only in the gesture of embrace and the impression of power, symbolized by the heavy stone and the orbs both men hold in their left hands. Despite their friendliness, they do not look at each other. Decorative elements – the details of their military garb, the leaves of their laurel wreaths – provide the only relief from the somber message here.

While the Tetrarchs were depicted as equals, other monuments of the fourth century telegraphed hierarchy. Consider Plate 1.7, an ivory carving made in 396 for Lampadius, a

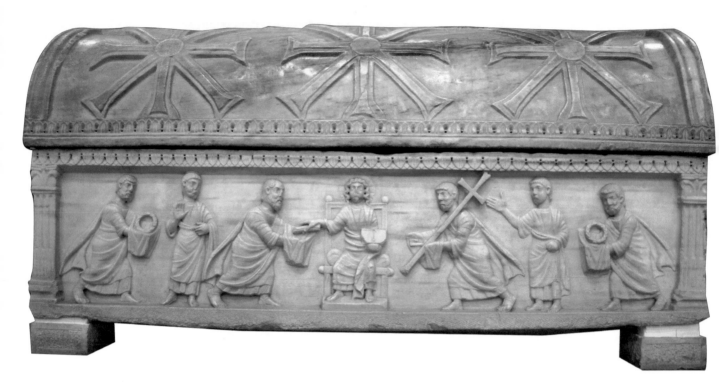

Plate 1.9 Sarcophagus of the Twelve Apostles, Ravenna (early 5th cent.). The figures of this relief are carved nearly in the round. They move and gesture, twist and turn. In those ways, they are "classical" in inspiration. However, the fact that they exist in a vast expanse of empty space, framed only by a bit of decorative architecture, betrays the sculptor's disinterest in the natural world. The event that the sarcophagus memorializes – Christ handing over the scroll of the New Law – is neither historical nor scriptural but rather meant to be understood as a timeless truth.

high imperial official charged with organizing spectacles to celebrate the "birth" of Rome. Originally the left side of a diptych, it depicts the moment when Lampadius, flanked by two lesser officials, has given the signal for a chariot race to begin. Stiff and straight, he looks out beyond the viewer, heedless of the two men at his side. The sculptor is interested in decoration and design – the folds of clothing, the cap-like hair-dos, the repeated heads and feet of the horses – rather than in depicting figures of weight and flesh. The ensemble is meant to show the high status of the Lampadii – Lampadius's whole family – and their importance beyond the here and now.

Although this new, official style of art was not initially Christian, it was quickly adopted by Christians. It was suited to a religion that saw only fleeting value in the City of Man, sought to transcend the world, and had a message to preach. A good example is the fourth-century wall painting decorating a small *confessio* – a place where martyrs or their relics were buried. (See Plate 1.8, mentioned earlier on p. 13.) The wall, originally in an alcove on the landing of a private house in Rome, is today beneath a church dedicated to two martyr-saints, John and Paul. Much like the figures on the stela in Plate 1.5, the painting immediately communicates a spiritual hierarchy. Whoever the standing orant (praying man) might represent (there are conflicting interpretations), it is clear that he dominates the scene while two figures in postures of humility touch his feet. The curtains that frame the scene may symbolize a place of eternal rest. Certainly, the fresco, like the stela, marked a burial site, since behind the grill above the orant were the remains of a martyr or martyrs. Like the figures on the stela, those in the fresco have no weight, exist in no landscape, and interact with no one. We shall continue to see the influence of this transcendent style throughout the Middle Ages.

Nevertheless, around the very same time as this fresco was produced, the "old" Roman artistic styles were making a brief comeback even in a Christian context. Sometimes called the "renaissance of the late fourth and early fifth centuries," this was the first of many recurring infusions of the classical spirit into medieval art. Consider the sarcophagus of the Twelve Apostles, carved in the early fifth century (Plate 1.9). Already in the second century, inspired by the fashion set by Emperor Hadrian (r.117–138), most Romans chose to be buried (rather than cremated as Vernasia Cyclas had been in the first century) and that practice continued into the Christian period. In Plate 1.9, the person who commissioned the sarcophagus was certainly Christian and very wealthy, possibly a bishop or archbishop living in or near Ravenna. Here, on the front of the tomb, a young and beardless Christ is approached by three apostles on either side (the remaining six apostles are depicted on the end panels of the sarcophagus). The one to his right, Saint Paul, is reverently receiving the scroll of the New Law from Christ's own hand; Paul's hands are covered by a veil, indicating how precious the object is. Although Christ himself is clearly the most important figure – seated on a throne in the center of the composition – there are no upper and lower zones to suggest a hierarchy. And although Christ is immobile, the apostles who come toward him move and gesture, suggesting a drama of awe, humility, and receptivity. All the figures are carved in the round, their garments revealing their form and heft.

THE BARBARIANS

The classicizing style exemplified by the sarcophagus of the Twelve Apostles did not long survive the sack of Rome by the Visigoths in 410. The sack was a stunning blow. Like a long-married couple in a bitter divorce, both Romans and Goths had once wooed one another; they then became mutually and comfortably dependent; eventually they fell into betrayal and strife. Nor was the Visigothic experience unique. The Franks, too, had been recruited into the Roman army, some of their members settling peacefully within the imperial borders.

The Romans called all these peoples "barbarians," though, borrowing a term from the Gauls, they designated those beyond the Rhine as "Germani" – Germans. Historians today tend to differentiate these peoples linguistically: "Germanic peoples" are those who spoke Germanic languages. Whatever name we give them (they certainly had no collective name for themselves), these peoples were not nomads (as an earlier generation of historians believed) but rather accustomed to a settled existence. Archaeologists have found evidence in northern Europe of some of their hamlets, built and inhabited for centuries before any Germanic groups entered the Empire. A settlement near Wijster, near the North Sea (today in the Netherlands), is a good example of one such community. Inhabited largely between *c.*150 and *c.*400, it consisted of well over fifty large rectangular wooden houses – these were partitioned so that they could be shared by humans and animals – and many smaller out-buildings, some of which were used as barns or workrooms, others as

Map 1.4 Wijster

dwellings. Palisades – fences made of wooden stakes – marked off its streets and lanes. The people who lived at Wijster cultivated grains and raised cattle. They also bred horses, as we know from the fact that they frequently buried their horses in carefully dug rectangular pits. Some were craftsmen, like the carpenters who built the houses, the ironworkers who made the tools, and the cobbler who made a shoe found on the site. Some were craftswomen, like the spinners and weavers who used the spindle-whorls and loom-weights that were found there.

The disparate sizes of its houses suggest that the community at Wijster was hardly egalitarian. Its cemetery made the same point since, while most of the graves contained no goods at all, a few were richly furnished with weapons, necklaces, and jewelry. The elite also seem to have had access to Roman products: archaeologists have unearthed a couple of Roman coins, bits of Roman glass, and numerous fragments of provincial Roman pottery. But even the rich at Wijster were probably not very powerful: it is very likely that here, as elsewhere in the Germanic world, kings with military retinues lorded it over this and other communities in their reach, commanding labor services and a percentage of agricultural production.

The better-off inhabitants of Wijster probably got their Roman dinnerware through trade with Roman provincials along the border. No physical trait distinguished buyers from sellers. But barbarians and Romans had numerous *ethnic* differences – differences created by preferences and customs surrounding food, language, clothing, hairstyle, behaviors, and all the other elements that go into a sense of identity. Germanic ethnicities were often in flux as tribes came together and broke apart (of course, Roman ethnic identity changed as well, as we have seen with the Lampadii choice of artistic style).

In the case of the Goths, historians have been able to trace a long "ethnogenesis" – the many ethnicities that they took on and shed over time. It is best to imagine them as not one people but many. If it is true that a group called the "Goths" (Gutones) can be found in the first century in what is today northwestern Poland, that does not mean that they much resembled those "Goths" who, in the third century, organized and dominated a confederation of steppe peoples and forest dwellers of mixed origins north of the Black Sea (today Ukraine). The second set of Goths was a splinter of the first; by the time they got to the Black Sea, they had joined with many other groups. In short, the Black Sea Goths were multi-ethnic.

Taking advantage – and soon becoming a part – of the crisis of the third century, the Black Sea

Map 1.5 The Huns and the Visigoths, *c.375–450*

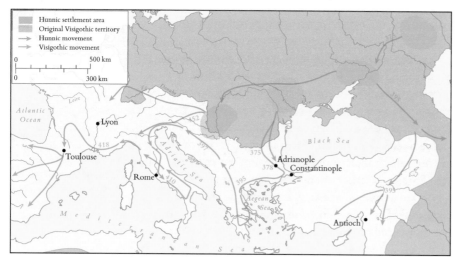

Goths invaded and plundered the nearby provinces of the Roman Empire. The Romans responded at first with annual payments to buy peace, but before long they stopped, preferring confrontation. Around 250, Gothic and other raiders and pirates plundered parts of the Balkans and Anatolia (today Turkey). It took many years of bitter fighting for Roman armies, reinforced by Gothic and other mercenaries, to stop these raids. Afterwards, once again transformed, the Goths emerged as two different groups: eastern (Ostrogoths), again north of the Black Sea, and western (Visigoths), in what is today Romania. By the mid-330s, the Visigoths were allies of the Empire and fighting in their armies. Some rose to the position of army leaders. By the end of the fourth century, many Roman army units were made up of whole tribes – Goths or Franks, for example – fighting as "federates" for the Roman government under their own chiefs.

This was the marriage.

It fell apart, however, in the later fourth century, when the Visigoths, soon joined by others, requested entry into the Empire. They were fleeing the Huns, largely Turkic-speaking pastoralists from the semi-arid, grass-covered plains (the "steppeland") of west-central Asia. One branch of this multi-ethnic group invaded the Black Sea region in 376 and then moved west into what is today Romania, uprooting the Gothic groups living there and driving some to treat with the Romans and enter the Empire.

Barbarians had long been settled within the Empire's borders as army recruits. But in this case the numbers were unprecedented: tens of thousands, perhaps even up to 200,000. The Romans were overwhelmed, unprepared, and resentful. They mistreated the refugees woefully, and in 378 a group of Visigoths and other barbarians rebelled, killing Emperor Valens (r.364–378) at the battle of Adrianople. The defeat meant more than the death of an emperor; it badly weakened the Roman army. Because the emperors needed soldiers and the Visigoths needed food and a place to settle, various arrangements were tried: treaties making the Visigoths federates; promises of pay and reward. None worked for long. Led by Alaric (d.410), an army of Visigoths set out to avenge their wrongs and to find land. Map 1.5 traces their long trek across Europe. Their sack of Rome in 410 inspired Augustine to write the *City of God*, but the Visigoths did not long remain in Italy. Joined by many other barbarian groups as well as Roman slaves taking advantage of the mayhem, they settled in southern Gaul by 418 and by 484 had taken most of Spain as well. The impact of the Visigoths on the western part of the Roman Empire was decisive enough, however, for some historians to take the date 378 to mark the end of the Roman Empire, while others have chosen the date 410. (Other historians, to be sure, have disagreed with both dates!)

Meanwhile, beginning late in 406 and perhaps also impelled by the Huns, other barbarian groups – among them Vandals and Sueves – entered the Empire by crossing the Rhine River. They first moved into Gaul, then into Spain. The Vandals crossed into North Africa; the Sueves remained in Spain, though the Visigoths conquered most of their kingdom in the course of the sixth century. When, after the death in 453 of the powerful Hunnic leader Attila, the empire that he had created along the Danubian frontier collapsed, still other groups – Ostrogoths, Rugi, Gepids – moved into the Roman Empire. Each arrived with a "deal" from the Roman government; each hoped to work for Rome and reap its

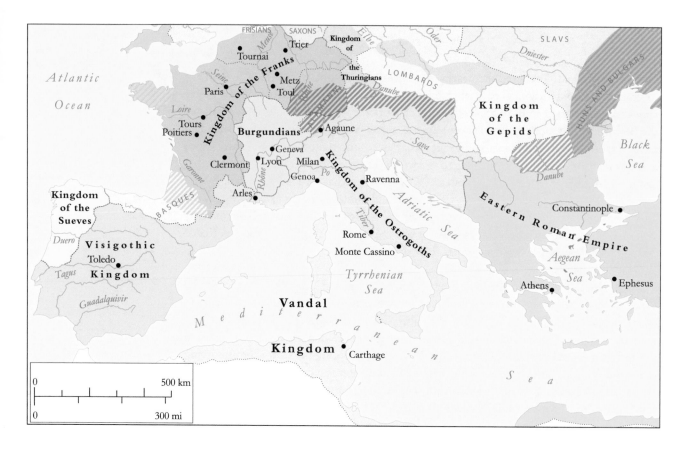

Map 1.6 The Former Western Empire, c.500

rewards. In 476 the last Roman emperor in the West, Romulus Augustulus (r.475–476), was deposed by Odoacer (433–493), a barbarian (from one of the lesser tribes, the Sciri) leading Roman troops. Odoacer promptly had himself declared king of Italy and, in a bid to "unite" the Empire, sent Romulus's imperial insignia to Emperor Zeno (r.474–491), ruler of the eastern half of the Roman Empire. But Zeno, unamused, authorized Theodoric the Great, king of the Ostrogoths, to attack Odoacer in 489. Four years later, Theodoric's conquest of Italy was complete; he ruled there from 493 to 526. Not much later the Franks, long used to fighting for the Romans, conquered Gaul under Clovis (r.481/482–511), king of the Franks, by defeating a provincial governor of Gaul and several barbarian rivals. Meanwhile, other barbarian groups set up their own kingdoms.

Around the year 500 the former Roman Empire no longer looked like a scarf flung around the Mediterranean; it looked more like a jigsaw puzzle. (See Map 1.6.) Much of North Africa was under Vandal rule, the Hispanic Peninsula was dominated by the Visigoths, a large swath of Gaul was ruled by the Franks, and Italy was now the Kingdom of the Ostrogoths. Continental immigrants joined indigenous populations in lowland Britain; the Burgundians formed a polity centered in what is today Switzerland. Only the eastern half of the Empire – the long end of the scarf – remained relatively intact. And yet few at the time thought that much had changed: most people still considered themselves Roman, and the barbarian kings thought they were ruling within – not against – the Empire.

THE NEW ORDER

Indeed, what was new about the "new order" of the sixth century was less the rise of barbarian kingdoms than it was, in the West, the decay of the cities balanced by the liveliness of the countryside, the increased dominance of the rich, and the quiet domestication of Christianity. In the East, the Roman Empire continued, made an ill-fated bid to expand, and, while keeping a foothold in the West, turned eastward to deal with Persia.

The Ruralization of the West

Where the barbarians settled, they did so with only tiny ripples of discontent from articulate Roman elites. How was that possible? Perhaps the barbarian kings did not confiscate Roman estates, but rather simply collected the normal imperial estate taxes. More likely, the barbarians were settled as "guests" directly on land belonging to Roman property owners. In that case, barbarian kings, influenced by their Roman advisors, managed to defuse outright conflict. In either scenario, the end result was that elite "Romans" and "barbarians" gradually came to belong to the same community of free landowners.

But before this merging could take place, the great barrier to assimilation between Romans and barbarians – divergent religious beliefs – had to be overcome. Recall that Ulfila had preached Arianism to the Goths (p. 9 above), and many other barbarian groups adopted this brand of Christianity as well. Clovis, king of the Franks, may have been the first Germanic king to choose the Roman version (though, if so, the ruler of Burgundy was close behind). Clovis had flirted with Arianism early on, but he soon converted to the Catholic Christianity of his Gallic neighbors. Bishop Avitus of Vienne welcomed this move with open arms: "Your faith is our victory."[9]

The new rulers adopted Roman institutions in another important way: they issued law codes that drew on Roman imperial precedents like *The Theodosian Code* (see below, p. 31), regulations governing rural life found in Roman provincial law codes, and possibly tribal customary law as well. *The Visigothic Code* was drawn up during the course of the fifth through seventh centuries. Another law book was issued in 517 by Sigismund, styling himself king of the Burgundians (r.516–524). A Frankish law code was compiled under King Clovis, fusing provincial Roman and Germanic procedures into a single whole.

Written in Latin, these laws revealed their Roman inspiration even in their language. Barbarian kings, some well-educated themselves, depended on classically trained advisors to write up their letters and laws. In Italy, in particular, a well-educated group of Roman administrators, judges, and officers served the Ostrogothic king Theodoric the Great. They included the learned Boethius (d.524/526), who wrote the tranquil *Consolation of Philosophy* as he awaited execution for treason, and the encyclopedic Cassiodorus (490–583), who wrote the letters issued by King Theodoric. Since the fourth century, Romans

9 Avitus of Vienne, *Letter to Clovis*, in *Reading the Middle Ages*, pp. 43–44.

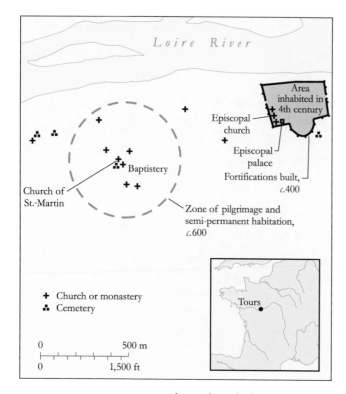

Loire River

Area inhabited in 4th century

Episcopal church

Episcopal palace

Fortifications built, c.400

Baptistery

Church of St.-Martin

Zone of pilgrimage and semi-permanent habitation, c.600

+ Church or monastery
⚘ Cemetery

Tours

0 500 m

0 1,500 ft

Map 1.7 Tours, c.600

had become used to barbarian leaders; in the sixth, it did not seem odd to have them ruling as kings.

But the disappearance of the urban middle class was strange indeed. It was largely due to the new taxes of the fourth century. The town councilors – the *curiales*, traditional leaders and spokesmen for the cities – used to collect the taxes for their communities, making up any shortfalls, and reaping the rewards of prestige for doing so. In the fourth century, new land and head taxes impoverished the *curiales*, while very rich landowners – out in the countryside, surrounded by their bodyguards and slaves – simply did not bother to pay. Now the tax burdens fell on poorer people. Pressed to pay taxes they could not afford, curial families escaped to the great estates of the rich, giving up their free status in return for land and protection. By the seventh century, the rich had won; the barbarian kings no longer bothered to collect general taxes.

The cities, most of them walled since the time of the crisis of the third century, were no longer thriving or populous, though they remained political and religious centers. Tours (in Gaul), for example, built a wall around its episcopal complex c.400. But few people apart from the bishop and his entourage actually lived within those walls any longer. At the same time, in a cemetery that the Romans had carefully sited outside the city, a new church rose over the tomb of the local saint, Martin. This served as a magnet for the people of the surrounding countryside and even farther away. A baptistery was constructed nearby to baptize the infants of pilgrims who came to the tomb hoping for a miracle. (See Map 1.7.) Sometimes people stayed for years. Gregory, bishop of Tours (r.573–594), our chief source for the history of Gaul in the sixth century, described Monegundis, a very pious woman:

> [she] left her husband, her family, her whole house, and went, full of faith, to the basilica of the holy bishop Martin. [After curing a sick girl on her way, she] arrived at the basilica of St Martin, and there, on her knees in front of the tomb, she gave thanks to God for being able to see the holy tomb with her own eyes. She settled herself in a small room [nearby] in which she gave herself every day to prayer, fasts and vigils.[10]

With people like Monegundis flocking to the tomb, it is no wonder that archaeologists have found evidence of semi-permanent habitations right at the cemetery.

The shift from urban to rural settlements brought with it a new localism. The active long-distance trade of the Mediterranean slowed down, though it did not stop. Consider

10 Gregory of Tours, *The Life of Monegundis*, in *Reading the Middle Ages*, pp. 38–40.

the fate of pottery, a cheap necessity in the ancient world. In the sixth century, fine mass-produced African red pottery adorned even the humblest tables along the Mediterranean Sea coast. Inland, however, most people had to make do with local handmade wares, as regional networks of exchange eroded long-distance connections. For some (mainly the rich), however, the disconnection of the rural landscape from the wider world was far less clear. Archeologists have recently found numerous artifacts buried with the dead in graves in northern Europe, including ivory rings, glass, beads, and semi-precious stones such as those used in the reliquary in Plate 1.10. These must have arrived in the West from Byzantium, the eastern Mediterranean, or even more far-flung workshops and trade centers. Indeed, there appears to have been a lively international exchange between East and West that continued throughout the period covered by this chapter – and beyond.

The Western Church in the New Order

Among the rich who took advantage of this relatively abundant material culture were bishops. They often rose to episcopal status in their twilight years, after they had married and had sired children to inherit their estates. (Their wives continued to live with them but not to sleep with them – or so it was expected.) Great lay landlords, kings, queens, warriors, and courtiers controlled and monopolized most of the rest of the wealth of the West, now based largely on land.

Monasteries, too, were becoming important corporate landowners. In the sixth century, many monks lived in communities just far enough away from the centers of power to be holy, yet near enough to be important. Monks were not quite laity (since they devoted their entire life to religion), yet not quite clergy (since they were only rarely ordained as priests), but something in-between and increasingly admired. It is often said that Saint Antony was the "first monk," and though this may not be strictly true, it is not far off the mark. Like Antony, monks practiced a sort of daily martyrdom, giving up their personal wealth, family ties, and worldly offices. Like Antony, who eventually gave up the solitary life, monks lived in communities. Some communities were of men only, some of women, some of both (in separate quarters). Whatever the sort, monks lived in obedience to a "rule" that gave them a stable and orderly way of life.

While some rules were passed down orally, the ones we know most about were written. Caesarius, bishop of Arles (r.502–542), wrote one for his sister, the "abbess" (head) of a monastery of women. He wrote another for his nephew, the "abbot" of a male monastery. In Italy, Saint Benedict (d.c.550/560) wrote the most famous monastic rule of all at some time between 530 and 560. With its adoption in the ninth century as the official rule of the Carolingian Empire (see Chapter 3), it became the monastic norm in the West. The Benedictine Rule insisted on the key virtues of obedience and humility. Dividing the day into discrete periods of prayer, reading, and labor, the chief of its activities was the "liturgy" – not just the Mass, but also an elaborate round of formal worship that took place seven times a day and once at night. At these specific times, the monks chanted – that is

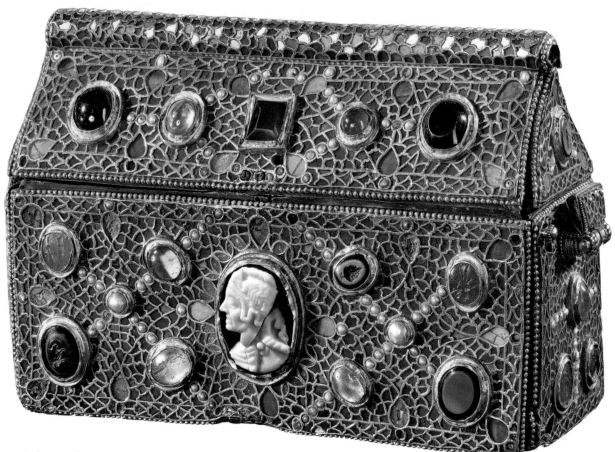

Plate 1.10 Reliquary of Theuderic (late 7th cent.). This reliquary is shaped like a miniature sarcophagus. Made of cloisonné enamel (bits of enamel framed by metal) and richly adorned with semi-precious stones, it bears the inscription, "Theuderic the priest had this made in honor of Saint Maurice." Paying for the creation of a reliquary – suitable housing for the remains of the saints – was itself an act of piety.

sang – the "Offices," most of which consisted of the psalms (a group of 150 poems in the Old Testament). For example, the Benedictine Rule specified that

> during wintertime ... first this verse is to be said three times: "Lord, you will open my lips, and my mouth will proclaim your praise." To that should be added Psalm 3 and the Gloria [a short hymn of praise]. After that, Psalm 94 [is sung] with an antiphon [a sort of chorus], or at least chanted. Then an Ambrosian hymn [written by Saint Ambrose of Milan] should follow, and then six psalms with antiphons.[11]

By the end of each week the monks were expected to have completed all 150 psalms.

Benedict's monastery, Monte Cassino, was in the shadow of the city of Rome, far enough to be an "escape" from society but near enough to link it to the popes. Pope Gregory the Great (590–604), a major force in Italy and, arguably, elsewhere as well, took the time to write a biography of Benedict and praise his Rule. Monks may have renounced wealth and power individually, but monasteries became partners of the wealthy and powerful and

11 The *Benedictine Rule*, in *A Short Medieval Reader*, pp. 15–19 and in *Reading the Middle Ages*, pp. 20–28.

benefited from their largess. The monks were seen as models of virtue, and their prayers were thought to reach God's ear. It was crucial to ally with them.

Little by little the Christian religion was domesticated to meet the needs of the new order, even as it shaped that order to fit its demands. That is why, for example, a woman such as Monegundis was not afraid to go to the cemetery outside of Tours. There were no demons there; they had been driven far away by the power of Saint Martin. Just as Benedict's monasteries had become perfectly acceptable alternatives to the old avenues of male prestige – armies and schools – so Monegundis, who retreated into a little room to fast and pray, became the center of a group of pious women who found their vocation in the religious life rather than marriage. When Monegundis was about to die, they did what was needed to perpetuate the community she had founded: they begged her "to bless some oil and salt that we can give to the sick who ask for a blessing." She did so, and they "preserved [it] with great care."[12] No doubt they kept the oil in a precious container, just as the monastery of Saint-Maurice d'Agaune kept some of its saintly relics in a gorgeous reliquary studded with garnets, glass gems, and a cameo (Plate 1.10). Relics like Monegundis's oil or Saint Martin's tomb brought the sacred into the countryside and into the texture of everyday life.

Retrenchment in the East

After 476 there was a "new order" in the East as well as the West, but initially the changes were less obvious. For one thing, there was still an emperor with considerable authority. The towns continued to thrive, and the best of the small-town educated elite went off to Constantinople, where they found good jobs as administrators, civil servants, and financial advisors. While barbarian kings in the West were giving in to the rich and eliminating general taxes altogether, the eastern emperors were collecting state revenues more efficiently than ever.

For the first time, emperors issued compendia of Roman laws. *The Theodosian Code*, which gathered together imperial "constitutions" (general laws) alongside "rescripts" (rulings on individual cases), was published in 438. Western barbarian law codes of the sixth century attempted to match this achievement, but they were overshadowed by the great legal initiatives of Justinian (r.527–565), which included an imperial law code known as the *Codex Justinianus* (529, revised in 534), and the *Digest* (533), an orderly compilation of Roman juridical thought from the pre-imperial period onward. From then on, the laws of the eastern Roman Empire were largely (though not wholly) fixed, though Justinian's books were soon eclipsed by short summaries in Greek, while in the West they had little impact until the twelfth century (see Chapter 5).

In the fifth and sixth centuries, the eastern half of the Empire recalibrated its priorities. When the Visigoths sacked Rome, Theodosius II (r.408–450) did not send an army

12 Gregory of Tours, *The Life of Monegundis*, in *Reading the Middle Ages*, pp. 38–40.

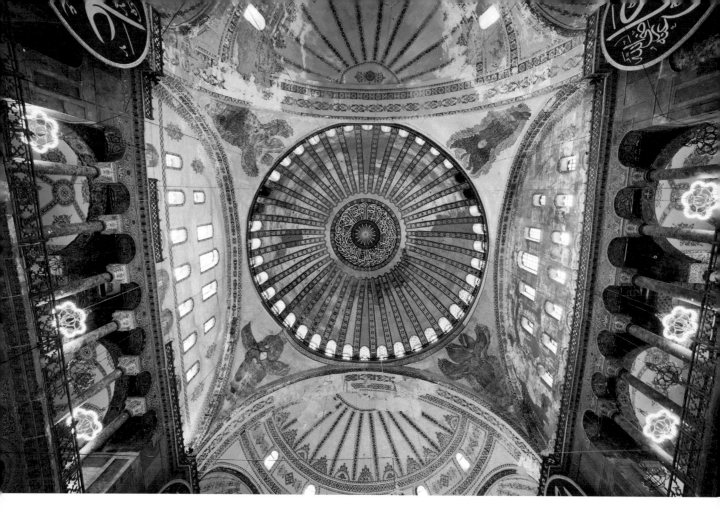

Plate 1.11 Dome of Hagia Sophia (532–537). Employing two architects unusually open to experimentation and making use of thousands of workers in its construction, Hagia Sophia featured a dome rising loftily over a rectangular base – an astonishing and unprecedented engineering feat. The church's white and gray marble floor, walls, piers and columns, along with its splendid mosaics, which reflected light on all sides, completed the effect of heaven prefigured.

to fight them; he built walls around Constantinople instead. When roads fell into disrepair, Emperor Justinian let many of them decay. When the Slavs pressed on the Roman frontier in the Balkans, he let them enter. But no policy could fully meet the challenge of the first recorded pandemic, which was caused by the exceptionally deadly plague bacterium, *Yersinia pestis*. It hit Justinian's Empire in 541 and lasted for 200 years. (A second wave – the one responsible for the so-called "Black Death" – wreaked terrible damage some six hundred years later and beyond.) Coupled with sudden climate change, which brought unaccustomed cold and frost to the eastern Roman Empire, the first pandemic, as one contemporary observer put it, "came close to wiping out the whole of mankind."[13]

Even so, Justinian financed a major effort to recover North Africa and Italy in a bid to revive the Roman Empire as it once had been. He succeeded, but at enormous cost, leaving much of Italy destroyed and prey to outside invaders, and crippling the economy of the eastern Empire. Ultimately, his successors failed to hold on to his reconquests.

Above all, Justinian took on the image of concentrated power associated with the ceremony and pomp of the Persian "king of kings," combining it with an exalted role

13 Prokopios, *The Wars of Justinian* 2.22, trans. H.B. Dewing, rev. Anthony Kaldellis (Indianapolis: Hackett Publishing, 2014), p. 120.

Figure 1.1 San Vitale, Ravenna, Reconstructed Original Ground Plan, 6th cent.

Narthex

Entry and exit

Passageway

N

Atrium

Central core topped by dome

Justinian panel

Apse

Theodora panel

0 5 10 15 20 m

in the Christian Church. An upstart from the lower classes, he drew on old and revered imperial traditions when, in the wake of fearsome popular tax revolts against his rule, he embarked on an extensive building program of churches, hospitals, and poor houses. Plates 1.11 and 1.12 illustrate some of the dazzling results at Constantinople and Ravenna. At Constantinople, he rebuilt the church of Hagia Sophia ("Holy Wisdom"), burned in the riots against him, making it a symbol of his power. It featured an astonishing dome that seemed to float over the building beneath it. (See Plate 1.11.)

After conquering Italy from the Ostrogoths, Justinian asserted his rule at Ravenna. Already in 402 that city had superseded Rome as the capital of the western half of the Roman Empire, and it had remained the capital of Italy under the Ostrogoths. Justinian inserted himself into the city's very fabric – both politically and physically. Politically, he found natural allies in the Christians living there who had chafed under the Arian Ostrogoths. Physically, he made his presence permanent in the city's chief church, San Vitale, which was still under construction when his troops arrived. Shaped in the unusual form of an octagon (see Figure 1.1), San Vitale is topped by a lofty dome (like Hagia Sophia) and glows with marble and mosaics. Its main apse – directly behind the altar – seamlessly merges heaven and earth, Church and State. Plate 1.12 conveys an idea of the whole as the viewer (perhaps a priest entering to celebrate the Eucharist, or others entering the church in liturgical procession at one of the building's many doors) might have seen it. The plate shows the central half dome of the apse. Beneath a youthful Christ, flanked by angels and sitting on a blue orb, run the Four Rivers of Paradise. Lilies and roses bloom on the rocky ground. The two angels flanking Christ look away from him, attending to the two men at their sides. These are, on the viewer's right, Bishop Ecclesius, who offers Christ a model

Plate 1.12 (following pages) San Vitale, Ravenna, Apse Mosaics (mid-6th cent.). The warm colors of the apse mosaics – especially greens and golds – emphasize the rich abundance of the offerings brought to the altar by the emperor and empress, a theme mirrored by the intersecting cornucopias that frame the image of Christ and his companions in heaven.

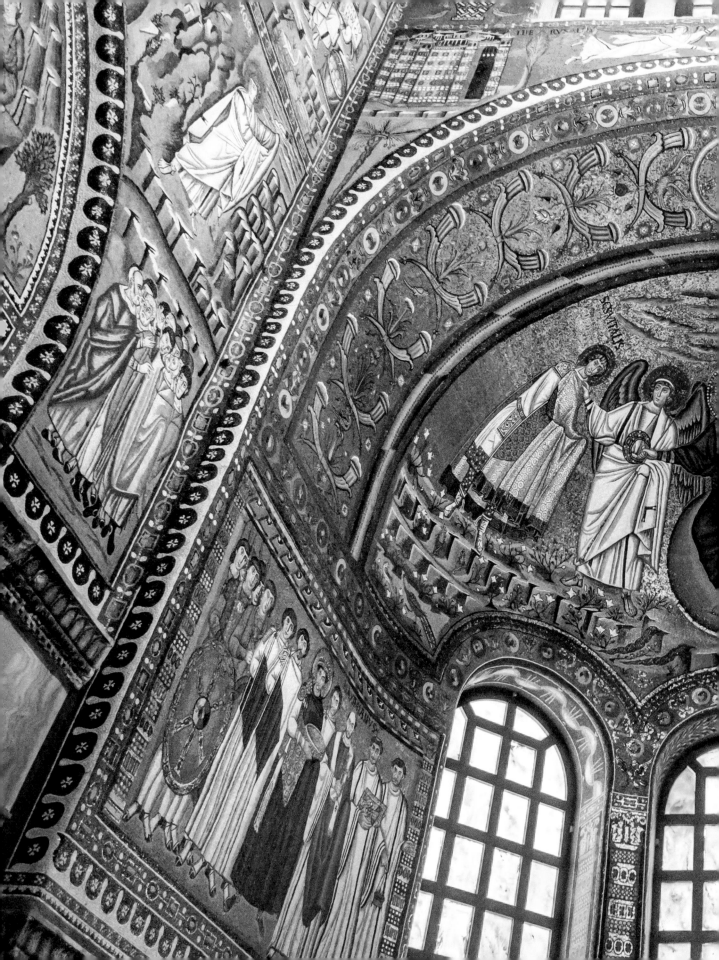

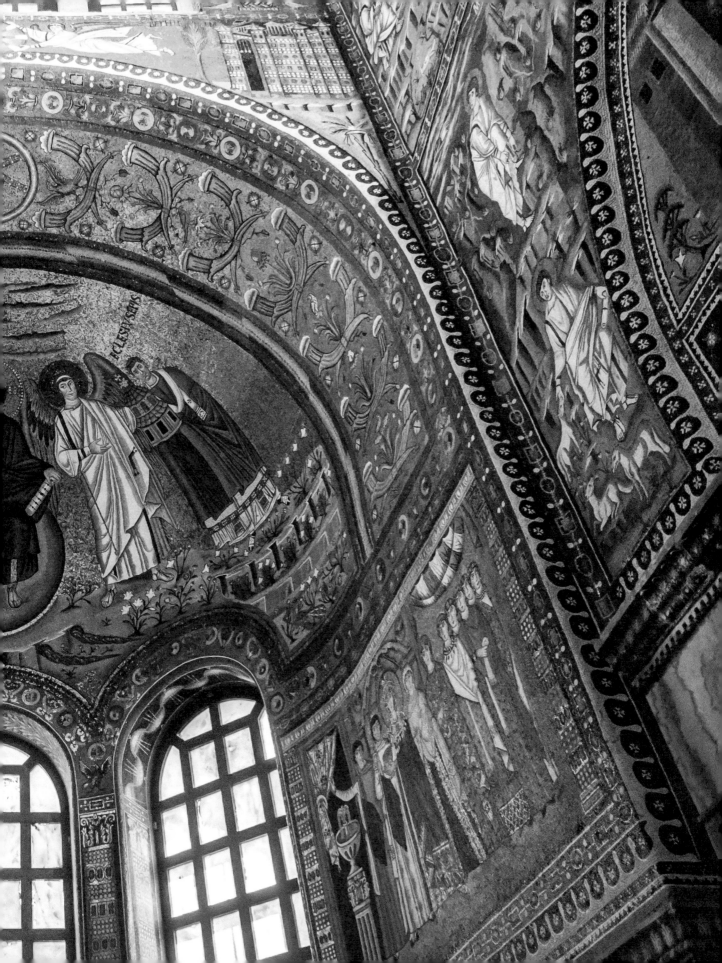

ECLESIA SCS

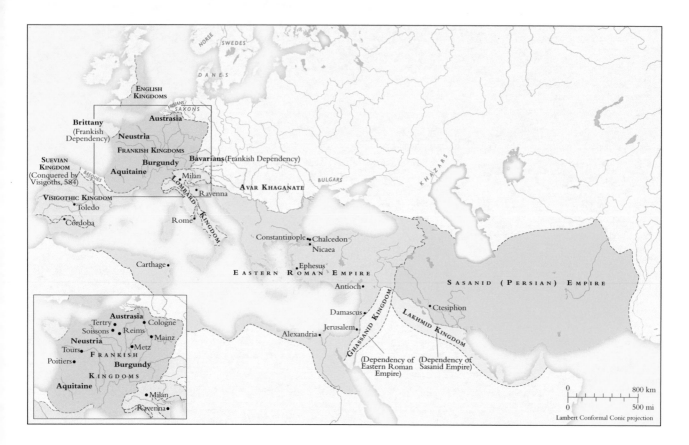

Map 1.8 Europe, the Eastern Roman Empire, and Persia, *c.*600

of the very church of San Vitale; and on the left, Saint Vitalis (after whom the church is named), who accepts the crown of martyrdom from Christ.

Three large windows below this heavenly scene light the apse. On either side are mosaic panels depicting (on the viewer's left) Emperor Justinian and (on the right) Empress Theodora. Justinian, the central and largest figure in his panel, has a halo and wears a crown. He holds a large golden paten – the bowl that contains the bread of the Eucharist – and offers it in the direction of both Christ above him and the altar, which would have been below. To his left is a bishop carrying a gem-studded gold cross; the name MAXIMIANUS is boldly outlined above his head. Justinian's appointee at Ravenna, Bishop Maximianus clearly wanted to associate himself permanently with the imperial majesty. Behind the bishop other churchmen bring more precious objects to the altar. On Justinian's right-hand side are members of his court: aristocrats and soldiers. It is no accident that the total number of people led by Justinian is twelve (or possibly thirteen), like the apostles of Jesus.

Facing the emperor's panel is a similar one for Empress Theodora. She, too, has a halo, and her garment (the same sort of purple *chlamys* that Justinian wears) has at the hem an image of the three Magi offering gifts to the Christ Child. Like them, she makes an offering, holding out to Christ (above her) and to the altar (below) a gold chalice, the vessel for the wine of the Eucharist. To her left are a group of splendidly dressed women, representing her retinue. To her right are two men of high rank.

The entire complex – reading it from the viewer's right to left – depicts a circle of gift-giving and mutual generosity: Theodora offers a chalice to Christ and the altar; Ecclesius, the bishop who initiated the construction of San Vitale, gives it to Christ; Christ presents a crown to Saint Vitalis; and finally, Emperor Justinian completes the circle by offering the paten back to Christ and to the altar on which Christ's sacrifice is celebrated.

Ravenna became a center of early Christendom. Even after the Lombards took most of Italy (see Map 1.8), the "Romans" of the East held on to an hourglass-shaped strip of land running from Ravenna to Rome. Ravenna's almost impregnable position (surrounded by the marshes and various waters of the Po River estuary) and its location near a major port allowed it to become a linchpin of East-West connectivity.

Yet, the eastern Roman Empire's focus was not on Ravenna. Rather it was toward the east, where the Sasanid Empire of the Persians challenged its hegemony. The two "superpowers" confronted one another with wary forays throughout the sixth century. They thought that to the winner would come the spoils. Little did they imagine that the real winner would be a new and unheard-of group: the Muslims.

<div align="center">★ ★ ★ ★ ★</div>

The crisis of the third century demoted the old Roman elites, bringing new groups to the fore. Among these were the Christians, who insisted on one God and one way to understand and worship him. Made the official religion of the Empire under Theodosius, Christianity redefined the location of the holy: no longer was it in private households or city temples but in the precious relics of the saints and the Eucharist; in those who ministered on behalf of the Church on earth (the priests, bishops, and emperors); and in those who led lives of ascetic heroism (the monks).

Politically the Empire, once a vast conglomeration of conquered provinces, was in turn largely conquered by its periphery. In spite of themselves, the Romans had tacitly to acknowledge and exploit the interdependence between the center and the hinterlands. They invited the barbarians in, but then declined to recognize the needs of their guests. That repudiation came too late. The barbarians were part of the Empire, and in the western half they took it over. In the next century, they would show how much they had learned from their former hosts.

For practice questions about the text, maps, plates, and other features – plus suggested answers – please go to

www.utphistorymatters.com

There you will also find all the maps, genealogies, and figures used in the book.

FURTHER READING

Brown, Peter. *Through the Eye of a Needle: Wealth, the Fall of Rome, and the Making of Christianity in the West, 350–550 AD*. Princeton: Princeton University Press, 2012.

Demacopoulos, George E. *Gregory the Great: Ascetic, Pastor, and First Man of Rome*. Notre Dame: University of Notre Dame Press, 2015.

Dunn, Marilyn. *Arianism*. Amsterdam: Amsterdam University Press, 2021.

Esders, Stefan, Yaniv Fox, Yitzhak Hen, and Laury Sarti, eds. *East and West in the Early Middle Ages: The Merovingian Kingdoms in Mediterranean Perspective*. Cambridge: Cambridge University Press, 2019.

Fleming, Robin. *The Material Fall of Roman Britain, 300–525 CE*. Philadelphia: University of Pennsylvania Press, 2021.

Fowlkes-Childs, Blair, and Michael Seymour, eds. *The World between Empires: Art and Identity in the Ancient Middle East*. New York: The Metropolitan Museum of Art, 2019.

Harper, Kyle. *The Fate of Rome: Climate, Disease, and the End of an Empire*. Princeton: Princeton University Press, 2017.

Herrin, Judith. *Ravenna: Capital of Empire, Crucible of Europe*. Princeton: Princeton University Press, 2020.

Heather, Peter. *Empires and Barbarians: Migrations, Development and the Birth of Europe*. Oxford: Oxford University Press, 2009.

Little, Lester K., ed. *Plague and the End of Antiquity: The Pandemic of 541–750*. Cambridge: Cambridge University Press, 2007.

McCormick, Michael. "Gregory of Tours on Sixth-Century Plague and Other Epidemics." *Speculum* 96, no. 1 (2021): 38–96.

O'Donnell, James J. *Pagans: The End of Traditional Religion and the Rise of Christianity*. New York: HarperCollins, 2015.

Potter, David. *Theodora: Actress, Empress, Saint*. Oxford: Oxford University Press, 2015.

Rotman, Youval. *Slaveries of the First Millennium*. Leeds: ARC Humanities Press, 2021.

Ward-Perkins, Bryan. *The Fall of Rome: And the End of Civilization*. Oxford: Oxford University Press, 2005.

CHAPTER TWO
HIGHLIGHTS

Merovingian dynasty
481–751
First Germanic dynasty to rule Francia.

Hijra
622
Muhammad's "flight" from Mecca to Medina; marks the year 1 of the Islamic calendar.

Battle of Badr
624
The first Islamic military victory.

Umayyad caliphate
661–750
First caliphal dynasty; Sunni Muslims, the Umayyads make Damascus their capital city.

Synod of Whitby
664
The meeting at which the English king Oswy chooses the Roman form of Christianity, tying England to the Continent ever more securely.

Islamic armies take Spain
711–715
Led by Musa, governor of Ifriqiya, the Islamic conquest of Spain marks Islam's arrival in Europe.

Iconoclasm at Byzantium
726–787, 815–843
Bans the depiction of holy beings, calling into question the nature of artistic representation.

TWO

THE EMERGENCE OF SIBLING CULTURES (c.600–c.750)

The rise of Islam in the Arabic world and its triumph over territories that for centuries had been dominated by either Rome or Persia is the first astonishing fact of the seventh and eighth centuries. The second is the persistence of the Roman Empire both politically, in what historians call the "Byzantine Empire," and culturally, in the Islamic world and Europe. By 750 three distinct and nearly separate civilizations – Byzantine, European, and Islamic – crystallized in and around the territory of the old Roman Empire. They professed different values, struggled with different problems, adapted to different standards of living. Yet all three bore the marks of common parentage – or, at least, of common adoption. They were sibling heirs of Rome.

SAVING BYZANTIUM

In the seventh century, the eastern Roman Empire was so transformed that, by convention, historians call it something new: the "Byzantine Empire" or simply "Byzantium," from the old Greek name for Constantinople. This terminology is entirely modern: the so-called Byzantines called themselves Romans, and their state was Romanía.

War, first with the Sasanid Persians, then with the Arabs, transformed Byzantium. Gone was the ambitious imperial reach of Justinian; by 700, Byzantium had lost all its rich territories in North Africa and its tiny Spanish outpost as well. True, it held on tenuously to bits and pieces of Italy and Greece. But in the main it had become a medium-sized state, in the same location but about two-thirds the size of Turkey today (see Map 2.2). Yet, if small, it was also tough.

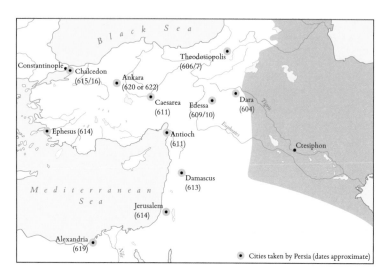

Map 2.1 Persian Expansion, 602–622

Sources of Resiliency

Byzantium survived the onslaughts of outsiders by preserving its capital city, which was well protected by high, thick, and far-flung walls that embraced farmland and pasture as well as the city proper. Within, the emperor (calling himself the Roman emperor) and his officials serenely continued to collect the traditional Roman land taxes from the provinces left to them. This allowed the state to pay regular salaries to its soldiers, sailors, and court officials. The navy, well supplied with ships, patrolled the Mediterranean Sea. It was proud of its prestigious weapon, Greek fire – a mixture of crude oil and resin, heated and projected via a tube over the water, where it burned, engulfing enemy ships with its flames.[1] The armies of the Empire, formerly posted as frontier guards, were pulled back in the face of the Arab invaders and set up as large regional defensive units within the Empire itself. Called *strategiai* (literally, "commands of a general"), they were led by *strategoi* (generals), appointed by the emperors. Officials were posted throughout the Empire to provide food and weapons to the army. They were authorized to collect foodstuffs as taxes in kind and to purchase materials for the army in the name of the state. Protected by fortresses, the *strategiai* managed to stave off Arab conquest. Well trained and equipped, Byzantium's troops served as reliable defenders of their newly compact state.

INVASIONS AND THEIR CONSEQUENCES

The Sasanid Empire of Persia, its capital at Ctesiphon, its ruler styled king of kings, was as venerable as the Roman Empire – and equally ambitious. (See Map 2.1.) King Chosroes II (r.590–628), not unlike Justinian a half-century before him, dreamed of recreating past glories. In his case the inspiration was the ancient empire of Xerxes and Darius, which had sprawled from a lick of land just west of Libya to a great swathe of territory ending near the Indus River. When Byzantine Emperor Maurice was deposed by Phocas in 602, Chosroes took advantage of the ensuing political chaos to invade Byzantine territory. By 604 he had captured Dara and soon other cities nearby; he took Theodosiopolis in Byzantine Armenia in 606/607, Damascus by 613, Jerusalem by 614, and Alexandria by 619. By mid-621 the whole of Egypt was in his hands.

1 For "Greek fire," see "Reading through Looking," in *Reading the Middle Ages: Sources from Europe, Byzantium, and the Islamic World*, 3rd ed., ed. Barbara H. Rosenwein (Toronto: University of Toronto Press, 2018), pp. X–XII.

Around that time, Byzantine Emperor Heraclius (r.610–641) found a way to turn the tide, deploying both his army and diplomatic initiatives. By 630 all territories taken by the Persians were back in Byzantine hands. On a map, it would seem that nothing much had happened. In fact, the cities fought over were depopulated and ruined, and both Sasanid and Byzantine troops and revenues were exhausted.

Although the Persians were pushed back, the Slavs – farmers and stock-breeders in the main – moved into the Balkans, sometimes accompanied by Avars, multi-ethnic horseback warriors and pastoralists. It took another half-century for the Bulgars, a Turkic-speaking nomadic group, to become a threat, but in the 670s they, too, began moving into what is today Bulgaria, defeating the Byzantine army in 680 and again in 681. By 700 very little of the Balkan Peninsula was controlled by Byzantium. (See Map 2.2.) The place where once the two halves of the Roman Empire had met was now a wedge – created by Bulgars, Avars, and Slavs – that separated East from West.

Map 2.2 shows an even more dramatic change to the old geography across Anatolia, down the coast of the Mediterranean and into North Africa. This was due to the invasion of Islamic armies, which conquered the lower half the Roman "scarf" and took over Persia as well. We shall soon see how and why the Arabs poured out of Arabia. But first we need to know what the shrunken Byzantium was like.

Map 2.2 The Byzantine Empire, *c.*700

DECLINE OF URBAN CENTERS AND RETRENCHMENT IN THE COUNTRYSIDE

The city-based Greco-Roman culture on which the Byzantine Empire was originally constructed had long been giving way. Invasions and raids hastened this development as did the Plague of Justinian. Many urban centers, once bustling nodes of trade and administration, disappeared or reinvented themselves. Some became fortresses; others were abandoned; still others remained as skeletal administrative centers. The public activities of marketplaces, theaters, and town squares yielded to the pious pursuits of churchgoers or the private affairs of the family. Old civic centers were turned into churches. Although some cities remained centers of habitation and a few continued to be productive, turning out ceramics, olive oil, building stones, and the like, they were no longer the hubs of Byzantine life.

Constantinople itself was spared this fate only in part. As with other cities, its population shrank, and formerly inhabited areas right within the walls were abandoned or turned into farms. As the capital of both the Byzantine Church and State, however, Constantinople boasted an extraordinarily thriving upper class composed of people attached to both the imperial court and the clerical elite. It also retained some trade and industry. Even in the darkest days of the seventh-century wars, it retained the features of an urban landscape, with taverns, brothels, merchants, and a money economy. Its factories continued to manufacture fine silk textiles. Although Byzantium's economic life became increasingly rural in the seventh and eighth centuries, institutions vital to urban growth remained at Constantinople, ensuring a revival of commercial activity once the wars ended.

With the decline of the cities came the rise of the countryside. Agriculture had all along been the backbone of the Byzantine economy. Apart from a few large landowners, including the state, the Church, and some wealthy individuals, most Byzantines were free or semi-free peasant farmers. In the interior of Anatolia, on the great plateau that extends from the Mediterranean to the Black Sea, peasants must often have had to abandon their farms when Arab raiders came. Some may have joined the pastoralists of the region, ready to drive their flocks upland to safety. Elsewhere (and, in times of peace, on the Anatolian plains as well), peasants worked small plots (sometimes rented, sometimes owned outright), herding animals, cultivating grains, and tending orchards.

These peasants were subject as never before to imperial rule. With the disappearance of the traditional town councilors (the *curiales*), the cities and their rural hinterlands were now controlled directly by the reigning imperial governor and the local "notables" – a new elite consisting of the bishop and big landowners favored by the emperor. Freed from the old buffers that separated it from commoners, the state adopted a thoroughgoing agenda of "family values," narrowing the grounds for divorce, establishing new punishments for marital infidelity, and prohibiting abortions. New legislation gave mothers greater power over their offspring and made widows the legal guardians of their minor children. Education was still important, but now for many pious Christians, reading the

ancient classics took second place to studying the Psalter, the book of 150 psalms in the Old Testament thought to have been written by King David.

New family values coexisted with old community practices, but the Church increasingly tried to suppress traditions it associated with paganism. A Church council that met at Constantinople in 691/692 (the so-called Quinisext) forbade, among other things, dancing on the first day of March, wearing comic masks at festivals, and cross-dressing in masquerade: "Moreover we drive away from the life of Christians the dances given in the names of those falsely called gods by the Greeks whether of men or women, and which are performed after an ancient and un-Christian fashion; decreeing that no man from this time forth shall be dressed as a woman, nor any woman in the garb suitable to men."[2]

CHANGES ON THE GROUND: FROM VOLUBILIS TO WALILA

Archaeologists have literally unearthed (at least in part) the story of the material changes undergone by the many regions that once made up the capacious Roman Empire. No place is "typical," but let us focus on one, Volubilis. It was founded in pre-Roman times and remained inhabited, on and off throughout the Middle Ages. Situated near the modern city of Meknes in Morocco, it was at first excavated only for its impressive Roman ruins, including its forum (the center of Roman civic life) and its more lavish houses, some with richly decorated mosaic floors. More recently, the very field of archaeology has changed: from looking for imposing artifacts and edifices, it now is devoted to discovering and chronicling the entire material culture of a site – including human, plant, and animal remains – over the course of centuries. Figure 2.1 suggests the major outlines of Volubilis's development.

Originally a Mauritanian settlement, Volubilis was annexed by the Romans in the first century CE. Reforming the city according to their own aesthetics, the Romans started with the Mauritanian center, where they constructed a forum and other public buildings. Gradually the population grew, expanding toward the north and east. The city's main street, the *decumanus maximus*, was paved and flanked by walkways shaded by arcaded porticoes and lined with shops. An aqueduct supplied the city with water for public fountains and baths as well as plumbing for the major private houses. The finest of those were built along the main street in the Roman style, with columned courtyards and elaborate mosaics. Yet, despite its "Roman" appearance, the city was inhabited mainly by locals. Even the *curiales*, who served the Romans as tax collectors, were recruited from the native population, as were the builders responsible for constructing the houses. In short, the indigenous inhabitants were happy to identify themselves as "Romans." Even when, in the wake of the crisis of the third century, Diocletian pulled Roman troops out of the region, the city's elites continued to build their houses in the Roman style – if anything even more opulently than before. The "House of Venus" – so called from its beautiful mosaic floor picturing the goddess – continued to be remodeled into the fourth century.

2 *The Quinisext Council*, Canon 62, in *Reading the Middle Ages*, pp. 60–62.

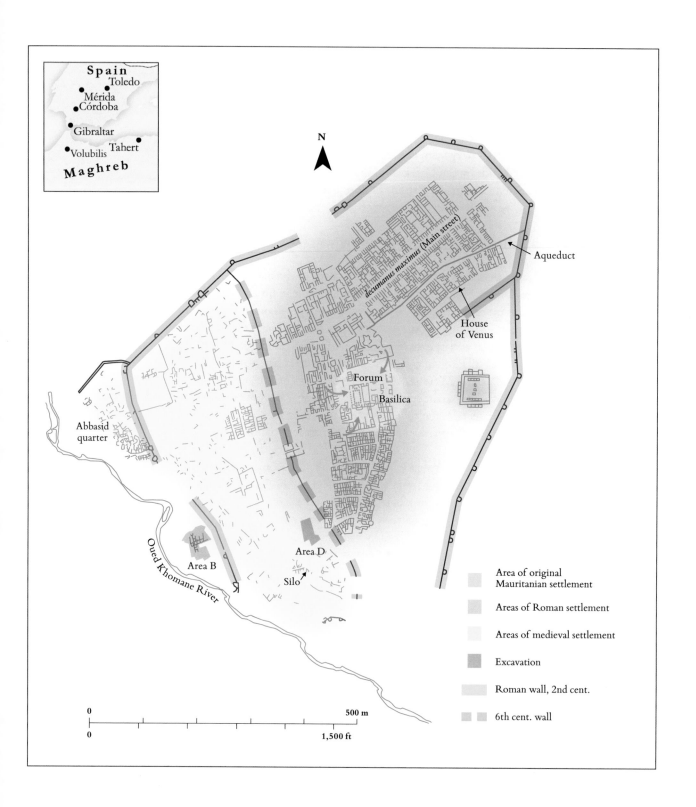

Spain
Toledo
Mérida
Córdoba
Gibraltar
Volubilis Tahert
Maghreb

N

decumanus maximus (Main street)

Aqueduct

House
of Venus

Forum
Basilica

Abbasid
quarter

Area D

Area B

Silo

Oued Khomane River

0 500 m

0 1,500 ft

Area of original
Mauritanian settlement

Areas of Roman settlement

Areas of medieval settlement

Excavation

Roman wall, 2nd cent.

6th cent. wall

Yet at some time in the fifth or sixth century the original city seems to have been largely abandoned, very likely because of an earthquake. Much of the old city was eventually turned into a cemetery. In the sixth century, a new wall was built (in Figure 2.1 it is indicated by orange dashes), and new habitations began to spring up to the wall's west (here Area D). New Berber (the indigenous terms for whom are sing. Amizigh and pl. Imazighen) settlers moved into this area. Some of the inhabitants of this "new city" were Christians, as is attested by dated tomb inscriptions. No aqueduct served this population, so it must have depended on water from wells and from the Oued Khomane River. Its habitations were small – one or two rooms, as was typical of Berber housing – alongside barns and storage areas.

When Islamic armies arrived in Volubilis – now called Walila – it had lost its urban character. Yet, towards the end of the eighth century (a period taken up in the next chapter) it experienced another building spurt, this one to the west of the Roman wall (Area B in Figure 2.1). Area B and the so-called "Abbasid quarter" were constructed and became important later, as we shall see.

To sum up: before 750, Volubilis/Walila experienced much the same transformation from highly urban to largely rural life that took place in the Byzantine world and (as we shall see) in Europe as well.

Iconoclasm

Pious tomb inscriptions such as those at Volubilis were one way in which popular Christian beliefs took material form. Saintly relics were another. As in the West, so too in the East, relics were housed in precious containers. Some were kept in churches, often under the altar; others were preserved at home by pious Christians. Many reliquaries were decorated with precious stones and metals and often, too, with images of saints, Christ, and his mother, Mary. Around 680, these images took on new importance in the Byzantine world. A cult of images became as important there as the cult of saints. The argument on their behalf was straightforward: the sacred could best be grasped by human beings when made visible and palpable. Stories circulated of saintly images that spoke, and it became common for worshippers to bow down to sacred portraits. Images became more than representations of divine beings; they were – like relics, like reliquaries – containers of the holy.

These developments responded to the crises of the day. In the late seventh century, as we have seen, Byzantium was confronted by plagues, earthquakes, and (above all) wars. How could this happen to God's Chosen People (as the Byzantines thought of themselves)? The answer was clear: God was angry with them for their sins. What recourse did they have but to seek new avenues to access divine favor? While still depending on relics to protect and fortify them, many Byzantines sought the aid of holy images as well. Monks and nuns were especially enthusiastic patrons of these powerful works of art.

Soon there was a backlash against these new-fangled ideas. Emperor Leo III the Isaurian (r.717–741) agreed that the crises were God's punishment for the sins of the Byzantines. But

Figure 2.1 (facing page)
Volubilis

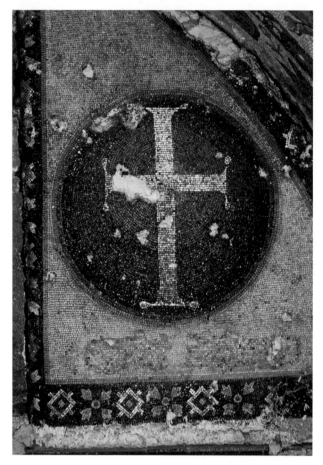

he thought that their chief sin was idolatry – their cult of images, which subverted true Christian belief. In 726, after a terrifying volcanic eruption in the middle of the Aegean Sea, Leo seems to have denounced sacred portraits publicly. Historians used to report that Leo had his soldiers tear down a great golden icon of Christ at the Chalke, the gateway to the imperial palace, and replace it with a cross. Newer research by Leslie Brubaker and John Haldon notes that no contemporary sources record this incident. Most likely it was a legend invented much later. Nevertheless, around 726, or perhaps a bit before, Leo erected a cross – which was an abstract symbol, not the same thing as an image – in front of the imperial palace. It affirmed not only the Cross's salvific place in the lives of all Christians but also its unwavering role in imperial victories. This may be taken to signify the beginning of the "iconoclastic" (anti-icon or, literally, icon-breaking) period. In 730, Leo required the pope at Rome and the patriarch of Constantinople to subscribe to a new policy: to remove sacred images, or at least to marginalize them, if they inspired the wrong kind of devotion.

Leo was the harbinger of a new religious current. There had always been churchmen who objected to compassing the divine in the form of a material image, but they had been in the minority. By the end of Leo's reign, a majority

Plate 2.1 Cross at Hagia Sophia (orig. mosaic 6th cent.; redone 768/769). In this section of a mosaic just off the gallery at Hagia Sophia, the original mosaicist depicted a holy figure in a medallion. Beneath the image was an inscription identifying the saint. During the iconoclastic period, the figure and inscription were hacked out. The saint was replaced by a gold cross with flared arm tips; it was surrounded by a rainbow of colored tesserae (the bits of glass or stone used in mosaics) to make the cross seem to glow. Below the cross can clearly be seen the rectangular space in which the original inscription was replaced by tesserae to match the background color.

was inspired to criticize images. At the Synod of 754, over 300 bishops and the emperor himself banned sacred images outright. Their decrees made clear how material representations threatened, according to iconoclasts, to befoul the purity of the divine. Christ himself had declared he should be represented through the bread and wine of the Eucharist – and in no other way. As for the saints, they (in the words of the Synod)

> live on eternally with God, although they have died. If anyone thinks to call them back again to life by a dead art, discovered by the heathen, he makes himself guilty of blasphemy.... It is not permitted to Christians ... to insult the saints, who shine in so great glory, by common dead matter.[3]

Above all, iconoclastic churchmen worried about losing control over the sacred. Unlike relics, images could be reproduced infinitely and without clerical authorization. Their cultivation at monasteries threatened to encroach on clerical authority. It was in their interest to ban icons.

3 *Synod of 754*, in *A Short Medieval Reader*, ed. Barbara H. Rosenwein (Toronto: University of Toronto Press, 2023), pp. 27–30 and in *Reading the Middle Ages*, pp. 62–66.

However vehement they may have been, the iconoclasts seem rarely to have wiped out already-existing icons – though later propagandists on the iconophile (icon-loving) side accused them of great damage. One example of obliteration, however, certainly remains from Hagia Sophia. A room used by the patriarch – located just off the southwest corner of the gallery – was originally covered with mosaics, including medallions with images of saints. During the iconoclastic period, the images were cut out and replaced by crosses. (See Plate 2.1.) Elsewhere, new churches were decorated with crosses from the start, while artists of the iconoclastic period were commissioned to depict (depending on the use of the building) ornaments, trees, birds, hunting, horse races, and other non-sacred motifs. The iconoclasts thought that they thereby ensured God's favor – that, once again, the Byzantines were God's "Chosen People."

Ultimately, iconoclasm was an utter failure, though the ban on icons lasted until 787 and was revived, in modified form, between 815 and 843. Not only did the iconoclastic movement come to an end, but during the eighth century the position of those who supported icons, already argued at the Quinisext Council, was elaborated at great length in learned treatises. Henceforth, the veneration of holy images in the Byzantine (Eastern Orthodox) Church was a normal part of its religious practices.

THE RISE OF THE "BEST COMMUNITY": ISLAM

Like the Byzantines, the Muslims thought of themselves as God's people. In the Qur'an, the "recitation" of God's words, Muslims are "the best community ever raised up for mankind ... having faith in God" (3:110). The Muslim's "God" is the same as the God of the Jews and the Christians. The Muslim community's common purpose is "submission to God," the literal meaning of "Islam." The Muslim (a word that derives from "Islam") is "one who submits." Under the leadership of Muhammad (c. 570–632) in Arabia, Islam created a new world power in less than a century.

The Shaping of Islam

"One community" was a revolutionary notion for the disparate peoples of Arabia (today Saudi Arabia), who converted to Islam in the first decades after 622. Pre-Islamic Arabia lay between the two great empires of the day – Persia and Byzantium – and felt the cross-currents as well as the magnetic pull of their economies and cultures. Most of its land supported Bedouin pastoralists (the word "Arab" is derived from the most prestigious of these, the camel-herders). But by far the majority of its population was sedentary. To the southwest, where rain was adequate, farmers worked the soil. Elsewhere people settled at oases, where they raised date palms, highly prized for their fruit. Some of these communities were prosperous enough to support merchants and artisans. Whether roaming or

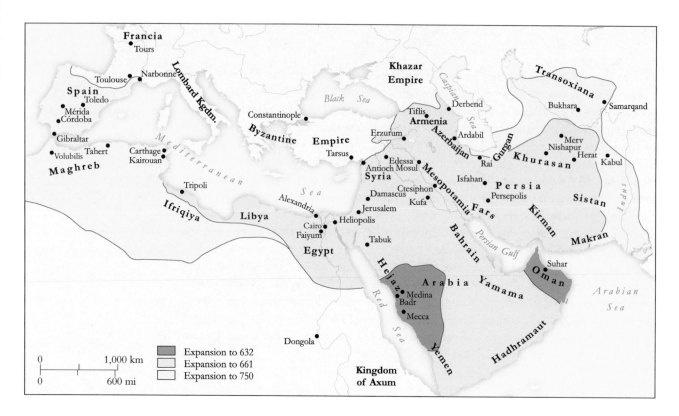

Map 2.3 The Islamic World to 750

settled, all were organized as tribes – communities whose members considered themselves related through a common ancestor.

The pastoralists lived in small groups, hunting on occasion; making good use of the products (leather, milk, meat) derived from their goats, sheep, and camels; and raiding one another for booty. They were proud of their mobile way of life.

By the time of Muhammad, the prophet of Islam, the tribes of Arabia had a well-developed literary as well as oral culture. Poetry was much honored (and remains so to this day); multipurpose, the ode alone (there were many other forms of poetry) could praise, mock, lament, and wax nostalgic. Most poets were "publicists" for their tribe, advertising its virtues. A few were appreciated even beyond Arabia.

Islam began as and largely remained a religion of the sedentary, though it did find support and military strength among the Bedouin. It arose at Mecca, a commercial center and the launching pad of caravans organized to sell tribal products – mainly leather goods and raisins – to the more urbanized areas at the Syrian border. (See Map 2.3.) Mecca was also a holy place. Its shrine, the Ka'ba, was rimmed with the images of hundreds of gods. Within its sacred precincts, where war and violence were prohibited, pilgrims bartered and traded.

Muhammad was born in this commercial and religious center. Orphaned as a child, he came under the guardianship of his uncle, a leader of the Quraysh tribe that dominated Mecca and controlled access to the Ka'ba. Muhammad became a trader, married, had children, and seemed comfortable and happy. But he sought something more: sometimes he would leave home and escape to a nearby mountain to pray.

"In the Name of God the Compassionate the Caring / Recite in the name of your lord who created – / From an embryo created the human / Recite your lord is all-giving."[4] Thus began a sequence of searing words and visions that, beginning around 610 (as tradition has it), came to Muhammad during his retreats. God – *one* God (the Arabic word for God is Allah) – was the key, and God's command was to "recite." Muhammad obeyed, and later his recitations of God's words were written down on scraps of parchment and elsewhere by Muhammad's companions. Once arranged – a process that was certainly completed by the mid-seventh century – God's recitations became the Qur'an, the holy book of Islam. (See Plate 2.2.) It is understood to be God's revelation as told to Muhammad by the angel Gabriel, and then recited in turn by Muhammad to others. Its first chapter – or sura – is the *fatihah*, or Opening:

> In the name of God
>> the Compassionate the Caring
> Praise be to God
>> lord sustainer of the worlds
> the Compassionate the Caring
> master of the day of reckoning
> To you we turn to worship
>> and to you we turn in time of need
> Guide us along the road straight
> the road of those to whom you are giving
>> not those with anger upon them
>> not those who have lost the way.

The Qur'an continues with a far longer sura, followed by others (114 in all) of gradually decreasing length. For Muslims, the Qur'an covers the gamut of human experience – the sum total of history, prophecy, and the legal and moral code by which men and women should live – as well as the life to come.

Banning infanticide, Islam gave girls and women new dignity. It allowed for polygyny (a traditional practice within pre-Islamic tribes), but limited it to four wives at one time, all to be treated equally. It mandated dowries (the husband's monetary obligation to the bride) and offered females some inheritance rights. At first the women even prayed with the men, though that practice ended in the eighth century. The nuclear family (newly emphasized, as was happening around the same time at Byzantium as well; see pp. 44–45) became more important than the tribe. In Islam, there are three essential social facts: the

4 *Qur'an Sura* 96 ("The Embryo"), in *A Short Medieval Reader*, pp. 33–34 or in *Reading the Middle Ages*, pp. 66–69.

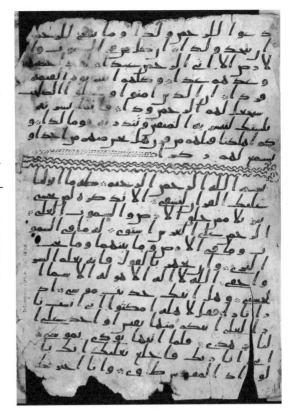

Plate 2.2 Page from an Early Qur'an (568–645). The parchment used for this Qur'an page has been radiocarbon dated to 568–645. Its precocity calls into question the traditional dating of Muhammad's revelations as well as when and how they were organized into an official text. Tradition gives the role of organization to Caliph Uthman (r.644–656), who had an authorized text prepared by a committee and issued *c*.650. The fragment shown in this plate (and other similar finds) suggests an earlier date and variant compilations of the Qur'an.

Reading from right to left and top to bottom, we see the end of sura 19 ("Maryam") and the beginning of sura 20 ("Ta Ha"). The verses of each sura are marked by little clusters of dots, and the division between the two suras is indicated by a decorative design in red ink.

individual, God, and the ummah, the community of the faithful. There are no intermediaries between the divine and human realms, no priests, Eucharist, icons, or relics. Jesus figures in Islam, but only as a prophet.

A community of believers coalesced around Muhammad as God's final prophet. It adhered to a strict monotheism, prepared for the final Day of Judgment, and carried out the tasks that piety demanded – daily prayers, charity, periods of fasting, and so on. Later these were institutionalized as the "five pillars" of Islam.[5] The early believers' idea of the righteous life included living in the world, marrying, and having children. For them, virtue meant mindfulness of God in all things. They could permit themselves moderate – though not excessive – pleasure in God's bounty. Their notions of righteousness did not call for asceticism.

At Mecca, where Quraysh tribal interests were bound up with the Ka'ba and its many gods, Muhammad's message was unwelcome. But it was greeted with enthusiasm at Medina, an oasis about 200 miles to the northeast of Mecca. Feuding tribes there invited Muhammad to join them and arbitrate their disputes. He agreed, and in 622 he made the *Hijra*, or flight from Mecca to Medina. There he became not only a religious but also a secular leader. This joining of the political and religious spheres set the pattern for Islamic government thereafter. After Muhammad's death, the year of the *Hijra*, 622, became the year 1 of the Islamic calendar, marking the establishment of the Islamic era.

Muhammad consolidated his leadership by asserting hegemony over three important groups: the Jews, the Meccans, and the pastoralists. At Medina itself, he took control by ousting and sometimes killing his main competitors, the Jewish clans of the city. Against the Meccans he fought a series of battles; the battle of Badr (624), waged against a Meccan caravan, marked the first Islamic military victory. After several other campaigns, Muhammad triumphed and took over Mecca in 630, offering leniency to most of its inhabitants, who in turn converted to Islam. Meanwhile, Muhammad allied himself with numerous Bedouin groups, adding their contingents to his army. Warfare was thus integrated into the new religion as a part of the duty of Muslims to strive in the ways of God; *jihad*, often translated as "holy war," in fact means "striving." Through a combination of military might, conversion, and negotiation, Muhammad united many of the tribes in the Arabian Peninsula under his leadership by the time of his death in 632.

5 The five pillars are: 1) the *zakat*, a tax to be used for charity; 2) Ramadan, a month of fasting and self-restraint; 3) the *hajj*, an annual pilgrimage to Mecca to be made at least once in a believer's lifetime; and 4) the *salat*, formal worship at least three times a day (later increased to five), including 5) the *shahadah*, or profession of faith: "There is no god but God, and Muhammad is His prophet."

Out of Arabia

"Strive, O Prophet," says the Qur'an, "against the unbelievers and the hypocrites, and deal with them firmly. Their final abode is Hell; And what a wretched destination" (9:73). Cutting across tribal allegiances, the Islamic *ummah* was itself a formidable "supertribe" dedicated to victory over the enemies of God. After Muhammad's death, armies of Muslims led by caliphs – a title that at first seems to have derived from *khalifat Allah*, "deputy of God," but that later came to mean "deputy of the Apostle of God, Muhammad" – moved into Sasanid and Byzantine territory, toppling or crippling the once-great ancient empires. (See Map 2.3.) Islamic armies captured the Persian capital, Ctesiphon, in 637 and continued eastward to take Persepolis in 648, Nishapur in 651, and then, beyond Persia, to conquer Kabul in 664 and Samarqand in 710. To the west, they picked off, one by one, the great Mediterranean cities of the Byzantine Empire: Antioch and Damascus in 635, Alexandria in 642, Carthage in 697. By the beginning of the eighth century, Islamic warriors held sway from India to the Iberian Peninsula.

What explains their astonishing triumph? Above all, they were formidable fighters, and their enemies were relatively weak. The Persian and Byzantine Empires had exhausted one another after years of fighting. Nor were their populations particularly loyal; in Persia, Syria, and Egypt some Jews welcomed the Muslims, as did those Christians whose beliefs were considered heretical by the Byzantines. The Muslims made no attempt to convert them, instead simply imposing a tax. Then, too, the Muslims sometimes conquered through diplomacy rather than battle. In Spain, for example, they treated with a local leader, Theodemir (or Tudmir), offering him and his men protection – the promise that "[they will not] be separated from their women and children. They will not be coerced in matters of religion" – in return for loyalty and taxes.[6]

True to their urban origins, the Muslims almost immediately fostered urban life in the regions that they conquered. In Syria and Palestine, most of the soldiers settled within existing coastal cities. Their leaders, however, built palaces and hunting lodges in the countryside. Elsewhere the Muslims created large encampments of their own, remaining separate from the indigenous populations. Some of these camps were impermanent, but others – such as those at Baghdad and Cairo (or, more precisely, Fustat, today absorbed into Cairo) – became centers of new and thriving urban agglomerations.

The caliphs fostered a well-ordered state. They appointed regional governors, who in turn worked with lower-level local indigenous officials to collect taxes, maintain law and order, and provision the military. Consider the administration of Egypt, for which we have a relatively large number of documents. Papyrus sheets, preserved for centuries beneath the ground (thanks to Egypt's dry climate), reveal a thriving bureaucracy under Islamic rule. The Egyptian governor (the *emir*) sent out orders to local pagarchs (officials) who in turn ordered underlings to help them collect taxes, regulate water use (of utmost importance in this largely agricultural society), and settle disputes. Numerous scribes

6 The *Treaty of Tudmir*, in *A Short Medieval Reader*, pp. 41–42 or in *Reading the Middle Ages*, pp. 78–79.

dutifully wrote letters and instructions, for even though most transactions were oral, the written word was highly valued. Sails, nails, woolen cloth, and Egyptian wheat – formerly exported to feed the people at Constantinople – were requisitioned for the Islamic army and navy. The Egyptian tax system, too, required the movement not only of money but of vast amounts of goods in kind: grapes, oil, beans, barley. The pagarchs were evidently very much at the beck and call of the *emir*. As one of them wrote to an underling: "The *emir* ... wrote to me with what he has calculated for me, of the amount in coin of the people of the province [and] of their taxes in kind. So pay this to him and ... hurry to me the amount in money."[7]

Living largely apart from their conquerors, the men and women who had long inhabited the Mediterranean Sea regions – Syria, Palestine, North Africa, and Spain – went back to work and play more or less as they had done before the arrival of Islamic troops. In return for a heavy tax, Christians and Jews could worship in their traditional ways. Safe in Muslim-controlled Damascus, Saint John of Damascus (d.749) was able to thunder against iconoclasm as he would never have been allowed to do in iconoclastic Byzantium. Another Christian, al-Akhtal (*c*.640–710), found employment at the court of Caliph 'Abd al-Malik (r.685–705), where he poured forth verses of praise:

7 *Letters to 'Abd Allah b. As'ad*, in *Reading the Middle Ages*, pp. 79–82.

So let him in his victory
 long delight!
He who wades into the deep of battle,
 auspicious his augury,
The Caliph of God
 through whom men pray for rain.[8]

Maps of the Islamic conquest sometimes divide the world into Muslims and Christians. But the "Islamic world" was only slightly Islamic; Muslims constituted a minority of the population. Then too, even as their religion came to predominate, they were themselves absorbed, at least to some degree, into the cultures that they had conquered.

The Culture of the Umayyads

Dissension, triumph, and disappointment followed the naming of Muhammad's successors. The caliphs were not chosen from the old tribal elites but rather from an inner circle of men close to Muhammad. The first two caliphs, Abu-Bakr and Umar, ruled without serious opposition. They were the fathers of two of Muhammad's wives. But the third caliph, Uthman, husband of two of Muhammad's daughters and great-grandson of the Quraysh leader Umayyah, aroused resentment. (See Genealogy 2.1.) His family had come late to Islam, and some of its members had once even persecuted Muhammad. The opponents of the Umayyads supported Ali, the husband of Muhammad's daughter Fatimah. After a group of discontented soldiers murdered Uthman, civil war broke out between the Umayyads and Ali's faction. It ended when Ali was killed in 661 by one of his own erstwhile supporters. Thereafter, the caliphate remained in Umayyad hands until 750.

Yet the *Shi'ah*, the supporters of Ali, did not forget their leader. They became the "Shi'ites," faithful to Ali's dynasty, mourning his martyrdom, shunning the "mainstream" caliphs of the other Muslims ("Sunni" Muslims, as they were later called), awaiting the arrival of the true leader – the *imam* – who would spring from the house of Ali.

Meanwhile, the Umayyads made Damascus, previously a minor Byzantine city, into their capital. Here they adopted many of the institutions of the culture that they had conquered, employing former Byzantine officials as administrators and issuing coins like those of the Byzantines (though, in the east, they minted coins based on Persian models). Caliph 'Abd al-Malik (who, as we have seen, won high praise from the poet al-Akhtal) turned Jerusalem – already sacred to Jews and Christians – into an Islamic holy city as well. His successor, al-Walid I (r.705–715) built major mosques (places of worship for Muslims) at Damascus, Medina, and Jerusalem. Plate 2.3 suggests how effortlessly the mosque at Damascus absorbed Byzantine motifs even as it transformed them into a new

8 Al-Akhtal, *The Tribe Has Departed*, in *Reading the Middle Ages*, pp. 82–85.

Plate 2.3 (facing page) Damascus Great Mosque Mosaic (706–715). Byzantine artisans were hired to work along with local craftsmen to cover the mosque at Damascus with mosaics. Compare the Christian mosaics decorating San Vitale at Ravenna (Plate 1.12 on pp. 34–35) with this detail of the western portico of the Damascus Great Mosque. Both mosaics boast a rich palette of greens and golds; both delight in vegetal forms; and both value symmetries. At the very top of the mosaic scene at San Vitale is an image of heaven: two angels hold a circle with the letter Alpha at the center of its glowing rays; to the viewer's left is a palace – the image of the heavenly Jerusalem – flanked by a stylized tree; to the right is the heavenly Bethlehem, also demarcated by a tree. Similarly, the Great Mosque mosaic offers a depiction of Paradise: a garden, represented by tall, fruiting trees, and fine bejeweled palaces. If, unlike San Vitale, the mosque mosaic rejected the depiction of human figures, so too would Byzantine art in a very few years, when iconoclasm took hold there.

Genealogy 2.1 (following pages) Muhammad's Relatives and Successors to 750

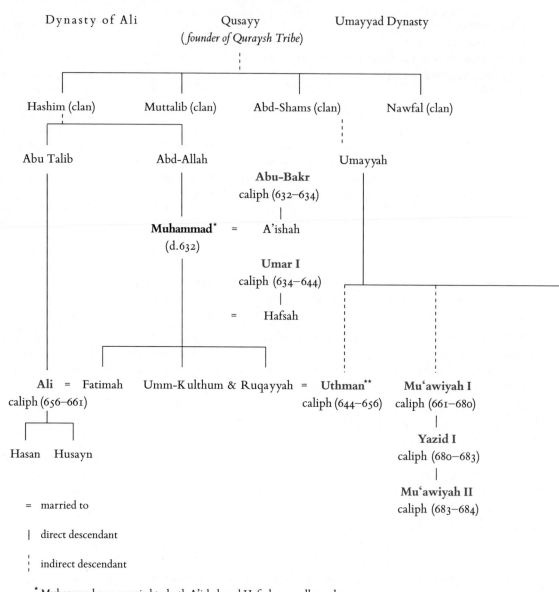

Dynasty of Ali Qusayy Umayyad Dynasty
(*founder of Quraysh Tribe*)

Hashim (clan) Muttalib (clan) Abd-Shams (clan) Nawfal (clan)

Abu Talib Abd-Allah Umayyah

Abu-Bakr
caliph (632–634)

Muhammad* = A'ishah
(d.632)

Umar I
caliph (634–644)

= Hafsah

Ali = Fatimah Umm-Kulthum & Ruqayyah = **Uthman**** **Mu'awiyah I**
caliph (656–661) caliph (644–656) caliph (661–680)

Hasan Husayn **Yazid I**
caliph (680–683)

Mu'awiyah II
caliph (683–684)

= married to

| direct descendant

┊ indirect descendant

 * Muhammad was married to both A'ishah and Hafsah, as well as others
** Uthman was married to two of Muhammad's daughters, Umm-Kulthum and Ruqayyah

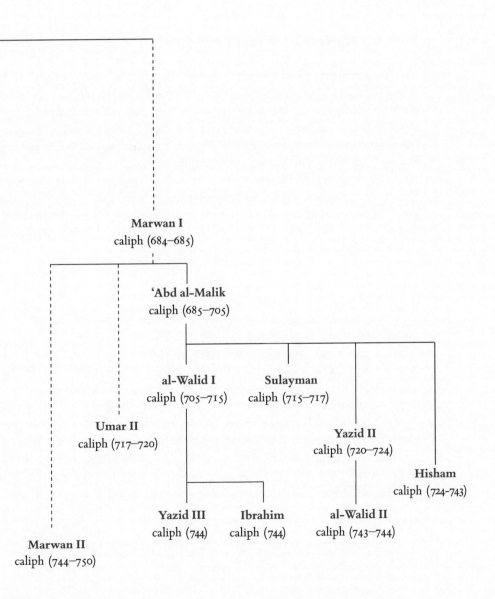

Marwan I
caliph (684–685)

ʿAbd al-Malik
caliph (685–705)

al-Walid I
caliph (705–715)

Sulayman
caliph (715–717)

Umar II
caliph (717–720)

Yazid II
caliph (720–724)

Hisham
caliph (724-743)

Yazid III
caliph (744)

Ibrahim
caliph (744)

al-Walid II
caliph (743–744)

Marwan II
caliph (744–750)

Islamic context. Here cityscapes and floral motifs drawn from Byzantine traditions were combined to depict an idealized world created by the triumph of Islam.

Arabic, the language of the Qur'an, became the official tongue of the Islamic world. As translators rendered important Greek and other texts into this newly prestigious language, it proved to be both flexible and capacious. A new literate class – composed mainly of the old Persian and Syrian elite, now converted to Islam and schooled in Arabic – created new forms of prose and poetry. Muslim scholars began to compile pious narratives about the Prophet's sayings, or *hadith*. The economy quickened as Caliph 'Abd al-Malik refurbished roads, standardized weights and measures, and helped turn the Red Sea into a busy trade route for Egyptian wheat, oil, and textiles to East Africa and Arabia. In return came gold, copper, ivory, and – requisitioned with depressing regularity by the caliph – hundreds of people captured in raids in Nubia (at the southern reaches of the Nile River).

THE MAKING OF WESTERN EUROPE

No reasonable person in the year 750 would have predicted that, of the three heirs of the Roman Empire, Western Europe would, by 1500, be well on its way to dominating the world. While Byzantium cut back and reorganized, while Islam spread its language and rule over a territory that stretched nearly twice the length of the United States today, Western Europe remained an impoverished backwater. Fragmented politically and linguistically, its cities (left over from Roman antiquity) mere shells, its tools primitive, its infrastructure – what was left of Roman roads, schools, and bridges – collapsing, Europe lacked identity and cohesion. That these and other strengths did indeed eventually develop over a long period of time is a tribute in part to the survival of some Roman traditions and institutions and in part to the inventive ways in which people adapted those institutions and created new ones to meet their needs and desires.

Impoverishment and Its Variations

Taking in the whole of Western Europe around this time means dwelling long on its variety. Dominating the scene was Gaul, now taken over by the Franks; we may call it Francia. To its south were Spain (ruled first by the Visigoths, and then, after *c.*715, by the Muslims) and Italy (divided between the pope, the Byzantines, and the Lombards). To the north, joined to, rather than separated from, the Continent by the lick of water called the English Channel, the British Isles were home to a plethora of tiny kingdoms, about three quarters of which were native ("Celtic") and the last quarter Germanic (Angles, Saxons, and Jutes).

There were clear differences between the Romanized south – Spain, Italy, southern Francia – and the north. (See Map 2.4.) Travelers going from England to Rome would have noticed them. There were many such travelers: some, like the churchman Benedict

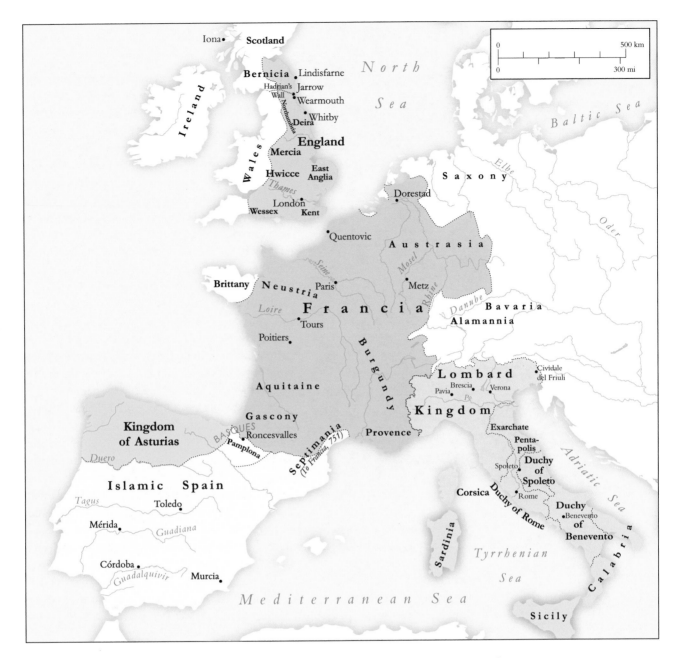

Map 2.4 Western Europe, c.750

Biscop, were voluntary pilgrims; others were slaves (generally prisoners of war) on forced march; still others were long-distance traders, keen to find exotic objects – such as the garnets that adorn the Sutton Hoo helmet (see Plate 2.4 on p. 67) – to entice the elites at home. Making their way across England, these voyagers would have taken still-intact Roman roads as they passed fenced wooden farmsteads much like the ones at Wijster (see pp. 23–24). Even royal estates were made of wood, however impressive in size they must have been. Figure 2.2 on p. 60 shows an artist's recreation of Yeavering (England) based on archaeological excavations there. Built within a landscape dominated by a great twin-peaked

Figure 2.2 Yeavering, Northumberland, Royal Estate, 7th cent.

hill, it was occupied – and used as a burial site – for millennia without having any special regional status. In the early seventh century, however, it became a major royal estate center that included a great hall, a theater (a feature clearly drawing on Roman precedents), and a large enclosure probably used for keeping animals but also serviceable for defense. The estate belonged to the king of the northern kingdom of Bernicia, who probably stayed there once or twice a year, hunting in the nearby woods, feasting in the great hall, and calling his chief men together in the theater. Right at the narrow point of this wedge-shaped wooden edifice was a small platform marked by a high post; the best guess is that from this acoustically well-placed spot the king greeted foreign dignitaries and declared his judgments and decisions. Even in the absence of the king, royal officials might have used the theater in this way to carry out business in his name.

More typically, farmsteads consisted of a relatively large house, outbuildings, and perhaps a sunken structure, its floor below the level of the soil, its damp atmosphere suitable for weaving. Ordinarily constructed in clusters of four or five, such family farmsteads made up tiny hamlets. Peasants planted their fields with barley (used to make a thick and nourishing ale) as well as oats, wheat, rye, beans, and flax. Two kinds of plows were used. One was heavy: it had a coulter and moldboard, often tipped with iron, to cut through and turn over heavy soils. The other was a light "scratch plow," suitable for making narrow furrows in light soils. Because the first plow was hard to turn, the fields it produced tended to be long and rectangular in shape. The lighter plow was more agile: it was used to cut the soil in one direction and then at right angles to that, producing a square field. But it worked only on light soils.

There were many animals on these farms: cattle, sheep, horses, pigs, and dogs. In some cases, the peasants who worked the land and tended the animals were relatively independent, owing little to anyone outside their village. In other instances, regional lords – often kings – commanded a share of the peasants' produce and, occasionally, labor services. But all was not pastoral or agricultural in England: here and there, and especially toward the south, were commercial settlements – real emporia.

Crossing the Channel, travelers would enter northern Francia, also dotted with emporia (such as Quentovic and Dorestad) but additionally boasting old Roman cities, now functioning mainly as religious centers. Paris, for example, was largely an agglomeration of

churches: Montmartre, Saint-Laurent, Saint-Martin-des-Champs – perhaps thirty-five churches were jammed into an otherwise nearly abandoned city. In the countryside around Paris, peasant families, each with their own plot, tended lands and vineyards that were generally owned by aristocrats. Moving eastward, our voyagers would pass through thick forests and land more often used as pasture for animals than for cereal cultivation. Along the Mosel River they would find villages with fields, meadows, woods, and water courses, a few supplied with mills and churches. Some of the peasants in these villages would be tenants or slaves of a lord; others would be independent farmers who owned all or part of the land that they cultivated.

Near the Mediterranean, by contrast, the terrain still had an urban feel. Here the great hulks of Roman cities, with their stone amphitheaters, baths, and walls, dominated the landscape even though, as at Byzantium, their populations were much diminished. Peasants, settled in small hamlets scattered throughout the countryside, cultivated their own plots of land. In Italy, many of these peasants were real landowners; aristocratic landlords were less important there than in Francia. The soil of Italy was lighter than in the north, easily worked with scratch plows to produce the barley and rye (in northern Italy) and wheat (elsewhere) that were the staples – along with meat and fish – of the peasant diet.

By 750 little was left of the old long-distance Mediterranean commerce of the ancient Roman world. Nevertheless, although this was an impoverished society, it was not without wealth or lively patterns of exchange. Money was still minted – increasingly in silver rather than gold. The change of metal was due in part to a shortage of gold in Europe. But it was also a nod to the importance of small-scale commercial transactions – sales of surplus wine from a vineyard, say, for which small coins were the most practical. At the same time, North Sea merchant-sailors – carrying, for example, ceramic plates and glass vessels – had begun to link together northern Francia, the east coast of England, Scandinavia, and the Baltic Sea. They probably also traded weapons and protective gear: the English warrior's helmet in Plate 2.4 on p. 67 has close counterparts to helmets from Sweden. Brisk trade gave rise to new emporia and revivified older Roman cities along the coasts. Alongside this familiar sort of commerce a gift economy – that is, an economy of give and take – flourished. Booty was seized, tribute demanded, harvests hoarded, and coins struck, all to be redistributed to friends, followers, dependents, and the Church. Kings and other rich and powerful men and women amassed gold, silver, ornaments, and jewelry in their treasuries and grain in their storehouses to give out in ceremonies that marked their power and added to their prestige. Even the rents that peasants paid to their lords, mainly in kind, were often couched as "gifts."

Politics and Culture

If variations were plentiful in even such basic matters as material and farming conditions, the differences were magnified by political and cultural factors. We need now to take Europe kingdom by kingdom.

FRANCIA

Francia was the major player, a real political entity that dominated what is today France, Belgium, the Netherlands, Luxembourg, and much of Germany. In the seventh century, it was divided into three related kingdoms – Neustria, Austrasia, and Burgundy – each of which included parts of a fourth, southern region, Aquitaine. By 700, however, the political distinctions between them were melting, and Francia was becoming one kingdom.

The line of Clovis – the Merovingians – ruled these kingdoms. (See Genealogy 2.2.) The dynasty owed its longevity to biological good fortune and excellent political sense: it allied itself with the major lay aristocrats and ecclesiastical authorities of Gaul – men and women of high status, enormous wealth, and marked local power. To that alliance, the kings brought their own sources of power: a skeletal Roman administrative apparatus, family properties, appropriated lands once belonging to the Roman state, and the profits and prestige of leadership in war.

The royal court was the focus of political life. It was not located in one fixed place but rather was constituted by an elite that moved with the king from one royal estate to another. Many of its members were young aristocrats on the rise. They ate together and hunted together (honing their warlike skills). Many of them later became bishops. The most important courtiers had official positions such as royal treasurer. Highest of all was the "mayor of the palace," who controlled access to the king and brokered deals with aristocratic factions.

Queens were an important part of the court as well. One of them, Balthild (d.680), may once have been among the unwilling captive travelers from England, as her biographer claimed. Or she may have been an aristocrat whose humility he wanted to emphasize. He praised her for ministering to all the men at court: "with attentive devotion she gave obedience to the king as to a master and showed herself to the princes as a mother, to the bishops as a daughter, to the young and immature as the finest of governesses."[9] When her husband, King Clovis II, died in 657, Balthild served as regent for her minor sons, acting, in effect, as king during this time. Meanwhile, she gave generously to churches and monasteries. In an era before formal canonization processes, Balthild was nevertheless deemed a saint by her biographer.

Just as a king's power radiated outward from his court, so too did aristocrats command their own lordly centers. Like kings, they had many "homes" at one time, scattered throughout Francia. Tending to their estates or hunting during their time at home, aristocratic men also regularly led armed retinues to war. They proved their worth in the regular taking of booty and rewarded their faithful followers afterwards at generous banquets.

And they had children. The focus of marriage was procreation, the key to the survival of aristocratic families and the transmission of their property and power. Though churchmen had many thoughts about marriage, they had little to do with it. The clergy were not

9 *The Life of Queen Balthild*, in *A Short Medieval Reader*, pp. 42–45 and in *Reading the Middle Ages*, pp. 88–92.

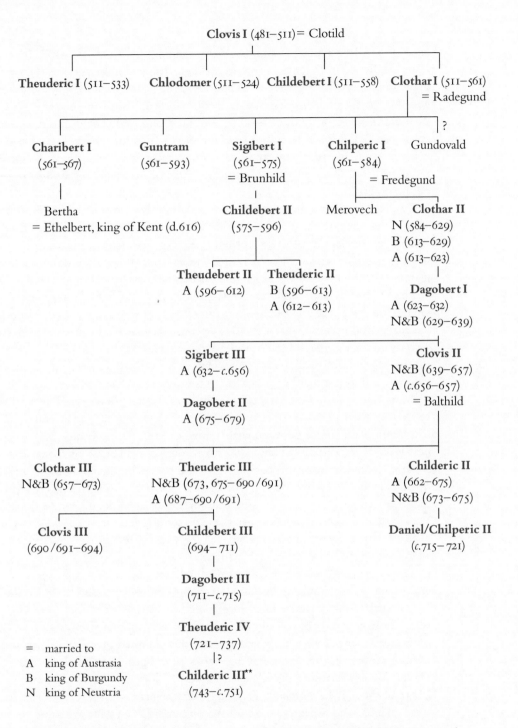

Clovis I (481–511) = Clotild

Theuderic I (511–533) Chlodomer (511–524) Childebert I (511–558) Clothar I (511–561)
= Radegund
?

Charibert I (561–567) Guntram (561–593) Sigibert I (561–575) = Brunhild Chilperic I (561–584) = Fredegund Gundovald

Bertha = Ethelbert, king of Kent (d.616)

Childebert II (575–596)

Merovech Clothar II
N (584–629)
B (613–629)
A (613–623)

Theudebert II A (596–612) Theuderic II B (596–613) A (612–613)

Dagobert I
A (623–632)
N&B (629–639)

Sigibert III A (632–c.656)

Clovis II
N&B (639–657)
A (c.656–657)
= Balthild

Dagobert II A (675–679)

Clothar III N&B (657–673) Theuderic III N&B (673, 675–690/691) A (687–690/691) Childeric II A (662–675) N&B (673–675)

Clovis III (690/691–694) Childebert III (694–711) Daniel/Chilperic II (c.715–721)

Dagobert III (711–c.715)

Theuderic IV (721–737)
|?

Childeric III** (743–c.751)

= married to
A king of Austrasia
B king of Burgundy
N king of Neustria

* Many of the Merovingian kings had more than one wife. The children listed (selected as only the most important of the fathers' progeny) are those of the king but not necessarily of the wife named here.

** The parentage of Childeric III is not clear. His father may equally well have been Daniel/Chilperic II as Theuderic IV.

needed to make a marriage valid, nor were weddings held in churches. Rather, marriage was a family affair. Parents, especially fathers, arranged marriages for their minor children, and parental consent seems to have been the norm, even for adult children. There were two sorts of marriage: in the most formal, the husband-to-be gave his future bride a handsome dowry of clothes, bedding, livestock, and land. Then, after the marriage was consummated, he gave his wife a morning gift of furniture and perhaps the keys to the house. Very rich men often had, in addition to their wife, one or more "concubines" at the same time. These enjoyed a less formal type of marriage, receiving a morning gift but no dowry.

The wife's role was above all to maintain the family. A woman passed from one family (that of her birth) to the next (that of her marriage) by parental fiat. When they married, women left the legal protection of their father for that of their husband. Yet wives had some freedom of action. They had considerable control over their dowries. Some participated in family land transactions: sales, donations, exchanges, and the like. Upon the death of their husbands, widows received a portion of the household property. We have seen that Balthild became a temporary ruler until her sons came of age. Although inheritances generally went from fathers to sons, many fathers left bequests to their daughters, who could then dispose of their property more or less as they liked. In 632, for example, the nun Burgundofara drew up a will giving to her monastery the land, slaves, vineyards, pastures, and forests that her father had given to her.

Burgundofara's generous piety was extraordinary only in degree. The world of kings, queens, and aristocrats intersected with that of the Church. The arrival (*c.*590) on the Continent of the fierce Irish monastic reformer Saint Columbanus (543–615) marked a new level of association between the two. Columbanus's brand of monasticism, which stressed exile, devotion, and discipline, made a powerful impact on Merovingian aristocrats. They flocked to the monasteries that he established in both Francia and Italy, and they founded new ones on their own lands in the countryside. In Francia alone there was an explosion of monasteries: between the years 600 and 700, an astonishing 320 new houses were established, most of them outside of the cities. Some of the new monks and nuns were grown men and women. Other entrants were young children, given to a monastery by their parents. This latter practice, called oblation, was well accepted and even considered essential for the spiritual well-being of both the children and their families.

The Irish monks introduced aristocrats on the Continent to a deepened religious devotion. Those who did not actively join or patronize a monastery still read – or listened to others read – books preaching penance, and they chanted the psalms. Irish and English clerics cultivated private penance; using books called "penitentials," they reminded people of their possible sins and assigned penances, usually fasting on bread and water for a certain length of time. The *Penitential of Finnian*, for example, assigns six years of fasting, three of them on bread and water and the last three abstaining from wine and meat, to "any cleric or woman who practices magic."[10] Evidently Finnian did not associate laymen with magic.

10 *Penitential of Finnian*, in *Reading the Middle Ages*, pp. 85–87.

Deepened piety did not, in this case, lead to the persecution of others – something that (as we shall see) happened in later centuries. In part, that was because the Franks were not particularly expansionist in this period. But perhaps more important, there were relatively few "others" within Francia's borders. Michael Toch's careful sifting of the evidence suggests (against much earlier historiography) that, apart from their presence in a handful of cities along the Mediterranean coast, there were no Jewish communities in Francia. The sources mentioning Jews – and there were many – were written not by Jews but by churchmen. For them, the Jews were not a religious group or a people but rather an abstract category against which Christianity could assert its superiority.

THE BRITISH ISLES

Roman-conquered Britain in the first century had a diverse population, though Celts preponderated, and in the nearly four centuries under Roman rule, that diversity only increased. After *c*.410, when the Romans pulled out of Britain, Germanic-speaking families from Saxony and elsewhere arrived piecemeal, settling on Britain's east coast as farmers. Irish immigrants gradually settled in the west. Celtic polities survived in Scotland, Ireland, and Wales.

Post-Roman England has traditionally been called "Anglo-Saxon." But the label is now problematic because in the United States it has been confounded with a mythical race, white and pure. Words matter, and these words have been put to dishonest use. Americans never were Anglo-Saxon and neither were the English. As Stephen J. Harris points out, "Anglo-Saxon England" was "a complex and shifting matrix of race and ethnicity."[11] There was no Anglo-Saxon "tradition" because there was no one sort of Anglo-Saxon – nor one Anglo-Saxon culture. Diversity and kaleidoscopic change are the key terms for understanding the historical reality of early medieval England.

Where the new peoples settled, their tastes, expectations, styles, and religious practices affected the former inhabitants, and vice versa. In the eighth century, the monk-historian Bede portrayed this amalgamated culture as utterly pagan: early medieval England was, in his words, "a barbarous, fierce, and unbelieving nation."[12] But the story that archaeology tells is more nuanced: holy sites dedicated to the saints established during the Roman occupation remained magnets long afterward for pilgrimage, burial, and settlement. Most, perhaps all, of the British Isles remained Christian. Wales was already Christian when, in the course of the fifth century, missionaries converted Ireland and Scotland. (Saint Patrick, apostle to the Irish, is only the most famous of these.)

But post-Roman Britain's Christianity, unlike that of Italy and Francia, was decentralized and local. Wales, Ireland, and Scotland supported relatively non-hierarchical Church organizations. Rural monasteries normally served as the seats of bishoprics as well as

11 Stephen J. Harris, *Race and Ethnicity in Anglo-Saxon Literature* (New York: Routledge, 2003), p. 1.
12 Bede, *The Ecclesiastical History of the English People*, in *A Short Medieval Reader*, pp. 45–50 and in *Reading the Middle Ages*, pp. 95–103.

centers of population and settlement. Abbots and abbesses, often members of powerful families, enjoyed considerable power and prestige.

At the end of the sixth century (597) the Roman Catholic brand of Christianity arrived in the British Isles to compete with the diverse forms already flourishing there. The initiative came from Pope Gregory the Great who sent the monk Augustine (*not* the fifth-century bishop of Hippo) to the court of King Ethelbert of Kent (d.616) to convert him. According to Bede, Ethelbert was a pagan. Yet he was married to a Christian Frankish princess, and he welcomed the missionaries kindly: "At the king's command they sat down and preached the word of life to himself and all his officials and companions there present." While he refused to convert because "[I cannot] forsake those beliefs which I and the whole people of the Angles have held so long," the king did give the missionaries housing and material support.[13]

Above all, the king let them preach. This was key: Augustine had in mind more than the conversion of a king: he wanted to set up an English Church on the Roman model, with ties to the pope and a clear hierarchy. Successful in his work of evangelization, he divided England into territorial units (dioceses) headed by an archbishop and bishops. Augustine himself became the first archbishop of Canterbury. There he constructed the model English ecclesiastical complex: a cathedral, a monastery, and a school to train young clerics.

There was nothing easy or quick about the conversion of England to the Roman type of Christianity. The old and the new Christian traditions clashed over matters as large as the organization of the Church and as seemingly small as the date of Easter. Everyone agreed that they could not be saved unless they observed the day of Christ's Resurrection properly and on the right date. But what was the right date? Each side was wedded to its own view. A turning point came at the Synod of Whitby, organized in 664 by the Northumbrian king Oswy to decide between the Roman and Celtic dates. When Oswy became convinced that Rome spoke with the very voice of Saint Peter, the heavenly doorkeeper, he opted for the Roman calculation of the date of Easter and embraced the Roman Church as a whole.

The pull of Rome – the symbol, in the new view, of the Christian religion itself – was almost physical. In the wake of Whitby, Benedict Biscop, a Northumbrian aristocrat-turned-abbot and founder of two important English monasteries, Wearmouth and Jarrow, made numerous arduous trips to Rome. He brought back books, saints' relics, liturgical vestments, and even a cantor to teach his monks the proper – the Roman – melodies in a time before written musical notation existed. A century later, the English monk Wynfrith (672/675–754) went to Rome to get a papal commission to preach to people living east of the Rhine. Though they were already Christian, their brand of Christianity was not Roman enough for Wynfrith, who signaled his own "Roman" identity by changing his name to Boniface.

13 Bede, *The Ecclesiastical History of the English People*, in *A Short Medieval Reader*, pp. 45–50 and in *Reading the Middle Ages*, pp. 95–103.

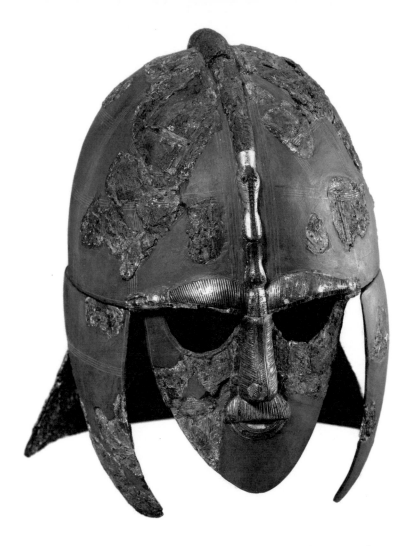

Plate 2.4 Sutton Hoo Helmet (early 7th cent.). This helmet was discovered along with many other useful and beautiful items (including the outlines of what was once a great ship) in a burial mound at Sutton Hoo, a village in eastern England. Now missing many elements, the helmet was once entirely covered with iron plaques incised with warriors, creatures, and interlacing animals. A sloping neck guard and two hinged cheek pieces protected the wearer's face, while the iron crest over the crown deflected blows. Descending both front and back, the crest is actually a two-headed snake, its eyes flashing with garnets. The form of the helmet, much like those made in Sweden at the same time, attests to England's close relations with Scandinavia. The most striking aspect of this piece is the "face" formed by the nose piece, eyebrows, and mustache which – viewed another way – also forms a bird, its garnet-outlined wings doubling as the brows.

Roman Christian culture had to confront Insular traditions in the arts as in everything else. The artists of the British Isles liked to adorn flat surfaces with decorative motifs. They embellished belt buckles, helmets, brooches, and other sorts of jewelry with semi-precious stones and enlivened them with abstract patterns, often made up of interlacing creatures and animal forms. The helmet in Plate 2.4 is a striking example of the effects that they achieved.

By contrast with these Insular artistic values, the Romans, as we have seen, privileged figures in the round (see Plate 1.9 on p. 22). When Benedict Biscop (and others like him) returned to England with books from Italy, they challenged scribes and artists to combine traditions. The imported books contained not only texts but also illustrations that relied, at least distantly, on late antique Roman artistic forms. Artists in the British Isles found ways to amalgamate decorative motifs with figural representation. The result was perfectly suited to flat pages.

Consider the Book of Durrow, which was probably made at Durrow itself or at a monastery influenced by the sixth-century Irish Saint Columba. Not to be confused with Columbanus, Columba founded the monastery of Iona (on an island off the west coast

of Scotland), which, along with its daughter monasteries, became a center of literature and art. The Book of Durrow (see Plates 2.5, 2.6, and 2.7) contains the Gospels (the four canonical accounts of the life and death of Christ in the New Testament) in Latin. The model for the text and the evangelist symbols used by the artists and scribes likely came from Italy, but the artists also delighted in Celtic scrolls and spirals as well as late-Roman interlace patterns.

Just as the people of the British Isles valued their traditional artistic styles, so too did they retain their native languages. In Ireland, the vernacular – the language of the people, as opposed to Latin – was turned into a written language known as Old Irish under the influence of Latin. In England, the vernacular was Old English (sometimes also known as Anglo-Saxon), and it was employed in every aspect of English life, from government to entertainment. Even Bede, a master of Latin, praised the common speech of the people, telling the story of Caedmon, a simple monk who dreamed a song in Old English about God's creation. Bede himself provided only a Latin translation of the poem in his *Ecclesiastical History*, but vernacular versions were soon available. Indeed, two manuscripts of Bede's work from the eighth century still survive today with Caedmon's hymn in both Latin and Old English.

THE IBERIAN PENINSULA

The mix of cultures characteristic of the British Isles was doubly the case in the Iberian Peninsula and Italy. In Spain, especially in the south and east, Roman cities had continued to flourish after the Visigoths arrived. Merchants from Byzantium regularly visited Mérida, and the sixth-century bishops there constructed lavish churches and set up a system of regular food distribution. King Reccared (r.586–601) converted from Arian to Catholic Christianity, thereby cementing the ties between the king and the Hispano-Roman population, which included the great landowners and leading bishops. In 589, at the Third Council of Toledo, most of the Arian bishops followed their king by announcing their conversion to Catholicism, and the assembled churchmen enacted decrees for a united Church in Spain, starting with the provision "that the statutes of the Councils and the decrees of the Roman Pontiffs be maintained."[14] Here, as in England a few decades later, Rome and the papacy became the linchpins of the Christian religion.[15]

The Roman inheritance in Visigothic Spain was clear not only in the dominance of the Hispano-Roman aristocracy and the adoption of its form of Christianity but also in the legal and intellectual culture that prevailed there. Nowhere else in Europe were Church councils so regular or royal legislation so frequent. Nowhere else were the traditions of classical learning so highly regarded. Only in seventh-century Spain could a man like Isidore of Seville (*c.*560–636) draw on centuries of Latin learning to write the encyclopedic *Etymologies*, in which the essence of things was explained by their linguistic roots.

14 *The Third Council of Toledo*, in *Reading the Middle Ages*, pp. 44–48.
15 The word "papacy" is an abstraction referring to the office and jurisdiction of the pope.

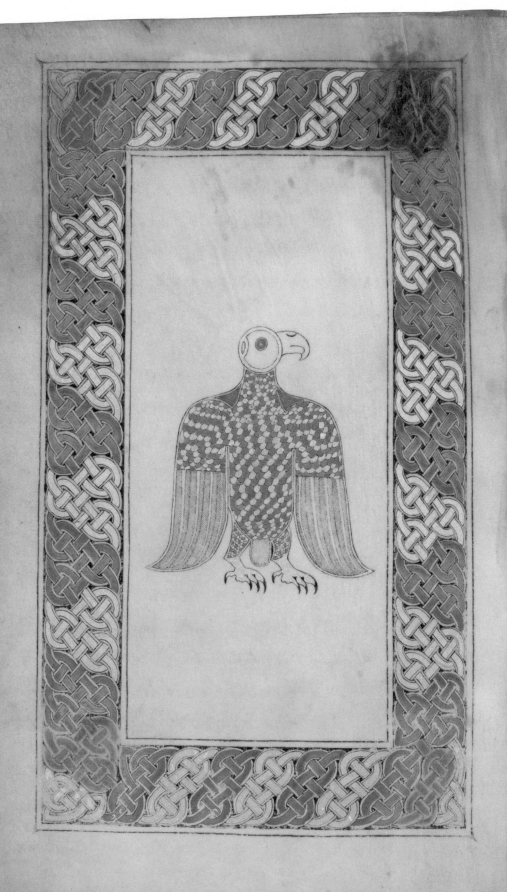

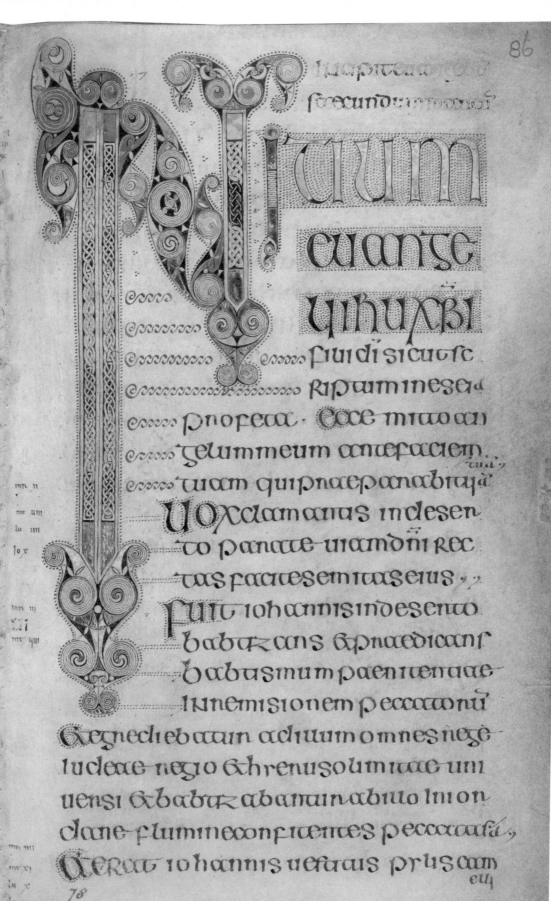

Incipit euangelii
secundum marcum

INitium
euange
lii ihu xpi
filii di sicut sc
riptum in esa
ia propheta · Ecce mitto an
gelum meum ante faciem
tuam qui praeparabit uiā
VOx clamantis in desen
to parate uiam dni rec
tas facite semitas eius
FUit iohannis in deserto
babtizans & praedicans
babtismum paenitentiae
In remisionem peccatorū
Et egrediebatur ad illum omnes rege
iudeae regio & hierusolimitae uni
uensi & babtizabantur ab illo in ior
dane flumine confitentes peccata sua
Et erat iohannis uestitus pilis cam
eli

Like so many others of his place and time, however, he took the opportunity to display not only his wide learning but also his sharp prejudices:

> [On the] heresies of the Jews (*De haeresibus Iudaeorum*) 1. The name "Jew" (*Iudaeus*) can be translated as "confessor," ... for confession ... catches up with many of those whom wrong belief possessed earlier. 2. Hebrews (*Hebraeus*) are called journeyers (*transitor*). With this name they are reminded that they are to journey ... from worse to better, and abandon their original errors.[16]

Words like Isidore's constituted but a small sample of the cascade of anti-Jewish writings and legislation churned out in the Visigothic Kingdom. That anti-Jewish focus has been taken to suggest a large Jewish presence on the peninsula, but there is almost no material evidence to support this claim. It is possible that, under enormous pressure, many Jews converted. Or it is possible that, as in Francia so in Visigothic Spain, "Jew" was largely a useful abstraction for zealous Christians to rail against.

On the whole, Visigothic society was high-pitched, its relatively small elite commanding private armies of warriors and peasants. It used to be thought that those peasants were slaves, abject and impoverished. Archaeology tells a different story, finding that peasants lived in stable and well-organized communities within a few miles of one another. These were real villages, with clearly demarcated areas for houses, farming, and numerous storage silos.

Strangely powerful yet weak at the same time were the kings. Despite their anointment (following the model of Old Testament kings, they were daubed with holy oil that gave them the status of divine election), their collection of the traditional Roman land tax (something only the Byzantines could match at the time), and their establishment of a royal capital at Toledo, they were unable to establish a stable dynasty. Nearly every royal succession provoked a successful rebellion by rival noble families. When King Witiza died in 711, the civil war that followed opened the way to the Islamic invasion of the Iberian Peninsula. While royal claimants competed, a large army led by Tariq ibn Ziyad acting in the name of Musa, the governor of Ifriqiya, killed all the Visigothic rivals and marched on Toledo. Its bishop fled and some of its nobles were executed. Musa and his son soon arrived with reinforcements, and between 712 and 715, as we have seen, most of the peninsula was taken over through a combination of war and diplomacy (see Map 2.4 on p. 59).

The conquest of Spain was less Arab or Islamic than Berber. Musa, his son, and other generals leading the invasion were Arabs, but the rank-and-file fighters were Berbers from North Africa. Although the Berbers were converts to Islam, they did not speak Arabic, and the Arabs considered them crude mountainfolk, only imperfectly Muslim. Perhaps a million people settled in the Iberian Peninsula in the wake of the invasions, the Arabs taking the better lands in the south, the Berbers getting the less rich properties in the

16 Isidore of Seville, *Etymologies* 8.4, in *The Etymologies of Isidore of Seville*, trans. Stephen A. Barney, W.J. Lewis, J.A. Beach, and Oliver Berghof (Cambridge: Cambridge University Press, 2006), p. 174.

center and north. Most of the conquered population consisted of Christians, along with (perhaps) a sprinkling of Jews. A thin ribbon of Christian states survived in the north. There was thus a great variety of peoples on the Iberian Peninsula. The history of Spain would for many centuries thereafter be one of both acculturation and war.

ITALY

Unlike Visigothic Spain, Italy was partitioned. In the north were Lombard kings; in the center of the peninsula was a swathe of territory claimed by the Byzantines (the Exarchate) and dominated on its southwestern end by the papacy, always hostile to the Lombard kings. To Rome's east and south were the dukes of Benevento and Spoleto. Although theoretically the Lombard king's officers, in fact they were virtually independent rulers. (See Map 2.5.) Although many Lombards were

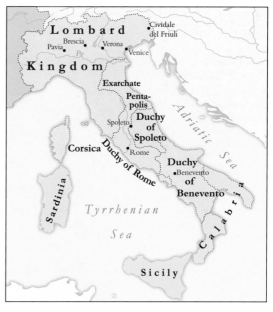

Map 2.5 Lombard Italy, *c.*750

Catholics, others, including important kings and dukes, were Arians. The "official" religion varied with the ruler in power. Rather than signal a major political event, then, the conversion of the Lombards to Catholic Christianity occurred gradually, ending only in the late seventh century. Partly as a result of this slow development, the Lombard kings never enlisted the wholehearted support of any particular group of churchmen.

Yet the Lombard kings did not lack advantages. They controlled extensive estates, and they made use of the Roman institutions that survived in Italy. The kings made the cities their administrative bases, assigning dukes to rule from them and designating Pavia as their capital. Recalling emperors like Constantine and Justinian, the Lombard kings maintained city walls and roads and issued law codes.

Yet, the cities taken over by the Lombards were no longer commercially active, even though the urban centers of Byzantine Italy (the narrow strip running from Ravenna to Rome) were still alive with trade. The Lombards also allowed Roman houses and apartment blocks to crumble, their places to be taken by burial plots and vegetable gardens.

More ambitiously, they constructed churches and monasteries. The influence of both classical Roman and "barbarian" or at least "provincial" artistic sensibilities in Lombard Italy is clear in two monuments from the period: the altar of King Ratchis (r.744–749) from the church of San Giovanni at Cividale del Friuli and carved figures in Cividale's Tempietto (i.e., small temple). Both probably date from the eighth century (though the Tempietto's date may be later), and both involve religious themes. At first glance, they seem very different. The altar (Plate 2.8) is made of slabs of marble carved in very low relief. The sculptors, here depicting the theme of the Three Magi bringing gifts to the Christ Child, showed no interest in the volume and weight of ordinary human bodies. Nevertheless, considering that most Lombard art was *purely* decorative, the figures on the altar may be seen as a real concession to Roman traditions.

Plate 2.8 The Altar of Ratchis (737–744). The sculptors of this marble slab – one side of a four-sided carved altar – were interested above all in pattern and transcendence. The three magi advance toward Mother and Child in lock step, their short tunics forming identical triangles, the folds of their clothing turned into incised lines. Mary, mother of God, and the Christ Child look outward, beyond the viewer, interacting with no one. The otherworldly character of the relief is stressed by the landscape – three "half daisy-wheels" rising from a decorative border – and an angel hovering above. A tiny Joseph, husband of Mary, hovers mid-air behind her throne. Originally the altar was studded with gems and was brightly painted in blues, yellows, and reds; traces of polychrome remain. An opening in the back panel of the altar allowed worshippers to view the relics within. A dedicatory inscription running along the top border of the altar declares that it was King Ratchis's gift to San Giovanni (Saint John).

The Tempietto (Plate 2.9), located next door, is in a very different style. Unlike the Mary of the Ratchis Altar, the women here have weight and volume. When they were originally made, they were part of an array of such female saints all along the Tempietto's walls. One turns toward another (see the two figures flanking the open space, the lunette). Yet even in the case of these Tempietto carvings, the artists' interest in design and decoration is clear: above and below the saints are decorative borders with flowers that recall the "daisy-wheels" of the Altar of Ratchis (Plate 2.8), and their robes fall into folds created by incised lines.

Cividale was not the only Lombard center to boast significant artistic activity. The monastery of San Salvatore at Brescia, for example, also built in the eighth century, was

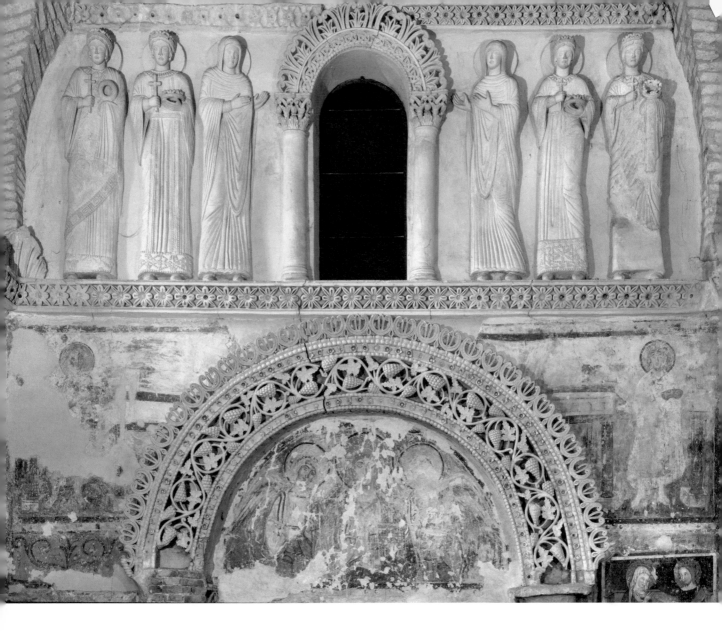

comparably decorated. The importance of both classical and Roman provincial styles in Lombard Italy suggests that the elites there welcomed artists not only from Europe but also from the Byzantine and Islamic worlds. This should not be surprising: Byzantium ran through the middle of Italy, while the Umayyad caliphs, not far from Sicily and Southern Italy, were themselves enthralled with Romano-Byzantine traditions, as we saw in the case of their mosque at Damascus (Plate 2.3 on p. 54).

Emboldened by their achievements in the north, the Lombard kings tried to make some headway against the independent dukes of southern Italy. But that move threatened to surround Rome with a unified Lombard kingdom. The pope, fearing for his position, called on the Franks for help.

Plate 2.9 The Cividale Tempietto (8th cent.?). These stucco figures stand above the main entrance of the small church of Santa Maria in Valle, originally an oratory for the church of San Giovanni.

THE MAN IN THE MIDDLE: THE POPE

At the end of the sixth century, the pope's position was ambiguous. As bishop of Rome, he wielded real secular power within the city as well as a measure of spiritual leadership farther afield. Yet in other ways he was subordinate to Byzantium. Pope Gregory the Great, whom we have already met a number of times, laid the foundations for the papacy's later spiritual and temporal ascendency. During Gregory's tenure, the pope became the greatest landowner in Italy; he organized Rome's defense and paid for its army; he heard court cases, made treaties, and provided welfare services. The missionary expedition he sent to England was only a small part of his involvement in the rest of Europe. A prolific author of spiritual works, Gregory digested and simplified the ideas of Church Fathers such as Saint Augustine, making them accessible to a wider audience. In his *Moralia in Job*, he set forth a model of biblical exegesis that was widely imitated for centuries. His handbook for clerics, *Pastoral Care*, went hand in hand with his practical Church reforms in Italy, where he tried to impose regular episcopal elections and enforce prohibitions against clerical marriages. At the same time, even Gregory was only one of many bishops in the Byzantine Empire.

For a long time, the emperor's views on dogma, discipline, and Church administration largely prevailed at Rome. However, this authority began to unravel in the seventh century. In 691/692, the Quinisext council did not just ban dancing on the first day of March (see p. 45), but drew up 102 rules of discipline for both churchmen and laity. Emperor Justinian II (r.685–695; 705–711) convened the council with the hope that the pope would attend, but Pope Sergius I (687–701) did not come, nor would he agree to the canons produced by the council. He objected in particular to two, one permitting priests to have wives if their marriages had occurred before ordination and the other prohibiting fasting on Saturdays in Lent (which the Roman Church required). Outraged by Sergius's refusal, Justinian tried to arrest the pope, but the imperial army in Italy (theoretically under the emperor's command) came to the pontiff's aid instead. Justinian's arresting officer was reduced to cowering under the pope's bed. Clearly Constantinople's influence and authority over Rome had become tenuous. Sheer distance as well as diminishing imperial power in Italy meant that the popes had in effect become the leaders of non-Lombard Italy.

The gap between Byzantium and the papacy widened in the early eighth century, when Emperor Leo III tried to increase the taxes on papal property to pay for his wars against the Arabs. The papacy responded by leading a general tax revolt. Meanwhile, Leo's fierce policy of iconoclasm collided with the pope's tolerance of images. Increasing friction with Byzantium meant that when the pope felt threatened by the Lombard kings, as he did in the mid-eighth century, he looked elsewhere for support. Pope Stephen II (752–757) appealed to the Franks – not to the Merovingians, who had just lost the throne, but to Pippin III, the king who had taken the royal crown. Pippin listened to the pope's entreaties and marched into Italy with an army to fight the Lombards. The new Frankish/papal alliance would change the map of Europe in the coming decades.

★ ★ ★ ★ ★

The "fall" of the Roman Empire meant the rise of its heirs. In the East, the Muslims swept out of Arabia but drew on many Roman governmental and administrative traditions where they conquered. The bit of the eastern Roman Empire that they did not take – the part ruled from Constantinople – still considered itself the real heir of Rome (and would always do so) even though historians call it Byzantium. In the West, impoverished kingdoms looked to the city of Rome for religion, language, culture, and inspiration. However much East and West, Christian and Muslim, would come to deviate from and hate one another, they could not change the fact of shared parentage.

MATERIAL CULTURE: FORGING MEDIEVAL SWORDS

The medieval sword was more than a weapon on which the warrior's life depended. It had magical, sacred, even moral significance. Usually expensive, it was available only to richer men and often handed down over generations. Medieval epic poetry sometimes made swords their very focus. Consider the story of Sigurd (or Siegfried) in the *Volsunga Saga*. His father's sword, Gram (in epic tales the hero's sword had names such as Excalibur and Durendal), broke in two, but the swordsmith Regin forged the two halves together, making Gram better than ever. Now unbreakable, it made possible Sigurd's slaying of the treasure-guarding dragon, Fafnir.

A carved wooden panel, originally part of a twelfth-century (or perhaps early thirteenth-century) church portal in Norway, shows one artist's view of how Gram was forged (see Plate 2.10). The carvings seem to display a "pattern-welded" blade, an early technique in which twisted strips of natural steel (iron with heterogeneous carbon content) and wrought iron (iron low in carbon) were welded together on a forge fire at a temperature of no less than 2,100°F/1,150°C. The result was a distinctive serpentine pattern on the blade's surface and the unique attributes of durability and resistance to fracture. The sword in the carvings also shows a "fuller," a groove that runs along almost the entire length of the blade to make the sword lighter.

Temperature control was key during the forging process. The lower roundel in Plate 2.10 shows an assistant (or perhaps Sigurd) manning two bellows. These blowing devices – generally made of wood and leather – provided constant air flow into the forge to keep the fire going. The swordsmith used heat-control techniques (and not just mechanical ones, like hammering) to modify the distribution of carbon inside the blade. He repeatedly quenched and then tempered the blade. Quenching had to be performed when the blade was cherry red by rapidly immersing it in cool water (or sometimes brine or oil) to improve its hardness, while tempering called for the blade to be reheated at lower temperatures to relieve brittleness.

Among the most remarkable swords from the period 700 to 1200 were those featuring blades in which the fuller sported an iron inlay with Latin lettering. The inscription ULFBERHT (variously spelled and accompanied by cross symbols [+]) has been found on many such swords throughout Europe. Scholars have long debated the meaning of Ulfberht. Ewart Oakeshott has argued that this likely was the name of a Frankish blacksmith operating in the lower or middle Rhine area (Germany). If so, Ulfberht founded a sword-production company that long outlived him, its products spreading elsewhere through trade. But Mikko Moilanen has recently argued that the composition of such swords was too diverse to have been produced in one place. While the Norwegian portal romanticized the making of the blade, by the ninth century whole workshops were dedicated to the task, often employing slaves to operate both forge and bellows. Some produced very fine blades, such as the ULFBERHT shops, but if illiterate slaves did the actual forging, this may explain the many variants of the Ulfberht signatures. In Plate 2.11, for example, ULFBERHT is missing the R. On the other hand, if Ulfberht was a "brand name" for a certain type of high-quality sword, then its precise spelling might have varied over time or have been different in different regions. It's also possible that variations were due to accidents in the manufacturing process.

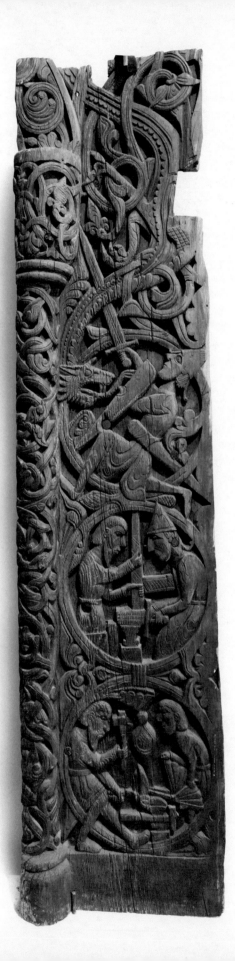

Plate 2.10 The Sigurd Portal, Hylestad Stave Church, Norway (12th–13th cent.). Shown here is the right-hand column of the portal, which reads from bottom to top. At the bottom, Gram is being forged. In the middle roundel, Sigurd (with the helmet) tests the sword, while in the top roundel he slays the dragon Fafnir.

A Carolingian Psalter illustration sheds light on the final step in the production of a sword: sharpening the blade. Plate 2.12 shows two techniques. On the right, the side where the psalmist himself stands inspired by a winged angel above, members of the army of the righteous sharpen a sword on a hand-operated rotary grindstone. That was the most up-to-date method, and this drawing is the first we have of it. On the left, the enemy army, the "wicked," as the psalmist puts it, uses an "old-fashioned" whetstone. The artist seems to be saying that virtue and advanced technology go hand in hand.

The invention of the blast furnace, a new technology for smelting iron ores, allowed for transformations in the production of weaponry, and – in particular – made all-steel swords a reality. Scholars now seem to agree that prototypes of this kind of shaft furnace were probably introduced earlier than c.1350 (the traditional date). It was in use at some point between the eleventh and thirteenth century in central Swabia (southwest Germany). However, from the late fourteenth century, it heralded an "industrial revolution." The transition from the traditional direct process smelting furnace to the blast furnace occurred when shafts were pitched higher and made larger and air was blasted into the furnace with water-powered bellows.

The furnace temperature could now go far above 2,100°F/1,150°C (the melting point of cast iron) and even up to the melting point of pure iron (2,795°F/1,535°C). This method produced massive quantities of liquid cast iron (or "pig iron"): a single blast furnace could yield up to nine tons of iron from a single "charge" – the load of iron ore and charcoal fed into the top of the furnace. The high carbon content (up to 3–4 per cent) in the liquid cast iron was then reduced in a refining furnace to obtain high quality wrought iron and/or natural steel. With these sweeping, "proto-industrial" improvements, medieval weaponry could include steel plate armor, wrought iron bombards (cannons that hurled stones) and handguns, and cast iron cannons, paving the way to modern warfare.

BIBLIOGRAPHY

Moilanen, Mikko. *Marks of Fire, Value and Faith: Swords with Ferrous Inlays in Finland during the Late Iron Age (ca. 700–1200 AD)*. Turku: Society for Medieval Archaeology in Finland, 2015.

Oakeshott, Ewart, Ian G. Peirce, and Lee A. Jones. *Swords of the Viking Age*. Woodbridge: Boydell Press, 2002.

Williams, Alan. *The Sword and the Crucible: A History of the Metallurgy of European Swords up to the 16th Century*. Leiden: Brill, 2012.

Plate 2.11 Ulfberht Sword (9th cent.). This sword was discovered in 1960 in the Rhine River near Mannheim (Germany).

Plate 2.12 (facing page) The Utrecht Psalter (first half of 9th cent.). This drawing of the two techniques of blade-sharpening depicts a passage in Psalm 64 (Douay 63):1–4, "Preserve my life from dread of the enemy, hide me from the secret plots of the wicked, from the scheming of evildoers, who whet their tongues like swords, who aim bitter words like arrows, shooting from ambush at the blameless."

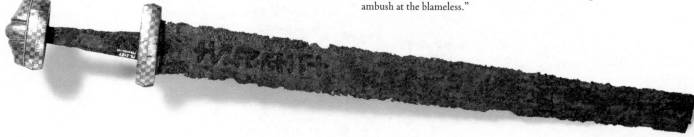

DS DŌS MEUS
ADTEDILUCEUIGILO SI
TIUITINTEANIMAMEA
QUAMMULTIPLICITER
TIBICAROMEA :
INTERRADESERTAETIN
UIAETININAQUOSA
SICINSCOAPPARUITTIBI
UTUIDEREMUIRTUTEM
TUAMETGLORIATUAM ;
QMMELIORESTMISERICOR
DIATUASUPERUITAS
LABIAMEALAUDABITE

SICBENEDICAMTFINUITA
MEA ETINNOMINETUO
LEUABOMANUSMEAS ;
SICUTADIPEETPINGUIDI
NEREPLEATURANIMA
MEA ETLABIAEXSULTATI
ONISLAUDABITOSMEU ;
SIMEMORFUITUISUPER
STRATUMMEUINMATU
TINISMEDITABORINTE
QUIAFUISTIADIUTORMS
ETINUELAMENTOALARU
TUARUMEXSULTABO

ADHAESITANIMAMEA
POSTTE MESUSCEPITDEX
TERATUA ;
IPSIUIROINUANUQUAE
SIERUNTANIMAMEA
INTROIBTININFERIORA
TERRAE TRADENTURIN
MANUSGLADIIPARTES
UULPIUMERUNT ;
REXUEROLAETABITINDŌ
LAUDABUNTOMSQUIIU
RANTINEO QUIAOBSTRUC
TUEOSLOQUENTIUINIQUA

EXAUDIDSORATI
ONEMMEAMCUMDE
PRECOR ATIMOREINI

MICIERIPEANIMAMEA
PROTEXISTIMEACONUEN
TUMALIGNANTIUM

AMULTITUDINEOPERAN
TIUMINIQUITATEM
QUIAEXACUERUNTUTGLA

For practice questions about the text, maps, plates, and other features — plus suggested answers — please go to

www.utphistorymatters.com

There you will also find all the maps, genealogies, and figures used in the book.

FURTHER READING

Al-Azmeh, Aziz. *The Emergence of Islam in Late Antiquity: Allah and His People.* Cambridge: Cambridge University Press, 2014.

Brown, Peter. *The Ransom of the Soul: Afterlife and Wealth in Early Western Christianity.* Cambridge, MA: Harvard University Press, 2015.

Brubaker, Leslie, and John Haldon. *Byzantium in the Iconoclast Era c.680–850: A History.* Cambridge: Cambridge University Press, 2011.

Cosentino, Salvatore, ed. *A Companion to Byzantine Italy.* Leiden: Brill, 2021.

Dell'Elicine, Eleonora, and Céline Martin, eds. *Framing Power in Visigothic Society: Discourses, Devices, and Artifacts.* Amsterdam: Amsterdam University Press, 2020.

Effros, Bonnie, and Isabel Moreira, eds. *The Oxford Handbook of the Merovingian World.* Oxford: Oxford University Press, 2020.

Esders, Stefan, Yitzhak Hen, Pia Lucas, and Tamar Rotman, eds. *The Merovingian Kingdoms and the Mediterranean World: Revisiting the Sources.* London: Bloomsbury Academic, 2019.

Evans, Helen C., with Brandie Ratliff. *Byzantium and Islam: Age of Transition, 7th–9th Century.* New Haven, CT: Yale University Press, 2012.

Fentress, Elizabeth, and Hassan Limane, eds. *Volubilis après Rome* [Volubilis after Rome]. Leiden: Brill, 2019.

Fleming, Robin. *Britain after Rome: The Fall and Rise, 400 to 1070.* London: Penguin, 2010.

Harris, Stephen J. *Race and Ethnicity in Anglo-Saxon Literature.* New York: Routledge, 2003.

Howard-Johnston, James. *The Last Great War of Antiquity.* Oxford: Oxford University Press, 2021.

Hunt, Guy, and Elizabeth Fentress. Volubilis. Updated by Dan Taylor. https://sitedevolubilis.org/.

Kreiner, Jamie. *Legions of Pigs in the Early Medieval West.* New Haven, CT: Yale University Press, 2020.

Marsham, Andrew, ed. *The Umayyad World.* Abingdon, UK: Routledge, 2021.

O'Hara, Alexander, and Ian Wood, trans. and eds. *Jonas of Bobbio: Life of Columbanus, Life of John of Réomé, and Life of Vedast.* Liverpool: Liverpool University Press, 2017.

Rambaran-Olm, Mary, "Misnaming the Medieval: Rejecting 'Anglo-Saxon' Studies." *History Workshop* (November 4, 2019). bit.ly/3ayoqcd.

Reynolds, Gabriel Said, ed. *The Qur'an in Its Historical Context.* Abingdon: Routledge, 2008.

Robinson, Chase F. *'Abd al-Malik.* Oxford: Oxford University Press, 2005.

Rouighi, Ramzi. *Inventing the Berbers: History and Ideology in the Maghrib.* Philadelphia: University of Pennsylvania Press, 2019.

Stathakopoulos, Dionysios. *A Short History of the Byzantine Empire.* London: I.B. Tauris, 2014.

Stevens, Susan T., and Jonathan P. Conant, eds. *North Africa under Byzantium and Early Islam.* Washington, DC: Dumbarton Oaks, 2016.

Toch, Michael. *The Economic History of European Jews: Late Antiquity and Early Middle Ages.* Leiden: Brill, 2013.

Trinity College Dublin. "Book of Durrow." Digital Collections, The Library of Trinity College Dublin. https://doi.org/10.48495/wm117t53k.

Abbasid dynasty
750
Displaces the Umayyads, though equally Sunni, signaling a shift of Islamic civilization from the West (Syria) to the East (Baghdad).

Pippin III
751–768
First Carolingian king, ruler of Francia.

Charlemagne (Charles the Great)
768–814
Ruler of Francia, creates the Carolingian Empire.

Coronation of Charlemagne
800
Crowned emperor by the pope on Christmas Day, Charlemagne sets a precedent for imperial rule in France and Germany that lasts for centuries.

Iconoclasm ends
843
The cult of images at Byzantium is reinstated.

Treaty of Verdun
843
Divides the Carolingian Empire into three parts, defining the configuration of Western Europe even today.

Bulgarian khan converts to Christianity
c.864
Along with the duke of Moravia, the khan is the first of East Central European rulers to convert to Christianity. Moravia opts for the Roman form, while Bulgaria chooses to follow that of the Byzantines.

THREE

CREATING NEW IDENTITIES (*c.750–c.900*)

In the second half of the eighth century the periodic outbreaks of the Plague of Justinian, which had devastated half of the globe for two centuries, came to an end. In their wake came a gradual but undeniable upswing in population, land cultivation, and general prosperity. At Byzantium an empress took the throne, in the Islamic world the Abbasids displaced the Umayyads, while in Francia the Carolingians deposed the Merovingians. New institutions of war and peace, learning, and culture developed, giving each culture – Byzantine, Islamic, and European – its own characteristic identity.

BYZANTIUM: FROM TURNING WITHIN TO CAUTIOUS EXPANSION

By 750 Byzantium had turned its back on the world: its iconoclasm isolated it from other Christians; its *strategiai* focused its military operations on internal defense; and its abandonment of classical learning set it apart from its own past. By 900, all this had changed. Byzantium was iconophile (icon-loving), aggressive, and cultured.

New Icons, New Armies, New Territories

Within the Byzantine Empire, iconoclasm sowed dissension. Some men and women continued to venerate icons even in the face of persecution and humiliation. The tide turned in 780 when Leo IV died and his widow, Irene, became head of the Byzantine state as regent for her son Constantine VI. (Later she became sole ruler 797–802 after her son was deposed.) Historians use to think that Irene had always been iconophile. It is more likely (as Leslie Brubaker and John Haldon argue) that she had been indifferent to the issue. The council that she called at Nicaea in 787 to condemn iconoclasm recognized

political reality: most people in the provinces were deeply attached to icons, and so were the other patriarchs, not least the pope at Rome. But the council of 787 went further than many iconophiles liked: it actually created a cult of images. All Christians were to prostrate themselves before icons, kiss them, and keep them lit perpetually. No wonder that there was a backlash, and a partial ban on icons was put into effect between 815 and 843. At that point the iconoclastic period definitively came to an end.

With that end came changes in the army, as the old guard, supporters of iconoclasm, were replaced. And even before that, the system of territorial *strategiai* had been reformed. That system had given too much power to a few generals who dominated their regions and often rebelled against imperial power. In the eighth century, the emperors divided the imperial army into smaller regional units (called themes: *themata*; sing. *thema*) led by less powerful generals (still called *strategoi*). Drawing the recruits for each unit from its immediate neighborhood, the emperors made the nearby rural communities pay for the equipment of any soldiers unable to foot the bill. Thus rooted in the rural landscape, the theme's very organization made clear how fully the once city-based Roman East had become rural.

One key element of the newly reformed army was not, however, based in the countryside: the *tagmata* (sing. *tagma*). Created by Emperor Constantine V (r.741–775), they consisted of mobile regiments of heavy cavalry. At first deployed largely around Constantinople itself to shore up the emperors, the *tagmata* were eventually used in cautious frontier battles. Under the ninth- and tenth-century emperors, they helped Byzantium to expand.

Throughout the ninth century, the Byzantines and Bulgarians vied for domination in Greece and the Balkans. By the first half of the tenth century, the region was fairly evenly divided (see Map 3.1). Compared to its size in around 700, the Byzantine Empire had done well, as a comparison of Map 3.1 with Map 2.2 on p. 43 makes clear.

Another glance at the two maps reveals a second area of modest expansion on Byzantium's eastern front. In the course of the ninth century the Byzantines worked out a strategy of skirmish warfare in Anatolia. When Muslim raiding parties attacked, the *strategoi* evacuated the population, burned the crops, and, while sending out a few troops to harass the invaders, largely waited out the raid within their local fortifications. By 860, the threat of invasion was largely over (though the menace of Muslim navies – on Sicily and southern Italy, for example – remained very real). In 900, Emperor Leo VI (r.886–912) was confident enough to go on the offensive, sending the *tagmata* in the direction of Tarsus. The raid was a success, and in its wake at least one princely family in Armenia broke off its alliance with the Arabs, entered imperial service, and ceded its principality to Byzantium. Reorganized as the theme of Mesopotamia, it was the first of a series of new themes that Leo created in an area that had been largely a no-man's-land between the Islamic and Byzantine worlds.

The rise of the *tagmata* eventually had the unanticipated consequence of downgrading the *themata*. The soldiers of the themes did the "grunt work" – the inglorious job of skirmish warfare – without much honor or (probably) extra pay. The *tagmata* were the professionals, gradually taking over most of the fighting, especially as the need to defend the interior of Anatolia receded. By the same token, the troops of the themes became increasingly

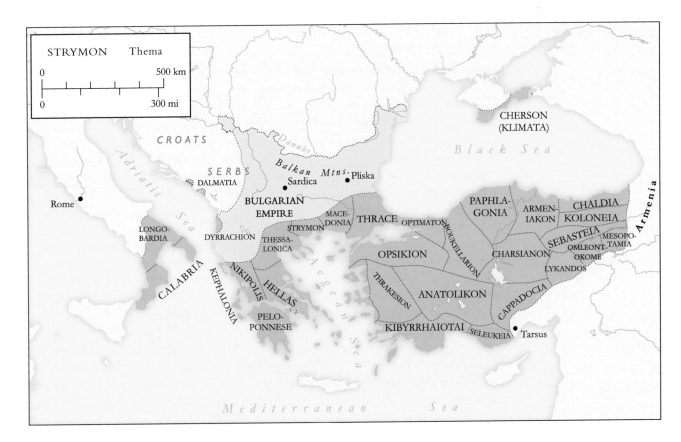

Map 3.1 The Byzantine and Bulgarian Empires, *c.*920

inactive, and the *strategoi*, whose original job had been to lead the themes, gradually also became regional governors. These were new men, not drawn from the traditional elites. They formed a military aristocracy that mirrored (as we shall see) the rise of a similar class in Europe and the Islamic world.

Christianity and the Rise of East Central Europe

To the north of Byzantium was a huge swathe of territory stretching to the Baltic Sea. New groups, mainly of Slavic and Turkic origins, entered, created ephemeral political entities, and then disappeared. For a time, much of the whole region was dominated by the Avars, Turkic-speaking warrior pastoralists who created a great empire on the Pannonian Plain. (See Map 3.2.) But the Avars were wiped out by the Franks in 796 (see below, p. 104).

Map 3.2 The Avar Khaganate, 7th–8th cent.

Thereafter, East Central Europe took political shape like a carpet unrolled from south to north; Bulgaria was the first to become a fairly permanent state, Lithuania the last. State formation went hand in hand with Christianization. In the ninth century, Byzantines (Orthodox Christians) and Franks (Roman Catholics) competed to take advantage of the new political stability in the region. For these proselytizers, spreading the Gospel had not only spiritual but also political advantages: it was a way to bring border regions under their respective spheres of influence. For the fledgling East Central European states,

conversion to Christianity meant new institutions to buttress the ruling classes, recognition by one or another of the prestigious heirs of Rome, and enhanced economic and military opportunities.

The process of Christianization began in Moravia and Bulgaria (see Map 3.4 on p. 105). Moravian Duke Ratislav (r.846–870) made a bid for autonomy from Frankish hegemony by calling on Byzantium for missionaries. The imperial court was ready. Two brothers, Constantine (later called Cyril) and Methodius, set out in 863 armed with translations of the Gospels and liturgical texts. Born in Thessalonica, they well knew the Slavic languages of Moravia and Bulgaria, which had been purely oral. Constantine devised an alphabet using Greek letters to represent the sounds of one Slavic dialect (the "Glagolitic" alphabet). He then added Greek words and grammar where the Slavic lacked Christian vocabulary and suitable expressions. The resulting language, later called Old Church Slavonic, was an effective tool for conversion. The Byzantine Church was willing to work with different regional linguistic and cultural traditions. This contrasted with the Roman Church, which insisted that the Gospels and liturgy be in Latin. Even so, in the end Moravia opted for Rome.

But the Byzantine brand of Christianity prevailed in Bulgaria, Serbia, and later (see Chapter 4) Rus'. The hostile relations between the Bulgar rulers and the Byzantine emperors diminished, and around 864, Khan Boris (r.852–889) not only converted to Christianity under Byzantine auspices but also adopted the name of the Byzantine emperor of the time, Michael III (r.842–867), becoming Boris-Michael.

It made sense for Bulgaria to end up in the Byzantine camp. The Bulgar khan governed two disparate peoples: Bulgar warrior-pastoralists and a large Christian population of Greek-speaking former Byzantines. For those, he was obliged to take on the trappings of a Byzantine ruler. He employed Greeks to administer his state, used Greek officials in his writing-office, authenticated his documents with Byzantine-style seals, and adopted Byzantine court ceremonies.[1] In addition, in the course of the ninth century, Bulgar contact with Byzantines increased as a result of Greek refugees fleeing – and war-prisoners being forced – into the Bulgar state. The religion of these newcomers began to "rub off" on the ruling classes. Finally, as questions Boris-Michael put to the pope in 866 suggest, the pagan religion of the Bulgars involved practices rather than dogma. It was therefore possible (though hardly easy) to convert by exchanging one sort of act with another: "When you used to go into battle," the pope replied, "you indicated that you carried the tail of a horse as your military emblem, and you ask what you should carry now in its place. What else, of course, but the sign of the cross?"[2] By writing to the pope, Boris made clear that he had no intention of becoming subservient to Byzantium. Similarly, he arranged for an archbishop independent of Constantinople to live near him at Pliska, his capital city.

1 For one of Boris-Michael's seals, see "Reading through Looking," in *Reading the Middle Ages: Sources from Europe, Byzantium, and the Islamic World*, 3rd ed., ed. Barbara H. Rosenwein (Toronto: University of Toronto Press, 2018), Plate I on p. II.

2 Pope Nicholas I, *Letter to Answer the Bulgarians' Questions*, in *Reading the Middle Ages*, pp. 164–68.

Cultural Flowering at Byzantium

The creation of the Glagolitic alphabet in the mid-ninth century was just one of many scholarly and educational initiatives taking place in the Byzantine Empire in the ninth century. Constantinople had always had schools, books, and teachers dedicated above all to training civil servants. But in the eighth century the number of bureaucrats was dwindling, schools were decaying, and books, painstakingly written out on papyrus, were disintegrating. Ninth-century confidence reversed this trend, while fiscal stability and surplus wealth in the treasury greased the wheels. So did competition with the rulers and elites of the Islamic world, who supported the translations of hundreds of classical Greek texts into Arabic. Emperor Theophilus (r.829–842) opened a public school in the palace headed by Leo the Mathematician, a master of geometry, mechanics, medicine, and philosophy. Controversies over iconoclasm sent churchmen scurrying to the writings of the Church Fathers to find passages that supported their cause. With the end of iconoclasm in 843, the monasteries, staunch defenders of icons, garnered renewed prestige and gained new recruits.

All of this intellectual and religious activity required more books. Papyrus was no longer easily available from Egypt, and paper was known only in the Islamic world. The new books produced in the Byzantine Empire were made out of parchment – animal skins scraped and treated to create a good writing surface. Far more expensive than papyrus or paper, parchment was nevertheless much more durable. Books of this period were not printed, since printing was unknown in the West until around 1450. Rather, books were written by hand; they were "manuscripts" from manus = hand and scriptus = written. This was taxing work, and scribes often shared in the production of just one manuscript. Practical need gave impetus to the creation of a new kind of script: minuscule. This was made up of lower-case letters, written in cursive, the letters strung together. It was faster and easier to write than the formal capital uncial letters that had previously been used. Words were newly separated by spaces, making them easier to read.

A general cultural revival was clearly under way by the middle of the century. As a young man, Photius, later patriarch of Constantinople (r.858–867; 877–886), had already read hundreds of books, including works of history, literature, and philosophy. As patriarch, he gathered a circle of scholars around him; wrote sermons, homilies, and theological treatises; and tutored Emperor Leo VI. He taught Constantine-Cyril, the future missionary to the Slavs, who had already made a name for himself in his home town, Thessalonica.

The new importance of classical Greek texts helped inspire an artistic revival. Even during the somber years of iconoclasm, artistic activity did not entirely end at Byzantium. But the new exuberance and sheer proliferation of mosaics, manuscript illuminations, ivories, and enamels after 870 suggest a new era. Sometimes called the Macedonian Renaissance, after the ninth- and tenth-century imperial dynasty that fostered it, the new movement found its models in both the hierarchical style that was so important during the pre-iconoclastic period (see Plate 1.12 on pp. 34–35) and the natural style of classical art (see Plate 1.1 on p. 12).

Plate 3.1 Christ on the Cross amid Saints (9th–early 10th cent.). Today this is the front cover of a liturgical book, joined to a matching portrayal of Mary, Mother of God, serving as the back cover. Perhaps originally the two together formed an icon diptych.

Plate 3.1 harks back to the hierarchical style. Christ is entirely flat and perpendicular except for his bent head. Images of the saints and angels appear in roundels made of cloisonné enamel and rimmed with pearls. The figures are complex and glowing, their richness set off by the simplicity of the silver-gilt flat surface of the plaque and its frame, which is made of cut glass and beads of gold and pearl. No one looks at anyone else; the figures are totally isolated from one another. The artist is far more interested in patterns and color than in delineating bodies. At the same time, their very weightlessness suggests a permanent, transcendental reality, so that Christ's tragic crucifixion becomes as triumphant as Justinian's procession at Ravenna.

In Plate 3.2, however, a very different – and more classical – artistic spirit is at play. Painted in a manuscript of homilies (sermons) given by Gregory of Nazianzus, a revered figure of the Byzantine Church, the figures gesture and interact in a landscape beneath a hail-filled sky. It is true that the hail is depicted as a polka-dotted veil, and the picture's frame is made of decorative curls of ribbon. But it is in just this way that the Byzantines melded classical traditions to their overriding need to represent transcendence.

Not surprisingly, the same period saw the revival of monumental architecture. Emperor Theophilus was known for the splendid palace that he commissioned on the outskirts of Constantinople, and Basil I was famous as a builder of churches. Rich men from the court and Church imitated imperial tastes, constructing palaces, churches, and monasteries of their own.

THE SHIFT TO THE EAST IN THE ISLAMIC WORLD

Just as at Byzantium the imperial court determined both culture and policies, so too in the Islamic world of the ninth century the caliph and his court functioned as the center of power. The Abbasids, who ousted the Umayyad caliphs in 750, moved their capital city to Iraq (part of the former Persia) and attempted to step into the shoes of the Sasanid king of kings, the "shadow of God on earth."

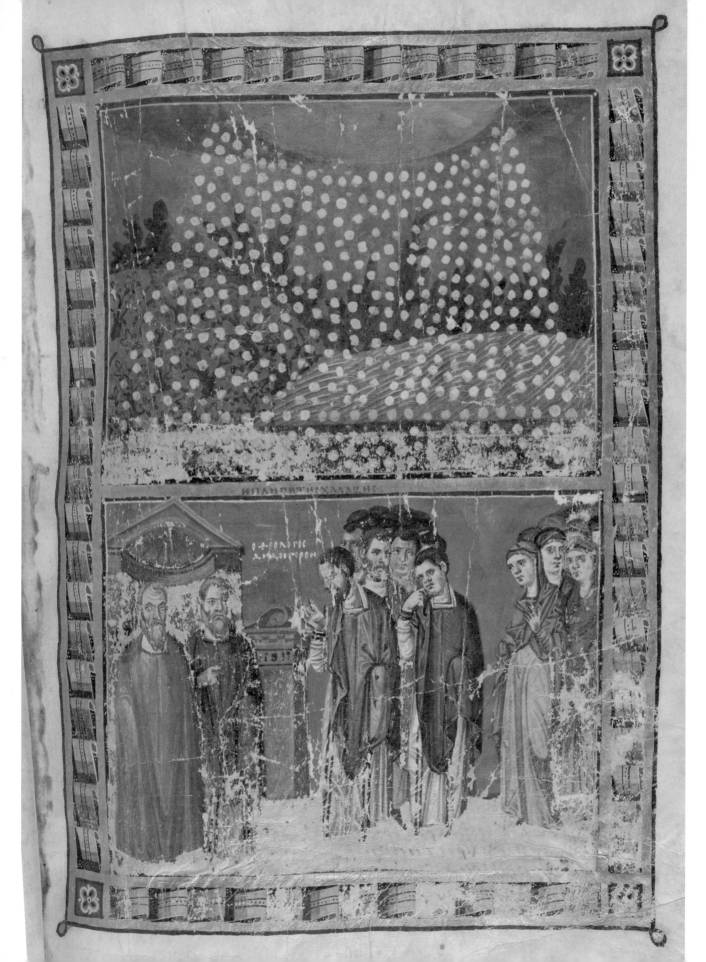

Plate 3.2 (previous page)
Gregory of Nazianzus Preaches
on the Plague of Hail, Gregory's
Homilies (*c*.880). There is a
human-interest story behind
this miniature, which illustrates
Gregory's *Homily* 16: "On the
plague of hail and his father's
silence." There had been a
hailstorm in 373 that ruined
the harvests in Nazianzus, a
small town in the province of
Cappadocia. Gregory's father,
who as local bishop should have
delivered the sermon, was too
depressed by the events to do so.
Gregory preached in his stead. In
the miniature, the hail falls from
the sky, a rare medieval portrayal
of a real natural disaster. Below
are three groups: on the left are
Gregory and his father, in the
middle are men – villagers, no
doubt – and to their right are
women. Gregory's father hides
his hands beneath his cloak to
show that he cannot preach;
Gregory gestures with his
right hand to indicate that he
is speaking. The villager in red
asks for an official response to
the disaster; the others indicate
their distress. In the homily,
Gregory admits the horror of
the event, attributes it to God's
just chastisement of sinners, and
counsels weeping, prayer, and
confession.

The Abbasid Reconfiguration

Years of Roman rule had made Byzantium relatively homogeneous. Nothing was less true of the Islamic world, made up of territories wildly diverse in geography, language, and political, religious, and social traditions. Each tribe, family, and region had its own expectations and desires. The Umayyads paid little heed. Their power base was Syria, formerly a part of Byzantium. There they rewarded their hard-core followers and took the lion's share of conquered land for themselves. They expected every other district to send its taxes to their coffers at Damascus. This annoyed regional leaders, even though they probably managed to keep most of the taxes that they raised. Moreover, with no claims to the religious functions of an *imam*, the Umayyads could never gain the adherence of the followers of Ali. Soon still other groups began to complain. Where was the equality of believers preached in the Qur'an? The Umayyads privileged an elite; Arabs who had expected a fair division of the spoils were disappointed. So too were non-Arabs who converted to Islam: they discovered that they had still to pay the old taxes of their non-believing days.

The discontents festered, and two main centers of resistance emerged: Khurasan (today eastern Iran) and Iraq. (See Map 3.3.) Both had been part of the Persian Empire; the rebellion represented the convergence of old Persian and newly "Persianized" Arab factions. In the 740s this defiant coalition at Khurasan decided to support the Abbasid family. This was an extended kin group with deep-rooted claims to the caliphate, tracing its lineage back to the very uncle who had cared for the orphaned Muhammad. With militant supporters, considerable money, and the backing of a powerful propaganda organization, the Abbasids organized an army in Khurasan and, marching undefeated into Iraq, picked up more support there. In 750 the last Umayyad caliph, Marwan II, abandoned by almost everyone and on the run in Egypt, was killed in a short battle. Al-Saffah was then solemnly named the first Abbasid caliph.

The new dynasty signaled a revolution. The Abbasids recognized the crucial centrality of Iraq and built their capital city, Baghdad, there. (Briefly, in the late-ninth century, they relocated to Samarra, 70 miles north.) The Abbasids took the title of *imam* and even, at one point, wore the green color of the Shi'ites. (For the Abbasids, see Genealogy 3.1.)

Yet, as they became entrenched, the Abbasids in turn created their own elite, under whom other groups chafed. In the eighth century most of their provincial governors, for example, came from the Abbasid family itself. When building Baghdad, Caliph al-Mansur (r.754–775) allotted important tracts of real estate to his Khurasan military leaders. In the course of time, as Baghdad prospered and land prices rose, the Khurasani came to constitute a new, exclusive, and jealous elite. Even so, the Abbasids succeeded in centralizing their control more fully than the Umayyads had done, secure in their ability to collect revenues from their many provinces.

That control, however, was uneven. Until the beginning of the tenth century, the Abbasid caliphs generally could count on ruling Iraq (their "headquarters"), Syria, Khurasan, and Egypt. But they never conquered the Iberian Peninsula or the Berbers of Morocco, and they lost real (though not nominal) power over Ifriqiya (today Tunisia) by about 800. In

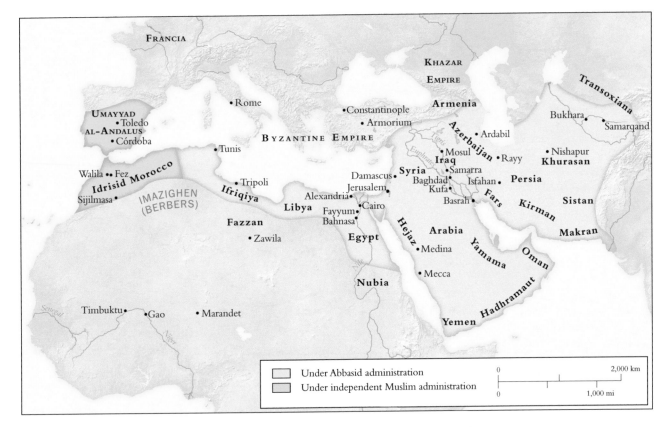

Map 3.3 The Islamic World, c.800

the course of the tenth century, they would lose effective authority even in their heartlands. That, however, was in the future (see Chapter 4).

Whatever sway the Abbasids had depended largely on their armies. Unlike the Byzantines, the Abbasids did not need soldiers to stave off external enemies or to expand outwards. (The caliphs led raids to display their prowess, not to take territory. The serious naval wars that took Sicily from Byzantium were launched from Ifriqiya, virtually independent of the caliphs.) Rather, the Abbasids needed troops to collect taxes in areas already conquered but weakly controlled.

Well into the ninth century the caliphs' troops were paid, but not mustered, by them. Generals recruited their own troops from their home districts, tribes, families, and clients. When the generals were loyal to the caliphs, this military system worked well. In the dark days of civil war, however, when two brothers fought over the caliphate after the death of Harun al-Rashid (r.786–809), no one controlled the armies. Turkish warriors captured from the Asian steppes made and unmade the caliphs until, beginning in the 870s, the caliphs found a way to ensure loyal Turkish warriors by capturing young boys from the steppes and training them militarily and politically for service. These were the first Mamluks. The caliphs could not foresee that in time they would come to constitute a new elite, one that would eventually help to overpower the caliphate itself.

Under the Abbasids, the Islamic world became wealthy. The Mediterranean region had always been a great trade corridor; in the ninth century, Baghdad took advantage of a

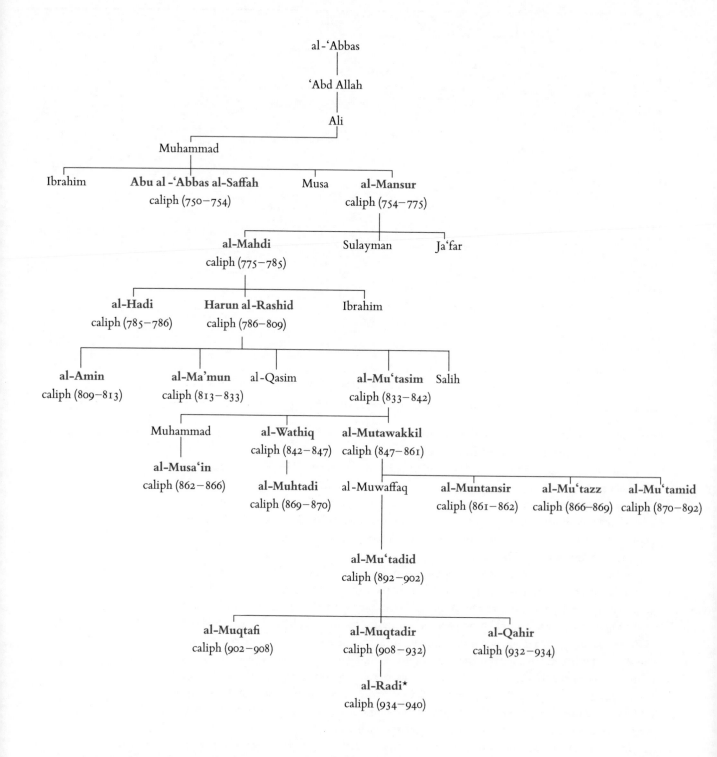

al-'Abbas

'Abd Allah

Ali

Muhammad

Ibrahim

Abu al -'Abbas al-Saffah
caliph (750–754)

Musa

al-Mansur
caliph (754–775)

al-Mahdi
caliph (775–785)

Sulayman

Ja'far

al-Hadi
caliph (785–786)

Harun al-Rashid
caliph (786–809)

Ibrahim

al-Amin
caliph (809–813)

al-Ma'mun
caliph (813–833)

al-Qasim

al-Mu'tasim
caliph (833–842)

Salih

Muhammad

al-Wathiq
caliph (842–847)

al-Mutawakkil
caliph (847–861)

al-Musa'in
caliph (862–866)

al-Muhtadi
caliph (869–870)

al-Muwaffaq

al-Muntansir
caliph (861–862)

al-Mu'tazz
caliph (866–869)

al-Mu'tamid
caliph (870–892)

al-Mu'tadid
caliph (892–902)

al-Muqtafi
caliph (902–908)

al-Muqtadir
caliph (908–932)

al-Qahir
caliph (932–934)

al-Radi★
caliph (934–940)

★ Abbasid caliphs continued at Baghdad – with, however, only nominal
power – until they were conquered by the Mongols in 1258. Thereafter, a
branch of the family in Cairo held the caliphate until the sixteenth century.

still wider network that included India, China, and the Khazar Empire. They also turned to sub-Saharan Africa, where urban centers along the Niger river had long been active in commerce, manufacturing, and agriculture. In the time of the Abbasids, the Berbers, once enslaved by the Umayyads, had become organized and were themselves the slavers. Sub-Saharan entrepots such as Zawila to the east and Sijilmasa in the far west were staging points for traffic in gold, food, ivory, animal skins, and enslaved human cargo. From Timbuktu, Gao, Marandet, and other West African towns, Berber traders made good use of oases such as Zawila in the Fazzan as stopping points on the way to coastal cities like Tunis and Tripoli as well as the more distant cities of Córdoba and Cairo. The traders returned south laden with textiles, ceramics, glass, armor, and other manufactured goods.

Genealogy 3.1 (facing page) The Abbasids

Islamic Arts and Literature

Open in every direction, the Islamic world was cosmopolitan, drawing on numerous traditions of arts and crafts. With revenues from commerce and (above all) taxes from agriculture in their coffers, the Abbasid caliphs paid their armies and salaried their officials. They drew on the talents of many sorts of men – Persian, Arab, Christian, and Jewish – but, in this relentlessly male-dominated society, not women. The cultural revival here helped to inspire (as we have seen) a similar one at Constantinople.

Dining off ornate plates and bowls (see Plate 3.3), pouring their water from richly decorated pitchers, the upper and middle classes in the Islamic world lived amid material splendor. Their clothing was made of richly woven fabrics (see Plate 4.11 on p. 160), and wall-hangings and rugs adorned their homes. Luxury followed them even into the graveyard (see Plate 3.4), and their mosques were built to impress. Consider the one built near (now incorporated into) Cairo by Ibn Tulun, the nearly independent ruler of Egypt. Still standing, its outer and inner courts are perfectly square, its interior sanctuary enlivened by an arcade of graceful pointed arches. (See Figure 3.1 and Plate 3.5.)

Plate 3.3 Bowl with Persian Inscription (779). This large and beautiful bowl, nearly one foot across and four inches deep, was probably used for soups; the Persian inscription says, "As long as the soup is good, do not worry if the bowl is pretty!" Ceramic-ware such as this were used communally, each person dipping into the nearest spot.

Plate 3.4 Chest or Cenotaph Panel (second half of 8th cent.). This inlaid wood panel, found in a cemetery near Cairo, brings together numerous different traditions. Marquetry, which uses thousands of pieces of tiny bone and woods of different shades to create an intricate design, was a skill practiced by the Coptic Christians in Egypt. The wings at the top of the columns and holding up the central wheel drew on a Sasanid Persian motif. The geometric pattern was pre-Islamic. The sequence of arches is Romano-Byzantine. Perhaps this remarkable piece may be connected to a military garrison established in the vicinity in the mid-eighth century.

Equally important were developments in literature, science, law, and other forms of scholarship. Books of all sorts were relatively cheap (and therefore accessible) in the Islamic world because they were written on paper. The caliphs launched scientific studies via a massive translation effort that brought the philosophical, medical, mathematical, and astrological treatises of the Indian and classical Greek worlds into Islamic culture. They encouraged poetry of every sort.

Thus, to celebrate his conquest of the Byzantine city of Amorium in 838, Caliph al-Mu'tasim paid the poet Abu Tammam handsomely for a long poem that praised both the victory and the victors:

> A victory of victories, so sublime
> > prose cannot speak nor verse can utter
> A victory at which Heaven threw wide its gates,
> > which Earth put on new dress to celebrate:
> O battle of Amorium, for which
> > our hopes returned engorged with milk and honey.
> The Muslims hast thou fixed in the ascendant,
> > pagans and pagandom fixed in decline![3]

It is obvious why such laudatory poetry, beautifully and cleverly written, should be cultivated under the Abbasids. But other kinds of poetry were equally prized: those celebrating wine and love, for example, were appreciated as *adab*, a literature (both in verse and prose) of refinement. (*Adab* means "good manners.")

Shoring up the regime with astrological predictions; winning theological debates with the pointed weapons of Aristotle's logical and scientific works; understanding the theories of bridge-building, irrigation, and land-surveying with Euclid's geometry – these were just some of the reasons why scholars in the Islamic world labored over translations and created original scientific works. Their intellectual pyrotechnics won general support. Patrons of scientific writing included the caliphs, their wives, courtiers, military generals,

3 Abu Tammam, *The sword gives truer tidings*, in *A Short Medieval Reader,* ed. Barbara H. Rosenwein (Toronto: University of Toronto Press, 2023), pp. 51–56 and *Reading the Middle Ages*, pp. 124–28.

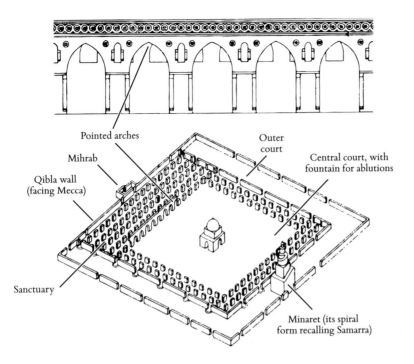

Figure 3.1 Mosque Plan (Cairo, Ibn Tulun Mosque, 876–879)

Pointed arches

Mihrab

Qibla wall
(facing Mecca)

Outer
court

Central court, with
fountain for ablutions

Sanctuary

Minaret (its spiral
form recalling Samarra)

and ordinary people with practical interests. Al-Khwarizmi (d.*c*.850), author of a book on algebra (a term derived from *al-jabr*, a word in its title), understood math's practical uses. Even handier was his treatise on the Indian method of calculation – Indian numerals are what *we* call Arabic numerals – and the use of the zero, essential (to give just one example) for distinguishing 100 from 1.

How should one live to be pleasing to God? This was the major question that inspired the treatises on *hadith* (traditions about the Prophet) that began to appear in the Abbasid period. Each *hadith* began with a chain of oral transmitters (the most recent listed first) that told a story about Muhammad; there then followed the story itself. Thus, for example, in the compilation of *hadith* by al-Bukhari (810–870) on the issue of fasting during Ramadan (the yearly period of fasting from sunrise to sunset), he took up the question of the distracted "faster who eats and drinks from forgetfulness":

> 'Abdan related to us [saying], Yazid b. Zurai' informed us, saying, Hisham related to us, saying: Ibn Sirin related to us from Abu Huraira, from the Prophet – upon whom be blessing and peace – that he said: "If anyone forgets and eats or drinks, let him complete his fast, for it was Allah who caused him thus to eat or drink."[4]

4 Al-Bukhari, *On Fasting*, in *A Short Medieval Reader*, pp. 60–65 and in *Reading the Middle Ages*, pp. 147–51.

Plate 3.5 (following pages) Ibn Tulun Mosque, Cairo (876–879). Built to last on land deemed holy, the mosque commissioned by Ibn Tulun was unusually spacious for its time and place and was meant to accommodate crowds. In the middle of its large courtyard is a defunct fountain; it was originally made of wood, octagonal in shape, and topped by a gilded dome. Thick piers pierced by pointed arches led from the courtyard into the sanctuary, lighted on all sides by an upper tier of arched windows in the thick walls. The spiral-shaped minaret (now only partially spiral) recalled the one at Samarra, the temporary alternative to the capital at Baghdad. Market stalls would have lined up along the outer walls. The dome shaped like a "watch cap" on the structure nearest the viewer belongs to a *madrasa* added in the fourteenth century.

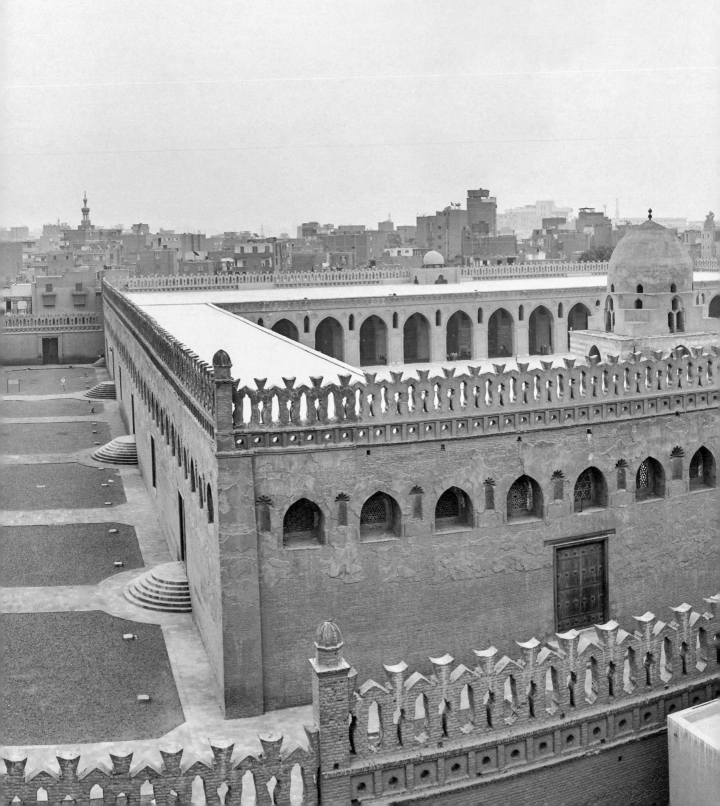

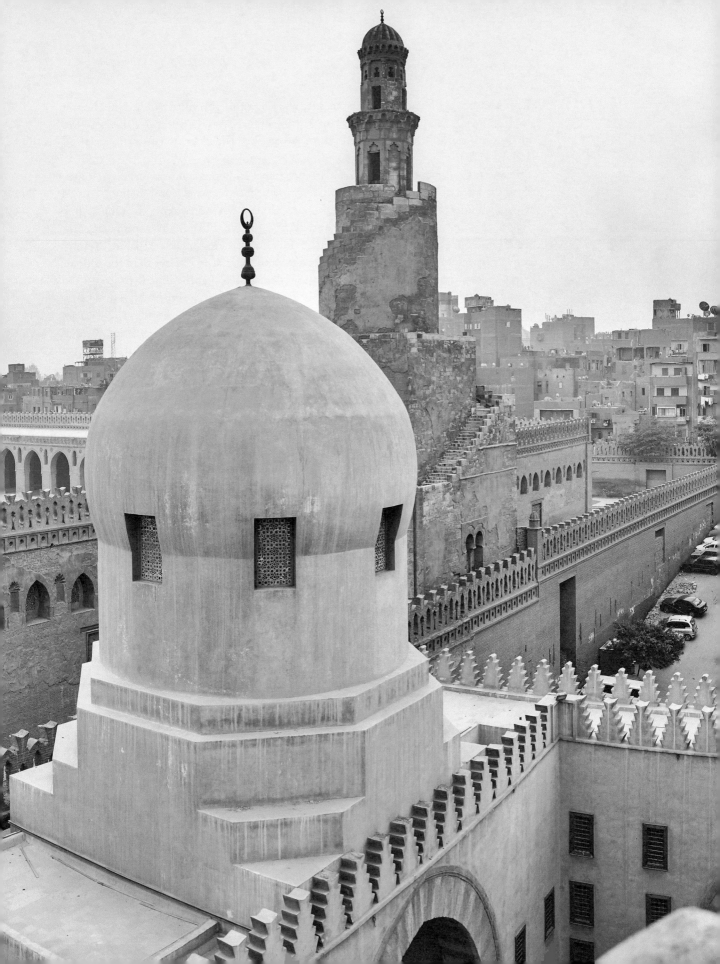

Here 'Abdan was the most recent witness to a saying of the Prophet, while Abu Huraira, a well-known "Companion" of the Prophet Muhammad, was the authority the closest to the original source. Indeed, Abu Huraira was named as the ultimate authority for thousands of *hadith*.

Even the Qur'an did not escape scholarly scrutiny. While some interpreters read it literally as the word of God and thus part of God himself, others viewed it as something created by God and therefore separate from Him. For Caliph al-Ma'mun, taking the Qur'an literally undermined the caliph's religious authority. Somewhat like the Byzantine emperor Leo III (see pp. 47–48), whose iconoclastic policies were designed to separate divinity from its representations, al-Ma'mun determined to make God greater than the Qur'an. In 833 he instituted the Mihna, or Inquisition, demanding that the literalists profess the Qur'an's createdness. But al-Ma'mun died before he could punish those who refused, and his immediate successors were relatively ineffective in pursuing the project. The scholars on the other side – the literalists and those who looked to the *hadith* – carried the day, and in 848 Caliph al-Mutawakkil ended the Mihna, emphatically reversing the caliphate's position on the matter. Sunni Islam thus defined itself against the views of a caliph who, by asserting great power, lost much. The caliphs ceased to be the source of religious doctrine; that role went to the scholars, the *ulama*. It was around this time that the title "caliph" came to be associated with the phrase "deputy of the Prophet of God" rather than the "deputy of God." The designation reflected the caliphate's decreasing political as well as religious authority.

Societies on the Fringe

The actual control of the Abbasids did not extend all the way to the western end of their Empire, and local leaders there used the opportunity to become independent rulers (see Map 3.3). One was Idris I, an 'Alid prince (that is, a descendent of 'Ali, the revered Shi'ite leader). On the run from the Abbasids in 787, he made his way to Volubilis/Walila (see pp. 45–47 and Figure 2.1), married a Berber woman, allied himself with the Berber leader who controlled Walila, and conquered all of northern Morocco. Making Walila his headquarters, he built a new settlement just outside of its Roman wall. (See Figure 2.1 Area B). In this, he was following the normal practice of Arab conquerors: they built their communities near – but not quite in – existing settlements, with a mosque serving as the meeting point between the two.

Idris's compound featured a domestic complex fit for perhaps twenty to twenty-five people, large silos for storing grain, and an elaborate bath house – a feature of Byzantine civilization adopted by the Arabs. The bath house at Walila had many rooms, including a cold plunge bath, a hot bath (warmed by fireplaces), and a latrine. Decorated with the relief of a shield taken from the Arch of Caracalla (originally part of the Roman settlement), the structure was a way for Idris to announce his triumphal rulership of northern Morocco. Coins found on the site, minted in Idris's name and featuring 'Ali on the reverse,

as well as imported tableware and cotton suggest that Walila had once again become a commercial center. That did not last long: Idris II (d.828), moved the capital to Fez, and in the tenth century the Idrisid state split apart as it was parceled out to numerous heirs in accordance with Berber practice. Walila seems to have been abandoned around that time. Even so, in the fourteenth century a new settlement was established within its walls, perhaps associated with the tomb of Idris I that was located there.

More successful than the Idrisids were the new rulers of al-Andalus (Islamic Spain). In the mid-eighth century Abd al-Rahman I, an Umayyad prince on the run from the Abbasids, managed to gather an army, make his way to Iberia, and defeat the provincial governor at Córdoba. In 756 he proclaimed himself "emir" (commander) of al-Andalus. His dynasty governed for two and a half centuries, and in 929, emboldened by his growing power and the depletion of caliphal power at Baghdad, Abd al-Rahman III (r.912–961) took the title caliph.

As was true of most parts of the Islamic world, al-Andalus under the emirs was not entirely Muslim, and it was even less Arab. As the caliphs came to rely on Mamluks, so the emirs relied on a professional standing army of non-Arabs, the *al-khurs*, the "silent ones" – men who could not speak Arabic. They lived among a largely Christian – and partly Jewish – population; even by 900, only about 25 per cent of the people in al-Andalus were Muslim. This had its benefits for the regime, which taxed Christians and Jews heavily. Although, like most Western European rulers, they did not have the land tax that the Byzantine emperors and caliphs could impose, the emirs did draw some of their revenues from Muslims, especially around their capital at Córdoba. Furthermore, Córdoba was a major entrepot for enslaved men and women. Some were the victims of the trans-Saharan trade; others came from Slavic Central and Eastern Europe. Many were destined for the Abbasid court.

Andalusian rulers had the money to pay salaries to their civil servants and to preside over an artistic and literary efflorescence that reflected the region's unique ethnic and religious mix. An ivory pyxis made for an Andalusian prince is a good example (see Plate 3.6).

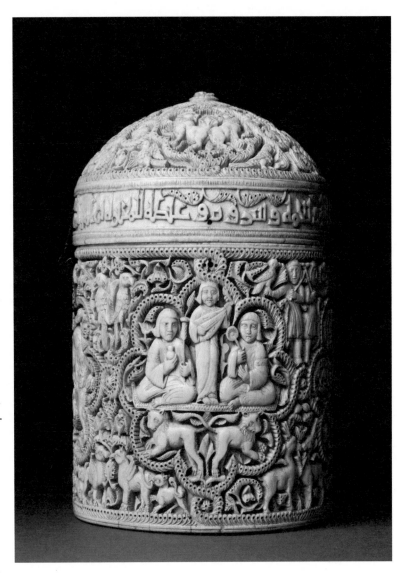

Plate 3.6 Pyxis of al-Mughira (968). A pyxis is a small container; this exceptionally fine one was carved for an Andalusian prince. Likely commissioned by his mother and carved by eunuchs working for the court's ivory workshop, it offers lush images of vegetation, animals, and courtly pastimes – hunting, music-making – connected by a continuous interlace that encloses four medallions. The ivory (from the cross-section of an elephant's tusk) came from West Africa.

Its use of pairs – here the prince across from his fan-bearer, with a lutenist between the two – recalls Byzantine textiles (themselves echoes of Sasanian Persian designs). But the carvers' transformation of traditionally flat patterns into high relief is an original take on those old forms.

The cultural mix extended far beyond the arts. Some Muslim men took Christian wives, and religious practices seem to have melded a bit. In fact, the Christians who lived in al-Andalus were called "Mozarabs" – "would-be Arabs" – by Christians elsewhere. It is likely that Christians and Muslims got along fairly well on the whole. Christians dressed like Muslims, worked side-by-side with them in government posts, and used Arabic in many aspects of their life. In the mid-ninth century, there were in the region of Córdoba alone at least four churches and nine monasteries. No doubt there were synagogues as well, but our sources for Jewish life in Islamic Iberia are very fragmentary until the tenth century, when at least a few high-ranking Jews burst onto the public stage.

To the north of al-Andalus, beyond the Duero River, were tiny Christian principalities. Their spokesmen donned the mantle of the Visigoths, claiming to be the legitimate rulers of Spain. A chronicler from the ninth century celebrated their triumphs as God-given: "Alfonso was elected king by all the people, receiving the royal scepter with divine grace. He always crushed the audacity of his enemies.... Killing all the Arabs with the sword, he led the Christians back with him to his country."[5] The hero here was Alfonso I (r.739–757), whose kingdom of Asturias partook in the general demographic and economic growth of the period. Alfonso and his successors built churches, encouraged monastic foundations, collected relics, patronized literary efforts, and welcomed Mozarabs from the south. As they did so, they looked to Christian models still farther north – to Francia, where Charlemagne and his heirs ruled as kings "by grace of God."

AN EMPIRE IN SPITE OF ITSELF

Between Byzantium and the Islamic world was Francia. While the first two were politically centralized, subject to sophisticated tax systems, and served by salaried armies and officials, Francia inherited the centralizing traditions of the Roman Empire without its order and efficiency. Francia's kings could not collect a land tax, the backbone of the old Roman and the more recent Byzantine and Islamic fiscal systems. There were no salaried officials or soldiers in Francia. Yet the new dynasty of kings there, the Carolingians, managed to muster armies, expand their kingdom, encourage a revival of scholarship and learning, command the respect of emperors and caliphs, and forge an identity for themselves as leaders of the Christian people. Their successes bore striking resemblance to contemporary achievements at Constantinople and Baghdad. How was this possible? The answer is at least threefold: the Carolingians took advantage of the same "Medieval Warm Period"

5 *The Chronicle of Alfonso III*, in *Reading the Middle Ages*, pp. 132–35.

that seems to have affected the North Atlantic region in general; they exploited to the full the institutions of Roman culture and political life that remained to them; and at the same time, they were willing to experiment with new institutions and take advantage of unexpected opportunities.

The Carolingians

The Carolingian takeover was a "palace coup." After a battle (at Tertry, in 687) between Neustrian and Austrasian noble factions, one powerful family with vast estates in Austrasia came to monopolize the high office of mayor for the Merovingian kings in both places. In the first half of the eighth century these mayors took over much of the power and most of the responsibilities of the kings.

Charles Martel (mayor 714–741) gave the name Carolingian (from *Carolus*, Latin for Charles) to the dynasty. In 732 he won a battle near Poitiers against an army led by the Muslim governor of al-Andalus, ending further raids. But Charles had other enemies: he spent most of his time fighting vigorously against regional Frankish aristocrats intent on carving out independent lordships for themselves. Playing powerful factions against one another, rewarding supporters, defeating enemies, and dominating whole regions by controlling monasteries and bishoprics that served as focal points for both religious piety and land donations, the Carolingians created a tight network of supporters.

Moreover, they chose their allies well, reaching beyond Francia to the popes and to English churchmen, who (as we have seen) were closely tied to Rome. When the English missionary Boniface (d.754) wanted to preach in Frisia (today the Netherlands) and Germany, the Carolingians readily supported him as a prelude to their military conquests. Although (as we have seen above, p. 66), many of the areas in which Boniface missionized had long been Christian, their practices were local rather than tied to Rome. By contrast, Boniface's newly appointed bishops were loyal to Rome and the Carolingians, not to regional aristocracies. They knew that their power came from papal and royal fiat rather than from local power centers.

Men like Boniface opened the way to a more direct alliance between the Carolingians and the pope. Historians used to think that Pippin III (d.768), the son of Charles Martel, obtained approval from Pope Zacharias (741–752) to depose the reigning Merovingian king in 751. More recent research strongly calls this into question: Pippin became king because he was supported by Frankish nobles and bishops. But it is certainly true that three years after Pippin took the throne, another pope, Stephen II (752–757), traveled to Francia. He anointed Pippin and his two young sons and begged them to send an army against the encircling Lombards: "Hasten, hasten, I urge and protest by the living and true God, hasten and assist! ... Do not suffer this Roman city to perish in which the Lord laid my body [i.e., the body of Saint Peter, with whom the pope identified himself] and which he commended to me and established as the foundation of the faith. Free it and

Map 3.4 (facing page) Europe, c.814

its Roman people, your brothers, and in no way permit it to be invaded by the people of the Lombards."[6]

In the so-called Donation of Pippin (756), the new king forced the Lombards to give some cities back to the pope. The arrangement recognized that the papacy was now the ruler in central Italy of a territory that had once belonged to Byzantium. Before the 750s, the papacy had been part of the Byzantine Empire; by the middle of that decade, it had become part of the West. It was probably soon thereafter that members of the papal chancery (writing office) forged a document, the *Donation of Constantine*, which had the fourth-century Emperor Constantine declare that he was handing the western half of the Roman Empire to Pope Sylvester. Thus did the papacy signal its independence from the East.

The chronicler of Charles Martel had already tied his hero's victories to Christ. The Carolingian partnership with Rome and Romanizing churchmen added to the dynasty's Christian aura. Anointment – daubing the kings with holy oil – provided the finishing touch. It reminded contemporaries of David, king of the Israelites: "Then Samuel took the horn of oil and anointed him in the midst of his brethren; and the spirit of the Lord came upon David from that day forward" (1 Sam. [or Vulgate 1 Kings] 16:13).

CHARLEMAGNE

The most famous Carolingian king was Charles (r.768–814), called "the Great" (*le Magne* in Old French). Large, tough, wily, and devout, he was everyone's model. The courtier and scholar Einhard (d.840) portrayed Charlemagne as a Roman emperor, patterning his biography of the ruler on the *Lives of the Caesars*, written in the second century by Roman historian Suetonius. Alcuin (d.804), also the king's courtier and an even more famous scholar, emphasized Charlemagne's religious side, nicknaming him "David," the putative author of the psalms, victor over the giant Goliath, and king of Israel. Empress Irene at Constantinople saw Charlemagne as a suitable husband for herself (though the arrangement eventually fell through).

Charlemagne's fame was largely achieved through wars of plunder and conquest. He invaded Italy, seizing the Lombard crown and annexing northern Italy in 774. He moved his armies northward to fight the Saxons and, after more than thirty years of bitter war, he annexed their territory and forcibly converted them to Christianity. To the southeast, he sent his forces against the Avars, capturing their strongholds, forcing them to submit to his overlordship, and making off with cartloads of plunder. An expedition to al-Andalus gained Charlemagne a ribbon of territory north of the Ebro River, a buffer between Francia and the Islamic world called the "Spanish March." (See Map 3.4.) Even his failures were the stuff of myth: a Basque attack on Charlemagne's army as it returned from Spain became the core of the epic poem *The Song of Roland*.

6 Pope Stephen II, *Letters to King Pippin III*, in *A Short Medieval Reader*, pp. 65–72 and in *Reading the Middle Ages*, pp. 151–58.

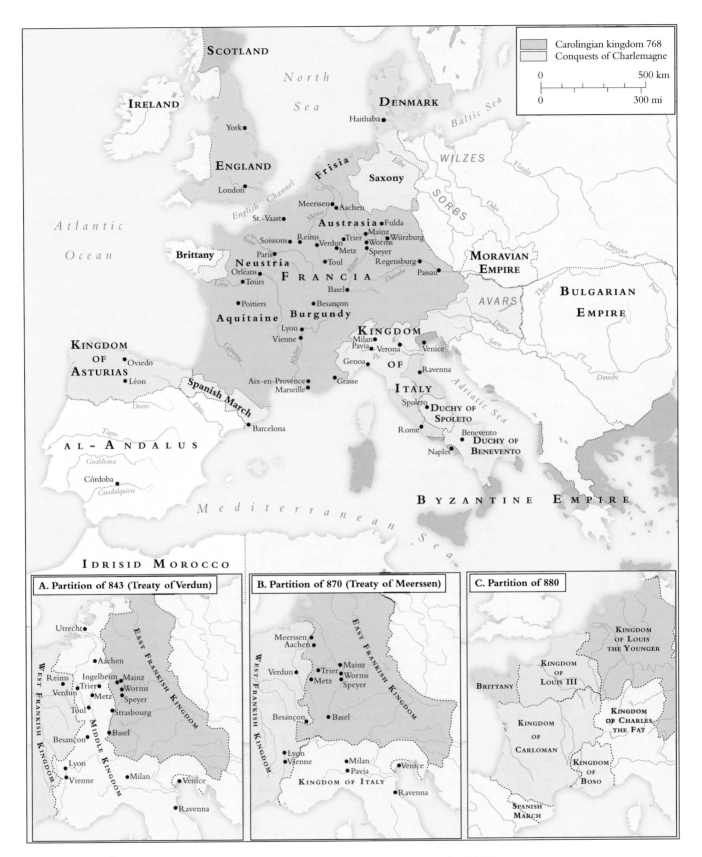

SCOTLAND

North Sea

IRELAND

DENMARK

Haithabu

Baltic Sea

WILZES

York

ENGLAND

Frisia

Saxony

Elbe

SORBS

Oder

Vistula

London

English Channel

Meerssen Aachen

Meuse

Atlantic Ocean

St.-Vaast

Soissons Reims

Austrasia Fulda

Mainz

Trier Worms Würzburg

MORAVIAN EMPIRE

Dniester

Brittany

Verdun

Metz

Speyer

Seine

Paris

Toul

Neustria

Regensburg

Orléans

FRANCIA

Passau

Tours

Loire

Basel

Danube

BULGARIAN EMPIRE

Prut

Poitiers

Besançon

AVARS

Theiss

Aquitaine

Burgundy

KINGDOM

Milan

Pavia Verona Venice

Drau

Po

KINGDOM OF ASTURIAS

Oviedo

Léon

Lyon

Vienne

Genoa

Ravenna

Sava

Danube

Spanish March

Duero

Ebro

Aix-en-Provence

Marseille

Grasse

OF

ITALY

Adriatic Sea

Spoleto

Barcelona

DUCHY OF SPOLETO

AL-ANDALUS

Tagus

Guadiana

Córdoba

Guadalquivir

Rome

Naples

Benevento

DUCHY OF BENEVENTO

Mediterranean Sea

BYZANTINE EMPIRE

IDRISID MOROCCO

| | Carolingian kingdom 768 |
| | Conquests of Charlemagne |

0 ——— 500 km
0 ——— 300 mi

A. Partition of 843 (Treaty of Verdun)

Utrecht

WEST FRANKISH KINGDOM

EAST FRANKISH KINGDOM

Aachen

Reims

Ingelheim Mainz

Trier Worms

Verdun Metz Speyer

Toul Strasbourg

Basel

MIDDLE KINGDOM

Besançon

Lyon

Vienne

Milan

Venice

Ravenna

B. Partition of 870 (Treaty of Meerssen)

WEST FRANKISH KINGDOM

Meerssen

Aachen

EAST FRANKISH KINGDOM

Verdun

Trier Mainz

Metz Worms

Speyer

Besançon

Basel

Lyon

Vienne

Milan

Venice

Pavia

KINGDOM OF ITALY

Ravenna

C. Partition of 880

KINGDOM OF LOUIS THE YOUNGER

KINGDOM OF LOUIS III

BRITTANY

KINGDOM OF CHARLES THE FAT

KINGDOM OF CARLOMAN

KINGDOM OF BOSO

SPANISH MARCH

Ventures like these depended on a good army. Charlemagne's was led by his *fideles*, faithful aristocrats, and manned by free men, many the "vassals" (clients) of the aristocrats. The king had the *bannum*, the ban, which gave him the right to call his subjects to arms (and, more generally, to command, prohibit, punish, and collect fines when his ban was not obeyed). Soldiers provided their own equipment; the richest went to war on horseback, the poorest had to have at least a lance, shield, and bow. There was no standing army; men had to be mobilized for each expedition. No *tagmata* or Mamluks were to be found here! Yet, while the empire was expanding, the Carolingian military organization was very successful; men were glad to go off to war when they could expect to return enriched with booty.

By 800, Charlemagne's kingdom stretched nearly 1,000 miles from east to west, even more from north to south when Italy is counted. On its eastern edge was a strip of "buffer regions" under Carolingian overlordship that extended from the Baltic to the Adriatic. Connections with the Islamic world, especially with the Abbasids, grew apace, drawing the Franks into sporadic contact with wider economic, diplomatic, and cultural networks. So wide a reach was reminiscent of an empire, and Charlemagne began to act according to the model of Roman emperors, sponsoring building programs to symbolize his authority, standardizing weights and measures, and acting as a patron of intellectual and artistic enterprises. He built a capital city at Aachen, complete with a chapel patterned on San Vitale, the church built by Justinian at Ravenna (see pp. 33–37). So keen was Charlemagne on Byzantine models that he had columns, mosaics, and marbles from Rome and Ravenna carted up north to use in his own structures.

Further drawing on imperial traditions, Charlemagne issued laws. These are extant in the form of "capitularies," summaries of decisions made at assemblies held by the ruler with the chief men of his realm. He appointed regional governors – counts – to carry out his laws, muster his armies, and collect his taxes. Chosen from among Charlemagne's aristocratic supporters, they were compensated for their work by temporary grants of land rather than with salaries. This was not Roman; but Charlemagne lacked the fiscal apparatus of the Roman emperors (and of his contemporary Byzantine emperors and Islamic caliphs), so he made land substitute for money. To discourage corruption, he appointed officials called *missi dominici* ("those sent out by the lord king") to oversee the counts on the king's behalf. The *missi* – abbots, bishops, and counts, aristocrats all – traveled in pairs across Francia. They were to look into the affairs – large and small – of the Church and laity.

In this way, Charlemagne set up institutions meant to echo those of the Roman Empire. It was a brilliant move on the part of Pope Leo III (795–816) to harness the king's imperial pretensions to papal ambitions. In 799, accused of adultery and perjury by a hostile faction at Rome, Leo narrowly escaped mutilation. Fleeing northward to seek Charlemagne's protection, he returned home under escort, the king following later in the year. Charlemagne arrived in Rome in late November 800 to an imperial welcome orchestrated by Leo. On Christmas Day of that year, Leo put an imperial crown on Charlemagne's head, and the clergy and nobles who were present acclaimed the king "Augustus," the title of the first

Roman emperor. In one stroke the pope managed to exalt the king of the Franks, down-grade Irene at Byzantium, and enjoy the role of "emperor maker" himself.

About twenty years later, when Einhard wrote about this coronation, he said that the imperial title at first so displeased Charlemagne "that he stated that, if he had known in advance of the pope's plan, he would not have entered the church that day, even though it was a great feast day."[7] In fact, Charlemagne continued to call himself simply "king" for about a year; then he adopted a new title that was both long and revealing: "Charles, the most serene Augustus, crowned by God, great and peaceful emperor who governs the Roman Empire and who is, by the mercy of God, king of the Franks and the Lombards." According to this title, Charlemagne was not the Roman emperor crowned by the pope but rather God's emperor, who governed the Roman Empire along with his many other duties.

CHARLEMAGNE'S HEIRS

When Charlemagne died, only one of his sons remained alive: Louis, nicknamed "the Pious." (See Genealogy 3.2.) He was emperor (from 814 to 840), but his "empire" was a conglomeration of territories with little unity. Louis had to contend with the revolts of his sons, the depredations of outside invaders, the regional interests of counts and bishops, and above all an enormous variety of languages, laws, customs, and traditions, all of which tended to pull his empire apart. He contended with gusto, his chief unifying tool being Christianity. His imperial model was Theodosius I, who had made Christianity the official religion of the Roman Empire (see p. 8). Calling on the help of the monastic reformer Benedict of Aniane (d.821), Louis imposed the Benedictine Rule on all the monasteries in Francia. He employed monks and abbots as his chief advisors. Organizing inquests by the missi, Louis looked into allegations of exploitation of the poor, standardized the procedures of his chancery, and put all Frankish bishops and monasteries under his control.

Charlemagne had employed his sons as "sub-kings," but Louis made even more political use of his family. Early in his reign he had his wife crowned empress; he named his first-born son, Lothar, emperor and co-ruler; and he had his other sons, Pippin and Louis (later called "the German"), agree to be sub-kings under their older brother. It was neatly planned. But when Louis's first wife died, he married Judith, daughter of a relatively obscure kindred (the Welfs) that stemmed from the Saxon and Bavarian nobility and would later become enormously powerful. In 823 Judith and Louis had a son, Charles (later "the Bald"), and this upset the earlier division of the Empire. A family feud turned into bitter civil war (much like the Abbasids at around the same time) as brothers fought one another and their father for titles and kingdoms. In 833 matters came to a head when Louis, effectively taken prisoner by Lothar, was forced to do public penance. Lothar expected the ritual to get his father off the throne for life. But Louis played one son against the other and made a swift comeback. The episode showed how Carolingian rulers could portray

7 Einhard, *Life of Charlemagne*, in *A Short Medieval Reader*, pp. 72–82 and in *Reading the Middle Ages*, pp. 115–24.

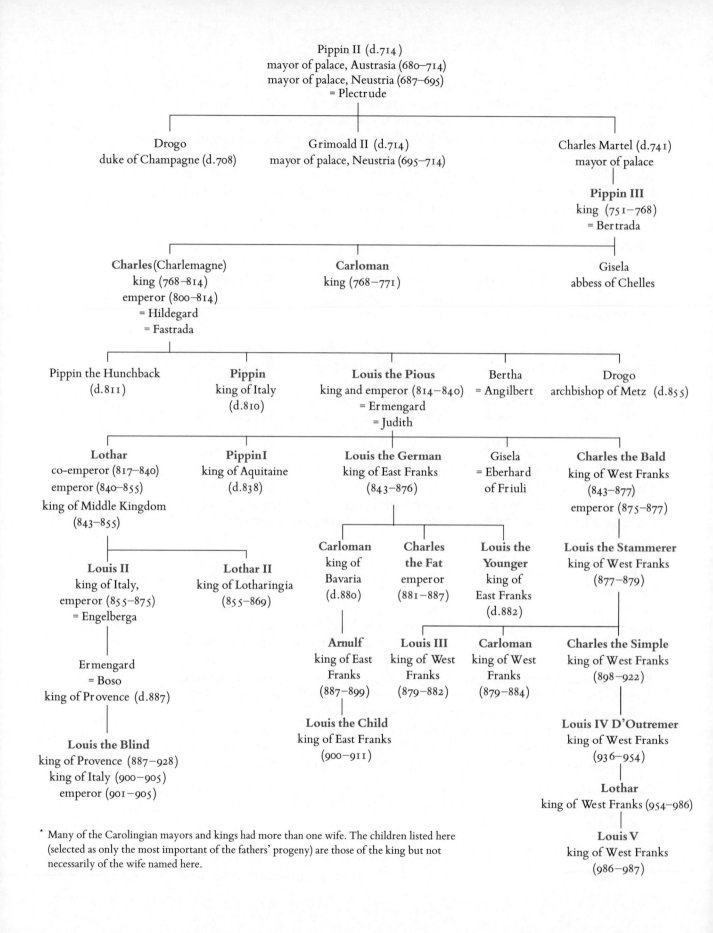

Pippin II (d.714)
mayor of palace, Austrasia (680–714)
mayor of palace, Neustria (687–695)
= Plectrude

Drogo
duke of Champagne (d.708)

Grimoald II (d.714)
mayor of palace, Neustria (695–714)

Charles Martel (d.741)
mayor of palace

Pippin III
king (751–768)
= Bertrada

Charles (Charlemagne)
king (768–814)
emperor (800–814)
= Hildegard
= Fastrada

Carloman
king (768–771)

Gisela
abbess of Chelles

Pippin the Hunchback
(d.811)

Pippin
king of Italy
(d.810)

Louis the Pious
king and emperor (814–840)
= Ermengard
= Judith

Bertha
= Angilbert

Drogo
archbishop of Metz (d.855)

Lothar
co-emperor (817–840)
emperor (840–855)
king of Middle Kingdom
(843–855)

Pippin I
king of Aquitaine
(d.838)

Louis the German
king of East Franks
(843–876)

Gisela
= Eberhard
of Friuli

Charles the Bald
king of West Franks
(843–877)
emperor (875–877)

Louis II
king of Italy,
emperor (855–875)
= Engelberga

Lothar II
king of Lotharingia
(855–869)

Carloman
king of
Bavaria
(d.880)

Charles
the Fat
emperor
(881–887)

Louis the
Younger
king of
East Franks
(d.882)

Louis the Stammerer
king of West Franks
(877–879)

Ermengard
= Boso
king of Provence (d.887)

Arnulf
king of East
Franks
(887–899)

Louis III
king of West
Franks
(879–882)

Carloman
king of West
Franks
(879–884)

Charles the Simple
king of West Franks
(898–922)

Louis the Blind
king of Provence (887–928)
king of Italy (900–905)
emperor (901–905)

Louis the Child
king of East Franks
(900–911)

Louis IV D'Outremer
king of West Franks
(936–954)

Lothar
king of West Franks (954–986)

Louis V
king of West Franks
(986–987)

* Many of the Carolingian mayors and kings had more than one wife. The children listed here
(selected as only the most important of the fathers' progeny) are those of the king but not
necessarily of the wife named here.

themselves as accountable to God and yet, through that very act of subservience, make themselves even more sacred and authoritative in the eyes of their subjects.

Genealogy 3.2 (facing page) The Carolingians

After Louis's death, a period of war and uncertainty (840–843) among the three remaining brothers (Pippin had died in 838) ended with the Treaty of Verdun (843). (See Map 3.4a.) The Carolingian Empire was divided into three parts, an arrangement that would roughly define the future political contours of Western Europe. The western third, bequeathed to Charles the Bald (r.843–877), would eventually become France, and the eastern third, given to Louis the German (r.843–876), would become Germany. The "Middle Kingdom," which became Lothar's portion (r. as co-emperor 817–840; as emperor 840–855), had a different fate: parts of it were absorbed by France and Germany, while the rest eventually coalesced into the modern states of Belgium, the Netherlands, and Luxembourg – the so-called Benelux countries – as well as Switzerland and Italy. All this was far in the future. As the brothers had their own children, new divisions were tried: one in 870 (the Treaty of Meerssen), for example, and another in 880. (See Map 3.4b and 3.4c.) After the death of Emperor Charles the Fat (888), various kings and lesser rulers, many of them non-Carolingians, came to the fore in the irrevocably splintered Empire.

Dynastic problems contributed to the breakup of the Carolingian Empire. So did invasions by outsiders – Vikings, Muslims, and, starting in 899, Magyars (Hungarians) – which harassed the Frankish Kingdoms throughout the ninth century (see the next chapter). These certainly weakened the kings: without a standing army, they were unable to respond to lightning raids, and what regional defense there was fell into the hands of local leaders such as counts.

The Carolingians lost prestige and money as they paid out tribute to stave off further attacks. Above all, the Carolingian Empire atomized because linguistic and other differences between regions – and familial and other ties within regions – were simply too strong to be overcome by directives from a central court. Even today a unified Europe is only a distant ideal. Anyway, as we shall see, fragmentation had its own strengths and possibilities.

The Wealth of a Local Economy

The Carolingian economy was based on plunder, trade, and agriculture. After the Carolingians could push no further and the raids of Charlemagne's day came to an end, trade and land became the chief resources of the kingdom. To the north, in Viking trading stations such as Haithabu and Birka (see Map 3.5), archaeologists have found Carolingian glass and pots alongside Islamic coins and cloth, showing that the Carolingian economy meshed with that of the Abbasid caliphate. (See Plate 4.2 on p. 125.) Silver from the Islamic world came north across the Caspian Sea, up the Volga River, and to the Baltic Sea settlements. There the coins were melted down and the silver traded to the Carolingians in return for wine, jugs, glasses, and other manufactured goods. The Carolingians turned the silver into coins of their own, to be used throughout the Empire for small-scale local trade. Baltic

Map 3.5 Northern Emporia in the Carolingian Age

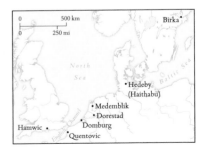

Sea emporia such as Haithabu and Birka supplemented those – Quentovic and Dorestad, for example – that served the North Sea trade.

Nevertheless, the backbone of the Carolingian economy was land. A few written records, called *polyptyques*, document the output of the Carolingian great estates – "villae," as they were called in Latin, "manors," as we term them. On the far-flung and widely scattered manors of rich landowners – churches, monasteries, kings, and aristocrats – a major reorganization and rationalization was taking place. The most enterprising landlords instituted a three-field rather than a two-field cultivation system. It meant that two-thirds of the land rather than one-half was sown with crops each year, yielding a tidy surplus.

Consider Lambesc, near Aix-en-Provence, one of the many manors belonging to the cathedral of Saint Mary of Marseille. It was not a compact farm but rather a conglomeration of essential parts, with its lands, woods, meadows, and vineyards scattered about the countryside. All were worked by peasant families, some legally free, some unfree, each settled on its own holding – here called a *colonica*; elsewhere often called a *mansus*, or "manse" – usually including a house, a garden, small bits of several fields, and so on. The peasants farmed the land that belonged to them and paid yearly dues to their lord – in this case the Church of Saint Mary, which, in its *polyptyque*, kept careful track of what was owed:

> [There is a] holding [*colonica*] at Nemphas. Martinus, *colonus*. Wife Dominica. Bertemarus, an adult son. Desideria, an adult daughter. It pays the tax: 1 pig, 1 suckling [pig]; 2 fattened hens; 10 chickens; 40 eggs. Savarildis, an adult woman. Olisirga, a daughter 10 years old. Rica, a daughter 9 years old.[8]

Martinus and his family apparently did not work the *demesne* – the land, woods, meadows, and vineyards directly held by Saint Mary – but they paid a yearly tax of animals and animal produce. Other tenants farmed the demesne, as at Nidis, in the region of Grasse, where a peasant named Bernarius owed daily service and also paid a penny (1 *denarius*) in yearly dues. On many manors women were required to feed the lord's chickens or busy themselves in the *gynecaeum*, the women's workshop, where they made and dyed cloth and sewed garments. (See Material Culture: Cloth and Clothing on pp. 157–60.)

Clearly the labor was onerous and the accounting system complex and unwieldy; but manors organized on the model of Saint Mary – including the extensive estates of the Carolingian kings – made a profit. Nevertheless, farming did not return great surpluses, and as the lands belonging to the king were divided up in the wake of the partitioning of the Empire, Carolingian dependence on manors scattered throughout their kingdom proved to be a source of weakness.

8 *Polyptyque of the Church of Saint-Mary of Marseille*, in *A Short Medieval Reader*, pp. 85–87 and in *Reading the Middle Ages*, pp. 105–7.

The Carolingian Renaissance

With the profits from their manors, many monasteries and churches invested in books. As in the Byzantine Empire, the Carolingians wrote their manuscripts on parchment. Like Byzantine scribes at around the same time, the Carolingians also created new cursive letter forms. Quick to write and easy to read, "Caroline minuscule" (as the new Carolingian script is called) lasted into the eleventh century, when it gave way to a more angular script, today called "Gothic." Caroline minuscule was then rediscovered in the fourteenth century – by scholars who thought that it represented ancient Roman writing! – and it became the model for modern lower-case printed fonts, such as those used in this book.

Assigning themselves the task of reviving Roman culture, the Carolingians encouraged the development of written music so that all churches and monasteries in the Empire would sing the same tunes – the ones sung at Rome. This reform – the imposition of the so-called Gregorian chant – posed great practical difficulties. It meant that every monk and priest had to learn a year's worth of Roman music; but how? A few cantors were imported from Rome, but without a system of notation, it was easy to forget new tunes. Thus, Carolingian scribes experimented with notes: in the ninth century these were little more than dots and dashes above the words of the liturgy to remind the singers of the melody. But by the end of the Middle Ages, notes had begun to resemble those used in today's musical scores.

The Carolingian court was behind much of this activity. Most of the centers of learning, scholarship, and book production began under men and women who at one time or another were part of the royal court. Alcuin, perhaps the most famous of the Carolingian intellectuals, was "imported" by Charlemagne from England – where, as we have seen (pp. 66–68), monastic scholarship flourished – to become a key advisor to Charlemagne. He eventually became abbot of Saint-Martin of Tours, where he orchestrated the production of an authoritative edition of the Bible, the so-called Vulgate. More unusual but equally telling was the experience of Gisela, Charlemagne's sister. She too was a key royal advisor, the one who alerted the others at home about Charlemagne's imperial coronation at Rome in 800. She was also abbess of Chelles, near Paris, a center of manuscript production. Chelles had a library, and its nuns were well educated. They wrote learned letters and composed a history (the "Prior Metz Annals") that treated the rise of the Carolingians as a tale of struggle between brothers, sons, and fathers eased by the wise counsel of mothers, aunts, and sisters.

Women and the poor made up the largely invisible half of the Carolingian Renaissance. But without doubt at least a few participated in it. One of Charlemagne's capitularies ordered that the cathedrals and monasteries of his kingdom should teach reading and writing to all who could learn. There were enough complaints (by rich people) about upstart peasants who found a place at court that we may be sure that some talented sons of the poor were getting an education. A few churchmen expressed the hope that schools for "children" would be established even in small villages and hamlets. Were they thinking of girls as well as boys? Certainly, the noblewoman Dhuoda proves that education was available even to laywomen. We would never know about her had she not worried enough about her absent child to write a *Handbook for Her Son* full of advice. It is clear in this deeply felt

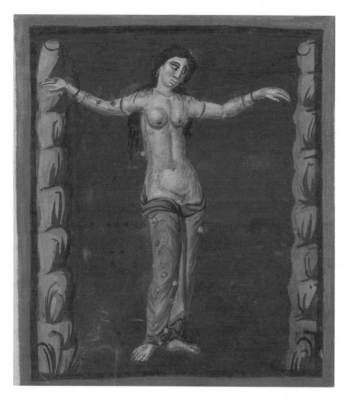

moral text that Dhuoda was drawing on an excellent education: she obviously knew the Bible, writings of the Church Fathers, Gregory the Great, and "moderns," like Alcuin. Her Latin was fluent and sophisticated. And she understood the value of the written word:

> My great concern, my son William, is to offer you helpful words. My burning, watchful heart especially desires that you may have in this little volume what I have longed to be written down for you, about how you were born through God's grace.[9]

The original manuscript of Dhuoda's text is not extant. Had it survived, it would no doubt have looked like other "practical texts" of the time: the "folios" (pages) would have been written in Caroline minuscule, each carefully designed to set off the poetry – Dhuoda's own and quotes from others – from the prose; the titles of each chapter (there are nearly a hundred, each very short) would have been enlivened with delicately colored capital letters. The manuscript would probably not have been illuminated (illustrated); fancy books were generally made for royalty, for prestigious ceremonial occasions, or for books that were especially esteemed, such as the Gospels.

To be sure, there were many such lavish productions. In fact, Carolingian art and architecture mark a turning point. For all its richness, Merovingian culture had not stressed artistic expression, though some of the monasteries inspired by Saint Columbanus produced a few illuminated manuscripts. By contrast, the Carolingians, admirers and imitators of Christian Rome, vigorously promoted a vast, eclectic, and ideologically motivated program of art and architecture. They were reviving the Roman Empire. We have already seen how Charlemagne brought the very marble of Rome and Ravenna home to Aachen to build his new palace complex. A similar impulse inspired Carolingian art. Here too, the Carolingians revered and imitated the past while building on and changing it. Their manuscript illuminations were inspired by a vast repertory of models: from the British Isles (where, as we have seen, a rich synthesis of decorative and representational styles had a long tradition), from late-antique Italy (which yielded its models in old manuscripts), and from Byzantium (which may have inadvertently provided some artists, fleeing iconoclasm, as well as manuscripts).

In Plate 3.7, a beautiful woman, half naked, stands with her arms outstretched, bound at her wrists by chains. Small stars are scattered over her body. She is the galaxy Andromeda.

Plate 3.7 Andromeda (840s?). In this notebook-sized (about 9 × 8 inch) Carolingian manuscript, probably made at Aachen or Metz, an artist painted nearly forty miniatures of the constellations named in a poem by Aratos.

Plate 3.8 (facing page) Saint-Vaast Gospels, Northern France (mid-9th cent.). In this sumptuous manuscript, much of it on purple-colored vellum and thus suggesting imperial patronage, the artist has framed the first words of the Gospel of John, "In principium" (In the beginning), with a majestic combination of curvilinear forms and small author portraits. Although each evangelist is different, all are writing within a similarly colored blue space. The device suggests the harmony of the Gospels.

9 Dhuoda, *Handbook for Her Son*, in *Reading the Middle Ages*, pp. 128–31.

CIRCUMDABITTE
ETPROPTERHANCINALTU
REGREDERE · DNSIUDI
CATPOPULOS ·
IUDICAMEDNESECUN
DUIUSTITIAMMEA · ET
SECUNDUMINNOCEN
TIAMMEAMSUPERME ·
CONSUMMETURNEQUITI
APECCATORUETDIRI
GESIUSTUM · ETSCRUTANS
CORDAETRENESDS
IUSTUMADIUTORIUM
MEUMADNO · QUISAL
VIII · INFINEM

UOSFACITRECTOSCORDE
DSIUDEXIUSTUSETFORTIS
ETPATIENS · NUMQUIDI
RASCETURPERSINGU
LOSDIES ·
NISICONUERSIFUERITIS
GLADIUMSUUMUIBRA
BITARCUMSUUMTE
TENDITETPARAUITILLU
ETINEOPARAUITUASA
MORTIS · SAGITTASSU
ASARDENTIBUSEFFECIT ·
ECCEPARTURITINIUS
TITIAM · CONCEPITDO
PROTORCOLARIBUS

LOREMETPEPERITINIQUI
TATEM
LACUMAPERUITETEFFODIT
EUM · ETINCIDITINFOUE
AMQUAMFECIT ·
CONUERTETURDOLOR
EIUSINCAPUTEIUS · ET
INUERTICEMIPSIUSINI
QUITASEIUSDESCENDET ·
CONFITEBORDNO · SECUN
DUMIUSTITIAMEIUS ·
ETPSALLAMNOMINI
DNIALTISSIMI ;

PSALMUSDAUID

DNEDNSNOSTER
QUAMADMIRABILE
ESTNOMENTUUM
INUNIUERSATERRA ·
QNMELEUATAESTMAG
NIFICENTIATUA · SU
PERCAELOS ·
EXORE INFANTIUMETLAC

TANTIUM · PERFECISTI
LAUDEMPROPTERINI
MICOSTUOS · UTDESTRU
ASINIMICUMETULTORE ·
QNMUIDEBOCAELOSTU
OSOPERADIGITORU
TUORUM · LUNAMETS
TELLASQUAETUFUNDASTI

QUIDESTHOMOQUOD
MEMORESEIUS · AUT
FILIUSHOMINISQUO
NIAMUISITASEUM ·
MINUISTIEUMPAULOMI
NUSABANGELIS · GLO
RIAETHONORECORO
NASTIEUM · ETCONS

In Greek mythology she was the daughter of Cepheus and Cassiopeia, king and queen of Aethiopia. When Cassiopeia boasted that Andromeda was more beautiful than even the daughters of the sea god, that god took his revenge on Aethiopia and forced Cepheus to sacrifice his daughter by stripping off her clothes and chaining her to a rock. She was saved by the hero Perseus, who married her, and after her death the goddess Athena turned her into a constellation in the northern sky. The Carolingian artist took his inspiration not only from the text he (or she) was illustrating – the *Phainomena* by the classical Greek poet Aratos (*fl.* 3rd cent. BCE) in the later Latin version by Germanicus Caesar (*fl.* 1st cent. CE) – but also from ancient classical artistic models. Compare Andromeda to the nereid in Plate 1.1 on p. 12. Both women have weight and flesh; both are absorbed in their own story and care nothing about hierarchy, ideology, or a world beyond their own.

Produced around the same time as Andromeda, a manuscript page in the Saint-Vaast Gospels in Plate 3.8 (p. 113) seems, at first glance, to come from a different world. It is closer to the earlier, Insular Book of Durrow of Plate 2.5 (p. 69) than to Andromeda. Like the Durrow artist, so this Carolingian illuminator rejoices in the decorative possibilities of pattern and interlace, bringing that same sensibility to the text, so that the letters IN are so ornate that it takes a moment to realize that they form a word. And yet in each of the corners of the elaborate square that encloses the text are four men as fleshy as Andromeda. Their bodies are solid, their garb drapes naturally over their limbs, and their gestures suggest excitement as well as absorption in their tasks. They care nothing about the viewer: they are authors in the fury of creation, bent over their task, writing, scraping off mistakes, reviewing their work. Were it not for their halos, we would hardly know that they are the evangelists busily composing the four Gospels.

Carolingian artists were inspired by still other traditions. Consider the light, impressionistic style of the Roman Empire in its heyday – the busy, almost dancing figures in the Harbor Scene in Plate 1.2 on pp. 14–15. These too were mirrored – and refracted – in the Carolingian Empire, as we may see in the Utrecht Psalter, commissioned by Archbishop Ebbo of Reims and executed at a nearby monastery. The manuscript contains all 150 psalms and 16 other songs known as canticles. Each is accompanied by lively drawings, turning the poems into a running story of human and divine interaction. Plate 3.9 shows the page for psalms 7 and 8. The illustration comes between the two, but refers to psalm 8, whose first verse has the dedication: "Unto the end, for the presses (musical instruments?): a psalm for David." Beneath the drawing are the first words of verse 2, "Domine dominus noster" (O Lord our Lord), written in gold letters. The words of that verse and those following continue in dark brown ink:

2. O Lord our Lord, how admirable is thy name in the whole earth! For thy magnificence is elevated above the heavens.

3. Out of the mouths of infants and sucklings thou hast perfected praise, because of thy enemies: that thou mayst destroy the enemy and the avenger.

4. For I will behold thy heavens, the work of thy fingers: the moon and the stars which thou hast founded.

Plate 3.9 (facing page) Utrecht Psalter, Northeastern France (first half of 9th cent.). The same drawing illustrates still more verses. In v. (verse) 5 of the psalm, the key question is posed: "What is man that thou art mindful of him?" The answer is that God has made man ruler of the things that God created on earth. Thus, at the far left of the drawing are the mammals (illustrating v. 8. "Thou hast subjected all things under his feet; all sheep and oxen; moreover the beasts also of the fields"). On the far right are the birds and fish (illustrating v. 9. "The birds of the air, and the fishes of the sea that pass through the paths of the sea"). For more such pictorial verse-by-verse depictions, see Plate 2.12 (p. 81), another page from this same charming and influential Psalter.

The illustrator has taken these words literally. To the left of center in the middle tier (corresponding to the verse 2) is the psalmist praying to the Lord above him. Christ is seated on a globe within a mandorla, symbol of his glory. The clouds beneath show that he is "above the heavens," elevated there by four angels. Just beneath Christ (illustrating verse 3) are little children looking up and gesturing in praise. Meanwhile, the enemies of the Lord, their hair long and spiky, are being driven into a pit (Hell) by an avenging angel. For verse 4, the artist has depicted (on Christ's right) the moon and stars.

It may plausibly be said that the various artistic styles elaborated during the Carolingian Renaissance – fed by classical, decorative, and abstract traditions combined in new and original ways – form the foundation of all subsequent Western art.

For practice questions about the text, maps, plates, and other features – plus suggested answers – please go to

www.utphistorymatters.com

There you will also find all the maps, genealogies, and figures used in the book.

FURTHER READING

Airlie, Stuart. *Making and Unmaking the Carolingians, 751–888*. London: Bloomsbury Academic, 2020.

Brubaker, Leslie, and John Haldon. *Byzantium in the Iconoclast Era, c.680–850: A History*. Cambridge: Cambridge University Press, 2011.

Cameron, Averil. *Byzantine Christianity: A Very Brief History*. London: SPCK, 2017.

Cooperson, Michael. *Al-Ma'mun*. Oxford: Oneworld Publications, 2005.

DeJong, Mayke. *The Penitential State: Authority and Atonement in the Ages of Louis the Pious, 814–840*. Cambridge: Cambridge University Press, 2009.

El-Hibri, Tayeb. *The Abbasid Caliphate*. Cambridge: Cambridge University Press, 2021.

Fauvelle, François-Xavier. *The Golden Rhinoceros: Histories of the African Middle Ages*. Trans. Troy Tice. Princeton, NJ: Princeton University Press, 2018.

Gantner, Clemens, and Walter Pohl. *After Charlemagne: Carolingian Italy and Its Rulers*. Cambridge: Cambridge University Press, 2021.

Gomez, Michael A. *African Dominion: A New History of Empire in Early and Medieval West Africa*. Princeton, NJ: Princeton University Press, 2019.

Gordon, Matthew S. *Ahmad ibn Tulun: Governor of Abbasid Egypt, 868–884*. London: Oneworld Academic, 2021.

—. "The Early Islamic Empire and the Introduction of Military Slavery." In *War and the Medieval World*, edited by Anne Curry and David A. Graff, pp. 17–49. Vol. 2 of *The Cambridge History of War*. Cambridge: Cambridge University Press, 2020.

Heather, Peter. *The Restoration of Rome: Barbarian Popes & Imperial Pretenders*. Oxford: Oxford University Press, 2014.

Hermans, Erik, ed. *A Companion to the Global Early Middle Ages*. Amsterdam: Amsterdam University Press, 2020.

Herrin, Judith. *Women in Purple: Rulers of Medieval Byzantium*. Princeton, NJ: Princeton University Press, 2002.

Nelson, Janet L. *King and Emperor: A New Life of Charlemagne*. Oakland: University of California Press, 2019.

Nol, Hagit, ed. *Riches beyond the Horizon: Long-distance Trade in Early Medieval Landscapes (ca. 6th–12th centuries)*. Turnhout: Brepols, 2022.

Pohl, Walter. *The Avars: A Steppe Empire in Central Europe, 567–822*. Ithaca, NY: Cornell University Press, 2018.

Turner, John P. *Inquisition in Early Islam: The Competition for Political and Religious Authority in the Abbasid Empire*. London: I.B. Taurus, 2013.

Wormald, Patrick, and Janet L. Nelson, eds. *Lay Intellectuals in the Carolingian World*. Cambridge: Cambridge University Press, 2011.

HIGHLIGHTS

Fatimids proclaim a Shi'ite caliphate

910

The Shi'ite Fatimid caliphate dominates Egypt and North Africa, signaling the decline of the Abbasids and of the Sunni form of Islam in the Islamic world.

Umayyad ruler of al-Andalus takes the title of caliph

929

The tenth century sees the height of Umayyad power in al-Andalus, but a century later, their caliphate splits into *taifas* (Islamic principalities).

Battle of Lechfeld

955

The victory of Otto I over the Hungarians at Lechfeld is a triumph that leads to his coronation as emperor in 962 and to the establishment of the Ottonian dynasty, which lasts until 1024.

Reign of Basil II the Bulgar-Slayer

976–1025

Basil expands the borders of the Byzantine Empire and successfully staves off the ascendency of the *dynatoi* (powerful regional leaders).

Peace of God

989

This movement in the Church begins in the tenth century in the south of France. It calls on the nobility to protect ecclesiastical and other property from armed depredations. The Truce of God, declared a bit later, declares certain periods during which warfare among Christians is prohibited.

Scandinavian and East Central European rulers convert to Christianity

c.1000

The conversion of the Scandinavian regions, much like that of East Central Europe, suggests that the adoption of the Christian religion goes hand in hand with monarchical power.

FOUR

POLITICAL COMMUNITIES REORDERED
(c.900–c.1050)

The large-scale centralized governments of the ninth century dissolved in the tenth. The fission was least noticeable at Byzantium, where, although important landowning families emerged as brokers of patronage and power, the primacy of the emperor was never effectively challenged. In the Islamic world, however, new dynastic groups established themselves as regional rulers. In Western Europe, the Carolingian Empire collapsed and new political entities – some extremely local and weak, others quite strong and unified – emerged in its wake.

BYZANTIUM: THE STRENGTHS AND LIMITS OF CENTRALIZATION

By 1025 the Byzantine Empire once again touched the Danube and Euphrates Rivers. Its emperors maintained the traditional cultural importance of Constantinople by carefully orchestrating the radiating power of the imperial court. At the same time, however, powerful men in both town and countryside gobbled up land and dominated the peasantry, challenging the dominance of the central government.

The Imperial Court

The Great Palace of Constantinople, a sprawling building complex begun under Constantine, was expanded and beautified under his successors. (See Map 4.1.) Far more than just the symbolic emplacement of imperial power, it was the central command post of the Byzantine Empire. Servants, slaves, and grooms; top courtiers and learned clergymen;

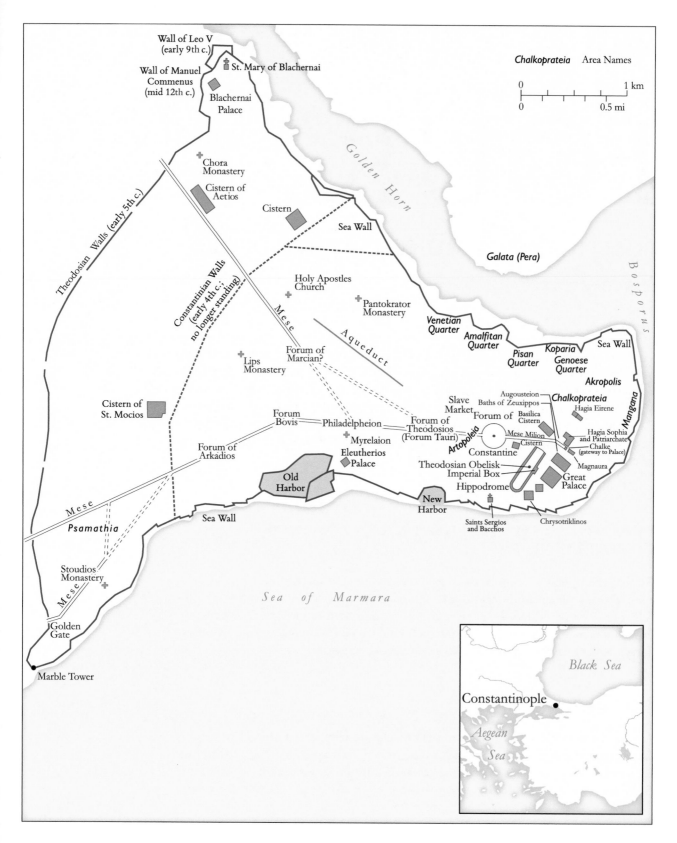

Wall of Leo V
(early 9th c.)

St. Mary of Blachernai

Wall of Manuel
Commenus
(mid 12th c.)

Blachernai
Palace

Golden Horn

Chalkoprateia Area Names

0 1 km
0 0.5 mi

Chora
Monastery

Cistern of
Aetios

Cistern

Sea Wall

Galata (Pera)

Bosporus

Theodosian Walls (early 5th c.)

Constantinian Walls
(early 4th c.;
no longer standing)

Mese

Holy Apostles
Church

Pantokrator
Monastery

Aqueduct

*Venetian
Quarter*

*Amalfitan
Quarter*

*Pisan
Quarter*

Koparia

*Genoese
Quarter*

Sea Wall

Akropolis

Forum of
Marcian?

Lips
Monastery

Cistern of
St. Mocios

Forum
Bovis

Philadelpheion

Myrelaion

Eleutherios
Palace

Forum of
Theodosios
(Forum Tauri)

Artopoleia

Slave
Market

Augousteion

Baths of Zeuxippos

Forum of
Constantine

Mese Milion

Basilica
Cistern

Cistern

Chalkoprateia

Hagia Eirene

Mangana

Hagia Sophia
and Patriarchate

Chalke
(gateway to Palace)

Magnaura

Forum of
Arkadios

Theodosian Obelisk
Imperial Box

Hippodrome

Great
Palace

Mese

Psamathia

Old
Harbor

New
Harbor

Saints Sergios
and Bacchos

Chrysotriklinos

Sea Wall

Stoudios
Monastery

Mese

Sea of Marmara

Golden
Gate

Marble Tower

Black Sea

Constantinople

Aegean
Sea

Map 4.1 (facing page)
Constantinople, *c.*1100

cousins, siblings, and hangers-on of the emperor and empress lived within its walls. Other courtiers – civil servants, officials, scholars, military men, advisors, and other dependents – tried to live near the palace, for they were "on call" at every hour. The emperor had only to give short notice and all were expected to assemble for impromptu but nevertheless highly choreographed ceremonies. These were in themselves instruments of power; the emperors manipulated courtly formalities to indicate new favorites or to signal displeasure. The imperial court assiduously cultivated the image of perfect, stable, eternal order.

The court was mainly a male preserve, but there were powerful women at the Great Palace as well. Consider Zoe (d.1050), the daughter of Constantine VIII. Contemporaries acknowledged her right to rule through her imperial blood, and through her marriages she "made" her husbands, Romanus III and Michael IV, into legitimate emperors. She and her sister even ruled jointly for one year (1042). But their biographer, Michael Psellus, a courtier who observed them with a jaundiced eye, was happy only when Zoe married: "The country needed a man's supervision – a man at once strong-handed and very experienced in government, one who not only understood the present situation, but also any mistakes that had been made in the past, with their probable results."[1]

There was also a "third gender" at the Great Palace: eunuchs – men who had been castrated. Unable to procreate and thus deemed less potent than other men, exotic because they were both male and yet not quite, they were chosen to occupy some of the highest government offices – financial, administrative, and military. Consider the career of John the Orphanotrophos. (So called because he ran an orphanage among his many other functions.) He was castrated by his parents because they intended for him to become a courtier. He began his career as a favorite of Emperor Basil II (r.976–1025). Thereafter, he served two more emperors and then engineered the elevation to the imperial throne of his brother, Michael IV (r.1034–1041) and his nephew, Michael V (r.1041–1042). Plate 4.1 suggests the power that contemporaries attributed to him, for he is shown enthroned as he orders the exile of Constantine Dalassenos, a powerful military commander and governor who had challenged the regime of Michael IV.

Eunuchs were status symbols, markers of the emperor's supreme power. Originally foreigners, they were increasingly recruited from the educated upper classes in the Byzantine Empire itself, even from imperial families, though John the Orphanotrophos seems to have come from a middle-class background. Eunuchs accompanied the emperor during his most sacred and vulnerable moments – when he removed his crown; when he participated in religious ceremonies; when he dreamed at night. They hovered by his throne, like the angels flanking Christ in the apse of San Vitale (Plate 1.12 on pp. 34–35). No one, it was thought, was as faithful, trustworthy, or spiritually pure as a eunuch.

1 Michael Psellus, *Zoe and Theodora*, in *A Short Medieval Reader*, ed. Barbara H. Rosenwein (Toronto: University of Toronto Press, 2023), pp. 117–22 and in *Reading the Middle Ages: Sources from Europe, Byzantium, and the Islamic World*, 3rd ed., ed. Barbara H. Rosenwein (Toronto: University of Toronto Press, 2018), pp. 200–5.

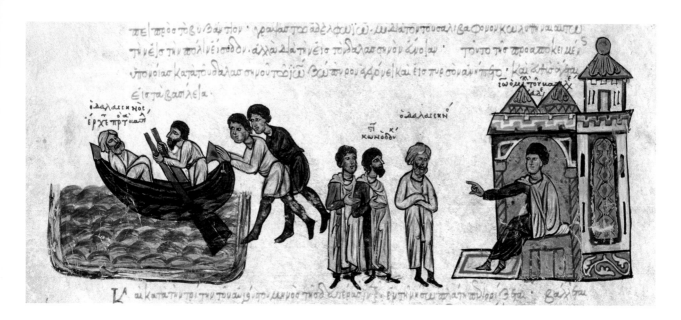

A Wide Embrace and Its Tensions

Emperor Basil II (r.976–1025), with whom John the Orphanotrophos got his start, liked to portray himself as a tireless warrior. Certainly, his epitaph reads that way:

> nobody saw my spear at rest,…
> but I kept vigilant through the whole span of my life …,
> marching bravely to the West,
> and as far as the very frontiers of the East.[2]

As ruler of the Byzantine Empire for nearly fifty years, Basil built on the achievements of his predecessors. They had pushed the Byzantine frontiers north to the Danube (taking half of the Bulgarian Empire), east beyond the Euphrates, and south to Antioch, Crete, and Cyprus (see Map 4.2). Basil thus inherited a fairly secure empire except for the threat from Rus', further to the north (for this new political entity, see below, pp. 125–27). This he defanged through a diplomatic and religious alliance, as we shall see (p. 127).

But if his borders were secure, Basil's position was not. It was challenged by powerful landowning families from whose ranks his two predecessors had come. Members of the provincial elite – military and government officers, bishops, abbots, and others – benefited from a general quickening of the economy and the rise of new urban centers. They took advantage of their ascendency by buying land from still impoverished peasants as yet untouched by the economic upswing. No wonder they were called *dynatoi* (sing. *dynatos*), "powerful men." Already, some forty years before Basil came to the throne, Emperor Romanus I Lecapenus (r.920–944) had bewailed in his *Novel* (New Law) of 934 the "intrusion" of the rich

2 *Epitaph of Basil II*, in *Reading the Middle Ages*, pp. 199–200.

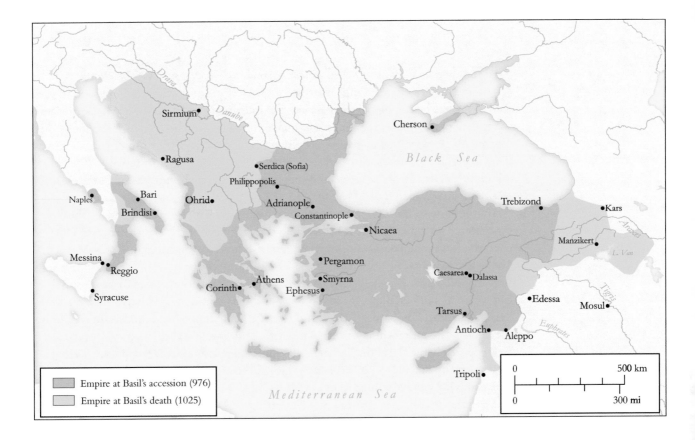

Empire at Basil's accession (976)
Empire at Basil's death (1025)

Map 4.2 The Byzantine Empire of Basil II, 976–1025

into a village or hamlet for the sake of a sale, gift, or inheritance.... For the domination of these persons has increased the great hardship of the poor ... [and] will cause no little harm to the commonwealth unless the present legislation puts an end to it first.[3]

The *dynatoi* made military men their clients (even if they were not themselves military men) and sometimes seized the imperial throne itself.

Basil had two main political goals: to stifle the rebellions of the *dynatoi* and to swell the borders of his empire. When the powerful Phocas and Scleros families of Anatolia, along with much of the Byzantine army, rebelled against him in 987, he created his own personal Varangian Guard, made up of Rus troops. Once victorious, Basil moved to enervate the *dynatoi* as a group. He reinforced the provisions of Romanus's *Novel* and others like it by threatening to confiscate and destroy the estates of those who transgressed the rules. He changed the system of taxation so that the burden fell on large landowners rather than on the peasants. He relieved the peasants and others of local military duty in the themes by asking for money payments instead. This allowed him to shower wealth on the Varangian Guard and other mercenary troops.

3 Romanus I Lecapenus, *Novel*, in *A Short Medieval Reader*, pp. 115–17 and in *Reading the Middle Ages*, pp. 177–79.

At the same time, Basil launched attacks beyond his borders: south to Syria and beyond; east all the way to Georgia and Armenia; southwest to southern Italy; and west to the Balkans, where he conquered the whole of the Bulgarian Empire and reached the Adriatic coast. Basil's victory over the Bulgarians used to be considered his defining feat, and in the fourteenth century he was given the epithet "Bulgar-Slayer." But more recently historian Catherine Holmes has stressed the importance of Basil's administrative – rather than military – achievements as he secured sufficient stability at the borders of Byzantium to ensure his government's fiscal health.

By the time of Basil's death in 1025, the Byzantine Empire was no longer the tight fist centered on Anatolia that it had been in the dark days of the eighth century. On the contrary, it was an open hand: sprawling, multi-ethnic, and multilingual. (See Map 4.2.) To the east it embraced Armenians, Syrians, and Arabs; to the north it included Slavs and Bulgarians (by now themselves Slavic speaking) as well as Pechenegs, a Turkic group that had served as allies of Bulgaria; to the west, in the Byzantine toe of Italy, the Byzantine Empire included Lombards, Italians, and Greeks. There must have been Muslims right in the middle of Constantinople: a mosque there, built in the eighth century, was restored and reopened in the eleventh. The emperor employed Rus as his elite troops (the Varangian Guard), and by the mid-eleventh century, his mercenaries included "Franks" (mainly from Normandy), Arabs, and Bulgarians as well.

All this openness went only so far, however. Toward the middle of the eleventh century, the Jews of Constantinople were expelled and resettled in a walled quarter in Pera, on the other side of the Golden Horn (see Map 4.1 on p. 120). Even though they did not expel Jews so dramatically, many other Byzantine cities forbade Jews from mixing with Christians. Around the same time, the rights of Jews as "Roman citizens" were denied; henceforth, in law at least, they had only servile status. The Jewish religion was condemned as a heresy.

Ethnic diversity and the emergence of the *dynatoi* fueled regional political movements that further threatened centralized imperial control. In southern Italy, where the Byzantines ruled through an official called a catapan, Norman mercenaries hired themselves out to Lombard rebels, Muslim emirs, and others with local interests. In the second half of the eleventh century, the Normans began their own conquest of the region. On Byzantium's eastern flank, *dynatoi* families rose to high positions in government. The Dalasseni family was fairly typical of this group. Its founder, who took the family name from Dalassa, a city near Caesarea in Anatolia, was an army leader and governor of Antioch at the end of the tenth century. One of his sons, Theophylact, became governor of "Iberia" – not Spain but rather a theme on the very eastern edge of the Empire. Another, Constantine (the man exiled by John the Orphanotrophos), inherited his father's position at Antioch. With estates scattered throughout Anatolia and a network of connections to other powerful families, the Dalasseni sometimes defied the emperor (as Constantine did Michael IV) and even coordinated rebellions against him. From the end of the tenth century, imperial control had to contend with the decentralizing forces of provincial *dynatoi* such as these. But the emperors were not dethroned, and Basil II triumphed over the families that challenged his reign to emerge even stronger than before.

The Formation of Rus'[4]

One element of his strength came with his alliance with the Rus. Known as Vikings in the West, the Rus originally came from Scandinavia, where petty kings gave their warrior followers the opportunity to acquire wealth by supplying them with weapons and housing and by controlling regional agricultural production, indigenous crafts, and long-distance trade.

Consider Birka, a settlement in eastern Sweden with access to the Baltic Sea. A powerhouse of manufacture as well as exchange, it and places like it produced the items – pendants, amulets, jugs, beads, bridles, and weapons – that the Rus brought with them to the region of Lake Ladoga and Novgorod (Lake Ilmen). (See Map 4.3.) Viking Birka had town ramparts, a market, houses, wells, track-ways, water barricades, and a large round hillfort. Archaeologists have excavated its numerous grave mounds, revealing a cosmopolitan and warlike culture. Beneath some mounds are simple burial pits, but others contain coffins (the nails still survive), and still others boast large chambers full of weapons, sewing tools, beads, and sometimes include feather beds for the corpse; a few make room for horses. Many people were buried with adornments: clothing, brooches, arm rings, and finger rings – including one inscribed in Arabic, "To Allah," though the owner probably had no idea of its meaning. Recently DNA analysis has shown that the most remarkable grave at Birka was that of a woman. She was fully dressed, outfitted with a large set of weapons, and accompanied by two horses. Whether she was a warrior or not, she certainly had a very high status in this clearly stratified society. Perhaps she had taken on the persona of a Valkyrie – the armed divine female escorts of fallen heroes to the other world's Hall of the Slain. Or perhaps she was indeed a fighter in Viking raids. It is well known that women accompanied men on their long-distant journeys.

The Vikings who went to Lake Ilmen, Novgorod, and eventually still further, to the region of Kiev (Kyiv), trapped animals for furs and captured people – the indigenous Slavs inhabiting these regions – as slaves. Taking advantage of river networks and other trade routes that led as far south as Iraq and as far west as Austria, they exchanged their human and animal cargos for silks and silver, forming crucial links between east and west, north and south. Such links explain why an Arabic-style finger ring was found in a grave at Birka and why Abbasid silver coins were hoarded there and at many other Scandinavian sites (see Plate 4.2).

Other long-distance traders in the region were the Khazars, a Turkic-speaking people, whose powerful state, straddling the

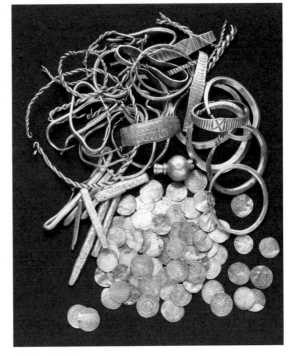

Plate 4.2 Silver Hoard from Grimestad, near Kaupang (921). This coin hoard from Norway boasted seventy-seven Islamic coins as well as arm rings, neck rings, rods, and other silver items, some of them already cut into "hacksilver" to exchange by weight. Hoards similar to this – some with copper and counterfeit coins as well – have been found throughout Russia, in Europe along the Rhine River, in northern Poland and Germany, and, of course, in Scandinavia.

4 Rus without the apostrophe is used for the people; Rus' for the state.

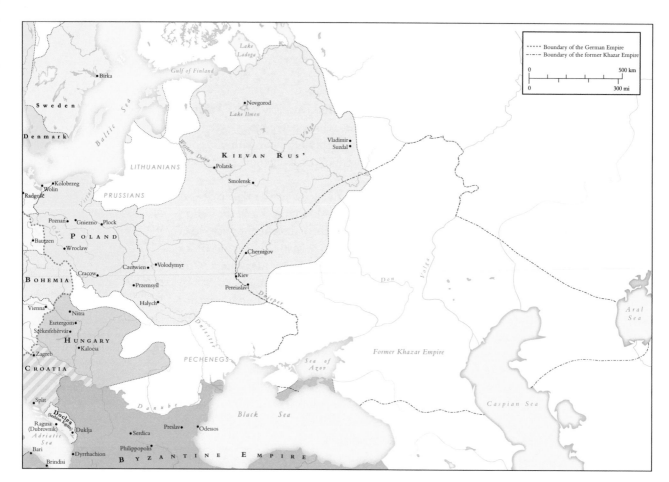

Map 4.3 Kievan Rus', *c.*1050

Black and Caspian Seas, dominated part of the silk road in the ninth century. The Khazars were ruled by a khagan (meaning khan of khans), much like the Avars, and, like other pastoralists of the Eurasian steppes, they were tempted and courted by the religions of neighboring states. Unusually, their elites opted for Judaism. The Rus were influenced enough by Khazar culture to adopt the title of khagan for the ruler of their own fledgling ninth-century state at Novgorod, the first Rus polity, but they did not embrace Judaism.

Eventually northern Rus moved south – to the region of Kiev – but this was not easy, for the area was already populated by Slavs and others. Moreover, Kiev was very close to the Khazars, to whom it is likely that the Kievan Rus at first paid tribute. While on occasion attacking both Khazars and Byzantines, Rus' rulers saw their greatest advantage in good relations with the Byzantines, who wanted their fine furs, wax, honey, and – especially – slaves. In the course of the tenth century, with the blessing of the Byzantines, the Rus brought the Khazar Empire to its knees.

Nurtured through trade and military agreements, good relations between Rus' and Byzantium were sealed through religious conversion. By the mid-tenth century, quite a few Christians lived in Rus'. But the official conversion of the Rus to Christianity came under Vladimir (r.980–1015). Ruler of Rus' by force of conquest (though from a princely family), Vladimir was anxious to court the elites of both Novgorod and Kiev. He did

so through wars with surrounding peoples that brought him and his troops plunder and tribute. Strengthening his position still further, in 988 he adopted the Byzantine form of Christianity, took the name "Basil" in honor of Emperor Basil II, and married Anna, the emperor's sister. Christianization of the general population seems to have followed quickly.

Vladimir's conversion was part of a larger process of state formation and Christianization taking place around the year 1000. In Scandinavia and East Central Europe, as we shall see, the end result was Catholic kingships rather than the Orthodox principality that Rus' became. Given its geographic location, it was anyone's guess how Rus' would go: it might have converted to the Roman form of Christianity of its western neighbors. Or it might have turned to Judaism under the influence of the Khazars. Or, indeed, it might have adopted Islam, given that the Volga Bulgars had converted to Islam in the early tenth century. It is likely that Vladimir chose the Byzantine form of Christianity because of the prestige of the Empire under Basil.

DIVISION AND DEVELOPMENT IN THE ISLAMIC WORLD

While at Byzantium the forces of decentralization were relatively feeble, they carried the day in the Islamic world. Where once the caliph at Baghdad or Samarra could boast collecting taxes from Kabul (today in Afghanistan) to Benghazi (today in Libya), in the eleventh century a bewildering profusion of regional groups and dynasties divided the Islamic world. Yet this was in general a period of prosperity and intellectual blossoming.

The Emergence of Regional Powers

The Muslim conquest had not eliminated, but rather papered over, local powers and regional affiliations. While the Umayyad and Abbasid caliphates remained strong, they imposed their rule through their governors and army. But when the caliphate became weak, as it did in the tenth and eleventh centuries, old and new regional interests came to the fore.

A glance at a map of the Islamic world c.1000 (Map 4.4) shows, from east to west, the main new groups that emerged: the Samanids, Buyids, Hamdanids, Fatimids, and Zirids. But the map hides the many territories dominated by even smaller independent rulers. North of the Fatimid Caliphate, al-Andalus had a parallel history. Its Umayyad ruler took the title of caliph in 929, but in the eleventh century he too was unable to stave off political fragmentation.

The key cause of the weakness of the Abbasid caliphate was lack of revenue. When landowners, governors, or recalcitrant military leaders in the various regions of the Islamic world refused to pay taxes into the treasury, the caliphs had to rely on the rich farmland of Iraq, long a stable source of income. But a deadly revolt lasting from 869 to 883 by the Zanj – black slaves from sub-Saharan East Africa who had been put to work to turn

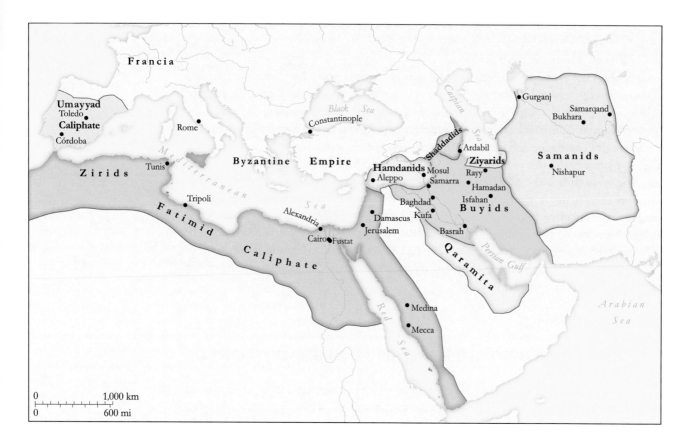

Map 4.4 Fragmentation of the Islamic World, *c.*1000

marshes into farmland – devastated the Iraqi economy. Although the revolt was put down and the head of its leader was "displayed on a spear mounted in front of [the winning general] on a barge," there was no chance for the caliphate to recover.[5] In the tenth century the Qaramita (sometimes called "Carmathians"), a sect of Shi'ites based in Arabia, found Iraq easy prey. The result was decisive: the caliphs could not pay their troops. New men – military leaders with their own armies – took the reins of power. They preserved the Abbasid line, but they reduced the caliph's political authority to nothing.

The new rulers represented groups that had long awaited their ascendency. The Buyids, for example, belonged to ancient warrior tribes from the mountains of Iran. Even in the tenth century, most were relatively new converts to Islam. Bolstered by long-festering local discontent, one of them became "commander of commanders" in 945. Thereafter, the Buyids, with help from their own Turkish mercenaries, dominated the region south of the Caspian Sea, including Baghdad. For a time, they presided over a glittering culture that supported (and was in turn celebrated by) scholars, poets, artists, and craftsman. Yet already in the eleventh century, competition between Buyid princes led to the regionalization and fragmentation of their state, an atomization echoed elsewhere in the Islamic world and in much of Western Europe as well.

5 Al-Tabari, *The Defeat of the Zanj Revolt*, in *A Short Medieval Reader*, pp. 89–93 and in *Reading the Middle Ages*, pp. 171–76.

THE FATIMIDS

The most important of the new regional rulers were the Fatimids. They, like the Qaramita (and, increasingly in the course of time, the Buyids), were Shi'ites, taking their name from Muhammad's daughter Fatimah, wife of Ali. The Fatimids professed a particular form of Shi'ism called Isma'ilism. The Fatimid leader claimed not only to be the true *imam*, descendant of Ali, but also the Mahdi, the "divinely guided" messiah, come to bring justice on earth. Because of this, the Fatimids were proclaimed "caliphs" by their followers – the true "successors" of the Prophet. Allying with the Berbers in North Africa, by 910 the Fatimids established themselves as rulers in what is today Tunisia and Libya. Within a half-century they had moved eastward (largely abandoning the Maghreb to the Zirids), to rule Egypt, southern Syria, and the western edge of the Arabian Peninsula. They cultivated contacts far beyond their borders as well: across the Mediterranean to Europe and Byzantium and beyond to India and China. Islamic religious scholars often served as the human links among these regions, financing their many voyages to noted centers of learning by acting as merchants or mercantile agents. A flourishing textile industry kept Egypt's economy buoyant: farmers produced flax (not only for Egypt but for Tunisia and Sicily as well); industrial laborers turned the plant fibers into linen; tailors cut and sewed garments; and traders exported the products from each phase or sold them at home. Public and private investment in both the agricultural and industrial sides of flax production guaranteed its success.

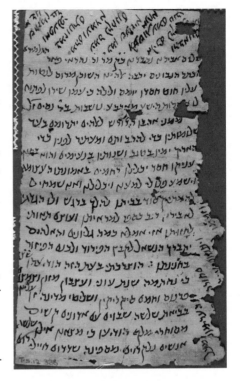

Plate 4.3 Letter from Yshu'a ha-Kohen to Nahray ben Nissim (1050). "Greetings," begins this long letter, showering praise on Nahray before recounting the immediate issue: three captive Jews have been brought to Alexandria by traders from Amalfi, who are anxious to sell them. (For Amalfi, see Map 4.6 on p. 147.) Before their capture (or purchase) by the Amalfitans, the three had been taken from their ship by Byzantine pirates, robbed of their merchandise, and enslaved. Now in Alexandria, these Jews must be ransomed, and Yshu'a is trying to raise the money and provide for their upkeep. But even with the "bargain price" offered by the Amalfitans and a bit of money offered in donation by others in Alexandria, he still needs forty dinars. Indirectly, and with plenty of flattering words, he asks Nahray, highly reputed for his charity, to help.

We know about this vibrant Egyptian society in part because of a trove of archival materials left by the Jewish community of Fustat. Following custom, the Jews there established a *geniza* – a repository for anything containing the name of God. While materials in *genizot* were usually destined for burial, the ones at Fustat just kept piling up, starting in the eleventh century and continuing for a thousand years. In effect, the *geniza* at Fustat served as the garbage dump for *everything* in Hebrew that was worn out or no longer needed. The documents from the Fatimid period – including letters, amulets, contracts, lawsuits, even shopping lists – reveal a cosmopolitan, middle-class community that served as a linchpin for the trade that flourished across the Mediterranean Sea and beyond. Plate 4.3 shows one side of some of the thousands of letters found in the *geniza*. Written by a Jew living in Alexandria to the wealthy and influential Nahray ben Nissim, a Jewish communal leader in Fustat, the letter suggests some of the vast networks involved in commerce as well as their perils – in this case piracy and enslavement.

Wealthy and sophisticated, the Fatimids created a new capital city, Cairo, filling it with palaces, libraries, shops, pavilions, gardens, private houses, and mosques which, following the Shi'ite practice of calling the congregation to prayer from the mosque door or roof, lacked minarets. As Shi'ites, too, they emphasized the commemoration of the dead (though Sunni Muslims often did so as well), hence the large Fatimid cemetery at Aswan (see Plate 4.4), filled with mudbrick tombs and mausolea (buildings for burials). Muhammad had

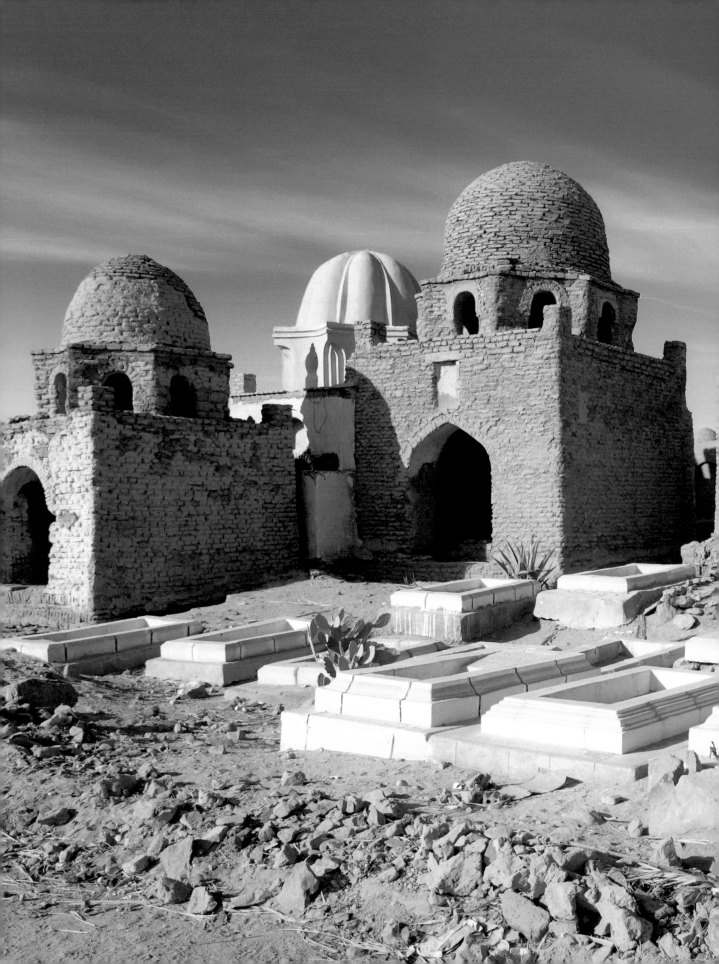

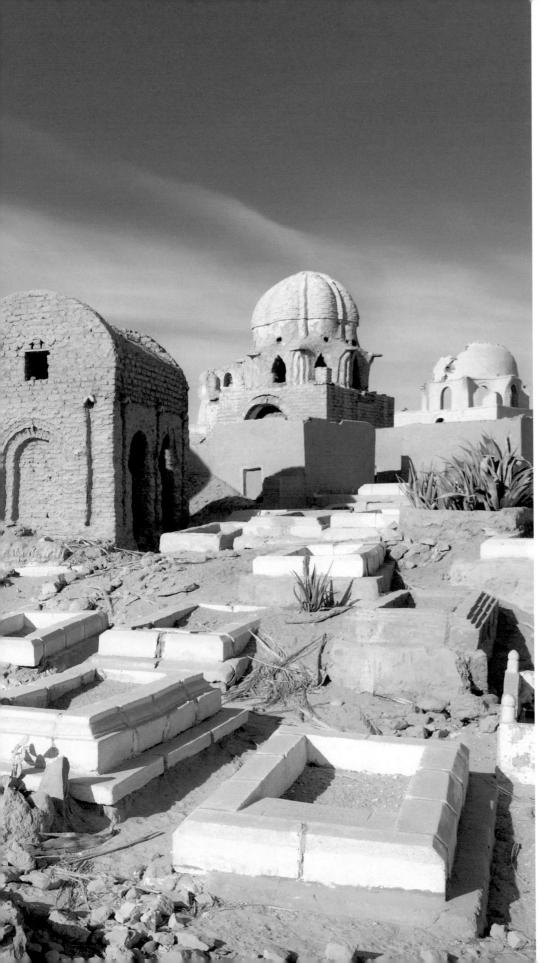

Plate 4.4 Fatimid Cemetery at Aswan (11th cent.). Five hundred miles south of Cairo, an exuberant architectural imagination held sway at the Fatimid cemetery at Aswan. Here a series of mausolea with cubic bases topped by domes are particularly inventive in the ways in which they manage the zone that bridges dome and base by using octagonal structures with wing-like projections.

prohibited ostentatious burials, but that ban was skirted as long as the tombs were open to the elements. That accounts for the many windows in the mausolea at Aswan.

The Fatimids achieved the height of their power before the mid-eleventh century. But during the rule of al-Mustansir (1036–1094), economic and climatic woes, factional fighting within the army, and a rebellion by Turkish troops weakened the regime. By the 1070s, the Fatimid caliphate had lost most of Syria and North Africa to other rulers.

THE UMAYYADS OF AL-ANDALUS

The Umayyad rulers at Córdoba experienced a similar rise and fall. Abd al-Rahman III (r.912–961) took the title caliph in 929 to rival the Fatimids and to assume the luster of the ruler of Baghdad. "He bore [signs of] piety on his forehead and religious and secular authority upon his right hand," wrote a court poet of the new caliph.[6] An active military man backed by an army made up mainly of Slavic slaves, Abd al-Rahman defeated his rivals and imposed his rule on all of al-Andalus. Under the new caliph and his immediate successors, Islamic Iberia became a powerful centralized state. Even so, regional elites sought to carve out their own polities. Between 1009 and 1031 bitter civil war undid the dynasty's power. After 1031, al-Andalus was split into small principalities, *taifas*, that were ruled by local strongmen.

Thus, in the Islamic world, far more decisively than at Byzantium, newly powerful regional rulers came to the fore. Nor did the fragmentation of power end at the regional level. To pay their armies, Islamic rulers often resorted to granting their commanders *iqta*—lands and villages—from which the *iqta*-holder was expected to gather revenues and pay their troops. As we shall see, this was a bit like the Western European institution of the fief. It meant that even minor commanders could act as local governors, tax-collectors, and military leaders. But there was a major difference between this institution and the system of fiefs and vassals in the West: while vassals were generally tied to one region and one lord, the troops under Islamic local commanders were often foreigners and former slaves, unconnected to any particular place and easily wooed by rival commanders.

Cultural Unity, Religious Polarization

The emergence of local strongmen meant not the end of Arab court culture but a multiplicity of courts, each attempting to out-do one another in brilliant artistic, scientific, theological, and literary productions. The Buyids created what one modern scholar, Joel L. Kraemer, has called a renaissance of literary culture echoing that of Greek antiquity. The Fatimids embroidered on Islamic themes. Equally impressive was the Umayyad court at Córdoba, the wealthiest and showiest city of the West. It boasted seventy public libraries

6 Ibn 'Abd Rabbihi, *Praise Be to Him*, in *A Short Medieval Reader*, pp. 93–98 and in *Reading the Middle Ages*, pp. 179–84.

in addition to the caliph's private library of perhaps 400,000 books. The Córdoban Great Mosque was a center for scholars from the rest of the Islamic world, while nearly thirty free schools were set up throughout the city. The pyxis in Plate 3.6 on p. 101 was made at a Córdoban workshop built and supported by Caliph Abd al-Rahman III.

Córdoba was noteworthy not only because of the brilliance of its intellectual and artistic life but also because of the role women played in it. Elsewhere in the Islamic world there were certainly a few unusual women associated with cultural and scholarly life. But at Córdoba this was a general phenomenon: women were not only doctors, teachers, and librarians but also worked as copyists for the many books widely in demand.

Male scholars were, however, everywhere the norm, moving easily from court to court. Ibn Sina (980–1037), who began his career serving the ruler at Bukhara in Central Asia, is one famous example. In the West, his name was Latinized as Avicenna. From Bukhara he traveled westward to Gurganj, Rayy, and Hamadan before ending up for thirteen years at the court of Isfahan in Iran. Sometimes in favor with regional governors and sometimes decidedly not (he was even briefly imprisoned), he nevertheless managed to study and practice medicine and to write numerous books on the natural sciences and philosophy. His pioneering systematization of Aristotle laid the foundations of future philosophical thought in the field of logic.

Despite its political disunity, then, the Islamic world of the tenth and eleventh centuries remained in many ways an integrated culture. This was partly due to the model of intellectual life fostered by the Abbasids, which even in decline was copied by the new regional rulers. It was also due to the common Arabic language, the glue that bound the astronomer at Córdoba to the merchant at Cairo.

Writing in Arabic, Islamic authors could count on a large reading public. Invented in China, paper was introduced to the Islamic world in the eighth century. Baghdad and Damascus became centers of production, turning rags into sheets that were sold throughout Islamic lands and beyond. Notes such as the letter in Plate 4.3, were written on paper. Finer manuscripts and books were churned out quickly via a well-honed division of labor: scribes, illustrators, page cutters, and binders specialized in each task. Though unknown in Europe and scorned in Byzantium, paper was behind the extraordinary intellectual, fanciful, and practical written outpouring that characterized the medieval Islamic world.

Children were sent to school to learn the Qur'an; listening, reciting, reading, and writing were taught in elementary schools along with good manners and religious obligations. Although a conservative educator like al-Qabisi (d. 1012) warned that "[a girl] being taught letter-writing or poetry is a cause for fear," he also insisted that parents send both boys and girls to school to learn "vocalization, spelling, good handwriting, [and] good reading." He even admitted that learning about "famous men and of chivalrous knights" might be acceptable.[7]

7 Al-Qabisi, *A Treatise Detailing the Circumstances of Students and the Rules Governing Teachers and Students*, in *Reading the Middle Ages*, pp. 211–13.

Educated in similar texts across the whole Islamic world and speaking a common language, Muslims could easily communicate, and this facilitated open networks of trade. With no national barriers to commerce and few regulations, merchants regularly moved from one region to another, dealing in various and sometimes exotic goods. From England came tin and salt; ivory, slaves, and gold arrived from Timbuktu in west-central Africa. Slavic regions and Rus' supplied slaves, gold, amber, and copper. Merchants from Islamic lands set up permanent headquarters in China and South-East Asia to sell flax and linen from Egypt (as we have seen), pearls from the Persian Gulf, and ceramics from Iraq. Much of this trade was financed by enterprising government officials and other elites, whose investments in land at home paid off handsomely.

Ironically, only the religion of Islam pulled Islamic culture apart. In the tenth century the split between the Sunnis and Shi'ites widened as various sects elaborated on the foundations of their divergent beliefs. One example comes from the Buyid period in Baghdad, when the Imami (or Twelver) strand of Shi'ism found an eloquent spokesman in al-Mufid (d. 1022). The use of reason (guided by revelation) in theology and the need for interpretation in jurisprudence were at the core of al-Mufid's teachings. He argued that the imamate (the true successors of Muhammad) resided not in the caliph nor in any political ruler. Rather, it inhered in men of great religious learning, and it would continue to do so until the end of time, when the Mahdi – the Islamic redeemer – would reappear. Imami quietism – its dissociation of Shi'ism from political power – was useful to the Buyids. Ruling a primarily Sunni population in Iraq and bolstered by a mainly Sunni Turkish army, the Buyids allowed the Abbasid caliphs to remain at Baghdad, yet deprived them of a political role.

Much like the Buyids, many of the other new dynasties – the Fatimids and the Qaramita especially – took advantage of the splintering of Islamic beliefs to bolster their power.

THE WEST: FRAGMENTATION AND RESILIENCE

Political fragmentation was equally true in Western Europe. Historians speak of "France," "Germany," and "Italy" in the post-Carolingian period as a shorthand for designating broad geographical areas, and that will be the practice in this book as well. But there were no national states, only various regions with more or less clear borders and rulers with more or less authority. In some places – in parts of "France," for example – regions as small as a few square miles were under the control of different lords who acted, in effect, as independent rulers. Yet this same period saw consolidated European kingdoms beginning to emerge. To the north were England, Scotland, and two relatively unified Scandinavian states – Denmark and Norway. Toward the east were Bohemia, Poland, and Hungary. In the center of Europe, a powerful royal dynasty from Saxony, the Ottonians, came to rule an empire stretching from the North Sea to Rome.

New Peoples Arrive in the West

Three new peoples arrived in Western Europe during the ninth and tenth centuries: the Vikings, the Muslims, and the Magyars (called Hungarians by the rest of Europe). (See Map 4.5.) While in the short run, they wreaked havoc on previous arrangements of land and people, in the long run, they were absorbed into the European population and became constituents of a newly prosperous and aggressive European civilization.

VIKINGS

While some Scandinavians made forays eastward toward Novgorod, others traveled to western shores. A few went to fight for foreign kings and share in the fruits of their victories. Others raided under Viking leaders. Traveling in long, narrow, and shallow ships powered by oars, wind, and sails (see Plate 4.5), they navigated the coasts and rivers of France, England, Scotland, and Ireland, terrorizing not only the inhabitants but also the armies mustered to fight them: "Many a time an army was assembled to oppose them, but as soon as they were to join battle, always for some cause it was agreed to disperse, and always in the end [the Vikings] had the victory," wrote a chronicler in southern England.[8]

Some Vikings crossed the Atlantic, making themselves at home in Iceland or continuing on to Greenland or, in about 1000, reaching the coast of the North American mainland. While the elites came largely for booty, lesser men, eager for land, traveled with their wives and children to settle where the Vikings had a foothold, especially in Ireland, Scotland, and England. In France, they gave their name to the region of Normandy, a word deriving from "Northmen," another term for the Vikings. A small contingent of Vikings settled for a short time far across the Atlantic, at L'Anse aux Meadows. These attempts to find new homes, many of them lasting and successful, led Judith Jesch recently to reconsider the Viking "invasions" as better termed a "diaspora."

In Ireland, where their settlements were in the east and south, the newcomers added their own claims to rule an island already fragmented among several competing dynasties. In Scotland, however, in the face of Norse settlements in the north and west, the natives drew together under kings who allied themselves with churchmen and other powerful local leaders. Cináed mac Ailpín (Kenneth I MacAlpin; d.858) established a hereditary dynasty of kings, and by *c.*900, most people in *Alba*, the nucleus of the future Scotland, shared a common sense of Scottish identity.

England underwent a similar process of unification. Initially divided into small and competing kingdoms, it was weak prey in the face of the Vikings. By the end of the ninth century, the newcomers were plowing fields in northeastern England and living in accordance with their own laws, giving the region the name Danelaw. In Wessex, the southernmost English kingdom, King Alfred the Great (r.871–899) bought time and peace by

8 The *Anglo-Saxon Chronicle*, in *A Short Medieval Reader*, pp. 129–30 and in *Reading the Middle Ages*, pp. 233–34.

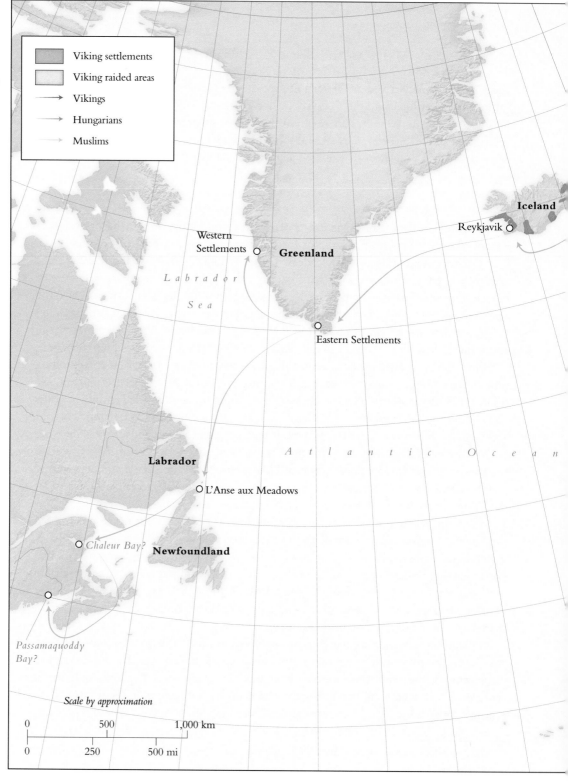

Map 4.5 Vikings, Muslims, and Hungarians on the Move, 9th and 11th cent.

Viking settlements
Viking raided areas
→ Vikings
→ Hungarians
→ Muslims

Iceland

Reykjavik ○

Western Settlements ○ **Greenland**

L a b r a d o r

S e a

○ Eastern Settlements

A t l a n t i c O c e a n

Labrador

○ L'Anse aux Meadows

○ *Chaleur Bay?* **Newfoundland**

○

Passamaquoddy Bay?

Scale by approximation

0 500 1,000 km

0 250 500 mi

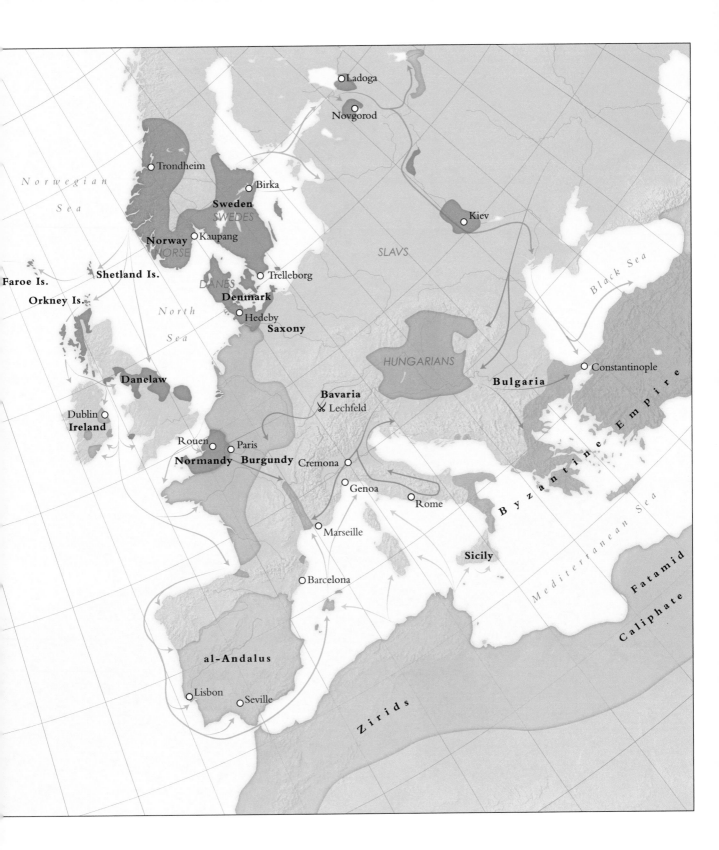

Norwegian Sea

Ladoga

Novgorod

Trondheim

Birka

Sweden
SWEDES

Norway Kaupang
NORSE

Faroe Is.

Shetland Is.

Trelleborg

DANES

Orkney Is.

North Sea

Denmark

Hedeby

Saxony

SLAVS

Kiev

Black Sea

HUNGARIANS

Bulgaria

Constantinople

Danelaw

Dublin
Ireland

Bavaria
⚔ Lechfeld

Rouen Paris

Normandy **Burgundy** Cremona

Genoa

Rome

B y z a n t i n e E m p i r e

Marseille

Mediterranean Sea

Barcelona

Sicily

Fatamid

Caliphate

al-Andalus

Lisbon Seville

Z i r i d s

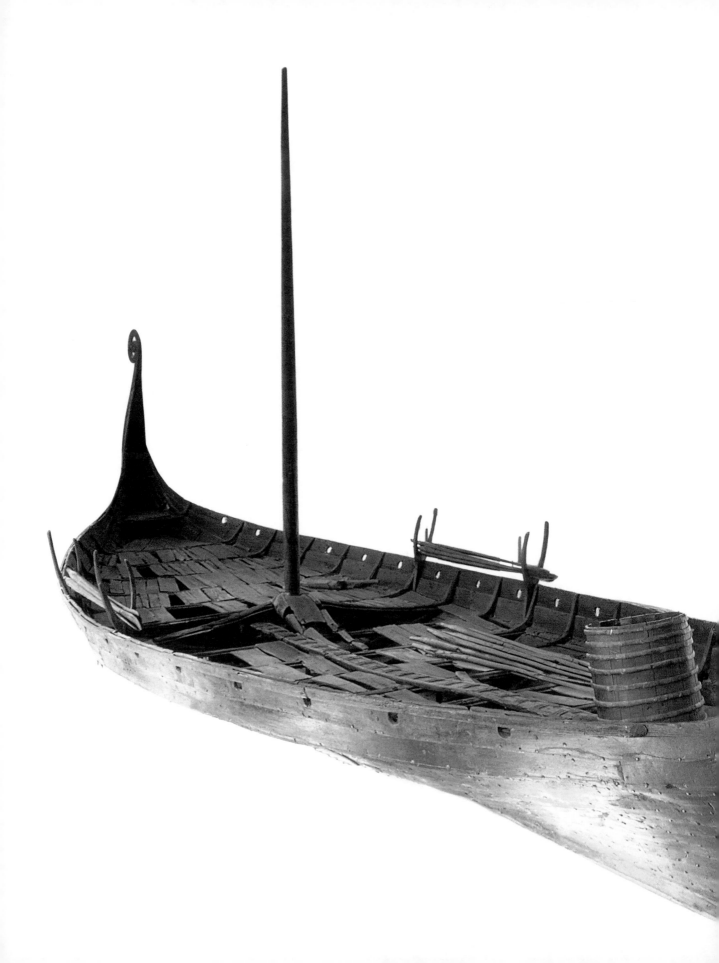

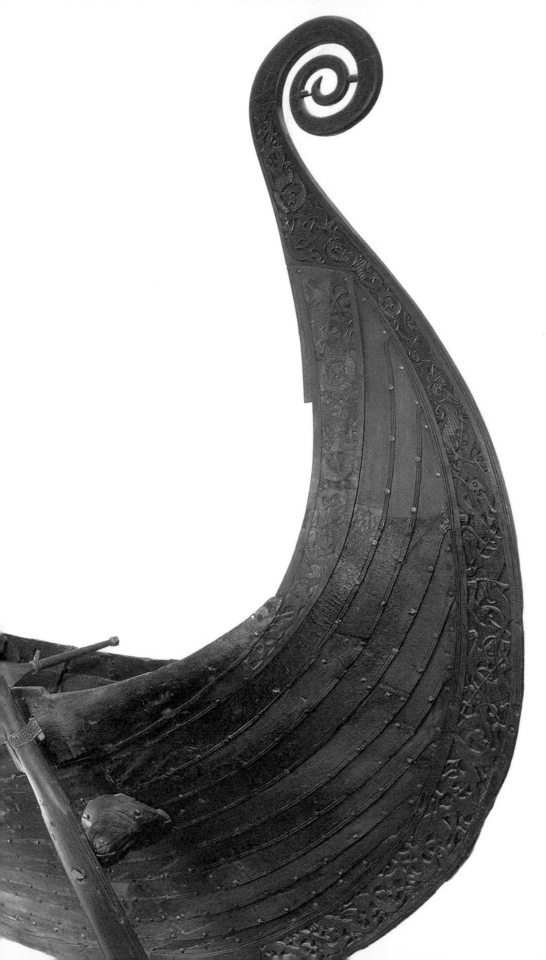

Plate 4.5 Oseberg Ship (834). This large ceremonial ship was found buried in a grave mound near the Oslo fjord in 1904. Within were the skeletons of two women, one more than eighty years old, the other in her early fifties. They were accompanied by high-quality artifacts, delicate foods (such as fruits, berries, and walnuts), and many animals and birds. Wooden carvings, including those of the ship's prow and stern-post, attest to the intricacy and finesse of Viking workmanship, characterized by interlaced animal motifs. Compare the interlace on the prow with that of the Book of Durrow in Plates 2.5, 2.6, and 2.7 (pp. 69–71). What similarities do you see in artistic motifs across the arc formed by Scandinavia and the British Isles?

paying tribute to the invaders with the income from a new tax, later called the Danegeld. (It eventually became the basis of a relatively lucrative taxation system in England.) In 878, inspiring the previously cowed English to follow him, Alfred led a series of raids against the Vikings in his kingdom, eventually camping outside their stronghold until their leader surrendered and accepted baptism.

Thereafter the pressure of invasion eased somewhat as Alfred reorganized his army, set up a network of strongholds (*burhs*), and created a fleet of ships – a real navy. An uneasy stability was achieved, with the Vikings dominating the east of England and Alfred and his successors gaining control over most of the rest.

On the Continent, the invaders were absorbed above all in Normandy, where in 911 their leader Rollo converted to Christianity and received Normandy as a duchy from the Frankish king Charles the Simple. Although many of the Normans adopted sedentary ways, some of their descendants in the early eleventh century ventured to the Mediterranean, where they established themselves as rulers of petty principalities in southern Italy. From there, in 1061, the Normans began the conquest of Sicily.

MUSLIMS

Sicily, once Byzantine, was the rich and fertile plum of the conquests achieved by the Muslim invaders of the ninth and tenth centuries. That they took the island attests to the power of a new Muslim navy developed by the dynasty that preceded the Fatimids in Ifriqiya. Briefly held by the Fatimids, by mid-century Sicily was under the control of independent Islamic princes, and Muslim immigrants were swelling the population.

Elsewhere (apart, of course, from Iberia) the Muslim presence in Western Europe was more ephemeral. In the first half of the tenth century, Muslim raiders pillaged southern France, northern Italy, and the Alpine passes. But these were quick expeditions, largely attacks on churches and monasteries. Some Muslims established themselves at La Garde-Freinet, in Provence, becoming landowners in the region and lords of Christian serfs. They even hired themselves out as occasional fighters for the wars that local Christian aristocrats were waging against one another. But they made the mistake of capturing for ransom the holiest man of his era, Abbot Majolus of Cluny. Outraged, the local aristocracy finally came together and ousted the Muslims from their midst.

MAGYARS (HUNGARIANS)

By contrast, the Magyars remained. "Magyar" was and is their name for themselves, though the rest of Europe called them "Hungarians," from the Slavic "Onoghur," a people already settled in the Carpathian basin in the seventh century. Before moving into the Danube region from the Urals, the Magyars practiced settled farming alongside the animal husbandry that required annual pasturing migrations. Herding cattle, sheep, goats, pigs, and horses, they were organized by clans. Because they were renowned as horsemen and effective warriors – experts at using bows and arrows, sabers, and combat axes – they

were employed in military enterprises by European and Byzantine rulers. Between 885 and 902, the Hungarians, as we may now call them, conquered much of the Carpathian basin for themselves.

From there, for over fifty years, they raided into Germany, Italy, and even southern France. At the same time, however, they worked for various western rulers. Until 937 they spared Bavaria, for example, because they were allies of its duke. Gradually they left off pastoralism in favor of settled farming, and their polity coalesced into the Kingdom of Hungary (see below, p. 156). This is no doubt a major reason for the end of their attacks. Nevertheless, the cessation of their raids was widely credited to the German king Otto I (r.936–973), who won a major victory over a Hungarian army at the battle of Lechfeld in 955.

Public Power and Private Relationships

The invasions left new political arrangements in their wake. Unlike the Byzantines and Muslims, European rulers had no mercenaries and no salaried officials. They commanded others by ensuring personal loyalty. The Carolingian kings had had their *fideles* – their faithful men. Tenth-century rulers relied even more on ties of dependency: they needed their "men" (*homines*), their "vassals" (*vassalli*). Whatever the term, all were armed retainers who fought for a lord. Sometimes these subordinates held land from their lord, either as a reward for their military service or as an inheritance for which services were due. The term for such an estate, fief (*feodum*), gave historians the word "feudalism" to describe the social and economic system created by the relationships among lords, vassals, and fiefs.

During the last half century, however, the term has provoked great controversy. Some historians argue that it has been used in too many different and contradictory ways to mean anything at all. Was it a mode of exploiting the land that involved lords and serfs? A condition of anarchy and lawlessness? Or a political system of ordered gradations of power, from the king on down? Scholars have used all of these definitions. Another area of contention is the date for the emergence of feudal institutions – around the year 1000, as used to be argued? Or in the twelfth century, as more recent historians maintain? In this book the *word* feudalism is generally avoided, but the institutions of personal dependency that historians associate with that term cannot be ignored. As for *when* they took hold, the answer depends on the region – in most of France by the late tenth century, in much of Germany in the twelfth, and in many parts of Italy never.

LORDS AND VASSALS

Personal dependency took many forms. Of the three traditional "orders" recognized by writers in the ninth through eleventh centuries – those who pray (the *oratores*), those who fight (the *bellatores*), and those who work (the *laboratores*) – the top two were free. The pray-ers (the monks) and the fighters (the nobles and their lower-class counterparts, the knights) participated in prestigious kinds of subordination, whether as vassals, lords, or

Plate 4.6 The Maccabean Revolt Depicted (first half of 11th cent.). To illustrate a battle of the Maccabees against the Syrians, the artist drew warriors decked out in wild colors. On the left, the army of Judas (the leader of the Jews) attacks the enemy. Some of the fighters wear chainmail armor; all are protected by helmets, and most hold shields and spears. The artist included stirrups in other battle scenes but forgot to include them here. As for the Syrian army: according to 1 Macc 6:35–37, it used elephants, "and upon the beast there were strong wooden towers ... and upon every one [were] thirty-two valiant men, who fought from above." Never having seen elephants, the artist made them up.

both. Indeed, they were usually both: a typical warrior was lord of several vassals and the vassal of another lord. In Plate 4.6 the artist has depicted the battle of the Jewish Maccabees against Antiochus IV Epiphanes, the Seleucid ruler of Syria who invaded Jerusalem in 167 BCE, by drawing on his imagination, the images of the warriors he found in other books, and his own observations of the knights of his day. The manuscript in which this illustration comes was made in a Catalan monastery, proof (if any were needed) that monasteries participated in the world of the warriors. Monasteries normally had vassals to fight for them, and their abbots in turn served as vassals of a king or other lord. At the low end of the social scale, poor vassals looked to their lords to feed, clothe, house, and arm them. At the upper end, vassals looked to their lords to enrich them with more fiefs.

Some women were vassals, and some were lords (or, rather, "ladies," the female version). Many upper-class laywomen participated in the society of warriors and monks as wives and mothers of vassals and lords and as landowners in their own right. Others entered convents and became *oratores* themselves. Through its abbess or a man standing in for her, a convent was itself often the "lord" of vassals.

Vassalage was considered to be voluntary and public. The personal fidelity that the Carolingian kings required of the Frankish elites became more general, as all lords wanted the same assurance from their retainers. Over time a ceremony of deference came increasingly to mark the occasion: a man (a vassal-to-be) knelt and placed his hands together (in a position we associate with prayer) within the hands of another (his lord-to-be) who stood: this was the act of homage. The kneeling man said, "I promise to be your man." He then rose and promised "fealty" – fidelity, trust, and service – which he swore with his hand on relics or a Bible. Then the vassal and the lord kissed. In an age when many people could not read, a public moment such as this represented a visual and verbal contract, binding the vassal and lord together with mutual obligations to help each other. On the other hand, these obligations were rarely spelled out, and a lord with many vassals, or a vassal with many lords, needed to satisfy numerous conflicting claims. "I am a loser only because

of my loyalty to you," Hugh of Lusignan complained to his lord, William of Aquitaine, after his expectations for reward were continually disappointed.[9]

LORDS AND PEASANTS

At the lowest end of the social scale were those who worked: the peasants. In many regions of Europe, as power fell into the hands of local rulers, the distinction between "free" and "unfree" peasants began to blur; many peasants simply became "serfs," dependents of lords. This was a heavy dependency, without prestige or honor. It was hereditary rather than voluntary: no serf did homage or fealty to his lord; no serf and lord kissed each other.

Indeed, the upper classes barely noticed the peasants – except as sources of labor and revenue. In the tenth century, the three-field system became more prevalent, and the heavy moldboard plows that could turn wet, clayey northern soils came into wider use. Such plows could not work around fences, and they were hard to turn. They produced the characteristic "look" of medieval agriculture – long, furrowed strips in broad, open fields. Peasants knew very well which strips were "theirs" and which belonged to their neighbors. A team of oxen was normally used to pull the plow (see Plate 4.7), but horses (more efficient than oxen) were sometimes substituted. The result was surplus food and a better standard of living for nearly everyone.

In search of still greater profits, some lords lightened the dues and services of peasants temporarily to allow them to open up new lands by draining marshes and cutting down forests. Other lords converted dues and labor services into money payments to provide themselves with ready cash. Peasants, too, benefited from paying fixed rents immune to

Plate 4.7 Peasants Plowing and Sowing (2nd quarter of 11th cent.). To decorate a calendar page for the month of January, an artist in England chose to show peasants plowing and sowing seed for the spring crop. The peasants in this picture are very prosperous, for they have the most up-to-date and well-equipped plow: not only is it pulled by four oxen, relieving the burden on the driver, but it also has wheels, a coulter (behind the wheel) to dig into the earth, and a moldboard to turn and aerate the soil.

9 *Agreement between Count William of the Aquitainians and Hugh IV of Lusignan*, in *A Short Medieval Reader*, pp. 106–11 and in *Reading the Middle Ages*, pp. 190–95.

inflation. As the prices of agricultural products went up, peasants became small-scale entre-preneurs, selling their chickens and eggs at local markets and reaping a profit.

In the eleventh century, and increasingly so in the twelfth, peasant settlements gained boundaries and focus, becoming real villages. The nucleus might be a lord's castle – not a luxurious chateau but rather a defensive earthwork-and-timber structure. And/or it would be a church with its declared "protected zone," including a cemetery, many houses of the living, and the barns, animals, and tools belonging to them. Boundary markers – some-times simple stones, at other times real fortifications – announced not only the physical limits of the village but also its identity as a community. Villagers depended on each other: peasants had to share oxen or horses to pull their plows and they needed craftspeople to fix their plow wheels and shoe their draft animals.

Variety was the hallmark of peasant society. In Saxony and other parts of Germany, free peasants prevailed. In France and England, most were serfs. In Italy, peasants ranged from small independent landowners to leaseholders; most were both, owning a parcel in one place and renting or leasing another nearby.

Where the power of kings was weak, peasant obligations became part of systems of local rule. As landlords consolidated their power over their manors, they collected not only dues and services but also fees for the use of their flour mills, bake houses, and brew-eries. In some regions – parts of France and in Catalonia, for example – lords often built castles and exercised the power of the "ban": the right to collect taxes, hear court cases, levy fines, and muster men for defense. These lords were "castellans."

WARRIORS AND BISHOPS

Although the developments described here did not occur everywhere simultaneously (and in some places hardly at all), in the end the social, political, and cultural life of the West came to be dominated by landowners who styled themselves both military men (and on occasion women) and regional leaders. The men and their armed retainers shared a common lifestyle, living together, eating in the lord's great hall, listening to bards sing of military exploits, hunting for recreation, competing with one another in military games. They fought in groups as well – as cavalry. In the month of May, when the grasses were high enough for their horses to forage, the war season began. To be sure, there were powerful vassals who lived on their own fiefs and hardly ever saw their lord – except for perhaps forty days out of the year, when they owed him military service. But they themselves were lords of knightly vassals who were not married and who lived and ate and hunted with them.

The marriage bed, so important to the medieval aristocracy from the start, now took on new meaning. In the seventh and eighth centuries, aristocratic families had thought of themselves as large and loosely organized kin groups. They were not tied to any particular estate, for they had numerous properties, scattered all about. With wealth enough to go around, the rich practiced partible inheritance, giving land (though not in equal amounts) to all of their sons and daughters. The Carolingians "politicized" these family relations. As some men were elevated to positions of dazzling power, they took the opportunity to pick

and choose their "family members," narrowing the family circle. They also became more conscious of their male line, favoring sons over daughters. In the eleventh century, family definitions tightened even further. The claims of one son, often the eldest, overrode all else; to him went the family inheritance. (This is called "primogeniture"; but there were regions in which the youngest son was privileged, and there were also areas in which more equitable inheritance practices continued in place.) The heir in the new system traced his lineage only through the male line, backward through his father and forward through his own eldest son.

What happened to the other sons? Some of them became knights, others monks. Nor should we forget that many became bishops. In many ways, the interests of bishops and lay nobles were similar: bishops were men of property, lords of vassals, and faithful to patrons, such as kings, who often were the ones to appoint them to their posts. In some places, bishops wielded the powers of a count or duke. Some bishops ruled cities. Nevertheless, bishops were also "pastors," spiritual leaders charged with shepherding their flock, which included the laity, priests, and monks in their diocese (a district that gained clear definition in the eleventh century).

As episcopal power expanded and was clarified in the course of the tenth and eleventh centuries, some bishops in southern France, joined by the upper crust of the aristocracy, sought to control the behavior of the lesser knights through a movement called the "Peace of God." They were not satisfied with the current practices of peace-making, in which enemies, pressured by their peers, negotiated an end to – or at least a cessation of – hostilities. (Behind the negotiation was the threat of an ordeal – for instance a trial by battle whose outcome was in the hands of God – if the two sides did not come to terms.)

The Peace movement began in 989 and grew apace, its forum the regional Church council, where bishops galvanized popular opinion, attracting both grand aristocrats and peasants to their gatherings. There, drawing upon bits and pieces of defunct Carolingian legislation, the bishops declared the Peace, and knights took oaths to observe it. At Bourges a particularly enthusiastic archbishop took the oath of the Peace of God himself: "I Aimon ... will wholeheartedly attack those who steal ecclesiastical property, those who provoke pillage, those who oppress monks, nuns, and clerics."[10] In the Truce of God, which by the 1040s was declared alongside the Peace, warfare between armed men was prohibited from Lent to Easter, while at other times of the year it was forbidden on Sunday (because that was the Lord's Day), on Saturday (because that was a reminder of Holy Saturday), on Friday (because it symbolized Good Friday), and on Thursday (because it stood for Holy Thursday).

To the bishops who promulgated the Peace and Truce of God, warriors fell conceptually into two groups: the sinful ones who broke the Peace, and the righteous ones who upheld Church law. Although the Peace and Truce were taken up by powerful lay rulers, eager to sanctify their own warfare and control that of others, the major initiative for the movement came from churchmen eager to draw clear boundaries between the realms of the sacred and the profane.

10 See Andrew of Fleury, *Miracles of Saint Benedict*, in *A Short Medieval Reader*, pp. 111–13 and in *Reading the Middle Ages*, pp. 196–98.

Map 4.6 (facing page) Europe, *c.* 1050

CITIES AND MERCHANTS

Such clerics were, in part, reacting to new developments in the secular realm: the growing importance of urban institutions and professions. Though much of Europe was rural, there were important exceptions. Italy was one place where urban life, though dramatically reduced in size and population, persisted. Italian power structures still reflected, if feebly, the political organization of ancient Rome. Whereas in northern France great lords built their castles in the countryside, in Italy they often constructed their family seats within the walls of cities still standing since Roman days. From these perches the nobles, both lay and religious, dominated the *contado*, the rural area around the city.

In Italy, most peasants were renters or lease holders, paying cash to urban landowners. Peasants depended on city markets to sell their surplus goods; their customers included bishops, nobles, and middle-class shopkeepers, artisans, and merchants. At Milan, some merchants were prosperous enough to own houses in both the city center and the *contado*.

Rome, although exceptional in size, was in some ways a typical Italian city. Powerful families built their castles within its walls and controlled the churches and monasteries in the vicinity. The population depended on local producers for their food, and merchants brought their wares to sell within its walls. Yet Rome was special apart from its size: it was the "see" – the seat – of the pope, the most important bishop in the West. In the tenth and early eleventh centuries, the papacy did not control the Church, but it had great prestige, and powerful families at Rome fought to place their sons at its head.

Outside Italy cities were less prevalent. Yet even so we can see the rise of a new mercantile class. This was true less in the heartland of the old Carolingian Empire than on its fringes. In the north, England, north Germany, Denmark, and the Low Countries bathed in a sea of silver coins; commercial centers such as Haithabu reached their grandest extent in the mid-tenth century. Here merchants bought and sold slaves, honey, furs, wax, and pirates' plunder. Haithabu was a city of wood, but a very rich one indeed.

In the south of Europe, beyond the Pyrenees, Catalonia was equally commercialized, but in a different way. It imitated the Islamic world of al-Andalus (which was, in effect, in its backyard). The counts of Barcelona minted gold coins just like those at Córdoba. The villagers around Barcelona soon got used to selling their wares for money, and some of them became prosperous. They married into the aristocracy, moved to Barcelona to become city leaders, and lent money to ransom prisoners of the many wars waged to their south.

Western Kingship in an Age of Fragmentation

In such a world, what did kings do? At the least, they stood for tradition, serving as symbols of legitimacy. At the most, they united kingdoms and maintained a measure of law and order. (See Map 4.6.)

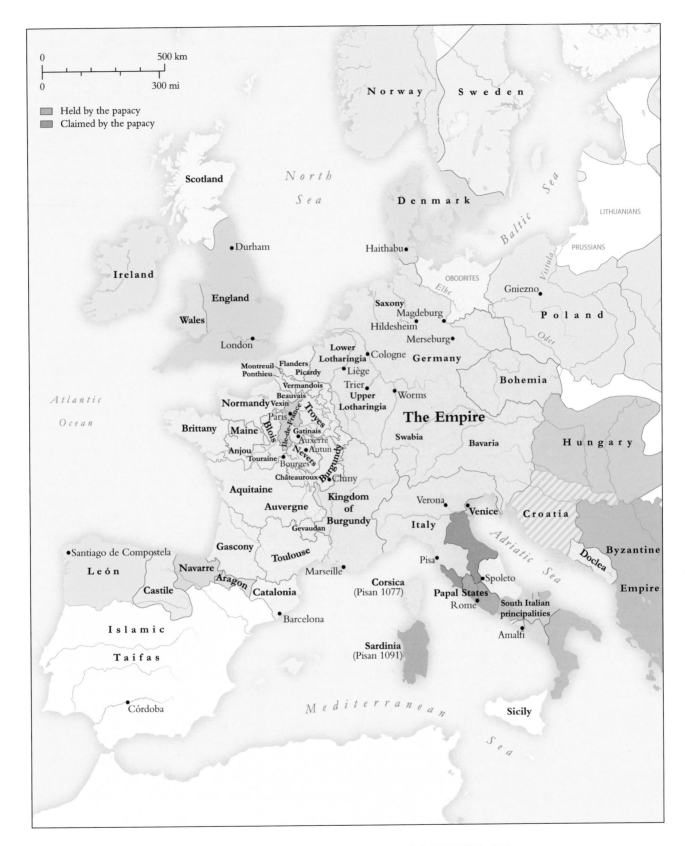

Alfred
king (871–899)
= Ealhswith (of Mercia)

Æthelflæd =
Æthelred II of Mercia

Edward the Elder
king (899–924)

Æthelstan
king (924–939)

Ælfweard
king (924)

Edmund
king (939–946)

Eadred
king (946–955)

Eadgifu
= Charles the
Simple

Edith
= Otto I
of Germany

Eadhild
= Hugh the
Great

Eadwig
king (955–959)

Edgar
king (959–975)

Edward
king (975–978)

Æthelred II
king (978–1016)
= Ælfgifu
= Emma (daughter of Richard I, duke of Normandy)

Edmund
king (1016)

Genealogy 4.1 Alfred and His Progeny

ENGLAND

King Alfred of England was a king of the second sort. In the face of the Viking invasions, he developed new mechanisms of royal government, creating institutions that became the foundation of English royal power. We have already seen his military reforms: a system of *burhs* and the creation of a navy. Alfred was interested in religious and intellectual reforms as well, for defense and education were closely linked in his mind. The causes of England's troubles (in his view) were the sins of its people, brought on by their ignorance. Alfred intended to educate "all free-born men." He brought scholars to his court and embarked on an ambitious program to translate key religious works from Latin into Old English, the vernacular. This was the spoken language of the people, but it also served some literary and administrative needs, and Alfred determined to increase its use. While England was not alone in its esteem of the vernacular – in Ireland, too, the vernacular language was more than oral – the British Isles *were* unusual by the standards of Continental Europe, where people spoke in the vernacular but wrote almost everything in Latin.

As Alfred harried the Danes who were pushing south and westward, he gained recognition as king of all the English not under Viking rule. His law code, issued in the late 880s or early 890s, was the first by an English king in about two centuries. Unlike earlier codes, which had been drawn up for each separate kingdom, Alfred's contained laws from and for all the English kingdoms in common. The king's inspiration was the Mosaic law of the Bible. He believed that God had made a new covenant with the victors over the

Vikings; as leader of his people, Alfred, like the Old Testament patriarch Moses, handed down a law for all.

His successors, beneficiaries of that covenant, rolled back the Viking rule in England. (See Genealogy 4.1.) Many Vikings fled back to Scandinavia, but others remained. Converted to Christianity, their great men joined the English to attend the king at court. The whole kingdom was divided into districts called "shires" and "hundreds," and in each shire, the king's reeve – the sheriff – oversaw royal administration.

Alfred's grandson Æthelstan (r.924–939) took advantage of all the institutions that early medieval kingship offered. The first king to unite all the English kingdoms, he was crowned in a new ritual created by the archbishop of Canterbury to emphasize harmony and unity. When Æthelstan toured his realm (as he did constantly), he was accompanied by a varied and impressive retinue: bishops, nobles, thegns (the English equivalent of high-status vassals), scholars, foreign dignitaries, and servants. Well known as an effective military leader who extended his realm northwards, he received oaths of loyalty from the rulers of other parts of Britain. Churchmen attended him at court, and he in turn chose bishops and other churchmen. Like Alfred, he issued laws and expected local authorities – the ealdormen and sheriffs – to carry them out.[11]

From the point of view of control, however, Æthelstan had nowhere near the power over England that, say, Basil II had over Byzantium at about the same time. The *dynatoi* might sometimes chafe at the emperor's directives and rebel, but the emperor had his Varangian Guard to put them down and an experienced, professional civil service to do his bidding. The king of England depended less on force and bureaucracy than on consensus. The great landowners supported the king because they found it to be in their interest. When they ceased to do so, the kingdom easily fragmented, becoming prey to civil war. Disunity was exacerbated by new attacks from the Vikings. One Danish king, Cnut (or Canute), even became king of England for a time (r.1016–1035). Yet under Cnut, English kingship did not change much. He kept intact much of the administrative, ecclesiastical, and military apparatus already established. By Cnut's time, much of Scandinavia had been Christianized, and its traditions had largely merged with those of the rest of Europe.

SCANDINAVIA

Two European-style kingdoms – Denmark and Norway – developed in Scandinavia around the year 1000, and Sweden followed a bit later. In effect, the Vikings took home with them not only Europe's plundered wealth but also its prestigious religion, with all its

11 Both ealdormen and sheriffs (shire reeves) were powerful men, and sometimes their functions were the same. Originally the ealdorman was the equivalent of a count or duke who ruled a large region independently of any king. That changed with Alfred and his successors, and by the tenth century the term referred to a local ruler, generally of a shire, who, while certainly a nobleman, acted (or was expected to act) as an agent of the king. Reeves were of more variable status: they were administrators, whether for kings, bishops, towns, or estates. Royal sheriffs were responsible for (among other things) ensuring the peace and meetings of the local court.

implications for royal power and state-building. The impetus for conversion in Scandinavia came from two directions. From the south, missionaries such as the Frankish monk Ansgar (d.865) came to preach Christianity, seconded by German bishops, who imposed what claims they could make. Within Scandinavia itself, kings found it worth their while to ally with these Christian representatives to enhance their own position.

When Danish King Harald Bluetooth (r.*c*.958–*c*.986), converted, he announced it with a meaningful ritual. Before converting to Christianity, he had buried his father in a mound – prestigious precisely for its *non*-Christian, pagan connotations. When he became Christian, he added a giant runestone to the mound and moved the body of his father into a new church he built for the occasion. The runestone included an image of Christ and announced in runes (letters that had magical connotations) that Harald had "won for himself all of Denmark and Norway and made the Danes Christian."[12] Thus Harald graphically turned a pagan site into a Christian one and, at the same time, announced that he was the ruler of a state that extended into what is today southern Sweden and parts of Norway. (His successors turned their sights further outward, culminating in the conquest of England and Norway, but that grand empire ended with the death of Cnut in 1035.)

The processes of conversion and kingly rule in Norway are less easily traceable than in Denmark because there are fewer sources from the time. It is clear, however, that after King Olav Haraldsson (r.1015–1030) was baptized, he helped organize the Norwegian Church, was active in legislating Christian holidays and banning pagan cults, sent churchmen to evangelize Sweden, and managed through war and alliance to rule most of Norway. After his death he was recognized as a saint, another unifying rallying point. Building on those successes, Olav's son Magnus the Good and then his half-brother, Harald Hardrada (r.1046–1066), established a stable dynasty that lasted for four generations.

The story of Sweden suffers even more fully from lack of written sources, but the archaeological remains are rich – Birka (see above, p. 125) is one good example. As was true at Birka, local settlements were often under the control of kings. Conversion to Christianity, initiated by missionaries from England and Germany in the ninth century, did not have much impact until the eleventh. While to some degree connected to the conversion of kings, Swedish Christianization was a slow and often voluntary process on the ground – quite literally "on the ground" because it is best traced through runestones erected by free commoners over burials and other important sites. Gradually these came to express adherence to the new faith. Even the eventual unification of Sweden in the mid-thirteenth century, Philip Line suggests, may have taken place less because a strong ruler at the top imposed his will than because the free elites agreed that it was in their best interests to form a confederation.

12 For an image and further discussion of this runestone, see *The Jelling Monument*, "Reading through Looking," in *Reading the Middle Ages*, p. IV.

Genealogy 4.2 The Ottonians

GERMANY

Unlike the kings of Sweden, the kings of "Germany" – the former East Frankish Kingdom – were powerful. It is true that as Carolingian power declined, Germany seemed ready to disintegrate into five duchies, each held by a military leader who exercised quasi-royal power. But, in the face of their own quarrels and the threats of outside invaders, the dukes needed and wanted a strong king. With the death in 911 of East Frankish King Louis the Child, they crowned one of themselves. Then, as attacks by the Hungarians increased, the dukes gave the royal title to their most powerful member, the duke of Saxony, Henry I (r.919–936), who proceeded to set up fortifications and reorganize his army, crowning his efforts with a major defeat of the Hungarians in 933.

Soon after coming to the throne, Henry's son Otto I (r.936–973) defeated all rivals as well as invading Slavic and Hungarian armies. Through astute marriage alliances and political appointments, he was able to get his family members to head up each of the duchies. In 951, he marched into Italy and took the Lombard crown. That gave Otto control, at least theoretically, of much of northern Italy. His victory at Lechfeld in 955 ended the Hungarian threat, and in the same year, he defeated a Slavic group, the Obodrites, who inhabited the territory between the Elbe and the Oder Rivers. (See Map 4.6.) Conquests such as these brought tribute, plum positions to disburse, and lands to give away, ensuring Otto a following among the great men of the realm. Little wonder that in 962 he received

the imperial crown from the pope at Rome, an act that recognized his far-flung power and burnished his image as a new Charlemagne.

Otto I's successors, Otto II (r.961–983), Otto III (r.983–1002) – hence the dynastic name "Ottonians" – and Henry II (r.1002–1024), built on his achievements. (See Genealogy 4.2 on p. 151.) Granted power by the magnates, they gave back in turn, distributing land and appointing their own supporters to duchies, counties, and bishoprics. But the power of these princes was tempered by hereditary claims and plenty of lobbying by influential men at court and at the great assemblies that met with the king to hammer out policies. The role of kings in filling bishoprics and archbishoprics was particularly important to them because, unlike counties and duchies, those positions could not be inherited. Otto I created a ribbon of new bishoprics along his eastern border, endowed them with extensive lands, and subjected the local peasantry to episcopal overlordship. Throughout Germany bishops had the right to collect revenues and call men to arms.

In fact, bishops and archbishops constituted the backbone of Ottonian rule. Once he had chosen the bishop (usually with the consent of the clergy of the cathedral over which the bishop was to preside), the king received a gift – a token of episcopal support – in return. Then the king "invested" the new prelate in his post by participating in the ceremony that installed him into office. (See Plate 5.6 on p. 183.) Archbishop Bruno of Cologne is a good – if extreme – example of the symbiotic relations between Church and State in the German realm. An ally of the king (as were almost all the bishops), he was also Otto I's brother. Right after he was invested as archbishop in 953, he was appointed by Otto to be duke of Lotharingia and to put down a local rebellion. Later Bruno's biographer, Ruotger, strove mightily to justify Bruno's role as a warrior-bishop:

> Some people ignorant of divine will may object: why did a bishop assume public office and the dangers of war when he had undertaken only the care of souls? If they understand any sane matter, the result itself will easily satisfy them, when they see a great and very unaccustomed (especially in their homelands) gift of peace spread far and wide through this guardian and teacher of a faithful people.... Nor was governing this world new or unusual for rectors of the holy Church, previous examples of which, if someone needs them, are at hand.[13]

Ruotger was right: there *were* other examples near at hand, for the German kings found their most loyal warriors and administrators among their bishops. Consider, as another example, the bishop of Liège; he held the rights and exercised the duties of several counts, had his own mints, and hunted and fished in a grand private forest granted to him in 1006.

Bruno was not only duke of Lotharingia, pastor of his flock at Cologne, and head (as archbishop of Cologne) of the bishops of his duchy. He was also a serious scholar. "There was nearly no type of liberal study in Greek or Latin," wrote the admiring Ruotger, "that escaped the vitality of his genius." Bruno's interest in learning was part of a larger

13 Ruotger, *Life of Bruno*, Archbishop of Cologne, in *Reading the Middle Ages*, pp. 224–28.

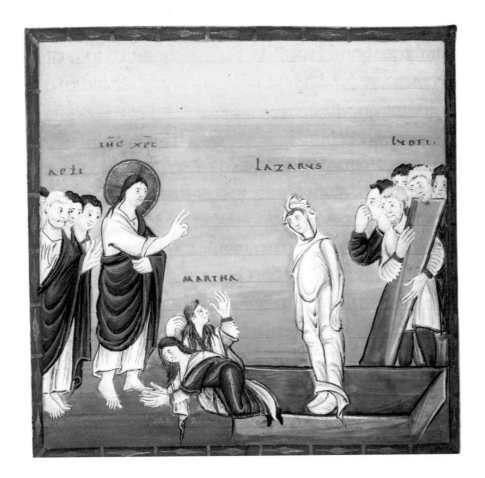

Plate 4.8 The Raising of Lazarus, Egbert Codex (985–990). This miniature is one of fifty-one illustrations in a Pericopes, a book of readings arranged for the liturgical year. The story of the Raising of Lazarus, which is recounted in John 11:1–45, is read in church during the week before Easter. Of the many elements of this story, the artist chose one important moment, arranging it into a unified scene that made room for abstract design (look at the sky, composed of broad stripes of rosy hues) alongside classically inspired figures suggesting volume and weight, reacting and interacting with no care for the viewer. Only the labels are jarringly didactic, teaching a moral lesson.

movement. With wealth coming in from their eastern tributaries, Italy, and the silver mines of Saxony (discovered in the time of Otto I), the Ottonians presided over a brilliant intellectual and artistic efflorescence. As in the Islamic world, much of this was dispersed; in Germany, the centers of culture included the royal court, the great cathedral schools, and women's convents.

The most talented young men crowded the schools at the cathedrals of Trier, Cologne, Magdeburg, Worms, and Hildesheim. Honing their Latin, they studied classical authors such as Cicero and Horace as well as Scripture, while their episcopal teachers wrote histories, saints' lives, and works on canon law. One such was the *Decretum* (1008/1012) by Burchard, bishop of Worms. This widely influential collection – much like the compilations of *hadith* produced about a century before in the Islamic world – winnowed out the least authoritative canons and systematized the contradictory ones. It also focused on sins, prescribing penances for immoral acts and putting particular emphasis on newly precise sexual sins, which were becoming preoccupations of the clergy as they dealt with new calls for their own chastity. Thus, Burchard wanted confessors to ask laymen:

Have you committed fornication, as sodomites do, that is in a man's behind and inserted the [male] member into the rear, and in such way mate in the manner of a

sodomite? If you have a wife and have done it once or twice, you should do penance for ten years, one of them on bread and water. Yet if you have [done it] habitually, you should do penance for twelve years. If, however, you have committed the same carnal crime with your brother, you should do penance for fifteen years.[14]

Even seemingly innocuous practices, such as married couples having sex on a Sunday had to be atoned for by days of penance.

The men at the cathedral schools were largely in training to become courtiers, administrators, and bishops themselves. Churchmen such as Egbert, archbishop of Trier (r.977–993), appreciated art as well as scholarship. Plate 4.8 on p. 153, an illustration of the Raising of Lazarus from the Egbert Codex (named for its patron), is a good example of what is called the "Ottonian style." Utterly unafraid of open space, which was rendered in other-worldly pastel colors, painters focused on the figures, who gestured like actors on a stage. In Plate 4.8 the apostles are on the left-hand side, their arms raised and hands wide open with wonder at Christ. He has just raised the dead Lazarus from the tomb, and one of the Jews, on the right, holds his nose. Two women – Mary and Martha, the sisters of Lazarus – fall at Christ's feet, completing the dramatic tableau.

Other patrons of the arts were Ottonian noblewomen, who lived in convents that provided them with comfortable private apartments. They wrote books and supported other scholars and artists. Equally active patrons of the arts were the Ottonian kings themselves, who were well aware of the propaganda value of pictures.

FRANCE

By contrast with the English and German kings, those in France had a hard time coping with invasions. Unlike Alfred's dynasty, which started small and built slowly, the French kings had half an empire to defend. Unlike the Ottonians, who asserted their military prowess in decisive battles such as the one at Lechfeld, the French kings generally had to let local men both take the brunt of the attacks and reap the prestige and authority that came with military leadership. Nor did the French kings have the advantage of Germany's silver mines, Italian connections, or money that came in from tribute. Much like the Abbasid caliphs at Baghdad, the kings of France saw their power wane. During most of the tenth century, Carolingian kings alternated on the throne with kings from a family that would later be called the "Capetians." At the end of that century the most powerful men of the realm, seeking to stave off civil war, elected Hugh Capet (r.987–996) as their king. The Carolingians were displaced, and the Capetians continued on the throne until the fourteenth century. (See Genealogy 5.5 on p. 196.)

The Capetians's scattered but substantial estates lay in the north of France, in the region around Paris. Here the kings had their vassals and their castles. This "Ile-de-France" (which was all there was to "France" in the period; see Map 4.6 on p. 147) was indeed an

14 Burchard of Worms, *Decretum*, in *A Short Medieval Reader*, pp. 104–6.

"island" – an île – surrounded by independent castellans. In the sense that he, too, had little more military power than other castellans, Hugh Capet and his eleventh-century successors were similar to local strongmen. But the Capetian kings had the prestige of their office. Anointed with holy oil, they represented the idea of unity and God-given rule inherited from Charlemagne. Most of the counts and dukes – at least those in the north of France – swore homage and fealty to the king, a gesture, however weak, of personal support. Unlike the German kings, the French could rely on vassalage to bind the great men of the realm to them.

New States in East Central Europe

Around the same time as Moravia and Bulgaria lost their independence to the Magyars and the Byzantines (respectively), three new polities – Bohemia, Poland, and Hungary – emerged in East Central Europe. In many ways, they formed an interconnected bloc as their ruling houses intermarried with one another and with the great families of Germany, the power that loomed to their west. Bohemia and Poland both were largely Slavic-speaking; linguistically, Hungary was the odd man out, but in almost every other way it was typical of the fledgling states in the region.

BOHEMIA AND POLAND

While the five German duchies were subsumed by the Ottonian state, Bohemia in effect became a separate duchy of the Ottonian Empire. (See Map 4.6.) Already Christianized, largely under the aegis of German bishops, Bohemia was unified in the course of the tenth century. (One of its early rulers was Wenceslas – the Christmas carol's "Good King Wenceslas" – who was to become a national saint after his assassination.) Its princes were supposed to be vassals of the emperor in Germany. Thus, when Bohemian Duke Bretislav I (d.1055) tried in 1038 to expand into what was by then Poland, laying waste the land all the way to Gniezno and kidnapping the body of the revered Saint Adalbert, Emperor Henry III (d.1056) declared war, forcing Bretislav to give up the captured territory and hostages. Although left to its own affairs internally, Bohemia was thereafter semi-depen-dent on the Empire.

What was this "Poland" of such interest to Bretislav and Henry? Like the Dane Harald Bluetooth, and around the same time, Mieszko I (r.c.960–992), the ruler of the region that would become Poland, became Christian. In 990/991, he put his realm under the protec-tion of the pope, tying it closely to the power of Saint Peter. Mieszko built a network of fortifications, subjected the surrounding countryside to his rule, and expanded his realm in all directions. Mieszko's son Boleslaw the Brave (or, in Polish, Chrobry; r.992–1025) continued that policy, for a short time even becoming duke of Bohemia. Above all, Boleslaw made the Christian religion a centerpiece of his rule. At his initiative Gniezno was declared an archbishopric in 1000 and Boleslaw declared his alliance with Christ by

issuing a coin: on one side he portrayed himself as a sort of Roman emperor, while on the other he displayed a cross.[15] Soon the Polish rulers could count on a string of bishoprics – and the bishops who presided in them. A dynastic crisis in the 1030s gave the Bohemian Bretislav his opening, but, as we have seen, that was quickly ended by the German emperor. Poland persisted, although somewhat reduced in size.

HUNGARY

Polytheists at the time of their entry into the West, most Magyars were peasants, initially specializing in herding (as we have seen, above pp. 140–41) but soon busy cultivating vineyards, orchards, and grains. Above them was a warrior class, and above the warriors were the elites, whose richly furnished graves reveal the importance of belts, weapons, and horses to this society. Originally led by chieftains, by the mid-tenth century the Hungarians recognized one ruling house – that of Prince Géza (r.972–997).

Like the ambitious kings of Scandinavia, Géza was determined to give his power new ballast via baptism. His son, Stephen I (r.997–1038), consolidated the change to Christianity: he built churches and monasteries, and required everyone to attend church on Sundays. Establishing his authority as sole ruler, Stephen had himself crowned king in the year 1000 (or possibly 1001). Around the same time, he issued a code of law that brought his kingdom into step with other European powers.[16]

★ ★ ★ ★ ★

Political fragmentation did not mean chaos. It simply betokened a new order. At Byzantium, in any event, even the most centrifugal forces were focused on the center; the real trouble for Basil II, for example, came from *dynatoi* who wanted to be emperors, not from people who wanted to be independent regional rulers. In the Islamic world, fragmentation largely meant replication, as courts patterned on or competitive with the Abbasid model were set up by Fatimid caliphs and other rulers. In Western Europe, the rise of local rulers was accompanied by the widespread adoption of forms of personal dependency – vassalage, serfdom – that could be (and were) manipulated even by kings, such as the Capetians, who seemed to have lost the most from the dispersal of power. Another institution that kings could count on was the Church. No wonder that in Rus', Scandinavia, and East Central Europe, state formation and Christianization went hand in hand. The *real* fragmentation of the period *c.*900–*c.*1050 was among the former heirs of the Roman Empire. They did not speak the same languages, they were increasingly estranged by their religions, and they knew almost nothing about one another. In the next centuries, the gaps would only widen.

15 For an image of this coin, see *A Short Medieval Reader*, p. 123 and Plate 2, "Reading through Looking," in *Reading the Middle Ages*, p. III.
16 King Stephen, *Laws*, in *Reading the Middle Ages*, p. 214.

MATERIAL CULTURE: CLOTH AND CLOTHING

In the Middle Ages, as today, cloth was used for more than clothing. Tapestries and other elaborate fabrics covered the walls of churches and palaces; cloth coats adorned horses and flew as military banners; bits of fine brocade wrapped relics before they were inserted into reliquaries. Less luxurious uses, but no less necessary, included the leather thongs that held together the metal in suits of armor and the shrouds in which the dead were wrapped. Even as clothing, textiles served more than the practical goals of protecting people from cold and rain. They vividly, sometimes ostentatiously, displayed (as they do today) gender, rank, and lines of work – or lives of pure leisure.

What was, however, utterly unlike the textiles of today's industrialized world was the extraordinary time and labor that was required to grow and gather raw materials, spin them into thread, weave them into cloth, and finally cut and sew the fabric into even the humblest cap, let alone the most fabulous garb of the wealthy.

Apart from the labor of growing and reaping, which was done mainly by men, most of the work involved in textile production was the preserve of women, many of them serfs. Only toward the end of the Middle Ages, when large horizontal looms were set up in workshops – the medieval version of mass production – did men become laborers in the textile industry.

Plants and animals formed the raw materials for clothing: linen (from flax) and cotton from plants, wool and fur from animals, and silk from the cocoons of silk worms. Short, rough wool as well as fur and flax were plentiful in the north; cotton, fine long-haired wool, and silk were available in Mediterranean regions. Long-distance

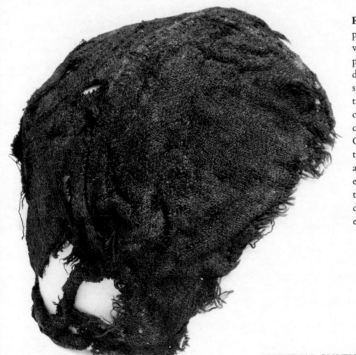

Plate 4.9 Woman's Woolen Cap (468–651). This cap, seemingly so plain, was once an attractive headdress worn by a relatively well-off woman living along the northern coast of the Netherlands. To produce it, raw wool had first to be turned into thread using a distaff (a stick on which the cleaned wool was tied) and a hand spindle (a thin rod fixed with a whorl onto which the fibers were twirled and twisted together). The resulting yarn was then woven on a loom, probably (at this early period) an upright one. In the case of this cap, the weave features a repeated diamond pattern. Once woven, the fabric was dyed brown-black and cut into three pieces, one large main panel and two side panels that, when attached, were designed to flip out to form a "Dutch cap." Using embroidery and other threads of a natural color – to contrast with the dark brown of the cap – the maker employed a variety of decorative stitches to hem the edges and join the side lengths to each other and to the main panel.

Plate 4.10 Guillaume de Machaut, *Le Remède de Fortune* (*c*.1350–1355). At the far left is the lover, accompanied by a bearded companion. He wears a cape decorated at the edges, a patterned tunic padded at the shoulders to emphasize his slender waist, tight-fitting set-in sleeves, skin-tight breeches, and long-pointed shoes. His lady, attended by her maids, is equally fashionably dressed in a gown with close-fitting sleeves and bodice, which is decorated with buttons. She points at her lover with her finger to acknowledge his gaze.

trade in these bulky goods dated back to Roman times and became denser and more robust from the tenth century on. The finest cotton came from Egypt. Silk, originally from China, had long been mastered in the Byzantine Empire, and Islamic craftspeople adopted it early on. Rulers in Spain and Sicily set up special silk workshops to clothe the royal household in textiles of breathtaking beauty. In the thirteenth century, fine silk cloth production became a specialty in some north Italian cities, and by the end of that century, Paris, too, had become a center of luxury silks. There, unlike most other centers of silk manufacture, women were not only employed as laborers but also controlled the craft as entrepreneurs.

The popularity of silk and fine woolens had little to do with its practical advantages and everything to do with fashion. In fourteenth-century Italy, there was no better way to show off wealth and status than to wear it on the streets – in form-fitting, costly, luxurious garb. Sumptuary laws – tied to anxieties about avarice, gender, and social order – tried to stamp out sartorial splendor, especially on the part of women: "no woman or female, of whatever state or condition, may dare or presume to wear on her head or on her person any pearl ... [nor] any belt, of any type or name, that exceeds the value of four gold florins ... [nor wear] any ornament of gold, silver, or any other metal."[17] So read the statutes of the city of Lucca issued in 1337. But such laws were hard to enforce.

In a thirteenth-century romance, *Flamenca*, written in Old Occitan, the language of southern France, a lover is described as dressing with care before he goes to gaze at his lady, who is imprisoned in a tower. First he puts on his fine undergarments, then a pair of exceptionally tight-fitting breaches, next come his elegant overgarments, and finally his pointy shoes. He was

a fashionable fellow, and his type was illustrated often, as in Plate 4.10 in a manuscript about a different love-smitten young man.

Colors, like materials, weaves, and stitches, were signs of status. Purple was a privileged color reserved for rulers. Scarlet, extracted from the kermes, an insect that flourished in Mediterranean regions, was highly precious; blue produced from woad, a common plant, cost less. Undyed fabric was the humblest of all. Benedictine monks of the traditional sort wore black habits, a deeply saturated and therefore expensive color. Cistercian monks demonstrated their poverty and simplicity by wearing undyed cloth made from the wool sheered from the sheep that they raised – though they were in fact very wealthy from the thriving wool market that they supplied.

Churchmen were to shun the things of this world, and indeed at first, they prided themselves on their plain dress. In Plate 1.12 on pp. 34–35, Emperor Justinian, on your left, is wearing a white tunic with tight sleeves and a purple cloak embellished with a gold-embroidered and begemmed panel. All is gathered at his shoulder by an enormous brooch decorated with a red gem surrounded by pearls. His shoes echo his clothing in red and purple. By contrast, the churchmen who flank him, even the proud Maximianus, who added his name to the mosaic, are dressed simply, in white vestments with elongated, loose sleeves. Only Maximianus wears a green chasuble – a poncho-like garment that priests put on to say Mass. Draped around his neck is a plain white wool scarf – a pallium that modestly suggests his ecclesiastical status.

But as the Church began to claim greater dignity for the clerical order, and as it competed with the secular nobility for honor, churchmen (as they dressed for Mass) donned garments of

17 Translated from the Latin by Catherine Kovesi Killerby in *Medieval Italy: Texts in Translation*, ed. Katherine L. Jansen, Joanna Drell, and Frances Andrews (Philadelphia: University of Pennsylvania Press, 2009), pp. 191–92.

stunning materials – generally embroidered by the industrious fingers of pious women. In Plate 4.11, showing the back of a chasuble, someone has embroidered the coat of arms of the Kerkhof family at the very top of the cross on the sumptuously worked orphrey (the middle strip), thereby associating the family of the donor with the holy garment, its priestly wearers, and the Church, saints, and God they served.

BIBLIOGRAPHY

Coatsworth, Elizabeth, and Gale R. Owen-Crocker. *Clothing the Past: Surviving Garments from Early Medieval to Early Modern Western Europe.* Leiden: Brill, 2018.

Miller, Maureen C. *Clothing the Clergy: Virtue and Power in Medieval Europe, c.800–1200.* Ithaca, NY: Cornell University Press, 2014.

Piponnier, Françoise, and Perrine Mane. *Dress in the Middle Ages.* Translated by Caroline Beamish. New Haven, CT: Yale University Press, 1997.

Scott, Margaret. *Fashion in the Middle Ages.* Los Angeles: Getty Publications, 2011.

Plate 4.11 Brunswick Chasuble (early 15th cent.). This chasuble, donated to an important parish church in Brunswick, Germany, is made of silk woven in Egypt. The original textile consists in a variety of patterned stripes, the broadest of which contains Kufic script praising the sultan. For the creators of the vestment, the foreign words signaled only the fabric's high value as an import. They cut and sewed it to make the chasuble, then added an embroidered orphrey employing silk and silver threads in a variety of colors and using specialized stitches. Here and there they added freshwater pearls and sequins. Only very accomplished artists, both in Egypt and in Germany, could have produced work of such fineness.

For practice questions about the text, maps, plates, and other features – plus suggested answers – please go to

www.utphistorymatters.com

There you will also find all the maps, genealogies, and figures used in the book.

FURTHER READING

Bayhom-Daou, Tamima. *Shaykh Mufid*. London: Oneworld Academic, 2005.

Berend, Nora, Przemysław Urbańczyk, and Przemysław Wiszewski. *Central Europe in the High Middle Ages: Bohemia, Hungary and Poland c.900–c.1300*. Cambridge: Cambridge University Press, 2013.

Berend, Nora, ed. *Christianization and the Rise of Christian Monarchy: Scandinavia, Central Europe, and Rus' c.900–1200*. Cambridge: Cambridge University Press, 2007.

Bolton, Timothy. *Cnut the Great*. New Haven, CT: Yale University Press, 2017.

Bonfil, Robert, Oded Irshai, Guy G. Stroumsa, et al., eds. *Jews in Byzantium: Dialectics of Minority and Majority Cultures*. Leiden: Brill, 2012.

Brett, Michael. *The Fatimid Empire*. Edinburgh: Edinburgh University Press, 2017.

Cameron, Averil. *Byzantine Matters*. Princeton, NJ: Princeton University Press, 2014.

Duczko, Wladyslaw. *Viking Rus: Studies on the Presence of Scandinavians in Eastern Europe*. Leiden: Brill, 2004.

Friðriksdóttir, Jóhanna Katrín. *Valkyrie: Women of the Viking World*. London: Bloomsbury, 2020.

Frenkel, Miriam, ed. *The Jews of Medieval Egypt*. Brookline, MA: Academic Studies Press, 2021.

Graham-Campbell, James. *Viking Art*. London: Thames & Hudson, 2021.

Hansen, Valerie. *The Year 1000: When Explorers Connected the World – and Globalization Began*. New York: Scribner, 2020.

Holmes, Catherine. *Basil II and the Governance of Empire (976–1025)*. Oxford: Oxford University Press, 2005.

Jaritz, Gerhard. *Medieval East Central Europe in a Comparative Perspective: From Frontier Zones to Lands in Focus*. London: Routledge, 2016.

Jesch, Judith. *The Viking Diaspora*. London: Routledge, 2015.

Kaldellis, Anthony. *The Byzantine Republic: People and Power in New Rome*. Cambridge, MA: Harvard University Press, 2015.

Kraemer, Joel L. *Humanism in the Renaissance of Islam: The Cultural Revival during the Buyid Age*. 2nd rev. ed. Leiden: Brill, 1993.

La Rocca, Cristina, ed. *Italy in the Early Middle Ages, 476–1000*. Oxford: Oxford University Press, 2002.

Line, Philip. *Kingship and State Formation in Sweden, 1130–1290*. Leiden: Brill, 2007.

Mägi, Marika. *The Viking Eastern Baltic*. Amsterdam: Amsterdam University Press, 2019.

Mossman, Stephen, ed. *Debating Medieval Europe: The Early Middle Ages, c.450–c.1050*. Manchester: Manchester University Press, 2020.

Nordeide, Sæbjørg Walaker, and Kevin J. Edwards. *The Vikings*. Amsterdam: Amsterdam University Press, 2019.

Outhwaite, B., M. Schmierer-Lee, and C. Burgess. *Discarded History: The Genizah of Medieval Cairo*. Cambridge: Cambridge University Library, 2017. Exhibition Guide and Translations. https://doi.org/10.17863/CAM.13917.

Raffensperger, Christian. *Reimagining Europe: Kievan Rus' in the Medieval World, 988–1146*. Cambridge, MA: Harvard University Press, 2012.

Romane, Julian. *Byzantium Triumphant: The Military History of the Byzantines, 959–1025*. Barnsley, UK: Pen & Sword Military, 2015.

Rustow, Marina. *The Lost Archive: Traces of a Caliphate in a Cairo Synagogue*. Princeton, NJ: Princeton University Press, 2020.

Stafford, Pauline. *After Alfred: Anglo-Saxon Chronicles and Chroniclers, 900–1150*. Oxford: Oxford University Press, 2020.

Tinti, Francesca. *Europe and the Anglo-Saxons*. Cambridge: Cambridge University Press, 2021.

Abbacy of Hugh of Cluny

1049–1109

The monastery of Cluny, a model for many monasteries and magnet for pious donations, is at the height of its influence and prestige.

The Almoravids found the city of Marrakesh

c.1070

Sunni Muslims, they take over the Maghreb, extend across the western Sahara, and (after entering Spain 1085) straddle the strait of Gibraltar.

Pope Gregory VII

1073–1085

Promulgator of Gregorian Reform, opponent of lay investiture, clerical marriage, and simony.

Reign of Emperor Alexius I Comnenus

1081–1118

Alexius reforms Byzantine government, and his request to Pope Urban II for mercenaries leads to the First Crusade.

Creation of Portugal

1095

Initially granted as a county by Alfonso VI.

The First Crusade

1096–1099

Begins with the massacre of Rhineland Jews; ends with the conquest of Jerusalem and the establishment of the Crusader States.

Cistercian Order established

1098

Benedictines, like the Cluniac monks, but with a different lifestyle. The Cistercians insist on simplicity; separate lay brothers from those of the choir.

Norman conquest of England

1066

The Normans had already established themselves in southern Italy; in 1066, they take England; and by 1093, they conquer Sicily. Yet this does not create one Norman empire but rather two largely separate Norman regions, one in the south (Sicily and Italy), the other in the north (England and Normandy).

Battle of Manzikert

1071

This battle marks the Seljuk Turks' defeat of the Byzantines in Anatolia. Soon they occupy Jerusalem (c.1075). Eventually they form two states: the Great Seljuk sultanate and the Seljuk sultanate of Rum.

Investiture Conflict

1075–1122

Pits King Henry IV against Gregory VII; begins to create a real, as well as theoretical, divide between Church and State.

King Alfonso VI of León and Castile captures Toledo

1085

The capture of Toledo is a major victory of the *reconquista*, but further expansion is temporarily prevented by the Almoravids.

Pope Urban II preaches the First Crusade

1095

At a Church Peace Council at Clermont (in southern France), Urban preaches the religious and military undertaking known as the First Crusade to a large and enthusiastic audience.

Milan commune established

1097

Evidence of the new power of urban dwellers and the importance of Church reform to the laity.

Concordat of Worms

1122

Divides the investiture ritual into two, one part granting the spiritual office, the other the material things that go with it.

FIVE

NEW CONFIGURATIONS (*c.* 1050–*c.* 1150)

In the second half of the eleventh century, three powerful groups – Seljuk Turks from the east, Almoravids from West Africa, and crusaders from Europe – entered the Byzantine and Islamic Empires, changing political, cultural, and religious configurations everywhere. Byzantium, though still a force to be reckoned with, was weakened. The Islamic world, tending toward Shiʻism with the Fatimids, now saw a revival of Sunnism. It elaborated new cultural forms to express its pride in its regained orthodoxy and to proclaim its cosmopolitanism. Europe, now connected more than ever with the rest of the world through commerce, created newly dynamic forms of monasticism, expanded its artistic horizons, and established a fragile foothold in the Middle East through conquest.

THE SELJUKS AND THE ALMORAVIDS

In the eleventh century, the Seljuks, a Turkic group from outside the Islamic world, entered and took over its eastern half. Eventually penetrating deep into Anatolia, they took a great bite out of Byzantium. Soon, however, the Seljuks themselves split apart, and eventually the Islamic world fragmented anew under dozens of rulers. Meanwhile, many Berbers united under the Almoravid dynasty to form a new empire in the Islamic far west.

From Mercenaries to Imperialists: The Seljuk Turks

The Seljuk Turks were herders and mercenaries from the Kazakh steppe – the extensive Eurasian grasslands of Kazakhstan. Some of them entered the region around the Caspian and Aral Seas at the end of the tenth century, hired by rival Muslim rulers. During the first half of the eleventh century, they began conquests of their own. The Ghaznavids, themselves Turks who had previously displaced the Buyids and Samanids, could perhaps

have contained them, but Ghaznavid Sultan Mas'ud I (r.1030–1041) led an ill-prepared and demoralized army against the Seljuks and lost disastrously at the battle of Dandanqan (1040).[1] (See Map 5.1.)

From about the year 1000 to 1900, the Middle East was dominated by peoples of steppe origin. The Seljuks, among the first to arrive, soon formed two separate states. The Great Seljuk sultanate (c.1040–1194) dominated the east, from the Aral Sea to the Persian Gulf, encompassing a region now occupied by Uzbekistan, Turkmenistan, Iraq, and Iran. The Seljuk sultanate of Rum (c.1081–1308) was formed to the west, looking a bit like a thumb stuck into what had been Byzantine Anatolia. It took its name from those whom it vanquished: Rum means Rome. Westerners were shocked by the Seljuk army's humiliating defeat of the Byzantine emperor at Manzikert (today Malazgirt, in Turkey) in 1071, which seemed to mark the conquest of Anatolia. And they were outraged by the Seljuk occupation of Jerusalem (c.1075), which inspired the First Crusade. But the more enduring victory of the Seljuks over formerly Byzantine regions was accomplished by quieter methods, as Seljuk families moved in, seeking pastureland for their livestock. Like the Vikings, the Seljuks generally traveled as families.

The Seljuk sultanates were staunchly Sunni. They rolled back the Shi'ite wave that had engulfed the Islamic world since the decline of the Abbasids. Nizam al-Mulk (d.1092), vizier for Alp Arslan and Malikshah I (see Genealogy 5.1) and in many ways *de facto* ruler himself for the last twenty years of his life, described Shi'ism as a fraud concocted out of pseudo-philosophy and mumbo-jumbo: "obscure words from the language of the imams, mixed up with sayings of the naturalists and utterances of the philosophers, and consisting largely of mention of The Prophet and the angels, the tablet and pen, and heaven and the throne."[2] It was a heresy, and its followers were dangerous to the state. To counter its influence, he sponsored the foundation of numerous *madrasas* – a whole "chain" of them named (after him) Nizamiya. He hoped that they would fan new life into political, religious, and cultural Sunnism.

The Islamic world had always supported elementary schools; now the *madrasas*, normally attached to mosques, served as centers of advanced scholarship. There young men attended lessons in religion, law, and literature. Sometimes visiting scholars arrived to debate in lively public displays of intellectual brilliance. More regularly, teachers and students carried on a quiet regimen of classes on the Qur'an and other texts.

While allowing the Abbasid caliphs in Baghdad to maintain their religious role in a city still splendid in material and intellectual resources, the Seljuks shifted the cultural and political centers of the Islamic world to Iran and Anatolia. Asserting their adherence to Sunni Islam in concrete form, the Great Seljuk sultanate built grand mosques and fitted

1 For an eyewitness account of the battle, see Abu'l-Fazl Beyhaqi, *The Battle of Dandanqan*, in *Reading the Middle Ages: Sources from Europe, Byzantium, and the Islamic World*, 3rd ed., ed. Barbara H. Rosenwein (Toronto: University of Toronto Press, 2018), pp. 241–43.

2 Nizam al-Mulk, *The Book of Policy*, in *Reading the Middle Ages*, pp. 244–46.

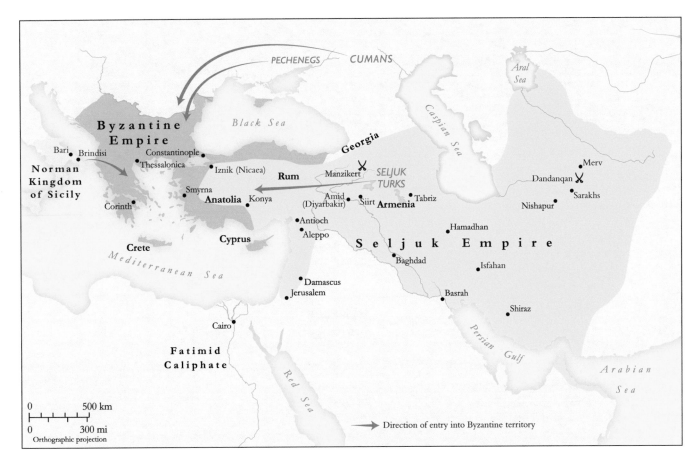

Map 5.1 The Byzantine and Seljuk Empires, c. 1090

them out with towering minarets – a feature that Shi'ite dynasties such as the Fatimids downplayed or omitted altogether.

Consider the Friday Mosque at Isfahan in Iran. First built in the tenth century, it received a major face-lift under Nizam al-Mulk, who focused his patronage on its courtyard, the heart of the complex. Nizam added four *iwans* – vaulted halls opening on the courtyard – one at each wall. (See Plate 5.1.) The most important was the south *iwan*, for that was in the *qibla* wall – the wall facing Mecca. That *iwan* led in turn to a large square room housing the *mihrab* (the niche of the *qibla*), which was topped by a lofty dome built by Nizam al-Mulk.

Competing with Nizam's al-Mulk, his rival Taj al-Mulk showed off his own importance by building another square-domed room on the very same axis as the *qibla* dome, but in his case directly to the north of the courtyard. Less imposing, but more elegant than the southern dome, the northern dome included an inscription dating it to 1088–1089 and naming Taj al-Mulk as its donor. (See Plate 5.2, p. 168.)

It was ironic that a people used to being on the move would indulge in such lavish expenditures on buildings. The ruling elite, in particular, was settling down. Malikshah made Isfahan his capital, far to the west of the original centers of the Seljuk Empire such as Merv. For his part, Nizam al-Mulk cemented his position as virtual ruler by distributing not only money but also *iqta* – land (see Chapter 4, p. 132). Under the Seljuks the

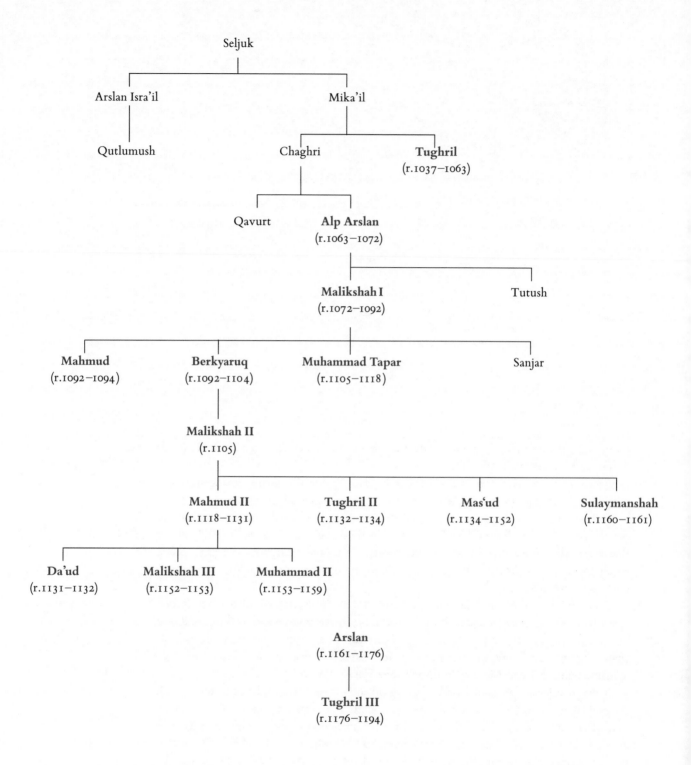

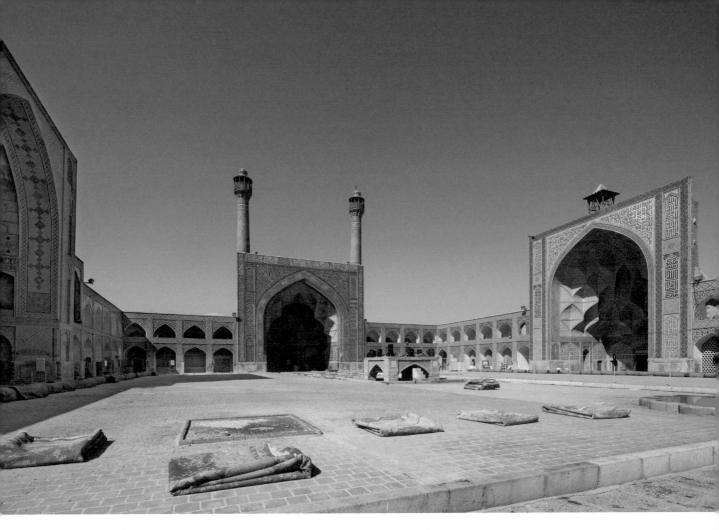

iqta was widely used; it recompensed not only army leaders (emirs), but also bureaucrats, and favored members of the dynasty. Like fiefs, iqtas were theoretically revocable by the ruler, but, again like fiefs, many iqta holders were able to make them hereditary.

Fortified by their revenues and land grants, the emirs of Iran and Iraq, originally appointed to represent the sultan's power at the local level, broke away from the centralized state. In the course of the twelfth century, in a process of fragmentation similar to those we have seen in the previous chapter, the Great Seljuk Empire fell apart. Yet this did not mean the end of Seljuk culture and institutions but rather their replication in numerous smaller centers. The decline of the power of the Great Seljuk dynasty did not end the Great Seljuk era.

Meanwhile, the Anatolian branch of the dynasty prospered. It benefited from the region's silver, copper, iron, and lapis lazuli mines and from the pastureland that supported animal products such as cashmere, highly prized as an export as far away as France. The Anatolian sultans did not need to give out iqtas; they could pay their soldiers. Even so, their Seljuk Sultanate of Rum was a sort of "wild west": most houses were made of mud, and the elites did not support the madrasas or the arts and literature as generously as did the rulers of most of the other centers of the Islamic world.

Plate 5.1 Isfahan Mosque Courtyard (c. 1086). In this view facing south, two of the mosque's four *iwans* are visible in full, with a third (to the east) visible in part. The courtyard is bordered by double-decker walls punctuated by openings, each leading to an aisle topped by domes. Note the two minarets towering above the central *iwan* and telegraphing adherence to Sunni Islam.

Genealogy 5.1 (facing page) The Great Seljuk Sultans

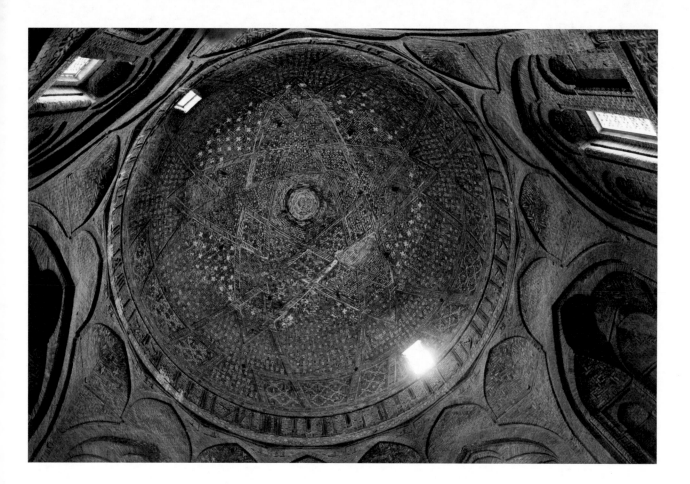

Plate 5.2 Isfahan Mosque North Dome (1088–1089). Built according to a precise geometric design, the circular dome sits on a sixteen-sided polygon that rests in turn on an octagon perched on a square base. The design within the dome is equally mathematical, with an oculus forming the mid-point of converging triangles.

Further setting it apart from other Islamic regions, the Sultanate of Rum had a significant Christian population as well as a mix of other ethnicities and a large and increasingly influential minority of Sufis – Islam's main mystical group. In Jerusalem (which the Seljuks took until forced back out by the Fatimids in 1098, after which it was taken by crusaders from Europe), they confronted Jews, Christian pilgrims, and of course the "native" Christians who had lived there for generations. To this eclectic mix, the Seljuks adapted. Rather than tearing down churches, they simply converted them into mosques. Many adopted the farming methods of the peasants. The elites, at least, included Byzantine women as wives or concubines in their harems. The children of those unions spoke Greek as well as the local language (Persian, and perhaps Turkic and Arabic as well). Muslim children in Rum were baptized as a matter of course by Orthodox priests because the rite was thought to ward off demons.

From Pastoralists to State-Builders: The Almoravids

In the western half of the Islamic world, tribes from the Sahara Desert forged a state equaling the size of that of the Seljuks (see Map 5.2). Originally Berber pastoralists who

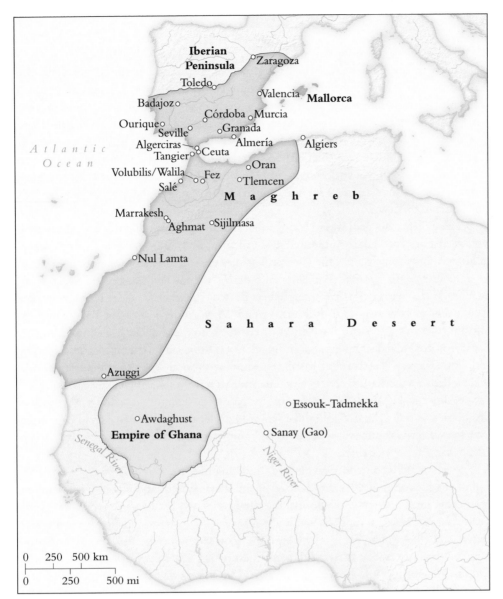

Map 5.2 The Almoravid Empire and the Empire of Ghana, *c.*1050

moved from one water source to another with their flocks and tents, they learned Islam from Muslim traders who needed guides and protectors to cross the Sahara. We met some of these tribes in Chapter 3, when they were facilitating trade to and from West Africa. In the 1030s they were inspired by a leader named Yahya ibn Ibrahim and his companions to follow a strict form of Sunni orthodoxy. In addition to adhering rigorously to Qur'anic injunctions, the men joined the women in wearing a veil over the lower part of their faces. The earliest sources for this practice did not connect it with Islam per se, but later sources reported that the Berbers had originally lived in Yemen. In order to practice their fledgling monotheism, they were forced to flee to the Sahara with their men disguised as women. Their veils thus demonstrated their devotion to Islam.

Fired with zeal on behalf of their religious beliefs (much like the Seljuks) and also seeking economic opportunity, disparate groups of Berbers formed a federation known as the Murabitun (Almoravids) and began conquering the (largely Shi'ite) regions to their north. Making common cause with local Sunni jurists and various tribal notables there, they took over cities bordering on the Sahara in the 1050s and soon had their eyes on the Maghreb. The foundation of their city of Marrakesh c.1070 was a milestone in their transition from a pastoral to a settled existence. Under their leader, Yusuf ibn Tashfin (d.1106), and members of his clan, they subdued much of the Maghreb, taking Tangier in c.1078 and Ceuta in the 1080s.

Because their main goal was to control the African salt and gold trade, the Almoravids were at first not particularly interested in al-Andalus. But the Andalusian *taifa* rulers kept calling on them to help fight the Christian armies encroaching from the north of Spain. Their chief nemesis was Christian King Alfonso VI of León and Castile. (He was ruler of León 1065–1109 with a one-year interruption in 1071–72, when his older brother usurped the throne, and was king of Castile 1072–1109.) When Alfonso captured Toledo from its Muslim ruler in 1085, Yusuf ibn Tashfin at last took up the challenge, meeting him near Badajoz in 1086 and dealing him a stunning defeat. Dismayed by the *taifa* leaders' feuding and (in their eyes) "lax" form of Islam, the Almoravids soon began to conquer the peninsula on their own behalf. By c.1115 all of al-Andalus not yet taken by Christian rulers was under Almoravid control. The gold coin that forms the icon for accessing the website of this book was one of many gold dinars minted under their rule. Almoravid hegemony over the western Islamic world began to end only in 1145 as the Almohads, a rival Berber group, came to replace them.

The Almoravids controlled an empire stretching over 2,000 miles, from the northern end of the kingdom of Ghana to half of Spain. Their wealth and power were based on prosperous urban centers and a flourishing rural economy. Farmers produced grains, irrigated their gardens with sophisticated water-management systems, and raised animals. Flax, cotton, and silk – "home-grown" by worms living on the mulberry trees of southern Spain – supplied town textile industries with plentiful supplies. The silks woven in Almería were famous. When King Alfonso VII of Castile and León took that city (temporarily) in 1147, he looted its silks to cut up and use to wrap precious relics for the cathedral of Sigüenza. Other fragments found their way into other church treasuries. (See Plate 5.3 and Material Culture: Cloth and Clothing, pp. 157–60.)

Poised to take advantage of long-distance commercial relations, the Almoravids mined marble, silver, copper, and iron for use and export. With one foot in sub-Saharan West Africa and the other in Spain, they profited from both cultures and the resources of both regions, a point nicely illustrated by the marble tombstone in Plate 5.4. This was quarried in Iberia; cut, polished, and inscribed with a Qur'anic-inflected poem at Almería; and ferried across the Sahara for wealthy clients in far-off Gao, today in Mali.

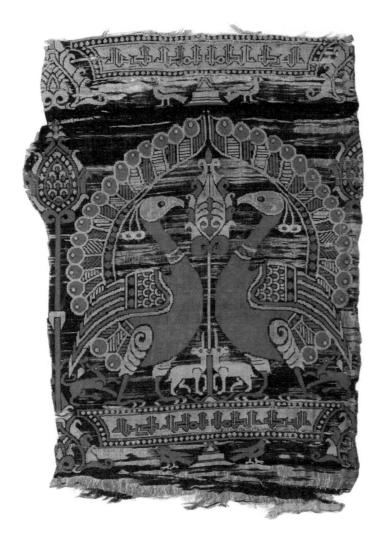

Plate 5.3 Almería Silk (first half of 12th cent.). Two unicorns shelter beneath two large peacocks that face a stylized palm tree in this fine silk weaving made by a workshop in Almoravid Almería. At the top and bottom are cartouches with Arabic inscriptions; the bottom one reads "perfect blessing." Although it originated in an Islamic atelier, Christians valued its beauty and used it to cover precious relics. Just as living bodies were clothed, and corpses were wrapped in shrouds, so relics were enfolded in textiles, preferably beautifully woven and made of costly silk such as this one.

West African Connections

That elites in Saney wanted to be buried as Muslims should not be surprising, for the Almoravids were zealous on behalf of both their religion and hegemony. Thus, the route between Sijilmasa and Awdaghust was not only a trade corridor but also a conduit for Islamization. Andalusian writer al-Bakri (d. 1094), basing his accounts on various written reports and live informants, noted that "in Awdaghust there is one cathedral mosque and many smaller ones, all well attended. In all the mosques there are teachers of the Qur'an." These *madrasas* were instruments in the missionary toolkit (along with forceable conversions). Yet the sort of Islam practiced in Gao and elsewhere in the Sahara was not simply derivative of Almoravid forms but rather drew on indigenous customs and sensibilities. The stele in Plate 5.4, for example, would not have been erected over a grave in Almería

Plate 5.4 Marble Tombstone from Almería (12th cent.). This is one of five extant steles produced at Almería and erected at a cemetery near what is today the archaeological site of Gao Saney, Mali. (See Map 5.2.) Other tombstones like it were produced by local craftspeople at Saney and elsewhere, including (a bit north of Saney) Essouk-Tadmekka, a thriving market crossroads for the trans-Saharan trade in slaves, gold, and ivory. Essouk-Tadmekka was itself a manufacturing center, producing iron, copper, unstamped gold coins (which probably circulated as money), and high-carbon steel, no doubt used to make weapons of exceptional quality.

itself because it included the name of the deceased; in Iberia, that practice was thought to undermine the glory of God.

At Awdaghust, al-Bakri continued, "transactions are in gold, and they have no silver. There are handsome buildings and fine houses." It was, he said, a town of expatriate merchants, most of the inhabitants having come there from Ifriqiya – the North African coast (see Map 3.3 on p. 93). But living there were also "Sudan women, good cooks, one being sold for 100 mithqals or more. They excel at cooking delicious confections such as sugared nuts, honey doughnuts, various other kinds of sweetmeats, and other delicacies. There are also pretty slave girls with white complexions."

For al-Bakri, traffic in human beings was an unremarkable fact of life. But was he inadvertently revealing eleventh-century color-based racism? Are we to think that people were typed by their epidermis even then? It is possible, for Arabic writers dubbed the region south of the Sahara the Bilad al-Sudan, "land of the Blacks." Historian Michael A. Gomez suggests, however, that al-Bakri's words were sexualizing, not racializing, distinguishing between the black, Sudanese servant who works and the "white" one who offers men comfort. It is certainly true that al-Bakri mentions the white complexions of these slave girls alongside a long list of their other alluring attributes, including "fat buttocks" and "slim waists."[3] But medievalist Geraldine Heng argues that racial thinking – which singles out one arbitrary identifier (skin color, religious belief, the food people eat), demonizes it, and applies it to people of diverse origins, languages, traditions, and self-conceptions – did indeed bear its poisonous fruit at this time, as we shall certainly see in connection with the crusades later in this chapter.

BYZANTIUM: BLOODIED BUT UNBOWED

The once triumphant empire of Basil II was unable to sustain the territorial successes of the early eleventh century. We have already seen the triumph of the Seljuk Turks in Anatolia; meanwhile, in the Balkans, Turkic Pechenegs raided with ease. The Normans, some of whom (as we saw on p. 140) had established themselves in southern Italy, began attacks on Byzantine territory there and conquered its last stronghold, Bari, in 1071, precisely when the Seljuks defeated the Byzantines at Manzikert. Entering Muslim Sicily in 1060, the Normans conquered it by 1093. Meanwhile, their knights attacked Byzantine territory in the Balkans. (See Map 5.1.) When Norman King Roger II (r.1130–1154) came to the throne, he ruled a realm that ran from southern Italy to Palermo – the Kingdom of Sicily. It was a persistent thorn in Byzantium's side.

Clearly the Byzantine army was no longer very effective. Few themes were still manned with citizen-soldiers, and the emperor's army was also largely composed of mercenaries – Turks

3 Nehemia Levtzion and J.F.P. Hopkins, eds., *Corpus of Early Arabic Sources of West African History* (Princeton, NJ: Markus Wiener Publishers, 2000), p. 68.

and Rus, as had long been the case, and increasingly Normans and Franks as well. But the Byzantines were not entirely dependent on armed force; in many instances they turned to diplomacy to confront their invaders. When Emperor Constantine IX (r. 1042–1055) was unable to prevent the Pechenegs from entering the Balkans, he shifted policy, welcoming them, administering baptism, conferring titles, and settling them in depopulated regions. Much the same process took place in Anatolia, where the emperors at times welcomed the Turks to help them fight rival *dynatoi*. Here the invaders were occasionally also welcomed by Christians who did not adhere to Byzantine orthodoxy; the Monophysites of Armenia were glad to have new Turkic overlords. The Byzantine grip on its territories loosened and its frontiers became nebulous, but Byzantium still stood.

There were changes at the imperial court as well. The model of the "public" emperor ruling alone with the aid of a civil service gave way to a less costly, more "familial" model of government. To be sure, for a time competing *dynatoi* families swapped the imperial throne. But Alexius I Comnenus (r. 1081–1118), a Dalassenus on his mother's side, managed to bring most of the major families together through a series of marriage alliances. (The Comneni remained on the throne for about a century; see Genealogy 5.2.) Until her death in *c.* 1102, Anna Dalassena, Alexius's mother, held the reins of government while Alexius occupied himself with military matters. At his revamped court, which he moved to the Blachernai palace, at the northwestern tip of the city (see Map 4.1 on p. 120), his relatives held the highest positions. Many of them received *pronoiai* (sing. *pronoia*), temporary grants of imperial lands that they administered and profited from. Just as the Seljuks turned to the *iqta* and the Europeans to the fief, so the Byzantines resorted to land grants to replace salaries.

Despite its territorial contraction, in some ways the Byzantine Empire had never been more prosperous. Its economy was buoyed by agricultural production and population growth. Its manufactured goods – silks, oil, dyes, pottery, bronzes, ivories, and glass – were in high demand in markets ranging from Rus' to Spain. Italian traders acted as intermediaries.

Genealogy 5.2 The Comnenian Dynasty

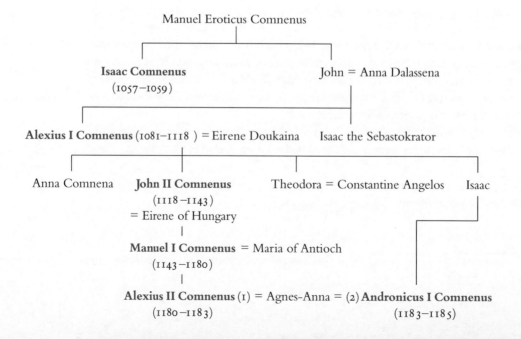

ECONOMIC NETWORKS IN EUROPE AND BEYOND

The enhanced role of Italian merchants in the Byzantine world was just one of the ways in which the European economy was now coming to mesh more tightly with that of the wider world. Its economic expansion began in the countryside. Draining marshes, felling trees, building dikes: this was the backbreaking work that brought new land into cultivation. Peasants using heavy moldboard plows, now often more efficiently drawn by horses, reaped better harvests. Profiting from the three-field system, they raised a greater variety of crops. Aristocratic landowners, the same "oppressors" against whom the Peace of God fulminated (see p. 145), became savvy entrepreneurs. They set up mills to grind grain, forced their tenants to use them, and then charged a fee for the service. Some landlords gave peasants special privileges to settle on especially inhospitable land: the bishop of Hamburg, for example, was generous to those who came from Holland to work soil that was, as he admitted "uncultivated, marshy, and useless."[4] Demographic growth fueled the development of real villages throughout Europe – communities with their own sense of identity, their own representatives, their own "common" structures centered on churches, cemeteries, squares, fields, woods, wasteland, and the blacksmith's shop where their tools were forged.

Taking advantage of their surpluses, villages connected with one another through trade. Better roads allowed wagons laden with goods to pass to and fro, while settlements near rivers were served by flat-bottomed barges. At weekly markets villagers bought and sold eggs, poultry, blankets, bales of wool, and animal hides. Barter increasingly gave way to cash.

The use of money offered villages access to wider commercial networks as well – those of towns and cities. Urban centers were dispersed all over the map of Europe but were especially dense in a ribbon of cities that began on the two sides of the English Channel (with trade between England and Flanders), curved around the southern coast of the North Sea, and then plunged southward along the Rhine (taking in the cities of Cologne, Mainz, Worms, and Speyer). (See Map 5.3.) The ribbon continued into Italy, including the Po River valley, the seafaring cities of Venice, Genoa, and Pisa, and, in the south, Naples and Amalfi – cities that were increasingly doing business in the Maghreb and at Constantinople and thus were linchpins in an increasingly hemisphere-wide circulation of goods.

Urban centers were intensely conscious of their interests and goals, elaborating new instruments of commerce, self-regulating organizations, and forms of self-government. Despite this intense focus on their internal concerns, some of their more enterprising denizens played a part in connecting Europe's economy more and more fully with markets in North Africa and the Middle East, both of which were fed by even more distant trading networks.

4 *Frederick of Hamburg's Agreement with Colonists from Holland*, in *Reading the Middle Ages*, pp. 246–47.

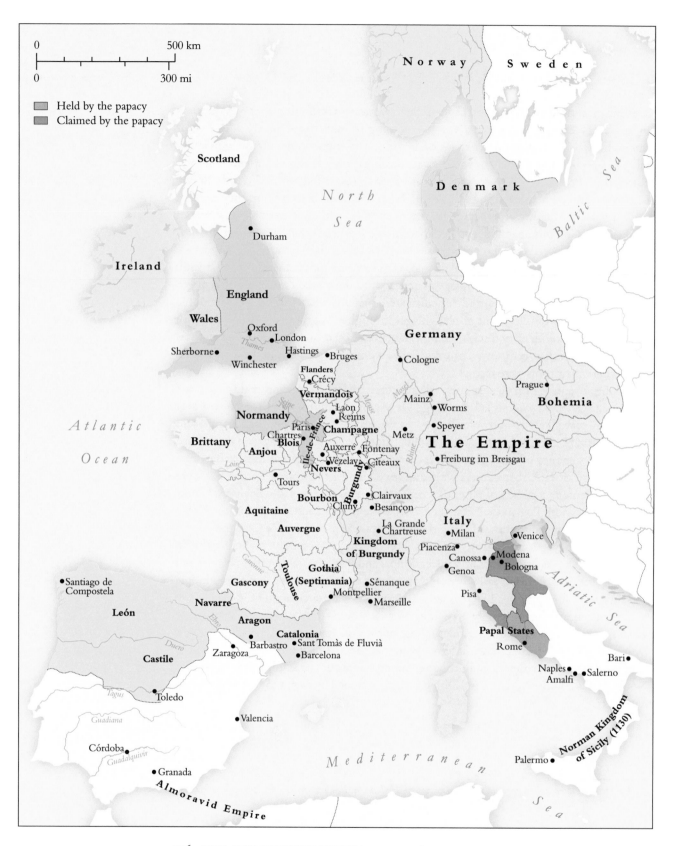

Scale:
0 — 500 km
0 — 300 mi

Legend:
- Held by the papacy
- Claimed by the papacy

NORWAY

Sweden

Scotland

North Sea

Denmark

Baltic Sea

Ireland

England

• Durham

Wales

• Oxford
• London
Sherborne •
• Hastings
• Winchester

• Bruges

Germany

• Cologne

Flanders
• Crécy

Vermandois
• Laon
• Reims

Mosel

• Mainz
• Worms

Prague •

Bohemia

Normandy

Paris •
Chartres •
Blois •

Seine

Champagne

• Metz

• Speyer

Meuse

Brittany

Île-de-France

• Auxerre
• Fontenay

Anjou

Vézelay •
• Cîteaux

Nevers

The Empire

Rhine

• Freiburg im Breisgau

Atlantic Ocean

• Tours

Loire

Burgundy

• Clairvaux
Bourbon
Cluny • • Besançon

Aquitaine

Kingdom of Burgundy

Auvergne

• La Grande Chartreuse

Italy

• Milan

Po

• Venice

Gothia (Septimania)

Toulouse

Gascony

• Sénanque

• Montpellier

• Marseille

Piacenza •
Canossa •
Genoa •

Modena •
Bologna

Adriatic Sea

Santiago de Compostela •

• Pisa

León

Navarre

Aragon

Catalonia

• Barbastro
Zaragoza •
• Sant Tomàs de Fluvià
• Barcelona

Ebro

Papal States
Rome •

Bari •

Naples • • Salerno
Amalfi

Castile

Duero

• Toledo

Tagus

• Valencia

Guadiana

Córdoba •

Guadalquivir

• Granada

Almoravid Empire

Mediterranean Sea

Palermo •

Norman Kingdom of Sicily (1130)

The Formation of Towns and Cities

Map 5.3 (facing page) Western Europe, *c.*1100

Around castles and monasteries in the countryside or outside the walls of crumbling ancient towns, merchants came with their wares and artisans set up their stalls. In some places, they were attracted by seasonal fairs; those in Lombardy began already in the tenth century. In other places, they stayed on as permanent residents. Recall Tours as it had looked in the early seventh century (see the left side of Map 5.4), with its semi-permanent settlements around the church of Saint-Martin out in the cemetery, and its lonely cathedral within the ancient walls. By the twelfth century (see the right side of Map 5.4), Saint-Martin was a monastery, the hub of a small town dense enough to boast eleven parish churches, merchant and artisan shops, private houses, and two markets. To the east, the episcopal complex was no longer alone: a market had sprung up outside the old western wall, and private houses lined the street leading to a bridge. Smaller than the town around Saint-Martin, the one at the foot of the old city had only two parish churches, but it was big and rich enough to warrant the construction of a new set of walls to protect it.

As at Tours, walls were a general feature of medieval cities. So, too were marketplaces, one or more fortifications, and many churches. City streets, made of packed clay or gravel, were narrow, dirty, dark, smelly, and winding. Most cities were situated near waterways, over which bridges were constructed to facilitate land routes; the bridge at Tours was built in the 1030s. Many cities had to adapt to increasingly crowded conditions. Towns ranged in size from (perhaps) less than 40 acres to over 500, and they had populations (equally uncertain) of less than 5,000 to 20,000 or more. Both size and population grew over time. This happened at Tours (which is why a new wall was constructed), but it happened even

Map 5.4 Tours *c.*600 vs. Tours *c.*1100

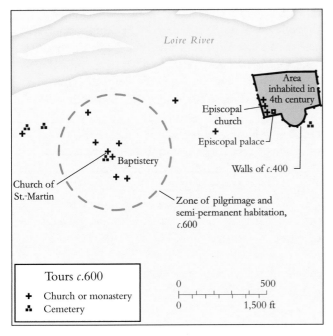

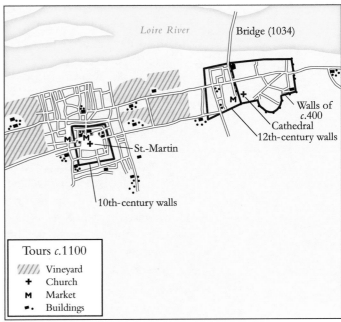

more spectacularly elsewhere, as at London, where the population ballooned from around 20,000 in 1100 to 40,000 a century later.

At first town housing was made of cheap materials – wood or unfired clay held together by woven twigs. Houses rose no more than two or three stories, with the ground floor serving as a shop or warehouse. Swelling populations inflated property values, and many families ascended to wealth and prominence through the rental and real estate markets. From the late eleventh century on, houses were increasingly constructed in stone and brick, evidence of active quarries and transport facilities. Those in turn were stimulated by a spate of major building projects – from parish churches to cathedrals, from castles and fortified towers to palaces. Yet, behind many houses, even the most splendid, were enclosures for livestock and a garden. City dwellers clung to rural pursuits, raising much of their food themselves.

Urban Arrangements

The revival of urban life and the expansion of trade are together dubbed the "commercial revolution" by historians. In the first half of the twelfth century merchants succeeded in getting rights to trade in cities other than their own; tolls were lifted for them and, in many port cities along the Baltic, North Sea, and Mediterranean coasts, they were given special sites to use for warehouses and temporary residences. A few of these may be seen on Map 4.1 on p. 120, where traders from Genoa, Pisa, Amalfi, and Venice had their own separate districts at Constantinople, strung like pearls along the Golden Horn.

Especially active in cross-Mediterranean trading networks were the ports of Alexandria (to which spices from South Asia came via the Red Sea) and al-Andalus, the most important of which was Almería, from which were exported timber, oil, fruit, gold, and, of course, luxury silks – see Plate 5.3. The ships that plied such routes made good use of important intermediate commercial centers in Sicily and above all at Kairouan, the Tunisian port of call for trans-Saharan gold and slaves. (See Map 5.5 on p. 187.) In Chapter 4, we saw one painful consequence of this lively yet predatory activity, as Jewish merchants from Egypt were taken by Byzantine pirates, sold to Amalfitan middlemen, and then returned to Alexandria for ransom.

Enterprising proto-capitalists invented new businesses and pooled their collective resources to finance large undertakings. They underwrote cloth industries powered by water mills and deep-mining technologies that provided Europeans with hitherto untapped sources of metals. Forging techniques improved (see Material Culture: Forging Medieval Swords on pp. 78–81), and iron was for the first time regularly used for agricultural tools, plows, and weapons. Beer, a major source of nutrition in the north of Europe, moved from the domestic hearth and monastic estates to urban centers, where brewers gained special privileges to ply their trade.

Brewers, like other urban artisans, cultivated a sense of group solidarity. Plate 5.5 illustrates one way in which sculptors working at Modena celebrated themselves, their craft,

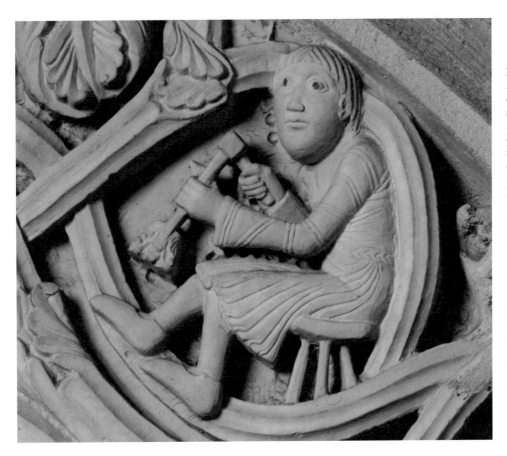

Plate 5.5 A Sculptor at Work, Modena Cathedral (early 12th cent.). The artisans who built and decorated the cathedral at Modena were intensely aware of the dignity of manual labor in general and of their own craft in particular. In stone carvings on the so-called Princes' Doorway (on the south side of the cathedral [see Figure 5.2 on p. 205]), sculptors working in the tradition of master Wiligelmo carved images of (among others) a blacksmith, a musician, a reaper, and the sculptor shown here, each with his most important tool (the sculptor is holding a chisel as he carves, upside-down, the decorative top – the capital – of a column). Each worker is delicately enclosed like a blossom within vine tendrils. For carvings by Wiligelmo himself, see Plate 5.12 on p. 204.

and all who worked with their hands. Whether driven by machines or human labor, the new economy was soon organized by guilds. In these social, religious, and economic associations, members prayed for and buried one another even as they regulated and protected professions ranging from trade and finance to shoemaking. Craft guilds determined standards of quality for their products and defined work hours, materials, and prices. Merchant guilds regulated business arrangements, weights and measures, and (like the craft guilds) prices. Guilds guaranteed their members – mostly male, except in a few professions – a place in the market. They represented the social and economic counterpart to urban walls, giving their members protection, shared identity, and recognized status.

The political counterpart of the walls was the "commune" – town self-government. City dwellers were keenly aware of their special identity in a world dominated by knights and peasants. They recognized their mutual interest in reliable coinage, laws facilitating commerce, freedom from servile dues and services, and independence to buy and sell as the market dictated. They petitioned or rebelled against the political powers that ruled over them – bishops, kings, counts, castellans, dukes – for the right to govern themselves.

Collective movements for urban self-government were especially prevalent in Italy, France, and Germany. Italy's political life had long been city-centered, and communes there began already in the second half of the eleventh century. At Milan, for example, popular discontent with the archbishop, who effectively ruled the city, led to numerous

armed clashes that ended, in 1097, with the transfer of power from the archbishop to a government of leading men of the city. Outside Italy, movements for urban independence – sometimes violent, as at Milan, at other times peaceful – often took place within a larger political framework. For example, around 1130, in return for a hefty sum, King Henry I of England freed the citizens of London from numerous customary taxes while granting them the right to "appoint as sheriff from themselves whomsoever they may choose, and [they] shall appoint from among themselves as justice whomsoever they choose to look after the pleas of my crown."[5] The king's law still stood, but it was to be carried out by the Londoners' officials.

CHURCH REFORM AND ITS AFTERMATH

Disillusioned citizens at Milan denounced their archbishop not only for his tyranny but also for his impurity; they wanted their pastors to be untainted by sex and money. In this they were supported by a newly zealous papacy, keen on reform in the Church and society. The "Gregorian Reform," as modern historians call this movement, broke up clerical marriages, unleashed civil war in Germany, changed the procedure for episcopal elections, and transformed the papacy into a monarchy. It began as a way to free the Church from the world, but in the end the Church was deeply involved in the new world it had helped to create.

The Coming of Reform

Free the Church from the world: what could that mean? In 910 the duke and duchess of Aquitaine founded the monastery of Cluny with some unusual stipulations. (For all the places involved, see Map 5.3 on p. 176.) They endowed the monastery with property (normal and essential if it were to survive), but then they did something unusual: they gave Cluny and its worldly possessions to Saints Peter and Paul. In this way, they put control of the monastery into the hands of the two most powerful heavenly saints. They designated the pope, as the successor of Saint Peter, to be the monastery's worldly protector if anyone should bother or threaten it. But even the pope had no right to infringe on Cluny's freedom: "From this day," the duke wrote,

> those same monks there congregated shall be subject neither to our yoke, nor to that of our relatives, nor to the sway of any earthly power. And, through God and all his saints, and by the awful day of judgment, I warn and abjure that no one of the secular princes, no count, no bishop whatever, not the pontiff of the aforesaid Roman see [i.e., the pope], shall invade the property of these servants of God,

5 Henry I, *Privileges for the Citizens of London*, in *Reading the Middle Ages*, pp. 250–51.

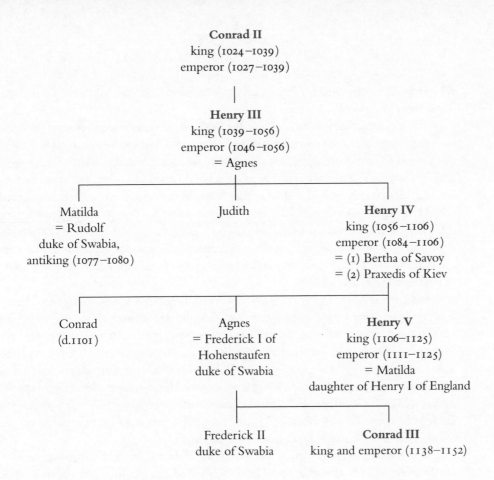

Conrad II
king (1024–1039)
emperor (1027–1039)

Henry III
king (1039–1056)
emperor (1046–1056)
= Agnes

Matilda
= Rudolf
duke of Swabia,
antiking (1077–1080)

Judith

Henry IV
king (1056–1106)
emperor (1084–1106)
= (1) Bertha of Savoy
= (2) Praxedis of Kiev

Conrad
(d.1101)

Agnes
= Frederick I of
Hohenstaufen
duke of Swabia

Henry V
king (1106–1125)
emperor (1111–1125)
= Matilda
daughter of Henry I of England

Frederick II
duke of Swabia

Conrad III
king and emperor (1138–1152)

or alienate it, or diminish it, or exchange it, or give it as a benefice to any one, or constitute any prelate over them against their will.[6]

Genealogy 5.3 The Salian Kings and Emperors

Cluny's prestige was great because of the influence of its founders, the status of Saint Peter, and the fame of the monastery's elaborate round of prayers. The Cluniac monks fulfilled the role of "those who pray" in dazzling manner. Through their prayers, they seemed to guarantee the salvation of all Christians. Rulers, bishops, rich landowners, and even serfs (if they could) gave Cluny donations of land, joining their contributions to the land of Saint Peter. Powerful men and women called on the Cluniac abbots to reform new monasteries along the Cluniac model.

The abbots of Cluny came to see themselves as reformers of the world as well as the cloister: priests should not have wives; powerful laymen should cease their oppression of the poor. In the eleventh century, the Cluniacs began to link their program to the papacy.

6 *Cluny's Foundation Charter*, in *A Short Medieval Reader*, ed. Barbara H. Rosenwein (Toronto: University of Toronto Press, 2023), pp. 98–104 and in *Reading the Middle Ages*, pp. 184–87.

When they disputed with bishops or laypeople about lands and rights, they called on the popes to help them out.

The popes were ready to do so. A parallel movement for reform had entered papal circles via a small group of influential monks and clerics. Mining canon (Church) law for their ammunition, these churchmen emphasized two abuses: nicolaitism (clerical marriage) and simony (buying Church offices). There were good reasons to single out these two issues. Married clerics were considered less "pure" than those who were celibate; furthermore, their heirs might claim Church property. As for simony: the new profit economy sensitized reformers to the crass commercial meanings of gifts. It was wrong, even heretical (they asserted), for a priest to accept payment for administering a sacrament such as baptism; it was evil and damnable for a man to offer money to gain a bishopric. These were attempts to purchase the Holy Spirit.

Initially, the reformers got imperial backing. German king and emperor Henry III (r.1039–1056) thought that, as the anointed of God, he was responsible for the well-being of the Church in the Empire. (For Henry and his dynasty, see Genealogy 5.3 on p. 181.) Henry denounced simony and personally refused to accept money or gifts when he appointed bishops to their posts. He presided over the Synod of Sutri (1046), which deposed three papal rivals and elected another. When that pope and his successor died, Henry appointed Bruno of Toul, a member of the royal family, seasoned courtier, and reforming bishop. Taking the name Leo IX (1049–1054), the new pope surprised his patron: he set out to reform the Church under papal, not imperial, control.

Leo revolutionized the papacy. He had himself elected by the "clergy and people" to satisfy the demands of canon law. Unlike earlier popes, he often left Rome to preside over Church councils and make the pope's influence felt outside Italy, especially in France and Germany. Leo brought to the papal curia the most zealous Church reformers of his day: Peter Damian, Hildebrand of Soana (later Pope Gregory VII), and Humbert of Silva Candida. They put new stress on the passage in Matthew's Gospel (Matt. 16:19) in which Christ tells Peter that he is the "rock" of the Church, with the keys to heaven and the power to bind (impose penance) and loose (absolve from sins). As the successor to the special privileges of Saint Peter, the Roman Church, headed by the pope, was declared the "head and mother of all churches." What historians call the doctrine of "papal primacy" was thus announced.

Its impact was soon felt at Byzantium. On a mission at Constantinople in 1054 to forge an alliance with the emperor against the Normans and, at the same time, to "remind" the patriarch of his place in the Church hierarchy, Humbert ended by excommunicating the patriarch and his followers. In retaliation, the patriarch excommunicated Humbert and his fellow legates. Clashes between the Roman and Byzantine Churches had occurred before and had been patched up, but this one, though not recognized as such at the time, marked a permanent schism. After 1054, the Roman Catholic and Greek Orthodox Churches largely went their separate ways.

More generally, the papacy began to wield new forms of power. It waged unsuccessful war against the Normans in southern Italy and then made the best of the situation by

granting them parts of the region and Sicily as well as a fief, turning former enemies into vassals. It supported the Christian push into the *taifas* of al-Andalus, and Pope Alexander II (1061–1073) transformed the "*reconquista*" (the conquest of Islamic Spain) into a holy war when he forgave the sins of the Christians on their way to the battle of Barbastro.

The Investiture Conflict and Its Effects

The papal reform movement is associated particularly with Pope Gregory VII (1073–1085), hence the term "Gregorian Reform." A passionate advocate of papal primacy, Gregory was not afraid to clash directly with the king of Germany, Henry IV (r. 1056–1106), over Church leadership. In Gregory's view – an astonishing one at the time, given the religious and spiritual roles associated with rulers – kings and emperors were simple laymen who had no right to meddle in Church affairs. Henry, on the other hand, brought up in the traditions of his father, Henry III, considered it part of his duty to appoint bishops and even popes to ensure the well-being of Church and Empire together.

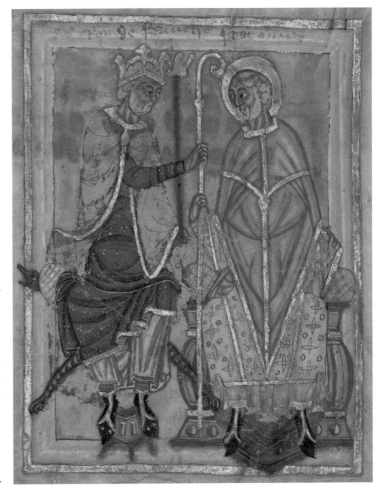

Plate 5.6 A King Invests a Bishop (*c.* 1100). In this manuscript made at Saint-Omer, a monastery named after Merovingian Saint Audomar in the region between Belgium and France today, King Dagobert is shown giving the saint a pastoral staff, the emblem of his ecclesiastical duty as the "shepherd" of his "flock." Though the monk-artist was painting this right in the middle of the Investiture Conflict and its reform ideas, he drew tranquilly on older practices. The fact that the king is slightly higher than the saint even suggests that he has greater dignity.

The pope and the king first collided over the appointment of the archbishop of Milan. Gregory disputed Henry's right to "invest" the archbishop (i.e., put him into his office). In the investiture ritual, the emperor or his representative symbolically gave the church and the land that went with it to the bishop or archbishop chosen for the job. (See Plate 5.6.) In the case of Milan, two rival candidates for archiepiscopal office (one supported by the pope, the other by the emperor) had been at loggerheads for several years when, in 1075, Henry invested a new man. Gregory immediately called on Henry to "give more respectful attention to the master of the Church," namely Saint Peter and his living representative – Gregory himself![7] In reply, Henry and the German bishops called on Gregory, that "false monk," to resign.[8] This was the beginning of what historians delicately call

7 Gregory VII, *Admonition to Henry IV*, in *A Short Medieval Reader*, pp. 131–33 and in *Reading the Middle Ages*, pp. 251–53.

8 Henry IV, *Letter to Gregory VII*, in *A Short Medieval Reader*, pp. 134–35 and in *Reading the Middle Ages*, pp. 253–54.

the "Investiture Conflict" or "Investiture Controversy." In fact, it was war. In February 1076, Gregory convened a synod that both excommunicated Henry and suspended him from office:

> I deprive King Henry [IV], son of the emperor Henry [III], who has rebelled against [God's] Church with unheard-of audacity, of the government over the whole kingdom of Germany and Italy, and I release all Christian men from the allegiance which they have sworn or may swear to him, and I forbid anyone to serve him as king.[9]

The last part of this decree gave it real punch: anyone in Henry's kingdom could rebel against him. The German "princes" – the aristocrats – seized the moment and threatened to elect another king. In part, they were motivated by religious sentiments, for many had established links with the papacy through their support of reformed monasteries. But they were also in part opportunists, glad to free themselves from the restraints of strong German kings who had tried to keep their power in check. Some bishops, too, joined with Gregory's supporters, a major blow to Henry, who needed the prestige and the troops that they supplied.

Attacked on all sides, Henry traveled in the winter of 1077 to intercept Gregory, barricaded in a fortress at Canossa, high in the Apennine Mountains. It was a refuge provided by the staunchest of papal supporters, Countess Matilda of Tuscany. (See Plate 5.7.) In an astute and dramatic gesture, the king dressed as a penitent, stripping himself of all the trappings of kingship. Standing barefoot outside the fortress walls, he suffered in the cold and snow for three days. Gregory was forced, as a pastor, to lift his excommunication and to receive Henry back into the Church, precisely as Henry intended. For his part, the pope had the satisfaction of seeing the king humiliate himself before the papal majesty. Although it made a great impression on contemporaries, the whole episode solved nothing. The princes elected an antiking, the emperor an antipope, and bloody civil war continued intermittently until 1122.

The Investiture Conflict ended with a compromise: the Concordat of Worms (1122). It relied on a conceptual distinction between two parts of investiture – the spiritual (in which the bishop-to-be received the symbols of his office) and the secular (in which he received the symbols of the material goods that would allow him to function in the world). Under the terms of the Concordat, the ring and staff, symbols of Church office, were to be given by a churchman in the first part of the ceremony. Then the emperor or his representative would touch the bishop with a scepter, signifying the land and other possessions that went with his office. Elections of bishops in Germany would take place "in the presence" of the emperor – that is, under his influence. In Italy, the pope would have a comparable role.

In the end, then, secular rulers continued to have a role in the appointment of churchmen. But just as the new investiture ceremony broke the ritual into spiritual and secular halves,

9 *Roman Lenten Synod*, in *The Correspondence of Pope Gregory VII: Selected Letters from the Registrum*, ed. and trans. Ephraim Emerton (New York: Columbia University Press, 1969), p. 91.

so too it implied a new notion of kingship separate from the priesthood. The Investiture Conflict did not produce the modern distinction between Church and State – that would develop only very slowly – but it set the wheels in motion. At the time, its most important consequence was to shatter the delicate balance between political and ecclesiastical powers in Germany and Italy. In Germany, the princes consolidated their lands and powers at the expense of the king. In Italy, the communes came closer to their goals: it was no accident that Milan gained its independence in 1097, as the conflict raged.

In every domain the papacy gained new authority. In Church law, papal primacy was enhanced by the publication *c.*1140 of the *Decretum*, written by a teacher of canon law named Gratian. Collecting nearly two thousand passages from the decrees of popes and councils as well as the writings of the Church Fathers, Gratian set out to demonstrate their essential agreement. In fact, the book's original title was *Harmony of Discordant Canons*. If he found any "discord" in his sources, Gratian usually imposed the harmony himself by arguing that the conflicting passages dealt with different situations. A bit later another legal scholar revised and expanded the *Decretum*, adding Roman law to the mix.

At a more intimate level, papal denunciations of married clergy made inroads on family life. While in the old heartland of the Carolingian Empire few eleventh-century priests were wed, the practice was fairly common in England, Normandy, and Italy. The Gregorian reformers were determined to end this, and they were eventually quite successful. For example, at Saint Paul's in England *c.*1100, even after a half-century push for reform, many of the canons (the priests who served the cathedral church) were married, and Church offices and their associated properties (prebends) passed from father to son. But thereafter the practice seems to have fallen off. Similarly, at Verona, "sons of priests" disappeared from the historical record in the twelfth century. Nevertheless, in some places, clerics resisted the call to repudiate their wives and children into the thirteenth century. While reformers might rail against the "lustful" women who tempted their priestly husbands to evil sin, other churchmen were glad to recognize and praise the help, piety, and benefactions of priest's wives.

As the papacy consolidated its territory, promulgated its laws and discipline, established an administrative bureaucracy, and set up collection agencies and law courts, it came to resemble the monarchs of its day.

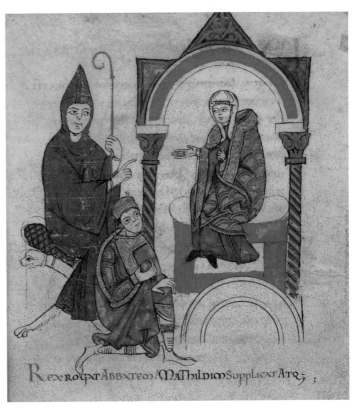

Plate 5.7 Henry IV Kneels before Countess Matilda (1115). This depiction of the confrontation at Canossa is among the illustrations in a *Life of Matilda* written by Donizo, monk and later abbot of Sant'Apollonio of Canossa. Donizo's account makes her the chief figure in the drama, since the king begs *her* pardon, not the pope's. Matilda is seated high on a throne and sheltered by a ciborium, an ornamental canopy. Henry IV, following the directive given him by his godfather Abbot Hugh of Cluny (1049–1109) (on the left), kneels before the countess, supplicating her favor and pardon. Matilda was a major supporter of Gregory VII, supplying both troops and finances to back him. Compare this image of royal power with that in Plate 5.6.

The First Crusade

It resembled them, too, in calling for wars. Monarchs might consider their wars "just"; popes could claim that *their* wars were "holy." In effect, Alexander II declared the *reconquista* in Spain to be holy when he forgave the sins of its soldiers. (See above, p. 183.) It was in the wake of this that the *taifa* rulers implored the Almoravids for help. When Byzantine Emperor Alexius asked Pope Urban II (1088–1099) for mercenaries to help retake Anatolia from the Seljuks, the pope responded by declaring a holy war to Jerusalem, the movement historians call the First Crusade. After attending a Peace Council in southern France, Urban called for a pious pilgrimage to the Holy Land to be undertaken by an armed militia. It would be commissioned like those of the Peace of God, but thousands of times larger. And it would fight under the leadership of the papacy. "Let your quarrels end," admonished Urban. "Let wars cease, and let all dissensions and controversies slumber. Enter upon the road to the Holy Sepulcher; wrest that land from the wicked race, and subject it to yourselves."[10]

What was that "wicked race"? Europeans adopted a catch-all word for it: Saracens. Originally referring to one group of Arabs living in the Sinai Peninsula, in Europe the term came to refer to all Muslims. By collapsing numerous factions, ethnicities, dynasties, and traditions into that simple word, Europeans created fertile soil at home for anti-Muslim racism to flourish. In a somewhat parallel development, Muslims came to call all crusaders *iFranj*, Franks.

The First Crusade (1096–1099) mobilized a force of some 100,000 people, including warriors, old men, bishops, priests, women, children, and hangers-on. Its armies were organized not as one military force but rather as separate militias, each authorized by Urban II and commanded by a different leader.

THE MASSACRE OF RHINELAND JEWS

Several unofficial bands were not authorized by the pope. Though called collectively the "Peasants' (or People's) Crusade," these irregular armies included nobles. They were inspired by popular preachers, especially the eloquent Peter the Hermit, who was described by chroniclers as small, ugly, barefoot, and – partly because of those very characteristics – utterly captivating. Starting out before the other armies, the Peasants' Crusade took a route to the Holy Land through the Rhineland in Germany.

This detour was no mistake. The crusaders were looking for "wicked races" closer to home: the Jews. Under Henry IV many Jewish settlers had gained a stable place within Germany, particularly in the prosperous cities that lined up along the Rhine River. The

10 Robert the Monk, *Pope Urban II Preaches the First Crusade*, in *A Short Medieval Reader*, pp. 136–38 and in *Reading the Middle Ages*, pp. 261–63.

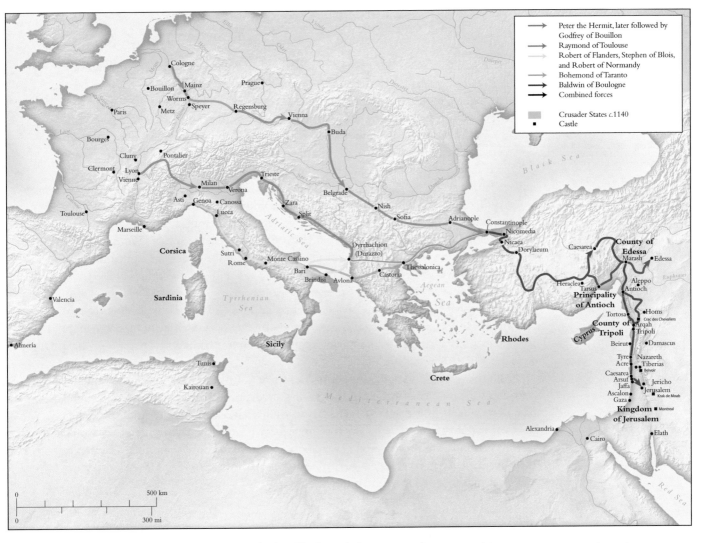

Legend:

→ Peter the Hermit, later followed by Godfrey of Bouillon
→ Raymond of Toulouse
→ Robert of Flanders, Stephen of Blois, and Robert of Normandy
→ Bohemond of Taranto
→ Baldwin of Boulogne
→ Combined forces
▨ Crusader States c.1140
■ Castle

Jews there received protection from the local bishops (often imperial appointees) in return for paying a tax.[11]

While scattered communities of Jews had lived in this region during the tenth century, they became clearly important players only in the eleventh. Established in their own neighborhoods within the cities, the Jews built synagogues to serve as schools, community centers, and places of worship, and they consecrated cemeteries to act as sites of communal and ancestral memories. Each community followed its own rules, based in part on Jewish learned tradition and in part on the norms of the Christians around them, and they and the

Map 5.5 The Mediterranean Region and the First Crusade

11 The Jews of this region in Germany and in northern France called themselves Ashkenazi, after one of the descendants of Noah. Gradually the term came to refer to most European Jews with the exception of those from Spain (the *Sefarad*). However, in the medieval period, the Jews also had many other and more precise terms to refer to various regional groups – e.g., Sicilians, Yemenites – and since medieval borders constantly shifted, even the notions of Ashkenaz and Sefarad were fluid.

bishops of each city negotiated the form of law that would be applied in their law court (*kehal*). Just as they adapted to their surrounding Christian community, so the Jews were much in demand by Christians for their skills as merchants and doctors – professions they and their ancestors had earlier plied in southern Italy, southern France, and Byzantium.

On the whole, the Rhineland Jews coexisted peacefully with their Christian neighbors until the First Crusade. Then the Peasants' Crusade, joined by some local nobles and militias from the region, threatened the "Jews," lumping them all together with this one now racialized word, no matter their differences. Giving them two bitter choices – forced conversion or death – some persecutors relented when their victims paid them money. Others, however, attacked. Beleaguered Jews occasionally found refuge with bishops or in the houses of Christian friends, but in many cities – Metz, Speyer, Worms, Mainz, and Cologne – they were massacred even so. "Even the bishop [of Mainz] fled from his church for it was thought to kill him also because he had spoken good things of the Jews," lamented chronicler Solomon bar Samson.[12]

Leaving the Rhineland, some of the irregular militias disbanded, while others sought to gain the Holy Land via Hungary, at least one stopping off at Prague to massacre more Jews there. Only a handful of these armies continued on to Anatolia, where most of them were quickly slaughtered.

From the point of view of Emperor Alexius at Constantinople, even the "official" crusaders were problematic. One of the crusade's leaders, the Norman warrior Bohemond, had, a few years before, tried to conquer Byzantium itself. Alexius got most of the leaders to swear that if they conquered any land previously held by the Byzantines, they would restore it; and if they conquered new regions, they would hold them from Alexius as their overlord. Then he shipped the armies across the Bosporus. (For the various armies and their routes, see Map 5.5 on p. 187.)

TAKING JERUSALEM

The main objective of the First Crusade – to conquer the Holy Land – was accomplished largely because of the disunity of the Islamic world and its failure to consider the crusade a serious military threat. Spared by the Turks when they first arrived in Anatolia, the crusaders' armies were initially uncoordinated and their food supplies uncertain, but soon they organized themselves. They set up a "council of princes" that included all the great crusade leaders, and the Byzantines supplied them with food at a nearby port. Surrounding Iznik (Nicaea) and besieging it with catapults and other war machines, the crusaders, along with a small Byzantine contingent, took the city on June 19, 1097. The city surrendered directly to Alexius, who rewarded the crusaders amply but also insisted that any leader who had not yet taken the oath to him do so.

12 Solomon bar Samson, *Chronicle*, in *A Short Medieval Reader*, pp. 138–40 and in *Reading the Middle Ages*, pp. 263–66.

However, the crusaders soon forgot their promise to the Byzantines. While most went toward Antioch, which stood in the way of their conquest of Jerusalem, one leader went off to Edessa, where he took over the city and its outlying area, creating the first of the Crusader States: the County of Edessa. Meanwhile the other crusaders remained stymied before the thick and heavily fortified walls of Antioch for many months. Then, in a surprise turnabout, they entered the town but found themselves besieged by Muslim armies from the outside. Their mood grim, they rallied when a peasant named Peter Bartholomew reported that he had seen in many visions the Holy Lance that had pierced Christ's body – it was, he said, buried right in the main church in Antioch. (Antioch had a flourishing Christian population even under Muslim rule.) After a night of feverish digging, the crusaders believed that they had discovered the Holy Lance, and, fortified by this miracle, they defeated the besiegers.

From Antioch, it was only a short march to Jerusalem, though disputes among the crusade leaders delayed that next step for over a year. One leader claimed Antioch. Another eventually took charge – provisionally – of the expedition to Jerusalem. His way was eased by quarrels among Muslim rulers, and an alliance with one of them allowed free passage through what would have been enemy territory. In early June 1099, a large crusading force amassed before the walls of Jerusalem and set to work building siege engines.[13] In mid-July they attacked, breaching the walls and entering the city. Jerusalem was now in the hands of the crusaders.

RULERS WITH CLOUT

While the papacy was turning into a monarchy, other rulers – some of them women, such as Matilda of Canossa – were beginning to turn their territories into states. They discovered ideologies to justify their hegemony, hired officials to work for them, and found vassals and churchmen to support them.

The Crusader States

In the Holy Land, the leaders of the crusade set up four tiny states, European colonies in the Levant. Two (Tripoli and Edessa) were counties, Antioch was a principality, Jerusalem a kingdom. (See Map 5.5 again.) These (except for Edessa) lasted – tenuously – until the late thirteenth century (the last holdout fell in 1291). Many new crusades had to be called in the interval to shore them up. The whole region was multi-ethnic, multi-religious, and habituated to rule by a military elite, and the Crusader States (apart from the religion of

13 For siege engines, see "Reading through Looking," in *Reading the Middle Ages*, pp. XII–XIII, esp. Plate 8.

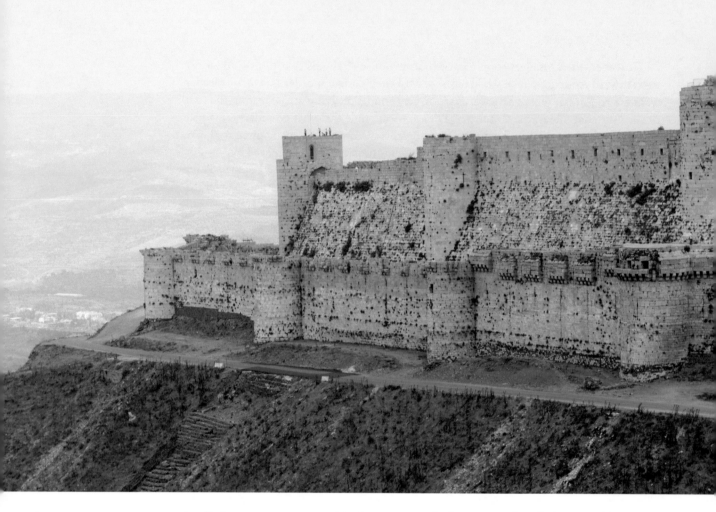

Plate 5.8 Crac des Chevaliers (12th and 13th cent.). This enormous castle, which housed a garrison of perhaps 2,000 men, was built in stages. An enclosure with defensive square towers and two gates was built before 1170. Within were vaulted chambers and a chapel. Earthquakes in 1170 and 1202 destroyed much of this structure and ushered in the busiest period of building, during which the castle took its present form. A huge outer circuit of walls surrounds the entire castle, which included halls, residences, and a chapel. The view here shows the aqueduct on the eastern side; it supplied water for drinking and

its elite) were no exception. Yet, however much they engaged with their neighbors, the Europeans in the Levant saw themselves as a world apart, holding on to their Western identity through their political institutions and the old vocabulary of homage, fealty, and Christianity.

The new rulers carved out estates to give as fiefs to their vassals, who, in turn, gave portions of their holdings in fief to their own men. Indigenous peasants continued to work the land as before, and commerce boomed as the new rulers encouraged lively trade at their coastal ports. Italian merchants, especially the Genoese, Pisans, and Venetians, were the most active, but others – Byzantines and Muslim traders – participated as well. Enlightened lordship dictated that the mixed population of the states – Muslims, to be sure, but also Jews, Greek Orthodox Christians, Monophysite Christians, and others – be tolerated for the sake of production and trade. Most Europeans had gone home after the First Crusade; those left behind were obliged to coexist with the inhabitants that remained. Eastern and Western Christians learned to share shrines, priests, and favorite monastic charities; when they came to blows, any violence tended to be local and sporadic.

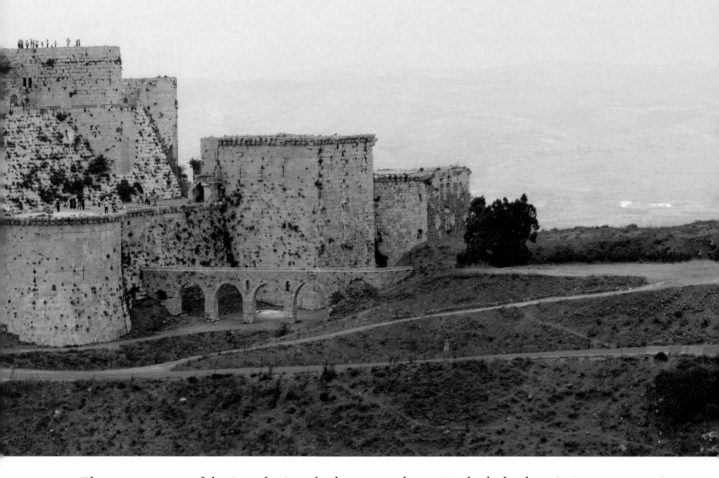

The main concerns of the Crusader States' rulers were military. Knights had to be recruited from Europe from time to time, and two new and militant forms of monasticism developed in the Levant: the Knights Templar and the Hospitallers. Both were vowed to poverty and chastity, yet devoted themselves to war at the same time. They defended the town garrisons of the Crusader States and ferried money from Europe to the Holy Land. Some of the castles that bristled in the Crusader States' countryside were constructed by these warrior-monks. One of the most impressive, and still standing, is Crac des Chevaliers, originally a simple fortification built by Muslims to fight the crusaders. It was taken, along with the fertile lands around it, by Count Raymond II of Tripoli in 1140, who granted both to the Hospitallers four years later. The stronghold was well situated to dominate the countryside, but it was also dangerously near Homs, which was under Islamic rule. Taking up the challenge, the Hospitallers proceeded to turn the originally modest structure into a model center of both defense and administration. (See Plate 5.8.)

Yet none of this could prevent Zangi, a Seljuk emir, from taking Edessa in 1144. The slow but steady shrinking of the Crusader States began at that moment. The Second Crusade (1147–1149), called in the wake of Zangi's victory, came to a disastrous end. After

for the moat. Jutting out from the wall at intervals are round towers – a very new shape for such structures. The archery slits in the turrets allowed bowmen to shoot in almost complete safety.

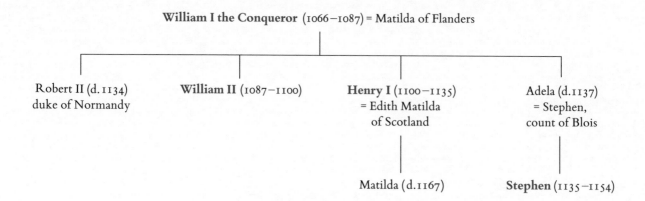

Genealogy 5.4 The Norman Kings of England

only four days of besieging the walls of Damascus, the crusaders, whose leaders could not keep the peace among themselves, gave up and went home.

England under Norman Rule

A more enduring conquest took place in England. Linked to the Continent by the Vikings, who had settled in its eastern half, England was further tied to Scandinavia under the rule of Cnut in the early eleventh century (see above, p. 149). But only when it was conquered by Duke William of Normandy (d. 1087) was it drawn inextricably into the Continental orbit. (See Map 5.6.)

When William left his duchy with a large army in the autumn of 1066 to dispute the crown of the childless King Edward the Confessor (r. 1042–1066), who had died earlier that year, he avowed that Edward had sworn on oath to leave the kingdom to him. Opposing his claim were Harald Hardrada, king of Norway, and Harold Godwineson, who had been crowned king of England the day after Edward's death. At Stamford Bridge in the north of England, Harold defeated the Norwegian king and then wheeled his army around to confront William at Hastings. That one-day battle was decisive, and William was crowned the first Norman king of England. (See Genealogy 5.4.)

Treating his conquest like booty (as rulers in the Crusade States would do a few decades later), William kept about 20 per cent of the land for himself and divided the rest, distributing it in large but scattered fiefs to a relatively small number of his barons – his elite followers – and to family members, lay and ecclesiastical, as well as to some lesser men, such as personal servants and soldiers. In turn, these men maintained their own vassals. They owed the king military service along with the service of a fixed number of their vassals; and they paid him certain dues, such as reliefs (money paid upon inheriting a fief) and aids (payments made on important occasions).

The king also collected land taxes, as English kings had done since the early eleventh century. To know what was owed him, in 1086 William ordered a survey of the land and

landholders of England. His officials consulted ancient tax lists and took testimony from locals, who were sworn to answer a series of formal questions truthfully. Compilers standardized the materials, using a shorthand vocabulary. Consider, by way of example, the entry for the manor of Diddington:

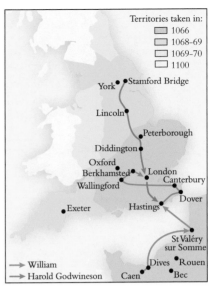

Map 5.6 The Norman Invasion of England, 1066–1100

> the bishop of Lincoln had 2½ hides to the geld. [There is] land for 2 ploughs. There are now 2 ploughs in demesne; and 5 villans having 2 ploughs. There is a church, and 18 acres of meadow, [and] woodland pasture half a league long and a half broad. TRE worth 60s; now 70s. William holds it of the bishop.[14]

This needs unpacking. The hides were units of tax assessment; the ploughs and acres were units of area; the leagues were units of length. The villans (sometimes spelled villeins) were one type of peasant (there were many kinds). Finally, the abbreviation TRE meant "in the time of King Edward." Anyone consulting the survey would know that the manor of Diddington was now worth more than it had been TRE. As for the William mentioned here: he was not William the Conqueror but rather a vassal of the bishop of Lincoln. No wonder the survey was soon dubbed "Domesday Book": like the records of people who will be judged at doomsday, it provided facts that could not be appealed. Domesday was the most extensive inventory of land, livestock, taxes, and people that had as yet been compiled anywhere in medieval Europe.

England and the Continent nearly merged. The new English barons who arrived with William spoke a brand of French; they talked more easily with the peasants of Normandy (if they bothered) than with those tilling the land in England. They maintained their estates on the Continent and their ties with its politics, institutions, and culture. English wool was sent to Flanders to be turned into cloth. The most brilliant intellect of his day, Saint Anselm of Bec (and Canterbury; 1033–1109), was born in Italy, became abbot of Bec, a Norman monastery, and was then appointed archbishop of Canterbury in England. English adolescent boys were sent to Paris and Chartres for schooling. The kings of England often spent more time on the Continent than they did on the island. When, on the death of King Henry I (r.1100–1135) no male descendent survived to take the throne, two counts from the Continent – Geoffrey of Anjou and Stephen of Blois – disputed it as their right through two rival females of the royal line, Matilda and Adela. (See Genealogy 5.4 again.)

Christian Spain and Portugal

While England was conquered in a day, the *reconquista* took centuries. (Then, again, Iberia is four and a half times as large as England!) It was a very lucrative enterprise, initially made possible by the disintegration of al-Andalus into weak and competitive *taifas*. The

14 *Domesday Book*, in *Reading the Middle Ages*, pp. 275–78.

fledgling Christian states in the north – León, Castile, Navarre, and Aragon – staged plundering raids, confiscated lands and cities, and (until the Almoravids put an end to it) collected tribute in gold from *taifa* rulers anxious to stave off attacks.

Nor were the northern states the only beneficiaries of these wars. When Rodrigo Díaz de Vivar, the Cid (from the Arabic *sidi*, lord), fell out of favor with his lord, Alfonso VI, king of Castile and León, he and a band of followers found employment with al-Mutamin, ruler of Zaragoza. There he defended the city against Christian and Muslim invaders alike. In 1090, he struck out on his own, conquering Valencia in 1094 and ruling there until his death in 1099. He was a Spaniard, but other opportunistic warriors sometimes came from elsewhere. In fact, Pope Alexander II's call to besiege Barbastro in 1064 appealed to knights from France.

Spain's French connections were symptomatic of a wider process: the Europeanization of Christian Spain. Initially the northern kingdoms were isolated islands of Visigothic culture. But already in the tenth century, pilgrims from France, England, Germany, and Italy clogged the roads to the shrine of Saint James (Santiago de Compostela; see Map 5.7), while in the eleventh century, monks from the French monastery of Cluny arrived to colonize Spanish cloisters. At the same time, Alfonso VI actively reached out beyond the Pyrenees. He cultivated ties with Cluny, doubling the annual gift of 1,000 gold pieces that his father, Fernando I, had given to the monks there in exchange for prayers for his soul. He also sought recognition from Pope Gregory VII as "king of Spain," and in return he imposed the Roman liturgy throughout his kingdom, stamping out traditional Visigothic music and texts.

In 1085 Alfonso made good his claim to be more than the king of Castile and León by conquering Toledo. This was the original reason why the Almoravids came to Spain, as we saw on p. 170. After Alfonso's death, his daughter, Queen Urraca (r. 1109–1126), ruled in her own right a realm larger than England. Her strength came from the usual sources: control over land, which, though granted out to counts and others, was at least in theory revocable; Church appointments; a court of great men to offer advice and give their consent; and an army to which all men – even arms-bearing slaves – were liable to be called up once a year.

In the wake of Almoravid victories, however, two new Christian states, Aragon-Catalonia and Portugal, began to challenge the supremacy of Castile and León. Aragon had always been a separate entity, but Portugal was the creation of Alfonso VI himself. As king of León, he ruled over the county of Portugal (the name came from Portucalia: land of ports), and in 1095 he granted his rights there to his illegitimate daughter Teresa and her husband, Henry of Burgundy. They became the first count and countess of Portugal as Alfonso's vassals. But their son, Count Afonso Henriques, chafed under the lordship of León, took the title of prince of Portugal in 1129, and began to encroach on Islamic territory to his south. In 1139 he defeated the Almoravids at the battle of Ourique and took the title of king of Portugal as Afonso I.

The continuing pressure of the *reconquista*, together with fierce opposition from a new group in the Maghrib – the Almohads – ended in the defeat of the Almoravids *c.*1150–*c.*1175.

Praising the King of France

Not all rulers had opportunities for grand conquest. Yet they survived and even prospered. Such was the case of the kings of France. Reduced to battling a few castles in the vicinity of the Ile-de-France (see Map 5.3 on p. 176), the Capetian kings nevertheless wielded many of the

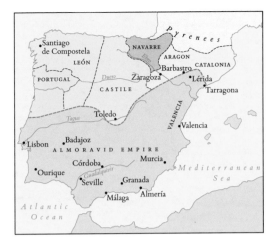

Map 5.7 The Iberian Peninsula, *c.*1140

same instruments of power as their conquering contemporaries: vassals, taxes, commercial revenues, military and religious reputations. Louis VI the Fat (r.1108–1137), so heavy that he had to be hoisted onto his horse by a crane, was nevertheless a tireless defender of royal power. (See Genealogy 5.5.)

Louis's virtues were amplified and broadcast by his biographer, Suger (1081–1151), the abbot of Saint-Denis, a monastery just outside Paris. A close associate of the king, Suger was his chronicler and propagandist. When Louis set himself the task of consolidating his rule in the Ile-de-France, Suger portrayed the king as a righteous hero. He was more than a lord with rights over the French nobles as his vassals; he was (asserted Suger) a peacekeeper with the God-given duty to fight unruly strongmen. Careful not to claim that Louis was head of the Church, which would have scandalized the papacy and its supporters, Suger nevertheless emphasized Louis's role as a vigorous protector of the faith and insisted on the sacred importance of the royal dignity.

When Louis died in 1137, Suger's notion of the might and right of the king of France reflected reality in an extremely small area. Nevertheless, Louis and his propagandist laid the groundwork for the gradual extension of royal power. As the lord of vassals, the king could call upon his men to aid him in times of war (though the great ones might refuse). As king and landlord, he collected dues and taxes with the help of his officials. Revenues came from Paris as well, a thriving commercial and cultural center. With money and land, Louis employed civil servants while dispensing the favors and giving the gifts that added to his prestige and power.

NEW FORMS OF LEARNING AND RELIGIOUS EXPRESSION

The commercial revolution and rise of urban centers, the newly reorganized Church, close contact with the Islamic world, and the revived polities of the early twelfth century paved

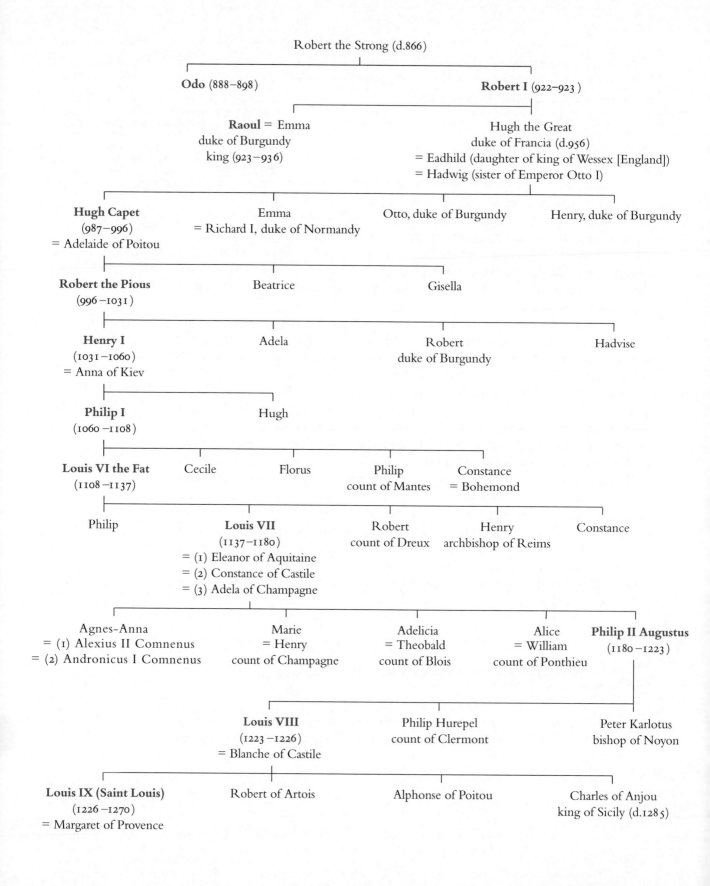

Robert the Strong (d.866)

Odo (888–898) **Robert I** (922–923)

Raoul = Emma Hugh the Great
duke of Burgundy duke of Francia (d.956)
king (923–936) = Eadhild (daughter of king of Wessex [England])
 = Hadwig (sister of Emperor Otto I)

Hugh Capet Emma Otto, duke of Burgundy Henry, duke of Burgundy
(987–996) = Richard I, duke of Normandy
= Adelaide of Poitou

Robert the Pious Beatrice Gisella
(996–1031)

Henry I Adela Robert Hadvise
(1031–1060) duke of Burgundy
= Anna of Kiev

Philip I Hugh
(1060–1108)

Louis VI the Fat Cecile Florus Philip Constance
(1108–1137) count of Mantes = Bohemond

Philip **Louis VII** Robert Henry Constance
 (1137–1180) count of Dreux archbishop of Reims
 = (1) Eleanor of Aquitaine
 = (2) Constance of Castile
 = (3) Adela of Champagne

Agnes-Anna Marie Adelicia Alice **Philip II Augustus**
= (1) Alexius II Comnenus = Henry = Theobald = William (1180–1223)
= (2) Andronicus I Comnenus count of Champagne count of Blois count of Ponthieu

 Louis VIII Philip Hurepel Peter Karlotus
 (1223–1226) count of Clermont bishop of Noyon
 = Blanche of Castile

Louis IX (Saint Louis) Robert of Artois Alphonse of Poitou Charles of Anjou
(1226–1270) king of Sicily (d.1285)
= Margaret of Provence

the way for the growth of urban schools and new forms of religious expression in Europe. Money, learning, and career opportunities attracted many to city schools.

At the same time, some people rejected urbanism and the new-fangled scholarship it supported. They retreated from the world to seek poverty and solitude. Yet the new learning and the new money had a way of seeping into the cracks and crannies of even the most resolutely separate institutions.

Genealogy 5.5 (facing page)
The Capetian Kings of France

The New Schools and What They Taught

Connected to monasteries and cathedrals since the Carolingian period, traditional schools had trained young men to become monks or priests. Some were better endowed than others with books and teachers; a few developed reputations for particular expertise. By the end of the eleventh century, the best schools were generally connected to cathedrals in the larger cities: Reims, Paris, Bologna, Montpellier. But some teachers (or "masters," as they were called), such as the charismatic and brilliant Peter Abelard (1079–1142), simply set up shop by renting a room. Students flocked to his lectures.

What the students sought, in the first place, was knowledge of the seven liberal arts. Grammar, rhetoric, and logic (or dialectic) belonged to the "beginning" arts, the so-called trivium. Grammar and rhetoric focused on literature and writing. Logic – involving the technical analysis of texts as well as the application and manipulation of arguments – was a transitional subject leading to the second, higher part of the liberal arts, the quadrivium. This covered four areas of study that would today be called theoretical math and science: arithmetic (number theory), geometry, music (theory rather than practice), and astronomy. Of these arts, logic had pride of place in the new schools, while masters and students who studied the quadrivium generally did so outside of the classroom.

Scholars looked to logic to clarify what they knew and lead them to further knowledge. Nearly everyone believed that God existed. But a scholar like Anselm (whom we met above as archbishop of Canterbury, p. 193), was not satisfied by belief alone. His faith, as he put it, "sought understanding." He emptied his mind of all concepts except that of God; then, using the tools of logic, he proved God's very existence in his *Monologion*.

In Paris a bit later, Peter Abelard declared that "nothing can be believed unless it is first understood." He drew together conflicting authoritative texts on 158 key subjects in his *Sic et Non* (Yes and No). The issues that he dealt with included matters of belief, such as "That God is one and the contrary," and of morality, such as, "That it is permitted to kill men and the contrary." Leaving the propositions unresolved, Abelard prefaced his book with techniques for critical reading. The easiest way to reconcile different authorities, he advised, was "to admit that the same words are given different meanings by different authors."[15] He offered other, more complex techniques as well. Soon Peter Lombard (*c.*1100–1160) adopted Abelard's method of juxtaposing discordant viewpoints, but he also

15 Peter Abelard, *Sic et Non*, in *A Short Medieval Reader*, pp. 142–44.

supplied his own resolutions. In this way, he created the most widely read theology text-book of the Middle Ages: the *Four Books of Sentences*.

Although logic was the tool that scholars such as Abelard and Peter Lombard considered crucial to solving the issues of their day, they had little access to the most systematic work on the topic, the treatises of Aristotle (d.323 BCE). Aristotle wrote in Greek, which Western Christians could not read. In the Islamic world, by contrast, Aristotle's works had not only been translated into Arabic but also commented upon by scholars such as Ibn Sina (Avicenna; 980–1037) (see above, p. 133) and Ibn Rushd (Averroes; 1126–1198). So, towards the end of the twelfth century and extending into the thirteenth, Western scholars traveled to Islamic or formerly Islamic cities – Toledo in Spain, Palermo in Sicily – to learn from Arabic as well as Hebrew translators and to arrive at workable Latin versions of Aristotle. In the course of the thirteenth century, Aristotle's works became the primary philosophical authority for the scholars of medieval European universities, known as the "scholastics."

The lofty subjects of the schools had down-to-earth, practical consequences in training preachers and advising rulers. They were written down in manuals for priests, textbooks for students, and guides for laypeople. Particularly important for "rulers with clout" were the scholars at Bologna, where Gratian worked on canon law. Other scholars achieved fame by teaching and writing about Roman law. By the mid-twelfth century, they had made real progress toward a systematic understanding of Justinian's law codes (see above, p. 31). The lawyers who emerged from the school at Bologna went on to serve popes, bishops, kings, princes, or communes. In this way, the learning of the schools was used by the newly powerful twelfth-century states, preached in the churches, and consulted in the courts.

Monastic Splendor and Poverty

Even as schools drew young men to them in droves, monasteries continued to exert their own magnetic pull. In the twelfth century they proliferated and took on new forms. There were "old-fashioned" Benedictine houses that continued to prosper – Cluny was a good example of that. Filled with many monks, model for numerous other monasteries both near and far, leader of an "order" of houses that were expected to coordinate their way of life with that of the "mother house," Cluny itself was a miniature city enclosed in walls. Under Abbot Hugh (1049–1109) its church was the largest in Christendom. The monastery had a refectory where the monks ate, a dormitory where they slept, a "chapter room" where they read the Benedictine Rule, an infirmary for the sick, and many other structures built so as to form a square around an open "cloister," lush and green, a taste of paradise. The whole purpose of this complex was to allow the monks to carry out a life of beautiful, arduous, and nearly continuous prayer. Every detail of their lives was ordered, every object splendid, every space adorned to render due honor to the Lord of heaven.

But not all medieval people agreed that such extravagance pleased or praised God. At the end of the eleventh century, the new commercial economy and the profit motive that fueled it led many to reject wealth and to embrace poverty as a key element of the religious

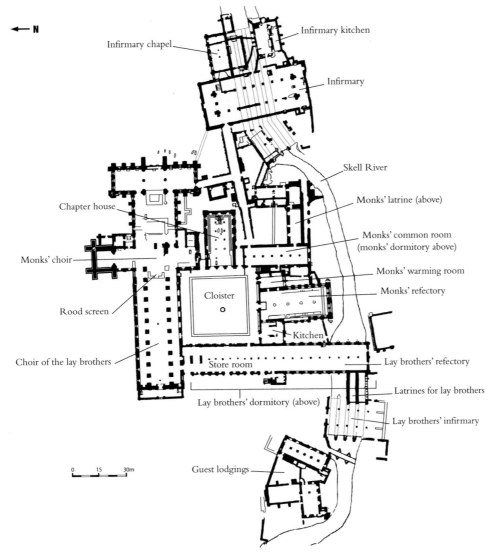

Figure 5.1 Plan of Fountains Abbey, a Cistercian Monastery Founded 1132

← N

Infirmary chapel

Infirmary kitchen

Infirmary

Skell River

Monks' latrine (above)

Chapter house

Monks' common room (monks' dormitory above)

Monks' warming room

Monks' choir

Monks' refectory

Cloister

Rood screen

Kitchen

Choir of the lay brothers

Store room

Lay brothers' refectory

Latrines for lay brothers

Lay brothers' dormitory (above)

Lay brothers' infirmary

0 15 30m

Guest lodgings

life. The Carthusian order, founded by Bruno of Cologne (d. 1101), represented one such movement. La Grande Chartreuse, the chief house of the order, was built in an Alpine valley, lonely and inaccessible. Each monk took a vow of silence and lived as a hermit in his own small hut. Only occasionally would the monks join for prayer in a common oratory. When not engaged in prayer or meditation, the Carthusians copied manuscripts: in their view, scribal work was a way to preach God's word with the hands rather than the mouth. Slowly the Carthusian order grew, but each monastery was limited to only twelve monks, the number of Christ's Apostles.

Another new monastic group proclaiming poverty as its watchword was the Cistercians. The first Cistercian house was Cîteaux (in Latin, *Cistercium*), founded in 1098 by Robert of Molesme (d. 1111) and a few other monks seeking a more austere way of life. Austerity they found – and also success. With the arrival of Saint Bernard (*c.* 1090–1153), who came to

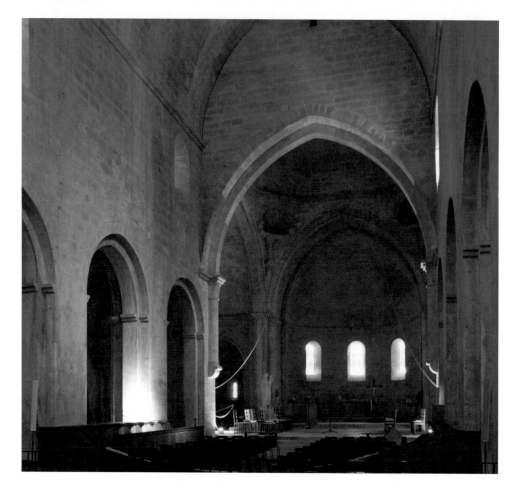

Plate 5.9 Sénanque Monastery Church, Interior (*c.*1160). Because of the geography of the valley where the monastery was constructed, the church is oriented so that the "north" end takes the usual place of the "east."

Cîteaux in 1112 along with about thirty friends and relatives, the original center sprouted a small congregation of houses in Burgundy. (Bernard became abbot of one of them, Clairvaux.) The order grew, often by reforming and incorporating existing monasteries. By the mid-twelfth century there were more than 300 Cistercian monasteries. Many were in France, but some were in Italy, Germany, England, Austria, and Spain. By the end of the twelfth century, the Cistercians were an order: their member houses adhered to the decisions of a General Chapter; their liturgical practices and internal organization were standardized. Many nuns, as eager as monks to live the life of simplicity and poverty that the Apostles had endured and enjoyed, adopted Cîteaux's customs, and some convents later became members of the order.

Although the Cistercians claimed the Benedictine Rule as the foundation of their customs, they elaborated a style of life and an aesthetic all their own. Dividing the tasks of the monastery into two kinds, they had the manual labor done by illiterate "lay brothers," while the "work of God" – prayer – was performed by the others. This made the Cistercian monastery a house divided (see Figure 5.1). While built around a cloister (like other Benedictine houses), the Cistercian plan relegated the western half to the lay brothers, while the eastern part was reserved for the "choir" monks. Each half had its

own dining room, latrines, dormitories, and infirmaries. The two sorts of monks were strictly separated from each other, even in the church, where a rood screen kept them from seeing one another.

In general, the lifestyle of the Cistercians was governed by the goal of simplicity. All their churches were dedicated to one saint, Mary, the mother of God and model of perfect love. All of their liturgy was simplified, eliminating the many additions that had been tacked on to the daily prayers of monks at Cluny, where the whole day was spent chanting and celebrating Masses. Only one daily Mass, only the prayers in the Rule: that was the Cistercian ideal. They rejected the conceit of dyeing their robes – hence their nickname, the "white monks." Their insistence on simplicity translated into the appearance of their churches as well. Plate 5.9 shows the nave of Sénanque, a French monastery begun in 1139. Although very plain, the articulation of the pillars and arches and the stone molding that gently breaks the vertical thrust of the vault lend the church a sober charm.

Yet their spiritual lives were not simple at all. Rather, they enlisted all their emotions and senses into understanding and exploring God's love for them and theirs for God. Historians have dubbed this "affective piety." Meditating on the life of Christ, they rejoiced and wept as the story unfolded. They longed to be welcomed as "brides" into the Lord's bedchamber. They did not hesitate to use maternal imagery to describe the nurturing care provided to humans by Jesus himself.

Plasticity vs Simplicity in Art and Architecture

"Romanesque" churches aimed at glorifying God. Most did so richly and grandly. But some, inspired by the new emphasis on simplicity, shunned all but the most basic motifs.

MAGNIFICENT ROMANESQUE

The size and splendor of the church at Cluny was meant to showcase both the solemn intoning of the chant and the honor due to God. Its architectural style, called Romanesque, represents the first wave of European monumental building. Constructed of stone or brick clad with stone, Romanesque edifices – whether cathedrals or monastic churches – were echo chambers for the sound of prayers. Massive, weighty, and dignified, they were often enlivened by sculpture, wall paintings, or patterned textures.

The Italian cathedral at Modena (see Map 5.3 on p. 176), begun in 1099, may serve as a case study of Romanesque architecture and sculpture. We have already seen a bit of this church when viewing the sculptor depicted in Plate 5.5 (on p. 179). The building as a whole is an impressive work both in conception and execution. The decision to replace an earlier, more modest church was made by the leading citizens of the city, and they and the canons (priests) connected to the cathedral chose master architect Lanfranco to build it, while its initial sculptures were the work of Wiligelmo, who inscribed his name near the central door on the west end.

Plate 5.10 Modena Cathedral, Interior (early 12th–14th cent.). The chief impression is of solidity and strength, made slightly less intimidating by the triforium and clerestory. Note the importance of the round arches that open onto the side aisles.

Plate 5.11 (facing page) Modena Cathedral, West Facade (early 12th cent. with 13th-cent. additions). The rose window and the jutting porch supported by lions were added to this otherwise early twelfth-century facade created by Lanfranco and Wiligelmo. The sculpted panels tell the sacred story, starting on the far left with creation (Plate 5.12). It continues (at the left of the central door) with the expulsion from the garden and (at the right of the central door) the murder of Cain. The sequence ends (above the far right door) with the landing of Noah's ark.

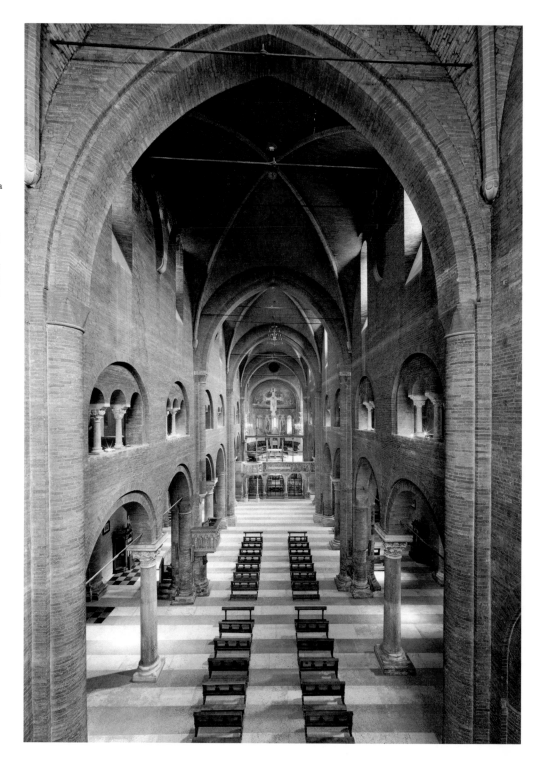

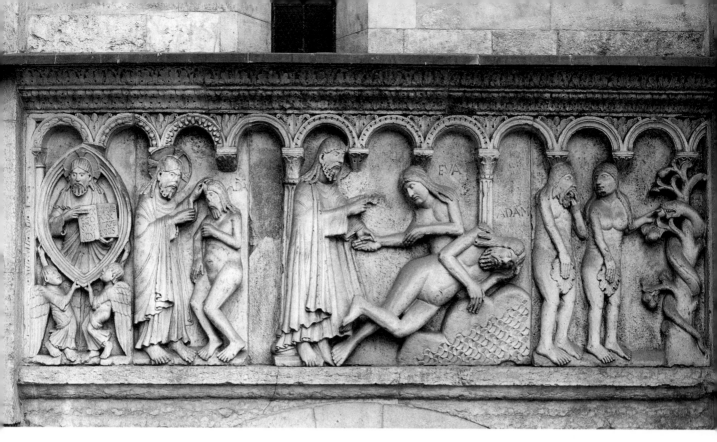

Plate 5.12 Adam and Eve, Modena Cathedral (early 12th cent.). God the Creator, holding a book that says "I am the light of the world, the true way, eternal life," creates Adam and then (as Adam sleeps) pulls Eve out of the side of his swollen belly. At the right Adam bites into the apple; already he and Eve feel shame at their nakedness and cover their genitals. To see how closely the sculptor observed ancient and late antique precedents, compare the deep and anatomically expressive carving of this twelfth-century relief by Wiligelmo with the figures on the cinerary coffer of Vernasia Cyclas in Plate 1.3 on p. 16 or those on the sarcophagus of the Twelve Apostles in Plate 1.9 (p. 22).

Figure 5.2 shows the main features of Modena cathedral and, by extension, of other Romanesque churches. It boasts three stories: the first is delineated by an arcade of arches, the second by the triforium (here round arches delicately bisected in three by thin pillars), and the third level is the clerestory, which lets in the light of the sun. The whole sets up an undulating horizontal rhythm marked by the curves of the triforium, which continue all around the church. The curves are repeated by the round arcades, which extend the length of the nave and are held up by graceful pillars topped by carved "capitals" that look like fancy hats.

Countering these horizontal thrusts are suggestions of upward movement, as heavy walls are progressively pierced by openings. Consider the Modena campanile, a feature of most Italian churches. Here the lower tiers are "blind arcades" behind which is pure masonry. But the viewer's eye is inexorably drawn upward as the tower's walls gradually sprout windows.

The most characteristic aspect of Romanesque churches are their round "tunnel" vaults (see Plate 5.10), though by the time the vault at Modena was finished, the "pointed" arches of Gothic style had become fashionable. Even so, as in all Romanesque churches, here too the viewer's eye is drawn toward the east, where the altar is located, rather than upward.

Much of the interior of this Romanesque church is anticipated on the exterior, which alerts the visitor to the three-part division of nave and flanking side aisles and the triforium level. (See Plate 5.11.) The sculptures on four panels flanking both sides of the central portal and above each of the side doors were carved by Wiligelmo, who was clearly inspired by classical Roman models. (See Plate 5.12.)

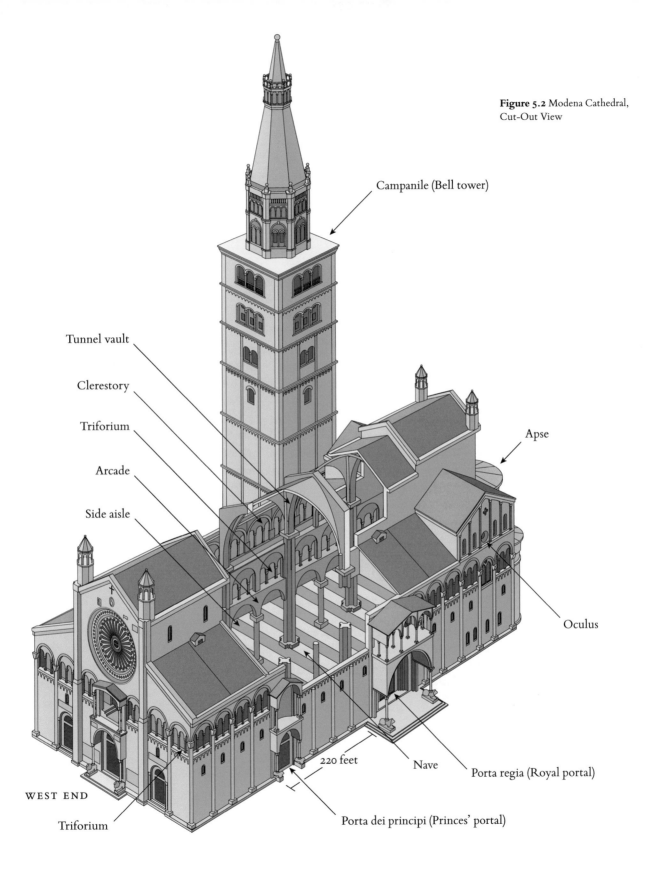

Figure 5.2 Modena Cathedral, Cut-Out View

Campanile (Bell tower)

Tunnel vault

Clerestory

Triforium

Arcade

Side aisle

Apse

Oculus

WEST END

Triforium

220 feet

Nave

Porta regia (Royal portal)

Porta dei principi (Princes' portal)

Cistercian Plainness

By contrast with Modena's splendor, yet equally "Romanesque," Cistercian churches were simple and devoid of ornament. Foursquare and regular, they were small and constructed of smooth-cut, undecorated stone. Any sculpture was modest at best. Yet the very simplicity of their buildings radiated a quiet sort of beauty. Illuminated by the pure white light that came through clear glass windows, Cistercian churches were luminous, cool, and serene. (See Plate 5.9 on p. 200.)

<p align="center">★ ★ ★ ★ ★</p>

In the eleventh and twelfth centuries, the Seljuk Turks and Berber Almoravids reconfigured the geography of the Islamic world and put their stamp on religion by affirming Sunnism. Byzantium, badly maimed by the Seljuks on its eastern flank, hoped to recoup its losses by calling on the papacy to help man its army. The papacy, however, had its own agenda. Invigorated by the Investiture Conflict, it called for an armed pilgrimage to the east that would both ensure peace in Europe and Christian control over regions that suddenly did not seem so far away.

Women partook in this seemingly all-male world in ways large and small. Countess Matilda, key to the success of Gregory VII, was also deeply involved in the building of the cathedral of Modena, which lay in her territory. Other women took advantage of the new learning of the schools; Abelard fell in love with one of the best-educated women of his day, Heloise, who shared in his philosophical breakthroughs. Other women partook in the new religious fervor of the era, and women's reformed monasteries proliferated at the same time as those of men. Women were involved in the crusades – as wives, as prostitutes, as suppliers of retinues, and as members (though probably not as warriors) of the military orders. But in the next century they, like so many others, found themselves increasingly silenced by sometimes overwhelming forces of conformity and intolerance.

For practice questions about the text, maps, plates, and other features – plus suggested answers – please go to

www.utphistorymatters.com

There you will also find all the maps, genealogies, and figures used in the book.

FURTHER READING

Barrow, Julia. *The Clergy in the Medieval World: Secular Clerics, Their Families and Careers in North-Western Europe, c.800–c.1200.* Cambridge: Cambridge University Press, 2015.

Bennison, Amira K. *The Almoravid and Almohad Empire.* Edinburgh: Edinburgh University Press, 2016.

Berzock, Kathleen Bickford, ed. *Caravans of God, Fragments in Time: Art, Culture, and Exchange across Medieval Saharan Africa.* Princeton, NJ: Princeton University Press, 2019.

Bom, Myra Miranda. *Women in the Military Orders of the Crusades.* New York: Palgrave Macmillan, 2012.

Catlos, Brian A. *Muslims of Medieval Latin Christendom, c.1050–1614.* Cambridge: Cambridge University Press, 2014.

Christie, Niall. *Muslims and Crusaders: Christianity's Wars in the Middle East, 1095–1382, from the Islamic Sources.* London: Routledge, 2014.

Cobb, Paul M. *The Race for Paradise: An Islamic History of the Crusades.* Oxford: Oxford University Press, 2014.

Freestone, Hazel. "Evidence of the Ordinary: Wives and Children of the Clergy in Normandy and England, 1050–1150." In *Anglo Norman Studies XLI: Proceedings of the Battle Conference 2018*, edited by Elizabeth van Houts, pp. 39–58. Suffolk, UK: Boydell & Brewer, 2019.

Gomez, Michael A. *African Dominion: A New History of Empire in Early and Medieval West Africa.* Princeton: Princeton University Press, 2018.

Griffiths, Fiona. "Froibirg Gives a Gift: The Priest's Wife in Eleventh-Century Bavaria." *Speculum* 96, no. 4 (2021): 1009–38.

Heng, Geraldine. *The Invention of Race in the European Middle Ages.* Cambridge: Cambridge University Press, 2018.

Jamroziak, Emilia. *The Cistercian Order in Medieval Europe, 1090–1500.* Abingdon, UK: Routledge, 2013.

Levtzion, Nehemia, and J.F.P. Hopkins, eds. *Corpus of Early Arabic Sources of West African History.* Princeton: Markus Wiener Publishers, 2000.

Little, Lester K. *Religious Poverty and the Profit Economy in Medieval Europe.* Ithaca, NY: Cornell University Press, 1978.

Miller, Maureen C., ed. *Power and the Holy in the Age of the Investiture Conflict: A Brief History with Documents.* Boston: Bedford, 2005.

Newman, Barbara. *Making Love in the Twelfth Century: "Letters of Two Lovers" in Context.* Philadelphia: University of Pennsylvania Press, 2016.

Nicholson, Helen J. *Knights Templar.* Amsterdam: Amsterdam University Press, 2021.

Nixon, Sam, ed. *Essouk-Tadmekka: An Early Islamic Trans-Saharan Market Town.* Leiden: Brill, 2017.

Peacock, A.C.S. *The Great Seljuk Empire.* Edinburgh: Edinburgh University Press, 2015.

Peacock, A.C.S, and Sara Nur Yildiz, eds. *The Seljuks of Anatolia: Court and Society in the Medieval Middle East.* London: I.B. Taurus, 2015.

Rubenstein, Jay. *The First Crusade: A Brief History with Documents.* Boston: Bedford/St. Martin's, 2015.

Yavari, Neguin. *The Future of Iran's Past: Nizam al-Mulk Remembered.* Oxford: Oxford University Press, 2018.

Yildiz, Sara Nur. *The Seljuk Empire of Anatolia.* Edinburgh: Edinburgh University Press, 2016.

SOURCES

PLATES

1.1 Photo by Luigi Spina. Reproduced by permission of the Ministero della Cultura–Parco Archeologico di Pompei.

1.2 Scala/Luciano Romano/Art Resource, NY.

1.3 Marble cinerary urn of Vernasia Cyclas. 1st century, marble. © The Trustees of the British Museum. All rights reserved.

1.4 The Society of Antiquaries of Newcastle upon Tyne/© Tyne & Wear Archives & Museums/ Bridgeman Images.

1.5 Votive Stele to Saturn. 2nd century CE. Limestone, 75 x 42 x 10.2 cm. Courtesy of Yale University Art Gallery.

1.6 Scala/Art Resource, NY.

1.7 © Archivio fotografico Civici Musei di Brescia–Fotostudio Rapuzzi.

1.8 "Orant" Fresco, SS. Giovanni e Paolo, Rome, view of confessio (late 4th c.). Reprinted by permission of the Ministero dell'Interno–Dipartimento per le Libertà civili e l'Immigrazione– Direzione Centrale per l'Amministrazione del Fondo Edifici di Culto.

1.9 Lanmas/Alamy Stock Photo.

1.10 © Trésor de l'Abbaye de Saint-Maurice. Photo by Jean-Yves Glassey and Michel Martinez.

1.11 Artur Bogacki/picfair.com.

1.12 Mihai Barbat/Alamy Stock Photo.

2.1 Cross from South Tympanum, Hagia Sophia. The Courtauld Institute of Art, London. Photograph by Ernest Hawkins. Reproduced by permission.

2.2 Islamic Arabic 1572a fol. 2r. Cadbury Research Library: Special Collections, University of Birmingham. Reproduced by permission.

2.3 Umayyad Mosque, Damascus, Syria. Photo © Andrea Jemolo/Bridgeman Images.

2.4 The Sutton Hoo helmet. Late 6th century–early 7th century, iron and copper alloy. 1939, 1010.93. © The Trustees of the British Museum. All rights reserved.

2.5 Reproduced by permission of The Board of Trinity College Dublin. Images may not be further reproduced from software. For reproduction, application must be made to the Head of Digital Collections, Trinity College Library Dublin.

2.6 Reproduced by permission of The Board of Trinity College Dublin. Images may not be further reproduced from software. For reproduction, application must be made to the Head of Digital Collections, Trinity College Library Dublin.

2.7 Reproduced by permission of The Board of Trinity College Dublin. Images may not be further reproduced from software. For reproduction, application must be made to the Head of Digital Collections, Trinity College Library Dublin.

2.8 Scala/Art Resource, NY.

2.9 Cameraphoto Arte, Venice/Art Resource, NY.

2.10 Janzig/Europe/Alamy Stock Photo.

2.11 *Spatha* (FG2187). Photograph © Germanisches Nationalmuseum. Reproduced by permission.

2.12 MS 32, fol. 35v. Courtesy of Utrecht University Library.

3.1 Werner Forman Archive/Bridgeman Images.

3.2 MS Grec 510, fol. 78r. Bibliothèque nationale de France.

3.3 Bowl with Persian inscription. AH 779/AD 1377. Stonepaste. Anonymous Gift, 1970. Courtesy of the Metropolitan Museum of Art, New York.

3.4 Panel (lid from a chest?), second half 8th century, wood (fig); mosaic with bone and four different types of wood, Samuel D. Lee Fund, 1937. Courtesy of the Metropolitan Museum of Art, New York.

3.5 eFesenko/Alamy Stock Photo.

3.6 © RMN-Grand Palais/Art Resource, NY.

3.7 Andromeda from the same MS as old 3.6 (MS Voss. lat. Q. 79, fol. 30v. 830s, Leiden, University Library). CC BY 4.0.

3.8 Arras, BM 0233 (1045), fol. 8, Media Library of the Abbey of Saint-Vaast. Courtesy of the Institut de recherche et d'histoire des textes.

3.9 MS 32, fol. 4v. Courtesy of Utrecht University Library.

4.1 Vitr/26/2, fol. 208v. Biblioteca Nacional de Madrid.

4.2 © Museum of Cultural History, University of Oslo, Norway. CC BY-SA 4.0.

4.3 T-S 12.338 (11). Reproduced by kind permission of the Syndics of Cambridge University Library.

4.4 Ivan Vdovin/Alamy Stock Photo.

4.5 akg-images/De Agostini Picture Library.

4.6 Detail from MS Vat. lat. 5729, fol. 342r. © 2022 Biblioteca Apostolica Vaticana.

4.7 Cotton MS Tiberius B V/1, fol. 3r. British Library, London, UK/Bridgeman Images.

4.8 MS 24, fol. 52v. Reproduced by permission of Bibliothek der Stadt Trier/Stadtarchiv Trier.

4.9 National Museum of Antiquities, Leiden (a 1913/11.223d).

4.10 MS Fr. 1586, fol. 23r. Bibliothèque nationale de France.

4.11 bpk Bildagentur/Herzog Anton Ulrich Museum/B.-P. Keiser/Art Resource, NY.

5.1 B. O'Kane/Alamy Stock Photo.

5.2 Uploaded by Sbuarchi. CC BY-SA 4.0. https://commons.wikimedia.org/wiki/File:Inner_view_of_north_dome_of_Isfahan_Jame_mosque.jpg.

5.3 CPA Media Pte Ltd/Alamy Stock Photo.

5.4 © Marie-Lan Nguyen. CC BY 4.0. https://commons.wikimedia.org/wiki/File:Stele_Almeria_Gao-Saney_MNM_R88-19-279.jpg.

5.5 Archivio fotografico del Museo Civico di Modena. Photo by Ghigo Roli.

5.6 Saint-Omer, BA, MS 698, fol. 7v. Reproduced by permission of Bibliothèque d'Agglomération du Pays de Saint-Omer.

5.7 MS Vat. lat. 4922, fol. 49r. © 2022 Biblioteca Apostolica Vaticana.

5.8 Sklifas Steven/Alamy Stock Photo.

5.9 Reproduced by permission of Stan Parry.

5.10 © Alinari Archives/Ghigo Roli/Art Resource, NY.

5.11 © Marage Photos/Bridgeman Images.

5.12 akg-images/De Agostini Picture Library/A. De Gregorio.

FIGURES

1.1 From Deborah Mauskopf Deliyannis, *Ravenna in Late Antiquity* (Cambridge: Cambridge University Press, 2010), fig. 78, p. 227. Reproduced with permission of Cambridge University Press through PLSclear.

2.2 Yeavering, Northumberland (also known as Ad Gefrin). Reconstruction drawing of Saxon Yeavering AD 627, by Peter Dunn (English Heritage Graphics Team). Historic England/Mary Evans.

3.1 Adapted from J.J. Norwich, ed., *Great Architecture of the World* (DeCapo, 2001), p. 133.

5.1 Adapted from Wolfgang Braunfels, *Monasteries of Western Europe: The Architecture of the Orders* (Princeton: Princeton University Press, 1972), p. 84. © Dumont Buchverlag GmbH.

MAPS

1.7 © Henri Galinie.

3.1 "Imperial Territory and the Themes, c. 917," from Mark Whittow, *The Making of Orthodox Byzantium, 600–1025*, p. 166. © Mark Whittow, 1996. Reproduced by permission of Red Globe Press, an imprint of Bloomsbury Publishing Plc.

4.1 Adapted from Linda Safran, *Heaven on Earth: Art and the Church in Byzantium* (University Park, PA: Penn State UP, 1998), Images 1.7 and 1.9 (pp. 21 and 23).

5.1 "Byzantium and the Islamic World, c. 1090," from Christophe Picard, *Le monde musulman du XIe du XVe au siecle*. © Armand Colin, 2000. ARMAND COLIN is a trademark of DUNOD Editeur. Reproduced with permission of Dunod Editeur, 11, rue Paul Bert, 92247 Malakoff.

INDEX

Note: Page numbers in italics indicate plates and figures.

Barcelona, 146
Bari, 173
Bartholomew, Peter, 189
Basil II (Byzantine emperor, r.976–1025), 122–25, 149
Bavaria, 141
Bec, Norman monastery, 193
Bede (monk-historian), 65, 66, 68
Benedict (saint, d.c.550/560), and monastic rules, 29–30, 107
Benedict of Aniane (d.821), 107
Benedict Biscop, 58–59, 66, 67
Benedictine Rule (530–560), 29–30, 107
Benevento, Lombard duchy, 73
Berbers
 conquest of Spain, 72–73
 and Islam, 95, 168–70
 at Walila, 100–1
Bernard (saint, abbot of Clairvaux, c.1090–1153), 199–200
Bernicia, Kingdom of, 60
Bible, 112, 148
 for taking oaths, 142
 translated, 9
 Vulgate, 111
Birka (settlement), 125, 150
bishops
 in 10th–11th cent., 145, 152
 definition of, 8
 power and importance, 29, 145, 152
Black Sea, 24–25, 44
blast furnaces, 80
Boethius (d.524/526), 27
Bohemia, 155
Bohemond (warrior), 188
Boleslaw I the Brave (or Chrobry; duke and king, r.992–1025), 155–56
Bologna, 197, 198
Boniface (saint, d.754), 66, 103
Book of Durrow (7th cent.), 67–8, 69–71, 72
books
 Byzantine, 89
 Carolingian, 111–12, 112
 cover, 90
 Islamic, 96, 198
 materials for and writing of, 89
Boris (khan, r.852–889), then Boris-Michael, 88
Bosporus, 188
Bourges, 145

Bretislav I (prince of Bohemia, d.1055), 155
Britain
 diversity of population, 65
 languages, 68, 148
 post-Roman Christianity, 65–67
 provincial art in Roman Empire, 17, 18, 21
 See also England
British Isles
 politics and culture in 7th cent., 65–68
 Vikings in, 135, 140
Brown, Peter, 1
Brubaker, Leslie, 48, 85
Bruno of Cologne (archbishop), 152–53
Bruno of Cologne (Carthusian abbot, d.1101), 199
Bruno of Toul. See Leo IX
Brunswick chasuble, 160
Bukhara, 133
al-Bukhari (810–870), 97, 100
Bulgaria, 87, 88, 124, 155
Bulgars, 43, 88, 127
Burchard (bishop of Worms), 153–54
bureaucracy and administration
 in Byzantium, 89
 and Carolingians, 106
 and Islamic rule, 53–54
Burgundofara (nun), 64
Burgundy, 27, 62
 See also Francia
Buyids, 127, 134
Byzantine Empire (Byzantium)
 army, 42, 86–87, 173–74
 centralization strengths and limits, 119–27, 156
 changes and expansion (c.750–c.900), 85–90
 Christianity in, 88
 culture in 8th–9th cent., 89–90
 description and changes in 7th–8th cent., 44–45, 47
 description in 11th–12th cent., 173–74
 dynatoi, 122–23, 124, 156, 174
 iconoclasm, 47–49, 85–86, 89
 imperial court in 10th–11th cent., 119, 121–22, 124, 174
 losses of territory in 11th–12th cent., 164, 173–74
 map (c.700), 43
 map (c.920), 87
 map (976–1025), 123
 map (c.1090), 165
 as model for Charlemagne, 106

trade in 11th–12th cent., 175, 178
See also East Central Europe; Western Europe

families and heirs, in 11th cent., 145
"family values," in 7th cent. Byzantium, 44–45
farming, 61, 72, 110, 168
 Magyar, 140–1
farms, 4, 44, 60
 See also manors
farmsteads, example in 7th cent., 60
fashion, in 14th cent., 159
fasting
 Christian, 10, 11, 64, 76
 Islamic (Ramadan), 52, 97
Fatimids
 cemetery, 129, *130–31*, 132
 as rulers, 129, 132, 140
fealty (to a lord). *See* homage
feudalism, as term and in Europe, 141
fief (*feodum*), description of, 141
First Crusade (1096–1099), 186–89
 map, 187
Flamenca (text), 159
flax, 129
Fountains Abbey, *199*, 200–1
France
 in 11th–13th cent., 195
 as Ile-de-France, 154–55, 195
 kingships 10th–11th cent., 154–55
 "Peace of God" movement, 145
 See also Francia
Francia
 in 8th–10th cent., 102–12, 115–16
 description in 7th cent., 60–62
 politics and culture in 7th cent., 62, 64–65
 See also France; Gaul
Franks, 23, 26, 76
Free Companies. *See* mercenaries
Friday Mosque. *See* Isfahan mosque
Frisia, 103
Fustat (Egypt), 129

Gallienus (Roman emperor, r.253–268), 5
Gao (or Saney) site (Ghana), 171, 172
garments. *See* cloth and clothing
Gaul, in 6th cent., 28
Gepids, 25
"Germani," description of, 23
"Germanic peoples," 23–24

Germanicus Caesar (*fl.* 1st cent. CE), 115
Germany
 free peasants in, 144
 in Investiture Conflict, 183–84, 185
 Jews in, 186–88
 kingships 10th–11th cent., 151–54
 learning in 10th–11th cent., 152–53, 154
Gervasius (saint), 13
Géza (prince of Hungary, r.972–997), 156
Ghana empire/kingdom, 171, 172
 map (*c.*1050), 169
Gibbon, Edward, 1
gift economy in 7th cent., 61
Gisela (sister of Charlemagne), 111
"Glagolitic" alphabet, 88, 89
God
 God's grace and Christianity, 10–13, 102
 in Qur'an, 100
 in Trinity, 9
Gomez, Michael A., 173
Gothic script, 111
Goths, 24–25
 See also Ostrogoths; Visigoths
governments
 in cities and towns, 179–80
Grand Chartreuse monastery, 199
Gratian (Italian scholar), 185, 198
 See also canon law
graves and cemeteries
 in Almería (Almoravid), *172*
 of Fatimids, 129, *130–31*, 132
 of Vikings and Rus, 125, *139*
Great Palace of Constantinople, 119–21
Great Seljuk sultanate (*c.*1040–1194), 164–67
 genealogy, 166
Greece
 and art in Roman Empire, 13, 17, 23
 language and texts in Byzantium, 88, 89
Greek fire. *See* weapons
Greek Orthodox Church, 182
Gregorian chant, 111
"Gregorian Reform" movement, 181–83
Gregory, bishop of Tours (r.573–594), 28
Gregory VII (pope, 1073–1085), 182, 183–84, 194
Gregory of Nazianzus, 90, *91*, 92
Gregory's *Homilies* (*c.*880), 92
Gregory the Great (pope, 590–604), 30, 66, 76
guilds, 179
Guillaume de Machaut, *157*

La Garde-Freinet, 140
laity
 definition of, 7
Lambesc, 110
Lampadii (396) diptych, *20*, 21–22
Lampadius (Roman consul), 21–22
land
 and economy of Carolingians, 110
 grants in Byzantium, 174
 inventory in England in 11th cent., 192–93
 iqta, 132, 165, 167
landownership, 29, 44, 144
Lanfranco (architect), 201, 202
Latin language, 88
law codes, 27, 31, 148–49, 198
law courts, 185
laws
 Carolingian, 106, 107
 English, 135, 148, 149
 Italian city-states, 179
 sumptuary, 159
 See also canon law
learning and education
 in 12th cent., 197–98
 in al-Andalus, 132–33
 and Carolingians, 111–12
 in Germany in 10–11th cent., 152–53, 154
 madrasas, 164, 171
 schools, 89, 133, 153, 197–98
 in Spain in 7th cent., 68, 72
Lechfeld, battle of (955), 141
legionaries, 4
Leo III (pope, 795–816), 106–7
Leo III the Isaurian (emperor of Byzantium, r.717–
 741), 47–48, 76, 100
Leo VI (emperor of Byzantium, r.886–912), 86
Leo IX (pope, 1049–1054), 182
Leo the Mathematician, 89
León, Kingdom of, 170, 194
letters (correspondence), 129, *129*
letters (in scripts). *See* scripts
liberal arts, 197
libraries, in al-Andalus, 132–33
Licinius (Roman emperor), 8
Life of Matilda (Donizo), *185*
Line, Philip, 150
literature
 in Islamic world, 50, 96–97, 100, 167
liturgy, 11, 29, 88, 194, 201

Lives of the Caesars (Suetonius), 104
logic, as knowledge, 197, 198
Lombard. *See* Peter Lombard
Lombard Italy, 73–75, 103–4
 map (*c.*750), 73
Lombards, 37, 58, 73
 and the Franks, 76, 103–4, 107
 included in the Byzantine Empire, 124
London, and urban independence, 180
lords, in 10th–11th cent., 141–44
Lothar (r. as co-emperor 817–840; as emperor
 840–855), 107, 109
Lothar (son of Louis), 107
Louis (king, later called "the German"), 107, 109
Louis VI the Fat (king of France, r.1108–1137), 195
Louis the Pious (emperor, 814–840), 107, 109
lovers, and clothing, *158*, 159
Low Countries, 146
Luxembourg, 62

Maccabean Revolt (11th cent.), *142*
Macedonian Renaissance, 89–90
madrasas, 164, 171
Maghreb, 170
Magyars (Hungarians), 137, 140–41, 156
 map, 137
 See also Hungary
Majolus (abbot of Cluny), 140
Malikshah I (sultan, r.1072–1092), 164, 165
Mamluks, 93
al-Ma'mun (caliph, r.813–833), 100
Manichees and Manichaeism, 9–10
manors, and Carolingians, 110
al-Mansur (caliph, r.754–775), 92
Manzikert, battle of (1071), 164
marquetry, *96*
marriage
 in 10th–11th cent., 145
 of clerics, 182, 185
 description in 7th–8th cent., 62, 64, 144–45
 types, 64
Martin (saint), 28
Marwan II (caliph), 92
Mary (mother of God)
 in Altar of Ratchis, 74
Mass, 11
 See also liturgy
Mas'ud I (sultan, r.1030–1041), 164
mathematics, in Islamic world, 97

poetry, 50, 96
Poland
 as new state, 155–56
polyptyques, 110
Pompeii, frescoes, 12
Pope and papacy
 in 8th cent., 76
 alliances, 76, 103–4
 as central ruler, 104
 "holy" wars, 186
 as institution, 185
 in Investiture Conflict, 183–84, 185
 "papal primacy" doctrine, 182–83, 185
 power and role, 76, 185
 protection of monasteries, 180–81, 182
 and reforms, 182–83
 in Rome, 76, 146
 See also Church (as institution); individual popes
Po River, 37, 175
ports, and trade in 11th–12th cent., 178
Portugal
 as state, 194
pottery, in 6th cent., 28, 29
poverty (religious), 159, 191, 197, 198–200
Prague, 188
priests
 definition of, 8
 garments of, *34–35*, 159–60, *160*
 See also clergy
primogeniture, 145
Protasius (saint), 13
Provence, 140
Psellus, Michael, 121
Pyrenees, 146, 194
pyxis of al-Mughira (968), *101*, 101–2, 133

al-Qabisi (d. 1012), 133
Qaramita, 128
quadrivium, 197
queens, in Francia, 62
Quinisext council. *See* Council of Constantinople
Qur'an, 49, *51*, 51–52, 100
Quraysh tribe, 50, 52, 55
 See also Umayyads

racism, 173
Raising of Lazarus, Egbert Codex (985–990), *153*, 154
al-Rashid, Harun (caliph, r. 786–809), 93

Ratchis (king of the Lombards, r. 744–749), 73, *74*
Ratislav (duke in Moravia, r. 846–870), 88
Ravenna, as capital, 33, 37
Raymond II of Tripoli (count), 191
real estate and rental markets, 178
Reccared (Visigothic king, r. 586–601), 68
reconquista (conquest of Islamic Spain), 183, 186, 193–95
relics and reliquaries, *30*, 31, 47
reliquary of Theuderic (late 7th cent.), *30*
Le Remède de Fortune (c. 1350–1355), *157*
Renaissance of Carolingians, 111–12, *112*, 115–16
Rhineland Jews, 186–88
Rhine River, 25, *80*, 125, 186
rich people, in 6th cent., 29
Robert of Molesme (d. 1111), 199
Rodrigo Díaz de Vivar, the Cid, 194
Roger II (king of Sicily, r. 1130–1154), 173
Rollo (Viking leader), 140
Roman Catholic brand of Christianity
 approach, 88
 in Britain, 65–67
 in Italy, 73
 in Spain, 68
 split with Orthodox Church, 182
Roman Empire
 archaeological evidence, 45–47, *46*
 army and weapons, 4, 5, 42
 art – Christian, 22–23
 art – classical Roman, 13, 17, 23
 art – provincial, *17*, 17–18, 21
 barbarians, 4, 23–28, 37
 as Byzantine Empire, 41
 capital cities (map), 5
 and Christianity's rise and appeal, 6–9, 37
 cities, 5, 28, 31, 45–47, *46*
 division of, 5
 "fall's" consequences, 77
 internal problems and invaders, 4–5
 law codes, 27, 31
 map (c. 300), 2–3
 map (c. 500), 26
 military service, 4
 "new order" of 6th cent., 27–33, 36–37
 provinces' description and role, 1, 4, 5
 provincialization, 4–13, 17–18, 21–23
 taxes, 28
 trade, 24, 29, 61
 transformation, 1, 4, 77

Zacharias (pope, 741–752), 103
Zangi (emir, r.1127–1146), 191
Zanj slaves, 127–28
Zaragoza, 194

Zeno (Roman emperor, r.474–491), 26
Zirids, 127, 129
Zoe (empress of Byzantines, d.1050), 121